THE PAINTINGS OF
GEORGE BELLOWS

THE PAINTINGS OF
GEORGE BELLOWS

MICHAEL QUICK

JANE MYERS

MARIANNE DOEZEMA

FRANKLIN KELLY

with an introduction by

JOHN WILMERDING

AMON CARTER MUSEUM
Fort Worth, Texas

LOS ANGELES COUNTY MUSEUM OF ART
Los Angeles, California

HARRY N. ABRAMS, INC., PUBLISHERS
New York

This publication was made possible by a generous grant from The Henry Luce Foundation, Inc. It accompanies an exhibition that was jointly organized by the Los Angeles County Museum of Art and the Amon Carter Museum, Fort Worth, and supported by grants from IBM Corporation, The Henry Luce Foundation, Inc., and the National Endowment for the Arts. *The Paintings of George Bellows* travels to:

LOS ANGELES COUNTY MUSEUM OF ART
February 16 – May 10, 1992

WHITNEY MUSEUM OF AMERICAN ART
June 5 – August 30, 1992

COLUMBUS MUSEUM OF ART
October 11, 1992 – January 3, 1993

AMON CARTER MUSEUM
February 20 – May 9, 1993

Published in 1992 by the Amon Carter Museum, Fort Worth; Los Angeles County Museum of Art, Los Angeles; and Harry N. Abrams, Incorporated, New York. A Times Mirror Company

Printed and bound in Japan

LIBRARY OF CONGRESS CATALOGING-IN-PUBLICATION DATA

The paintings of George Bellows / by Michael Quick, Jane Myers, . . . [et al.], with an introduction by John Wilmerding.
 p. cm.

Published in conjunction with the exhibition, The paintings of George Bellows; Los Angeles County Museum of Art, Whitney Museum of American Art, Columbus Museum of Art, Amon Carter Museum.

Includes index.
ISBN 0–8109–3119–2 — ISBN 0–88360–068–4 (pbk.)
1. Bellows, George, 1882–1925—Exhibitions. I. Quick, Michael. II. Myers, Jane.
ND237.B45A4 1992
759.13—dc20 91–26691
 CIP

Contents

Foreword

Although George Bellows was one of the most prominent painters of his generation, there have been surprisingly few comprehensive studies of his paintings. Recent catalogues have concentrated on specific groups of paintings, such as his boxing pictures or his portraits, but the time has clearly arrived for a fresh appraisal of Bellows's overall career as a painter. Between 1905 and his untimely death in 1925, he produced at least six hundred paintings. He may be best remembered today for his sporting scenes, but in fact Bellows had a broad range of subject interests: landscapes and seascapes, portraits of friends and family, scenes of city streets and waterfronts, and even newsworthy contemporary events.

There have been five previous exhibitions that comprehensively surveyed Bellows's paintings and graphic works—at the Metropolitan Museum of Art (the memorial exhibition of 1925), the Art Institute of Chicago (1946), the National Gallery of Art (1957), the Gallery of Modern Art, New York (1966), and the Columbus Museum of Art (1979). In the late 1980s two institutions simultaneously determined that another comprehensive exhibition and new study of Bellows's paintings were needed. The Los Angeles County Museum of Art has two exceptional paintings by Bellows in its collection, including the magnificent *Cliff Dwellers*, the first painting acquired by the young museum in 1916 and still the most admired and reproduced painting in the American art collection. The Amon Carter Museum had acquired a complete set of Bellows's lithographs in 1985 and wished to provide a broader view of Bellows's work to complement its 1988 exhibition of the lithographs, which touched on many of the same themes and subjects.

Generous grants from IBM Corporation, The Henry Luce Foundation, Inc., and the National Endowment for the Arts were the means for turning these wishes into reality. These funds enabled the organizing curators, both Jane Myers from the Amon Carter Museum and Michael Quick of the Los Angeles County Museum of Art, to view hundreds of Bellows paintings in dozens of museums, galleries, and private collections and to consider most of the acknowledged masterpieces of Bellows's painting in selecting works for the exhibition and catalogue. Some of Bellows's fine paintings, regrettably, are unable to travel, but nonetheless, the curators have been able to select both old favorites and significant but less-well-known works for this exhibition. The grant also enabled the authors to travel as needed for their research, consulting the George Bellows Papers at Amherst College Library, examining curatorial files and archives at institutions with extensive Bellows holdings, and working with Jean Bellows Booth, the artist's surviving daughter, who graciously shared her father's hand-written record books and added an important personal dimension to our knowledge of Bellows and his family. What has emerged from all of this research is a deeper understanding and appreciation of Bellows's art and personality. Without attempting to write a biography, the authors have considered not only the events in Bellows's life, but also the broader culture (both high and popular) in which he worked and the individuals—teachers, family, and friends—who influenced his paintings. We

would like to express our gratitude to Mr. Quick and Ms. Myers for their diligent research and insightful scholarship in producing this catalogue and exhibition.

The intention of this volume is to present a varied selection of viewpoints on Bellows's work, and the authors have each brought a particular critical consciousness to the task. Like critics in Bellows's own lifetime, they do not always agree completely in their interpretations of works and the events that influenced them. The authors, however, all share a keen appreciation of Bellows's larger-than-life personality, his enormous range of painterly interests, and his importance to other artists of his own and later generations.

A grant from The Henry Luce Foundation, Inc., has made this publication possible. Many individuals have also given freely of their time and expertise to bring this exhibition and book to fruition. Linda Ayres, formerly at the Amon Carter Museum and now Deputy Director of the Wadsworth Atheneum, provided crucial direction early in this project. At the Columbus Museum of Art, E. Jane Connell and Nannette V. Maciejunes, as well as Steven Rosen, now Director of the Nora Eccles Harrison Museum of Art at Utah State University, lent important support to the project and helped to facilitate arrangements for the national tour. Numerous curators, dealers, and private collectors around the country have augmented this study of Bellows in many ways, providing access to many of the artist's paintings and sharing their perceptive insights with the authors. We are especially grateful to the institutions and private collectors who have generously agreed to lend their paintings to the exhibition.

At the Amon Carter Museum, editor Nancy Stevens took on the monumental task of seeing the publication through to completion; to her thoughtful reading of the essays and her tireless energies we owe a tremendous debt. Tom Dawson of DUO Design Group, Fort Worth, created a distinctive design that enhances both Bellows's work and the author's words. Sandra Scheibe and Jane Posey at the Amon Carter Museum and Ondine Jarl at the Los Angeles County Museum of Art provided invaluable assistance in the mechanics of assembling the catalogue. A large measure of appreciation also goes to Doreen Bolger at the Amon Carter Museum, who provided thoughtful readings of the essays. Glenn Peck and Franklin Riehlman of Allison Gallery, New York, generously assisted in the documentation of Bellows's career. Daria D'Arienzo, John Lancaster, and Deborah Pelletier of the Special Collections Department, Amherst College Library, have aided the research in Bellows's personal papers. Finally, the project would not have been possible without the gracious participation of the artist's daughter, Jean Bellows Booth, who gave the curators access to her father's record and account books, read each essay, and responded to numerous questions, both large and small, posed by the authors over the course of the project.

Jan Keene Muhlert
Amon Carter Museum

Earl A. Powell III
Los Angeles County Museum of Art

The Art of George Bellows
and the Energies of Modern America

JOHN WILMERDING

Opposite page:
Photographer unknown.
George Bellows, n.d. Bellows Papers,
Special Collections Department,
Amherst College Library.

George Bellows's productive years as a painter almost exactly spanned the first quarter of the twentieth century, during which he created a body of work that expressed some, but not all, of the energies of that tumultuous period. His art belongs firmly in the mainstream of the American realist tradition, yet the disruptions of modernism left him unsettled and out of sync with the original forces of the new century. His career, unexpectedly cut short by appendicitis at age forty-two, stands framed by the towering realist legacies of Thomas Eakins and Winslow Homer at the end of the nineteenth century and by Edward Hopper's austere clarities in the twentieth. Born in 1882 into a generation of unusually powerful and original artistic figures, including Hopper (born the same year), Charles Demuth (b. 1883), Marsden Hartley (b. 1877), Arthur Dove (b. 1880), and Georgia O'Keeffe (b. 1887), Bellows triumphed, at least during his lifetime, as the strongest and most eloquent realist. As a sheer handler of paint, a mover of brush and pigment, none was more sensuous and visceral.

Inseparable from his expression as a painter is his fundamental and enduring work as a graphic artist, a medium which also shaped the careers of several key painters in the American tradition, from John Singleton Copley through Fitz Hugh Lane to Winslow Homer. Like them, Bellows learned to draw both broadly and precisely with a brush, to exploit line and detail in the service of narration, and to handle color within a framework of tonal gradations and contrasts. More explicitly, he learned the power of graphic expression from his early study with Robert Henri. As he later noted, in 1904 when he "arrived in New York . . . I found myself in my first art school under Robert Henri having never heard of him before. . . . My life begins at this point."[1] Henri in turn had taken over the leadership of teaching and painting in a direct manner from William Merritt Chase, who himself had earlier traveled to Paris and studied in Munich. Through Chase and others of his generation, American artists discovered the inspiring precedents of mid-nineteenth-century French and seventeenth-century Dutch realism. In particular, Bellows drew a powerful graphic inheritance from Goya, Daumier, and Manet, as well as the more contemporary precedents of Henri and his Ashcan School colleagues, who trained as newspaper illustrators during the early years of the twentieth century. The fusion of these several artistic examples gave Bellows the flexibility to be social observer, journalist, and occasional critic. As both a painter and a printmaker, he soon grew technically to be unrivaled in his time.

Along with his training in graphics, Bellows found a sympathetic spirit in Henri's teaching approach of directness of vision and technique. Together these helped him to shape a vigorous style, full of physicality and personal energy. Partly because of his relatively short career, but just as arguably due to an early formulation of artistic purpose, Bellows's overall style remained, even with occasional detours and experiments, remarkably consistent through much of his life. Although we are well aware of his later efforts to take account of the new compositional and color theories of Jay Hambidge and Hardesty Maratta, we might best approach the breadth of Bellows's work not by its chronology but by the principal subjects which preoccupied him over several decades. Indeed, most of his output may be divided almost evenly into a few large groupings, three of which have solid grounding in the history of American art: portraits, genre, and landscapes. A fourth category combining the

figure with the landscape also commanded Bellows's special attention; as an artist he equally relished nature's physical presence and the proximate company of his immediate family. In each of these areas his art calls to mind the diverse imagery of numerous American predecessors and colleagues.

From his early *Portrait of My Father* in 1906 to the late image of *Lady Jean* in 1924, we can readily see echoes of Chase and Sargent in Bellows's dashing brushwork, of Whistler in the carefully isolated poses, and of Eakins in the nuances of psychological presence and attention to family. Henri's example as teacher and artist is evident in the democratic subject matter and deft manipulation of summary brushwork. At their strongest, Bellows's portraits present figures with an almost sculptural mass—for example, *Geraldine Lee, No. 2* (1914), *Lucie* (1915), and *Aunt Fanny* (1920)—with faces, torsos, and limbs modeled as if with a palette knife. After his marriage to Emma Story and the birth of his daughters, Bellows regularly painted them, along with his aging mother, over the rest of his career. Comfortable and supported as he felt in his family of women, he nonetheless was able to bring a measured balance of scrutiny and affection, seriousness and delicacy to his images of them. In such memorable works as *Anne in White* (1920) and *My Mother* (1921), he convincingly gives us the weight of flesh and spirit, the heavy stuffs of clothing and the private glances of thought.

With his genre pictures, by contrast, Bellows's figures often gather in crowds and are physically active, set in motion within an enclosed landscape or interior setting. Like his other subjects, he produced genre paintings during much of his active career, from the early *River Rats* (1906) and *Forty-Two Kids* (1907) to *Riverfront, No. 1* (1915). His early athletic pursuits doubtless led him to undertake sporting subjects, such as *Polo at Lakewood* (1910) and *Tennis at Newport* (1920), as well as the familiar boxing pictures that bracketed his career.[2] Young men swimming and boxing naturally recall the treatment of these images by Thomas Eakins, one of the artists Bellows particularly admired. But where the earlier artist's *The Swimming Hole* (1883, Amon Carter Museum, Fort Worth) is a distilled composition of academically modeled and carefully poised forms, Bellows's youths are a blur of exuberant activity, inhabitants of the new century's urban landscape rather than an arcadian retreat in Victorian America.

Likewise, his boxing pictures are tense and explosive confrontations of interlocking masses, in contrast to Eakins's cerebral and controlled moments before or between rounds in the boxing ring. Less than a decade before Bellows began his own series in 1907, Eakins painted a sequence of canvases examining various moments in the ceremony and perfor-mance of the sport. These works, including *Salutat* (1898, Addison Gallery of American Art, Andover, Massachusetts), *Taking the Count* (1899, Yale University Art Gallery), and *Between Rounds* (1899, Philadelphia Museum of Art), are heroic and spacious in effect. Light surrounds, even caresses, the figures with a careful touch, to the extent that we feel the clarity and substance of both physical and mental exertion. Bellows is also concerned with the relationships of audience to performers and with critical moments in the contest, but without Eakins's air of anticipation, calculation, and assessment. Instead, Bellows's crowds press in with excitement and passion; his boxers clash in awkward and intense confrontation. Rather than the scientific approach of an anatomist and precarious draftsman, these paintings reveal the eye and hand of a journalist himself engaged in the heat of the moment.

Further, the anonymous packed crowds in Bellows's fight scenes reflect his early response to the pace and density of New York and anticipate his subsequent interest in contributing to the socialist magazine *The Masses*. He clearly enjoyed depicting the mix of ethnic and social classes, from the back rooms of sporting clubs and the larger settings of the circus and popular religious meetings to the more exclusive enclosures of the polo field and tennis lawn. What is striking about almost all of these genre subjects, whether set indoors or out, is Bellows's consistency in composing them as arenas or stages in the round for volatile and dynamic human activity. In this regard he shared a common approach with several of his Ashcan School colleagues, most notably John Sloan, William Glackens, and George Luks, who also were fascinated with assembled groups and gathered spectators in similar cafe, circus, and theater scenes. Night life in the city, with its artificial illumination and animated crowds, especially seemed to capture the accelerated pulse of the modern age.[3] Although later in his career, responding to the barbarism and inhumanity associated with

World War One, Bellows did undertake more explicit historical and religious subjects such as *Edith Cavell* (1918) and *The Crucifixion* (1923), these, too, are strange settings. Starkly dramatic as they are, they remain exceptions to his central concentration on the history and passion of daily life around him.

Bellows brought a comparable intensity to the landscapes he painted throughout his career, investing the surface textures of nature, the most visible marks of changing seasons, and the turbulence of weather with the same gusto and physicality as his figure subjects. For the most part human elements are diminutive or absent in this group, although occasionally small silhouettes in the middle distance indicate the forces of industry at work, as in *North River* (1908). In several late works, like *The White Horse* (1922), foreground figures or animals turned away from us stand as mute and mysterious observers of a landscape's unfolding evocative power. Collectively, Bellows's cityscapes follow in a long American tradition going back to Francis Guy and William James Bennett at the beginning of the nineteenth century, while his snow scenes call to mind the evocative precedents of George Durrie, George Inness, and Winslow Homer later in that century. Among his early twentieth-century contemporaries, Arthur B. Davies, Maurice Prendergast, and Charles Burchfield—different in personal styles as they were—also produced landscapes rhythmically punctuated with figures or forms like musical notations. In Bellows's purest landscapes, there is a paradoxical austerity and richness of effect, in which daily anecdote is left behind, and nature's elemental strengths stand alone. The Monhegan sketches especially bear the mantle of Homer's late expressive and abstracted seascapes; their paint seems almost plastic and creamy, and color almost startling in its vividness. In canvases that have been cleaned and well conserved, Bellows's blues, greens, and whites are unforgettable.

There is yet another way of looking at Bellows's subjects. Less a discrete category in itself, it fuses elements of the foregoing groups into a distinct artistic interest. This blend of landscape and genre directly reflects Bellows's love of nature and of people, as well as his perception of the modern scene as one of energetic interaction between people at work or leisure and their surroundings. Again there is a consistency of approach in works early and late, a subtle balancing of the size and number of figures with the setting, whether urban or rural. In such city views from 1911 to 1913 as *Snow Dumpers* and *Men of the Docks*, groups or crowds of people fill the foregrounds with a visual interest comparable to the architectural or commercial shapes in the background. Fewer but larger figures dominate a number of subsequent Maine fishing scenes, like *Launching* (1913) and *The Rope* (1916). Do we look at these as landscapes or as genre paintings? Bellows's figures do more than give scale or make incidental detail: they participate, even struggle, within these landscapes, which in turn are often roiled or churned up with their own narrative power.

Among the twentieth-century realists, Hopper comes to mind as one also attentive to the respective presence of people and landscapes, but he tended to emphasize one over the other, seldom merging them in form and content as Bellows did. Figural and storytelling elements often join with their landscape settings in the work of Andrew Wyeth, who with Hopper and Bellows shared deep feelings for the Maine coast. But the balancing of narrative and natural elements always seems a special achievement of Bellows's work. It is poignantly appropriate that one of Bellows's last pictures, *Fisherman's Family* (1923), for which the artist, his wife, and daughter served as models, should bring portraiture, genre, and the landscape of Monhegan Island together.

But overriding all of the possible influences and associations we might cite in placing Bellows's work, there are three whom we can acknowledge as he himself did: "Winslow Homer is my particular pet. And one other American or better, two, stand on the same pedestal with him, in my mind . . . Thomas Eakins and Whistler."[4] The latter especially is a salutary reminder that underlying Bellows's familiar realism is frequently a sense of tonal and abstract values. Bellows's compositions, which frequently pose female models centrally against strongly contrasting backgrounds, readily call to mind Whistler's symphonies of figural still lifes. Whistler's several paintings of women in white stand as earlier (and to be sure, more aesthetic) relatives to Bellows's *Queenie Burnett* (1907), with her alternate title, *Little Girl in White*, in obvious tribute; to *Portrait of Mrs. Albert M. Miller* (1913), with her alternate title of *Lady With Scarf*; and more distantly to later portraits of his daughters like

Anne in White (1920) and *Lady Jean* (1924). And surely Whistler's famous portrait of his mother provided some inspiration, as it had for other American artists from Homer on, for Bellows's concentrated images of his own mother, Aunt Fanny, and Mrs. Mary Brown Tyler.

If Whistler offered him ways of shaping and posing forms within a pictorial structure, the powerful legacy of Eakins's portraits put Bellows in touch with the inherited tradition of seventeenth-century Dutch painting. Reacting to the Eakins exhibition in New York in 1917, Bellows asserted that it "proves him one of the best of all the world's masters. The greatest one man show I've ever seen and some of the very greatest pictures . . . 'Mrs. Frishmuth' [1900, Philadelphia Museum of Art], the musical instrument collector, is the most monumental work I ever looked at. 'The Gross Clinic' must equal 'The Night Watch.'"[5] Such enthusiasm for Rembrandt is apparent in the forceful frontality and psychological presence of a portrait like *Aunt Fanny* of 1920.

By contrast, Bellows's "particular pet," Winslow Homer, served him best in the vigorous recording of the elemental landscape. Bellows must have been pleased to be linked as early as 1908 with his great predecessor, when a *New York Times* reviewer of the National Academy of Design exhibition compared Bellows's *North River* with Homer's *The West Wind* (1891, Addison Gallery of American Art, Andover, Massachusetts).[6] Five years later, when Bellows joined his friend Leon Kroll for a summer on Monhegan Island, he began to practice Homer's advice on painting the sea: "Do it with one wave, not more than two."[7] A glance at the broad masses, reductive handling, and rich brushwork in Bellows's several Monhegan oils from 1913 confirms his mastery of the Homer tradition.

Successful as Bellows was in standing artistically, as it were, on the shoulders of giants, we can see that his art is nonetheless caught between some of the larger tensions and transitions of his time. For example, as a realist painting the human figure, he stands between Chase, Sargent, and Eakins on the one side and Hopper and Guy Pène du Bois on the other; as a landscapist, he stands between Homer before him and John Marin, Marsden Hartley, and Andrew Wyeth after him in the twentieth century. Bellows's subjects share something of the sense of manners and the elegance of observation of such literary figures as Henry James and William Dean Howells, but at the same time that they look forward to the directness of vision and physical roughness of Ernest Hemingway. During the decades of Bellows's maturity, the nation as a whole was in tension, wavering between isolationism and internationalism, between war and peace, and between the physical gusto of Theodore Roosevelt and the intellectual idealism of Woodrow Wilson. At home and abroad, art was torn between realism and abstraction. Even the group with whom Bellows is most usually associated in New York, the Ashcan School, was radically divided in styles; there were distinctive differences even among the painters associated as The Eight, as well as in comparison with their immediate contemporaries in the Stieglitz circle.

Arguably, the first two cataclysmic events in history and art of the twentieth century's first quarter—the Armory Show and World War One—only marginally impinged on Bellows's consciousness. To be sure, he did paint a late series of Belgian occupation pictures, and even later *The Crucifixion*, but they have an air of stilted contrivance and lack deep personal feeling. Like other artists, he was unnerved by the Armory Show and attempted to absorb certain current theories of artistic design, most notably Jay Hambidge's Dynamic Symmetry and the color notions of Hardesty Maratta. The former proposed compositions based on an intricate structure of interlocking geometric angles and planes, partially as a means of addressing the new formal challenges presented by European cubism.[8] Indeed, *Emma and Her Children* (1923), a rare group composition in Bellows's oeuvre, is familiarly cited as Bellows's embodiment of these new ideas and of Hambidge's theories especially. More than a successful design of interlocking diagonals and balanced triangular massings, the painting also blends the Whistlerian tonal values with intimations of familial relationships and psychological character worthy of Eakins. The result is one of Bellows's finest demonstrations of his ability to synthesize from tradition as well as current thought, ultimately expressing the force of his own personal style.

Still, it must finally be admitted, the contribution of his art is more a fresh and vigorous mastery of an American realist tradition than a bold confrontation with innovation or the

jolting shifts unfolding with modernism. One way of seeing the broad dichotomy of cultural expression that emerged during the decades of Bellows's maturity is to note the divergent forms that appeared in art, music, and literature. On the one hand, there was the more traditional, conservative, and popular voice to be found during the teens in Edgar Lee Masters's *Spoon River Anthology*, Robert Frost's *A Boy's Will* and *North of Boston*, and Sherwood Anderson's *Winesburg, Ohio*; and during the twenties in F. Scott Fitzgerald's *The Great Gatsby* and Sinclair Lewis's *Babbitt*. During these same years, it is worth observing, Norman Rockwell also began his first covers for the *Saturday Evening Post*, and *Reader's Digest*, *Time* magazine, the *New Yorker*, and the Book-of-the-Month Club were founded. This world of the American scene is generally where we are likely to place Bellows. On the other hand, the avant-garde was experimenting with an original language altogether different from Bellows's: for example, T.S. Eliot's "The Love Song of J. Alfred Prufrock" and *The Waste Land*, Gertrude Stein's *Tender Buttons* and *The Making of Americans*, the early verse of e.e. cummings, and musically in the new atonalism of Igor Stravinsky and Arnold Schoenberg.[9] To be sure, while few American artists grasped the significant breakthroughs and disruptions of early twentieth-century abstraction, Bellows's vision remains a world apart from the radical changes underway in his lifetime: Monet's *Nympheas* series, Fauvism, Cubism, Expressionism, de Stijl, Precisionism, and Dada.

To be fair, only a few American artists of Bellows's generation confronted, and then not always with full comprehension, the innovations of European artists being introduced during the first decades of the twentieth century. The most avant-garde of his colleagues tended to be those who had spent considerable periods of study or travel abroad, where they had opportunities to see firsthand the new currents evolving from Postimpressionism to the first phases of Cubism and Expressionism. Among the members of The Eight, for example, Maurice Prendergast spent time in the years around the turn of the century in Paris and Venice. From various sources of inspiration he developed a style of mosaic patterns of bright pure color and separate dabs of paint in the manner of Edouard Vuillard. Although Prendergast was able to flatten pictorial space and achieve a colorful sense of abstract design, his subjects of parks and holiday festivals remained nineteenth-century in their nostalgic reverie.

Pushing somewhat further was the strong core of painters in the circle of Alfred Stieglitz, who gave encouragement, exhibitions, and financial support for European travel to his favorite protégés. Most prominent were Marsden Hartley, Arthur Dove, John Marin, and Georgia O'Keeffe. Hartley's trips to Germany inspired him to explore adaptations of the emotional colorism and symbolic associations he found in the current work of the German Expressionists, particularly Wassily Kandinsky. Dove with his collages and O'Keeffe with her early watercolors and charcoal drawings were among the first Americans to make almost fully abstract pictures. For his part, Marin attempted to adapt Cubist fragmentation and multiple viewpoints to his early watercolors of New York City, especially in the Woolworth Building series.

The Armory Show of 1913, with its broad if incomplete survey of recent experiments by Braque, Matisse, Duchamp, and others, startled and unsettled many Americans. The displays of abstracted space and forms, unrealistic and nondescriptive uses of color, shifting points of view, and visualized motion and velocity all challenged traditional conventions of picture-making. In part lacking direct exposure to the foreign avant-garde and in part confident in his own native talent, Bellows kept his vision intact from these disruptions of modernism. More broadly, his life and art passed largely unaffected by the profound intellectual upheavals in those years, especially those changing perceptions of time and space.[10] While Bellows did perceive something of nature's elemental forces and painted many of his later seascapes with an appropriate sense of gestural energy, in the manner of Homer, he produced no single work matching the daring spatial abstractions of Homer's own twentieth-century pictures, *Kissing the Moon* (1904, Addison Gallery, Andover, Massachusetts) and *Right and Left* (1909, National Gallery of Art, Washington).

With occasional exceptions, Bellows largely stood back from directly engaging most contemporary social issues, such as women's suffrage and the eventual passage of the Nineteenth Amendment in 1920; the radical labor movement and union vigilantism;

increased waves of immigration, racism and discrimination, and accelerated movement in transportation, communication, and "motion" pictures. Except for *Both Members of This Club*, blacks do not much appear in Bellows's pictures, yet it was an age marked by intensified discrimination and segregation, the presence of Booker T. Washington and W.E.B. Du Bois, formation of the NAACP in 1909, the refounding of the Ku Klux Klan, and D.W. Griffith's production of *Birth of a Nation* in 1915.[11] Only in *Cliff Dwellers* do immigrants and the impoverished preoccupy Bellows, and even then they are not a subject for strong social commentary or criticism as we find in occasional works by Luks or the photography of Jacob Riis. In the few steamships at the wharves or on the Hudson River, there is a periodic recognition of the age's new uses of electrical or other forms of power, represented in such individuals as Thomas A. Edison, Alexander Graham Bell, and Henry Ford. Interestingly, though, two of the century's pioneering achievements in transportation make a parenthesis around Bellows's active career: the Wright brothers first lifting off the earth in a plane in 1903 and Robert H. Goddard's first launching of a liquid-fuel rocket in 1926. Both actions would contribute not just new forms of motion but new ways of seeing the earth and space.

Yet if it is obvious to conclude that Bellows was not an inventor, reformer, or iconoclast, he did embody a broad exuberance and self-confidence central to his age and to the American character. In this regard, his down-to-earth and muscular style of painting is perhaps in good company with the American symphonies of Charles Ives and the early novels of John Dos Passos. Even more, we might see his art aligned with the spirit of Theodore Roosevelt, not in the president's internationalism, but in his blustery and energetic manner, his encompassing social vision and love of the outdoors. Roosevelt's concern for the environment led, at the outset of Bellows's career, to the passing of the Newlands Reclamation Act in 1902 and to the creation of the U.S. Forest Service as a separate agency under Gifford Pinchot in 1905.[12] The strength of character represented in such phrases as "bully pulpit" and the "big stick" might also suit elements in Bellows's art and personality. Just as Roosevelt oversaw the building of the Panama Canal between 1903 and 1914, Bellows celebrated with comparable enthusiasm the possibilities of modern construction over nature in his sequential canvases of skyscrapers, urban construction, and excavation for Pennsylvania Station in New York City.

Throughout, he surely painted with a zeal and gusto worthy of an age led by other big thinkers and doers, among them Woodrow Wilson, William Howard Taft, William Du Bois, Walter Lippman, Oliver Wendell Holmes, and Louis Brandeis.[13] Before the failure of the League of Nations, the sense of resignation and deflation that came with the 1920 election, and his own untimely death, George Bellows expressed an optimism and sense of control seldom to be enjoyed so directly again. But lest we look at his art just as pictures of churning cultural forces during the first quarter of the century, consider that his handling of paint in its luscious, tumultuous, eloquent purity would not find reincarnation in American art for another half-century or more, in the hands of Willem de Kooning, Franz Kline, Jasper Johns, and Wayne Thiebaud.

NOTES

[1] Quoted in Charles W. Morgan, *George Bellows: Painter of America* (New York: Reynal and Company, 1965), p. 37.

[2] See *Bellows: The Boxing Pictures*, exhibition catalogue (Washington, D.C.: National Gallery of Art, 1982).

[3] See John Wilmerding, "Bellows' Boxing Pictures and the American Tradition," in *Bellows: The Boxing Pictures*, pp. 13–25.

[4] Quoted in Morgan, *George Bellows: Painter of America*, p. 272.

[5] Morgan, *George Bellows: Painter of America*, p. 215. Bellows had his mind's eye on other European masters as well, when he added, "'Man at a Table' good as the best of Renoir and Cezanne. Something here also to remind one of Manet and Titian."

[6] Morgan, *George Bellows: Painter of America*, p. 82.

[7] Morgan, *George Bellows: Painter of America*, p. 171.

[8] "Jay Hambidge . . . became the most important single influence on George's work for the rest of his life;" Morgan, *George Bellows: Painter of America*, p. 216.

[9] A useful compendium is in Laurence Urdang, ed., *The Timetables of American History* (New York: Simon and Schuster, 1983), pp. 266–306. See also John Milton Cooper, Jr., *Pivotal Decades: The United States, 1900–1920* (New York: W. W. Norton and Company, 1990), p. 138.

[10] For example, by the time Bellows began painting, Niels Bohr had developed his theory of atomic structure (1900), Wilhelm Röntgen's earlier discovery of X-rays had been recognized by a Nobel Prize in 1901, Madame Curie had discovered radium and radioactivity (1902–03), Freud had published works on the unconscious and his theory of psychoanalysis (1899–1904), and Einstein developed his theory of relativity (1905). See Urdang, *Timetables*, pp. 265–269.

[11] See Cooper, *Pivotal Decades*, pp. 52–131, passim. He points out that during the first decade of the century alone more than eight million immigrants came to America, most through New York—the largest number ever in such a period and representing approximately ten percent of the total population (p. 3).

[12] Cooper, *Pivotal Decades*, pp. 37–52.

[13] Cooper, *Pivotal Decades*, p. 374.

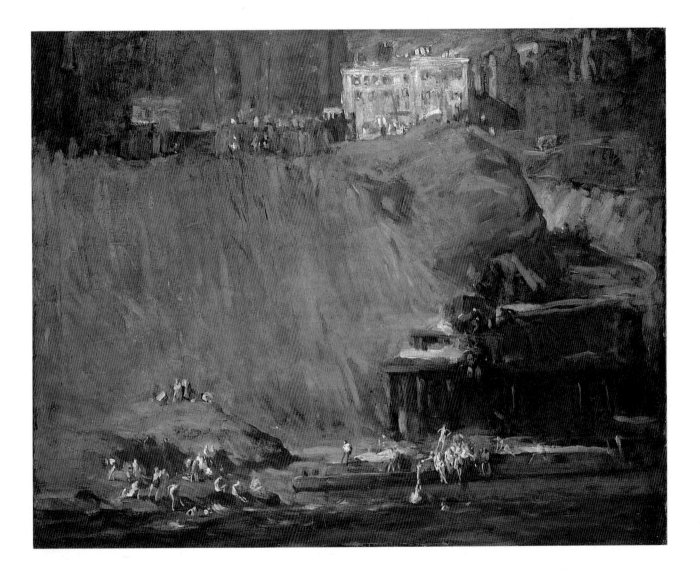

Technique and Theory: The Evolution
of George Bellows's Painting Style

MICHAEL QUICK

FIGURE 1
George Bellows. *River Rats*, 1906.
Oil on canvas, 30½ x 38½ in.
Private collection, Washington, D.C.

George Bellows was the kind of large personality that fills a biography to the brim.[1] An athlete, artist, treasured friend, and loving family man, he moved in many spheres of joyous activity. Even just as an artist, he proved himself as an exceptionally gifted draughtsman, a pioneering printmaker, and perhaps the finest painter of his generation, moving from medium to medium and genre to genre with perfect ease. There is a great deal to be said about this fascinating life and career.

Bellows's paintings, on the other hand, are less well understood. Certain subjects and themes have received insightful study, but the way the individual paintings look, as paintings, and the overall development of Bellows's style still await analysis. It has been easy to write about the man and difficult to write about his style, because he kept changing it, at some points in his career dramatically altering it at approximately two-year intervals, with sharp breaks and reversals separating these phases. The rapidity and range of these frequent changes can seem bewildering.

The key to understanding Bellows's stylistic development is recognizing the central, determining role of art theories and systems in his work. Bellows was, by nature, a thinker and planner, although this certainly is not the way he usually is described. Probably because his early masterpiece, *Stag at Sharkey's* (1909, see page 108) is so familiar—it is found in almost every survey of American art—Bellows generally is characterized as an impetuous, brilliant, natural talent. Beginning in the 1950s and 1960s, in the train of triumphant Abstract Expressionism, commentators saw him as an iconoclast, an enemy of the academy (like other Ashcan School artists), who painted boldly and from the gut rather than with his mind. This traditional view of Bellows does help to explain the appearance of some famous early works, but it fails to illuminate large parts of his career; in fact, it has encouraged the view that many magnificent late paintings should be considered less successful, even failed works.

As a matter of fact, *Stag at Sharkey's* and Bellows's other widely admired early works of that year were not painted spontaneously, in the heat of the inspired moment. He carefully planned those very paintings, arranging the elements of their design according to geometrical principles. By 1909, just four years after he began painting, Bellows already was deeply involved in compositional systems, using geometrical methods as a central feature of his style. Indeed, his personal style first emerged with his adoption of strong compositional structure. He also began to study color systems at this same, early point. Those writing on Bellows have discussed his use of the Maratta color system after about 1911 and the Dynamic Symmetry compositional system after about 1917, but his use of theory is far more extensive and complicated than that. During the course of his career, he employed at least three distinct compositional systems and four color systems, made a major change from a direct to an indirect method, and developed a late preoccupation with painting materials. His active involvement with compositional and color theories pervaded every part of his mature career and was inseparable from the appearance of his paintings.

Because it is possible to establish precise dates when Bellows began to use some of these systems, it seems clear that the adoption of a system had an immediate effect upon his work. New concepts and their accompanying ranges of possibilities often sent his style off in a new direction.

Accepting this view, that Bellows was a thinking artist—that planning rather than impulse, the mind rather than the gut drove his art—removes Bellows from the Ashcan School context and places him among the modernist painters of his generation, who were deeply involved in theoretical matters.[2] Theories are what kept the cafes of Paris buzzing; for example, the Synchromists' elaboration of the color theories of Percival Tudor-Hart[3] was directly analogous to Bellows's use of Maratta's color theories. A theory of one kind or another generally is what defined a modernist movement: the balance of theoretical rigor and stylistic expression set it apart and lent it integrity. Bellows's various theories were homegrown, rather than Parisian, but they worked upon his art the same way. The friend and champion of modernist artists, such as Andrew Dasburg and Max Weber,[4] Bellows was closely aligned with their approach to art. Some of his paintings rival theirs for brilliance of color, and he employed the same compositional system, Dynamic Symmetry, that some of the modernists were using.

Most of Bellows's color and compositional theories were held in common with other artists. Usually he followed the lead of his mentor, Robert Henri, who drew his former students and associates into his own exhaustive investigations of color theory and painting materials.[5] In just a few instances Bellows took the initiative, pursuing a system much more thoroughly than Henri, while keeping the older artist abreast of his studies. This was the case with Dynamic Symmetry, indirect painting, and Bellows's three-color system of 1923–24. Generally speaking, Henri studied color more extensively than Bellows, but the latter investigated compositional systems more completely.

Nonetheless, even among the modernists, who shared Bellows's interest in theory and perhaps some of the very theories, it would be hard to find an artist who changed his style as often and as completely as did Bellows. The same new systems that Robert Henri incorporated so smoothly into his style during these years seem to have sent Bellows's style rocketing off in one new direction after another. Finally, one must return to the personality of the man himself. From the excited and discouraged feelings that alternate in his letters, from the long, fallow periods that follow bursts of intense activity, from the once-favorite paintings he later destroyed, it would appear the Bellows may have suffered from wide swings of mood. One might imagine that his absorption in a new theoretical system would fire up fresh enthusiasm and energy, spurring his efforts to apply it as fully as possible, until, seeing its limitations in the course of time, he would become discouraged with it, reject it, and rest his hopes upon finding something quite different. Thus the point of adopting each new system would be to obtain a fresh start in a new direction.

Bellows's thoroughly rational and systematic application of theory thus may have served to unleash expressive potential. The fact that, beginning from entirely different theoretical starting points in his campaigns of 1913, 1916–17, and 1923–24, Bellows ended up each time painting with intense color in dazzling combinations, may indicate that a voluptuous enjoyment of color is one of the constants defining his essential painting style. A granite-ribbed pictorial structure is another. In all cases, in Bellows's work, thought produced strength. The largest trend of his entire, thought-intensive career is steadily increasing power, climaxing in the monumental paintings of his final years.

THE EARLY STYLE

In the fall of 1904, Bellows enrolled in William Merritt Chase's New York School of Art and began to study under Robert Henri, who was to become a lifelong friend and a potent influence upon his entire career. The following year he started keeping a record of his paintings, at that time mostly sketchy city scenes and portrait studies. This earliest style naturally was a borrowed one, that of the brilliant student still finding his own way among powerful influences. Over the next four years his style gradually took on more individual

FIGURE 2
Van Dearing Perrine. *Road Round the Cliff*, c. 1904. Oil on canvas, 35 x 42 in. Private collection.
Photograph courtesy of Graham Gallery.

character, until in 1909 it was distinctly his own, notable for vigorous handling of solid paint, clear color, and strong pictorial structure.

Bellows's earliest style came out of the milieu of Robert Henri and the dominant international style of the turn of the century, especially after the memorial exhibitions of the works of James McNeill Whistler in 1904 and 1905. As seen in *Robin, Portrait of Clifton Webb* (1905, see page 176) and *River Rats* (1906, fig. 1; see also page 100), it is a tenebrous style, in which soft forms swim in darkness, close to the surface of the painting. These earliest works are also what are called tonalist paintings, in that a single, dominant hue pervades every part of the image.[6] *River Rats*, a daylight scene carried out in warm umbers, can be compared, for instance, with *Road Round the Cliff* (ca. 1904, fig. 2), a nocturne painted in cool blues by the successful New York artist Van Dearing Perrine (1869–1955).[7] In both paintings, large, soft shapes are defined almost entirely by highlights; light paint is drawn over a dark underpainting so thinly that darkness seems to encroach upon the lighted forms, partially dissolving them. In places, the dragging of thicker, light paint over dark creates an intermittent, shimmering effect that enhances the sense of softness and uncertainty of definition. The qualities of this style, suggesting insufficiency of light, difficulty of perception, and the insubstantiality of objective reality, contribute to a fin-de-siècle sense of slight anxiety, melancholy, and inwardness that persisted in Bellows's works through 1908, even as the energy of his personal style began to emerge.

This tenebrist style continued to shape Bellows's paintings of 1907, although the effect of a stronger, flat light created areas of greater contrast than before. In *Little Girl in White*, (*Queenie Burnett*) (see page 180) and *Portrait of Prosper Invernizzi* (fig. 3), this is the strong studio light of Caravaggio, no doubt as interpreted by Edouard Manet and embraced by Henri. Despite the strength of the light, however, shadows still seem to encroach upon the edges of the forms, threatening their solidity. When this style is applied to an out-of-doors scene, its artificiality is apparent. The water in the delightful *Forty-Two Kids* (page 101) is so black that the uninhibited urchins would appear to be swimming either in tar by daylight or in water by lamplight. The overall tone is a cool blue, warmed in places by red and yellow.

FIGURE 3
George Bellows. *Portrait of Prosper Invernizzi*, 1907. Oil on canvas, 38 x 30 in.
Private collection, Beverly Hills. Photograph courtesy of Peter A. Juley & Son Collection, National
Museum of American Art, Smithsonian Institution, Washington, D.C.

Bringing the images to the picture surface remained an objective of the early tenebrous style: the figure of Invernizzi is made to stretch to nearly the top and bottom of the canvas, and that of Queenie Burnett is viewed from a very high vantage point. A similar vantage point in *Forty-Two Kids* also flattens the image, although in this painting strong diagonals serve to open up space.

Entirely unexpected in *Forty-Two Kids* is the inspired novelty of the close-up, comic-strip quality of the naked boys, as well as the deft calligraphy of the brushwork with which they are rendered. Although its precise theme was Bellows's choice, the painting's spirit is close to that of Henri's circle, in its apparently unedited portrayal of the life of the city. Like many of Bellows's urban subjects and also those of John Sloan,[8] for instance, it affects the reportorial quality of observing an unguarded moment. Unlike the American Impressionist artists such as Childe Hassam and Maurice Prendergast, who painted the apparently random movement of modern life on the city's more fashionable streets during these

FIGURE 4
George Bellows. *Basketball*, 1906. Black crayon on paper, 12½ x 16 in. Private collection.
Photograph courtesy of Jordan-Volpe Gallery, Inc.

years, members of the Ashcan School imparted a journalistic and a sometimes voyeuristic quality, with the tang of modern realism, through their choice of distinctly lower-class subjects.

More than a whiff of this realism of subject comes pouring out of Bellows's *Club Night* (see page 104), begun in August 1907, immediately after *Forty-Two Kids*. However, Bellows's stylistic objectives of the period considerably limited the realism of its presentation. Philip L. Hale, reviewing an exhibition, remarked: "It looks too much like a clever woman's idea of a boxing match. The game isn't played that way."[9] Like other works from these early years, *Club Night* was developed in terms of a dramatizing, but highly artificial, studio light.[10] Again the insufficiency of light, the thin paint, and scumbling impart to the figures an insubstantial, wraith-like aspect. As in his drawing, *Basketball* (1906, fig. 4), Bellows sought to find rhythmic curves and decorative shapes in the dissolving forms. As a result of the schematic treatment of the struggle, seen against the ghoulish faces of the half-seen onlookers, both of these sports subjects take on an abstract significance and Symbolist feeling. Like George Luks's painting, *The Wrestlers* (1905, Museum of Fine Arts, Boston)[11] and the painting *Ringkampf* (ca. 1909, fig. 5), by German artist Ernest Burmester (1877–after 1910), they are images of struggle itself. Their excessively aggressive, life-and-death nature may reflect the Social Darwinist belief in the desirability of conflict, very much in the air as the international community lurched from crisis to crisis toward the actual outbreak of war in 1914.

Over the course of the following year, 1908, and on into early 1909, Bellows's skill

FIGURE 5
Ernst Burmester. *Ringkampf*. In *Die Kunst für Alle* 24, no. 22 (August 1909): 528. Photograph courtesy of Library, National Gallery of Art, Washington, D.C.

14 *George Bellows*

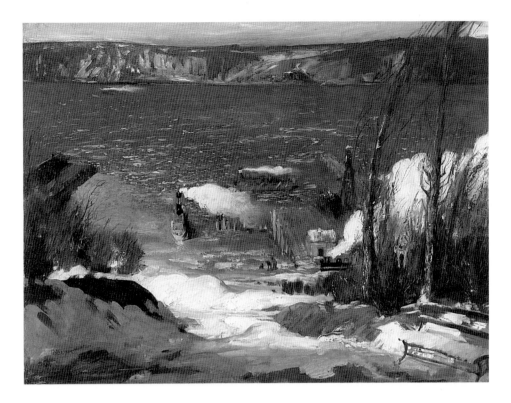

FIGURE 6
George Bellows. *North River*,
1908. Oil on canvas, 32⅞ x 43 in.
Pennsylvania Academy of the
Fine Arts, Philadelphia;
Joseph E. Temple Fund.

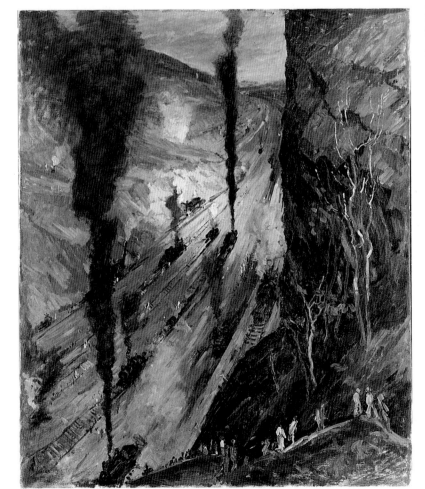

FIGURE 7
Jonas Lie. *The Conquerors; Culebra Cut*, 1913.
Oil on canvas, 59¾ x 49⅞ in. Metropolitan
Museum of Art, New York; purchase,
Hearn Fund, 1914.

and range in the handling of paint increased dramatically, as he progressed from the thin paint textures of the tenebrous style toward much thicker, heavily textured paint. If the thin paint had conveyed suggestion and mood, the thick paint established fact, replaced softness with solidity, dimness with bright daylight, and shallowness with open space.

The very beginnings of this progression can be seen in Bellows's first paintings of 1908, *North River* (fig. 6), painted in February, and *Up the Hudson* (see page 134), painted in April. They began the series of river views that were the foundation of his early success. Still in his early manner, both have a high vantage point and high horizon, with little overlapping of forms to counter the flattening of the image; a unified tonality of muted, pastel colors; shifting areas of light and dark; and active patterns of highlighting, including the dragging of drier paint to achieve a shimmering, lambent effect in places. With their overall decorative quality and shifting, amorphous shapes, these early paintings are more the style of the period than of just Bellows himself; similar qualities can be found in the work of such artists as Henry Ward Ranger and Jonas Lie (fig. 7). New for Bellows, however, is the greater variety of his more skillful touch, including the use of the palette knife in the thicker whites of *North River*.

By the following summer, Bellows was taking these tentative beginnings at a more vigorous paint texture much further, accompanying them with a pronounced change in palette and brightness. In his next landscape, *In Virginia* (fig. 8), painted while he taught a

FIGURE 8
George Bellows. *In Virginia*, 1908. Oil on canvas, 29¼ x 37 in. Private collection.

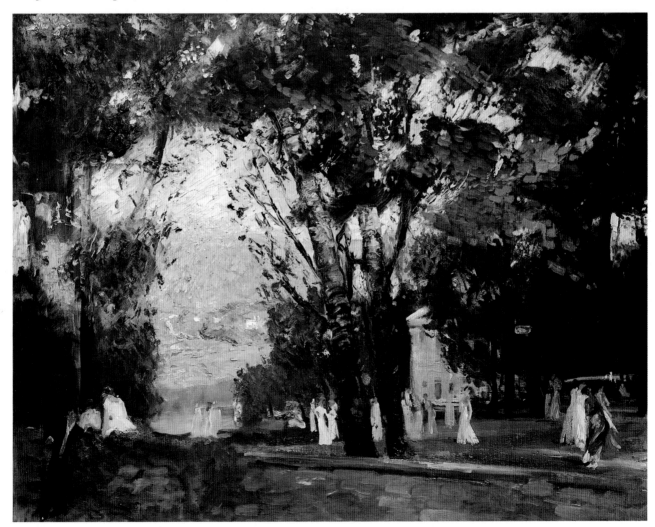

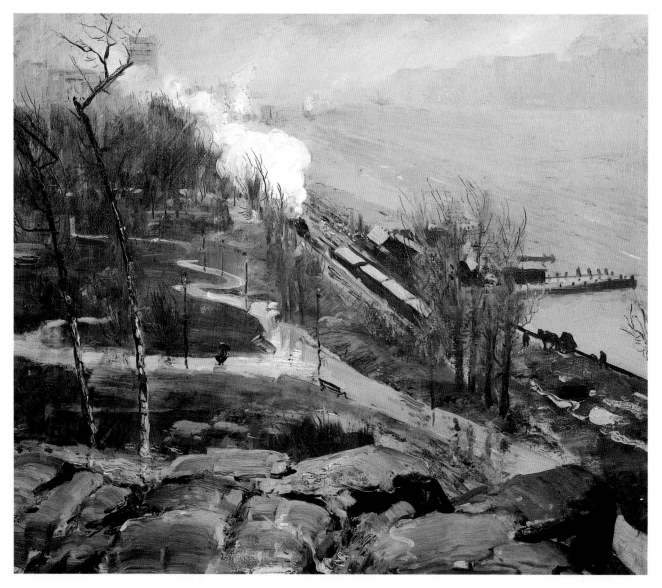

FIGURE 9
George Bellows. *Rain on the River*, 1908. Oil on canvas, 32³⁄₁₆ x 38³⁄₁₆ in.
Museum of Art, Rhode Island School of Design, Providence; Jesse Metcalf Fund.

summer course at the University of Virginia that year, Bellows reversed his usual method, this time painting a pattern of darks over lights to obtain a similar effect of decorative patterning. *In Virginia* is enlivened by considerable attention to paint textures. In fact, the paint in the lightest area of the sky appears to have been worked with the palette knife specifically to develop texture. The cross-brushing evident in places in *Up the Hudson* is taken much further here: Bellows wove the hazy mountain out of short, criss-crossed motions of the palette knife and, after painting foliage in one direction, laid over it a layer of larger strokes in another direction. His familiar dragging of dry paint is absent here.

The development of a more solid paint quality, largely through use of the palette knife, was decisive in the emergence of Bellows's own, distinctive style over the following year.[12] With heavy paint came more solid form and stronger color. This paint quality and the element of fantasy of *In Virginia* carried over to his next landscape, *Excavation at Night* (see page 112), although the two paintings are thematically unlike in every way. Instead of leisure in the country in the afternoon, Bellows chose to paint work in the city at night. Its almost demonic quality was virtually a convention of industrial subjects at the time, dramatizing both the labor of lighted and smoking factories against a night sky, as in the Pittsburgh nocturnes of Aaron Harry Gorson (1872–1933), and the scale of great excavations, as in the Panama Canal works of Joseph Pennell and others (see fig. 7). The true subject of *Excavation*

at Night is the intensity and artificiality of the white arc lights upon the cut stone, contrasted with the warmer and weaker light of the streetlights and bonfire, and the way that strong, central light creates space over a considerable distance, before being swallowed by darkness. The ragged, scraped paint of the arc-lighted rock face stands out against the streetlight-illuminated buildings, where fluid strokes of yellow and red blend into the blue of their shadows.

One measure of the development of Bellows's style can be seen in the differences between *Rain on the River* (fig. 9), painted at the end of 1908, and the pair of river landscapes he painted earlier that year. All three overcast landscapes share an elegiac, faintly melancholic feeling for the rural area on the margin of the city, but in *Rain on the River*, the considerably stronger color; the more vigorous paint handling, especially in the use of the palette knife and scraping in the foreground; and the strong diagonal convey the mood more vividly and forcefully.

Although Bellows continued to paint his figures and portraits in a darkened studio, with a more somber palette, a similar increase in audacity is evident when comparing his last painting of 1908, *Paddy Flannigan* (see page 184), with any of his earlier character studies of street urchins. The exposed flesh, grin, and pugnacious stare of the pose are matched by a new precision in the control of color and value in the brightly lighted areas. Even though this stronger light gives greater solidity than before to these areas, shadows still soften the forms in the darker passages. In the boundaries between light and dark Bellows once again found the sinuous curves so familiar in paintings and decorative arts of the period.

Bellows took another critical step in the development of substantial paint textures and a distinct, personal style with a new subject that would be of lasting interest to him, the winter landscape. In the middle of January 1909, he left New York with friends to spend somewhat less than a month in Zion, New Jersey, at a summer house belonging to the family of a roommate, the future playwright Eugene O'Neill. Like Bellows's later encounters with

FIGURE 10
George Bellows. *Winter in Zion*, 1909. Oil on canvas, 22 x 28 in. Lehigh University Art Galleries. Photograph by Robert Walch.

landscape at sketching grounds in Maine, this turned out to be an unusually productive period, in terms of both the number of small-scale paintings completed and the inventiveness of their technique. As it happened, snow made possible what probably are the first of Bellows's winter landscapes; a large proportion of the Zion paintings depict snow scenes. Several of them, including *Winter in Zion* (fig. 10), were painted principally in terms of blue and an orange that, depending on its mixture, ranged from the near red of a burnt sienna to a muted tan. Bellows's use of complementary colors, even before he was introduced to the color theories of Hardesty Maratta, leads one to wonder how and when he first discovered color theory. The painting also contains a multitude of textures: while some passages are flatly painted, most of the snow was applied with the palette knife and then worked in places to produce additional texture. There is a considerable amount of scratching with the end of a brush and with a dry brush. The deepest scratches seem to expose a black underpainting, producing both texture and sharp contrast.

Bellows's records indicate that he painted another winter landscape, *Winter Afternoon* (fig. 11), before his trip to Zion. This painting employs the Zion palette of blue and of orange into yellow and red and a similar development of paint textures. Once again the palette knife has sculpted the bush at the left, the tree trunk at the right, and especially the

FIGURE 11
George Bellows. *Winter Afternoon*, 1909. Oil on canvas, 30 x 38 in.
Norton Gallery of Art, West Palm Beach.

FIGURE 12
George Bellows. *The Palisades*, 1909. Oil on canvas, 30 x 39 in. Terra Museum of American Art, Chicago; Daniel J. Terra Collection.

snow on ice. The trees and branches have been dug through the upper, lighter paint layers. Its technique, however, is much more sophisticated than that of the Zion paintings—so much so that one must wonder whether Bellows's records are in error or if he repainted it subsequently. In fact, *Winter Afternoon* is quite similar to *The Palisades* (fig. 12), painted immediately after the Zion pictures. *The Palisades* builds upon the more forceful color and paint handling of *Winter Afternoon*, but in its more dramatic contrast and spatial development and in its much stronger structure, *The Palisades* represents a critical step in Bellows's rapidly evolving style: it is the first interpretation of the river motif in a style that is specifically Bellows's own.

A similar advance in color and paint handling, if not in structure, can be seen in comparing *Pennsylvania Station Excavation* (fig. 13), Bellows's next painting, with his previous attempt at the same subject only months before, *Excavation at Night*. Again a special lighting situation adds excitement to the scene, although now it is the more familiar and natural poetry of dawn at the start of a winter workday at the huge construction site.

Having developed a style that was distinctively his own, Bellows used it to create several masterpieces, one after another, beginning in August 1909. First and foremost among these was the justly celebrated pair of boxing pictures, *Stag at Sharkey's* (see page 108) and *Both Members of This Club* (see fig. 14). A family resemblance to the earlier boxing painting, *Club Night* (see page 104), certainly is to be found in the contest of light and darkness, particularly in the way some secondary forms—even that of the referee in *Stag at*

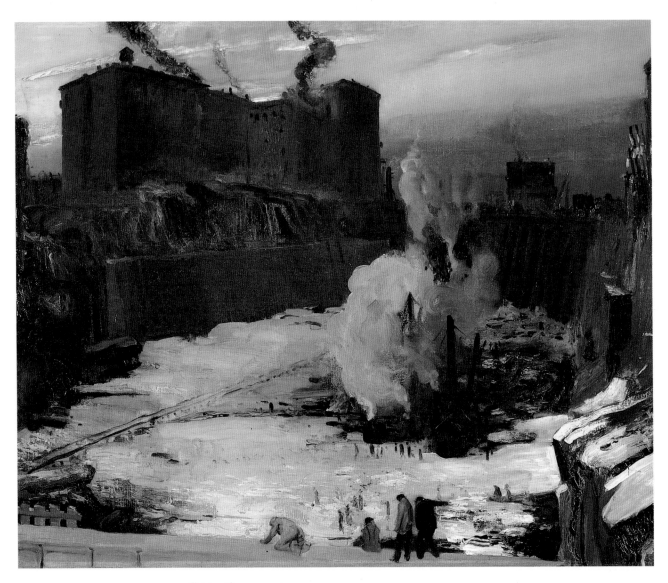

FIGURE 13
George Bellows. *Pennsylvania Station Excavation*, 1909. Oil on canvas, 31¼ x 38¼ in.
Brooklyn Museum; A. Augustus Healy Fund.

Sharkey's—are obscured and flattened as they merge with the darkness, their only solidity
in the shapes of highlights. These curving shapes and rounded silhouettes create a feeling
of movement throughout the picture. New, however, are the increased color, more
confident paint handling, angularity, and structure, all contributing to an entirely new
degree of thematic realism. Bellows began *Stag at Sharkey's* by applying a thin, blue-green
paint over the grounded canvas. This he allowed to appear in places, such as the boxer's
glove, as part of the design. The thickest paint was applied with the palette knife in places
such as the floor of the ring, where it may have received additional texture from use of a dry
brush. The painting's glory is the active quality of the brushwork in the flesh of the boxers.
Bellows followed the forms with his flowing paint, blending the pale flesh color into stronger
red and yellow colors, underneath, wet into wet. Direct painting of this kind was almost a
religion among the Henri circle, who admired Frans Hals for the distinct brushstrokes of
distinguishable color in his incompletely blended paint passages, and who proudly displayed
their own skill at that demanding feat. The active movement of the brush adds its energy
to the clash of forms.

Early Compositional Systems

Essential to the power of the pair of boxing paintings and to Bellows's personal style, as seen in those paintings and in *The Palisades*, is a new sense of compositional structure. Clear, strong structure was a constant in Bellows's work from this time forward. In fact, a growing sense of structure or evidence of a need for structure can be seen in the fact that he altered the shapes of a number of his paintings, beginning at least in early 1908.

The story has come down to us that Bellows and his roommate, Edward Keefe, restretched the canvas of *Up the Hudson* several times until it suited them.[13] Examination of *North River* reveals that it, too, went through several restretchings at different points during the extended process of its creation, finally ending up larger than it began. Indeed, evidence of restretching also can be seen in *Club Night, Rain on the River* (1908), *Winter Afternoon* (1909), *Pennsylvania Station Excavation* (1909, Brooklyn Museum), *The Bridge, Blackwell's Island* (1909), *Blue Morning* (1909), *Blue Snow, the Battery* (1910), and *New York* (1911)— a remarkable number, considering that such evidence is not always apparent and not all paintings were examined. Rare among Bellows's later paintings, restretching was frequent enough during this early period to suggest that Bellows felt considerable uncertainty about the amorphous, unstructured compositions of his early works. As his style became increasingly his own, his sense of structure became increasingly evident and methodical, and the amount of restretching decreased greatly.

It is possible that Bellows used geometry in earlier compositions, such as the artfully arranged *Paddy Flannigan*, but *The Palisades* was his first painting to clearly declare its structure. The system he used in that painting is similar to all of the systems he used throughout his career (except for a brief interlude in about 1912–13), in that the geometry was derived from the shape of the canvas. Some systems used by other artists simply placed regular, geometrical shapes within the composition, while others were based upon the repetition of a certain module, but Bellows's systems reflected the proportions of the rectangle. The structure of *The Palisades*, for instance, is derived from the simplest procedure of this kind, rebatment, in which the shorter side of the rectangle is rotated upon the longer. The distance from the single tree on the left to the right edge of the painting is as great as the height of the painting—thus creating a square area to the right of the tree.[14] Traditional, practical systems of this kind were handed down from one generation to the next among European painters and presumably also among American painters. Although little has been written about their use among American artists,[15] it can be assumed that knowledge of these systems was widespread. Most artists, of course, would have concealed the mechanics within their pictures, but Bellows was notable among his generation for the degree to which geometry asserts itself in his paintings. It attracted comment: an exhibition review in February 1910 noted that "in structural composition [*A Morning Snow—Hudson River*; see fig. 20] is no less architectonic than Mr. Eaton's. Its tall trees form a right angle with the strongly marked horizontal line of its river and the farther bank."[16] A review in 1911 described *The Lone Tenement* (see page 110) as being "stiff with straight lines and angles."[17] In 1912 a reviewer remarked on the conspicuous geometry in *Men of the Docks* (see fig. 32): "It is one of the most effective things that Bellows has achieved, really a meritorious canvas, but it has one peculiarity that is rather strange: the whole composition resolves itself into a series of squares in perspective; square lines of buildings, square edges of wharves, square patches of water, even the transatlantic steamer seems to have been set in the same uncompromising mold."[18] This evidence of structure and the very modern sense of strength it provides became key elements in Bellows's personal style.

The boxing paintings provide further evidence of the kind of planning that lay behind Bellows's early compositional systems. For all the flowing movement in *Stag at Sharkey's* and *Both Members of This Club* (fig. 14), the paintings are also notable for their angularity and firm structure, although these opposite qualities receive much less commentary. They are among the earliest of Bellows's paintings to be so clearly marked by the geometrical ordering that was to continue as a preoccupation of the artist and a hallmark of his style. Their basic structure is similar: from a firm horizontal base, the diagonal of an outstretched leg thrusts upward toward the top of a vertical line descending through the other fighter's body. While

George Bellows

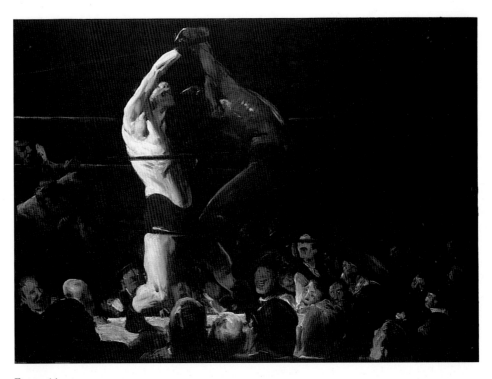

FIGURE 14
George Bellows. *Both Members of This Club*, 1909. Oil on canvas, 45¼ x 63⅛ in.
National Gallery of Art, Washington, D.C.; Chester Dale Collection.

FIGURE 15
Basic geometry of *Both Members of This Club*.

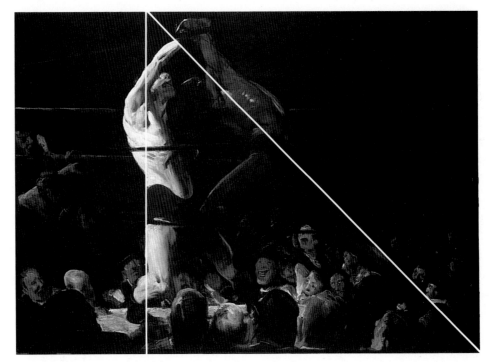

embodying the essential action, this geometry also serves as a firm armature, around which the action can swirl without dissipating its energy. In *Both Members of This Club*, the vertical line representing the rebatment of the right edge of the painting passes through the body of the white boxer, and the diagonal of that square, from the lower right corner to the top of the line, passes through the leg and body of the black fighter (fig. 15).

The structure of *Stag at Sharkey's* is as pronounced, but more complicated. One of three different systems may have been used. The simplest of these again would have been

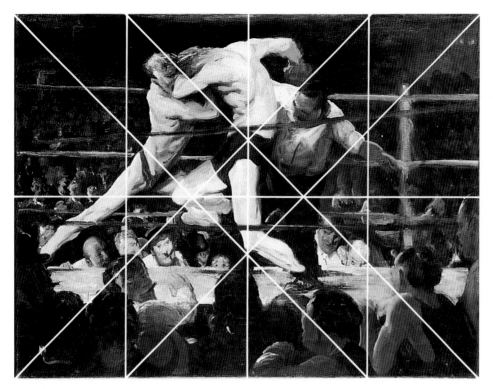

FIGURE 16
Stag at Sharkey's, showing lines generated by rebatment.

FIGURE 17
Stag at Sharkey's, showing proportionate division.

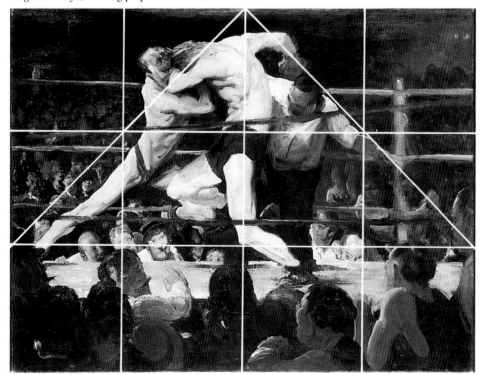

rebatment. If diagonals are drawn in both directions to the rebatment of both sides of *Stag at Sharkey's*, and verticals are drawn at the intersections of the diagonals, some of these lines seem to conform to the design, most closely in the bent leg of the right-hand boxer (fig. 16). (The vertical through that figure is the midline of the painting, used in most geometrical compositions.)

 That more lines do not coincide suggests some other system may underlie the design. The proportions of the painting are in the ratio of three to four, allowing for equal intervals

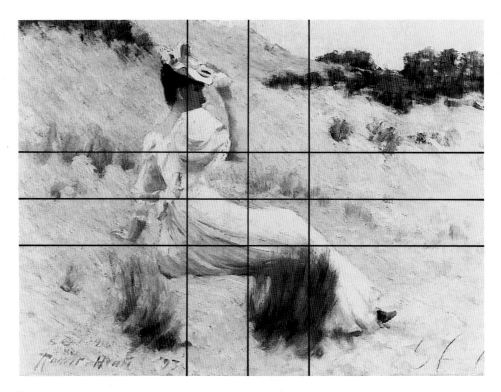

FIGURE 18
Robert Henri. *Woman in Pink on Beach*, 1893. Oil on canvas, 17½ x 23½ in. Hunter Museum of Art, Chattanooga, Tennessee; gift of the Benwood Foundation. Lines show golden-section divisions.

to be marked on each edge (and hence within the area of the painting) and diagonals drawn from one point to another, if desired. This system of proportionate division would account for the position of the foot of the left-hand boxer and, although not exactly, the diagonal direction of his leg toward the top of the midline, as well as the symmetrical diagonal of the referee's arm, completing a broad triangle (fig. 17).

A third compositional system that Bellows probably would have known at this point was based upon the "golden section," an incommensurable ratio venerated since the days of the Greeks and approximated by the ratio .618 to 1.000. Harold Spencer has diagrammed its use in *The Bridge, Blackwell's Island* (1909, see fig. 19) and *Criehaven, Large* (1916, see fig. 59) and asserts that Bellows used it in other paintings between those years.[19] This system, which had enjoyed renewed popularity among Impressionist and Postimpressionist artists such as Caillebotte, Seurat, and Sérusier, continued to fascinate younger avant-garde artists; in 1912 they held a Salon de "La Section d'Or" in Paris, to which Juan Gris contributed paintings based on the golden-section.[20] Bellows's teacher Henri well may have become acquainted with the golden section during his time in Paris during the 1890s; the rather unnatural pose of his *Woman in Pink on Beach* (1893, fig. 18) can be explained by lines representing the simplest golden section proportions and the midline. A number of Bellows's paintings of 1907 to 1909, leading up to *Stag at Sharkey's*, were stretched in the proportion of two golden-section rectangles side-by-side, and there is strong evidence that Bellows used the golden section in planning pictures he painted within just a year after *Stag at Sharkey's*. There are several ways to use the golden section and the triangle derived from it, but the method Bellows appears to have used at this point resulted from dividing the sides. Typically he would divide each of the four sides into basic golden section proportions in both directions; then divide the side in half and each of these halves into golden-section proportions in both directions, as well. (Further divisions are also possible.) The seven or more points on each side then could be connected in various ways—either perpendicularly, from point to point across the rectangle, or diagonally—as the basis for the composition. Although basic golden-section proportions fail to explain the composition of *Stag at Sharkey's* more convincingly than the other systems, geometry certainly is present in this painting—no doubt organized according to a variation of one of these basic systems.

Bellows's interest in geometrical structure became an integral part of his work and clearly manifested itself in his paintings from this point onward. It is evident in his first painting after the great boxing pictures, *The Bridge, Blackwell's Island* (1909, fig. 19). It is not clear that, at this point, Bellows limited himself to just one of the several systems available to him. A golden-section analysis[21] applied to this painting is not completely persuasive because Bellows substantially altered the shape of the canvas halfway through painting it. A change in the paint surface indicates that he folded about three and a half inches back around the stretcher along the left edge, reducing the painting's width. According to those dimensions, the right-hand edge of the face of the pier would have fallen on the midline, and the left-hand edge on a line along one quarter of the width of the painting. The upper edge of the water would lie along the midline, and the upper edge of the city (as averaged through the lower, dark line across the face of the pier) along a line one quarter of the height of the painting, thus dividing the painting into quarters along its width and height. The rectangle of the pier, so firmly locked into the proportions of the canvas, would have given the design an even more emphatically geometrical quality. Bellows then opened up the canvas to its present, larger dimensions (also turning the canvas slightly, so that the image sloped downward to the right) and finished the picture, painting in the symmetrical, foreground diagonals, which very well may connect golden-section divisions of the edges. After

FIGURE 19
George Bellows. *The Bridge, Blackwell's Island*, 1909. Oil on canvas, 34$\frac{1}{16}$ x 44$\frac{1}{16}$ in.
Toledo Museum of Art, Ohio; gift of Edward Drummond Libbey.

changing the dimensions, he thus applied a different system of geometry. In the end, the most prominent and active element in the painting, the pier, is no longer aligned to either the horizontal proportions of the canvas or the foreground symmetry. This, together with the very fresh palette of blue and pale yellow, may contribute to the picture's considerable feeling of vigorous realism.

In his next painting, *The Lone Tenement* (1909, see page 110), Bellows again used a large, rectangular form as a dominant, central mass both to generate space and to introduce geometrical markers. But this time he returned to the palette of the color opposites, blue and orange, to portray an overcast day viewed from under the same bridge (now known as the Queensboro Bridge).

In his two winter landscapes painted the following month, *A Morning Snow—Hudson River* (fig. 20) and *Floating Ice* (fig. 21), Bellows pushed all strong vertical elements to the sides, leaving the centers open and vacant. A somewhat better balance between horizontal and vertical elements gives *A Morning Snow—Hudson River* a more comfortable sense of structure. A significant number of these elements—the near (under ice) and far banks of the river, the rail fence, and the left side of the pile driver, for instance—coincide with golden-section divisions of the height and width. In *Floating Ice*, this precarious equilibrium is further undermined; the painting has numerous parallel, horizontal lines, but hardly any vertical structure at all. The lone, thin tree trunk far to the left is the very minimum necessary to create a sense of recession. It is able to balance the numerous horizontals only because it is so firmly locked into the top and bottom of the painting.

FIGURE 20
George Bellows. *A Morning Snow—Hudson River*, 1910. Oil on canvas, 45⅜ x 63¼ in.
Brooklyn Museum; gift of Mrs. Daniel Catlin.

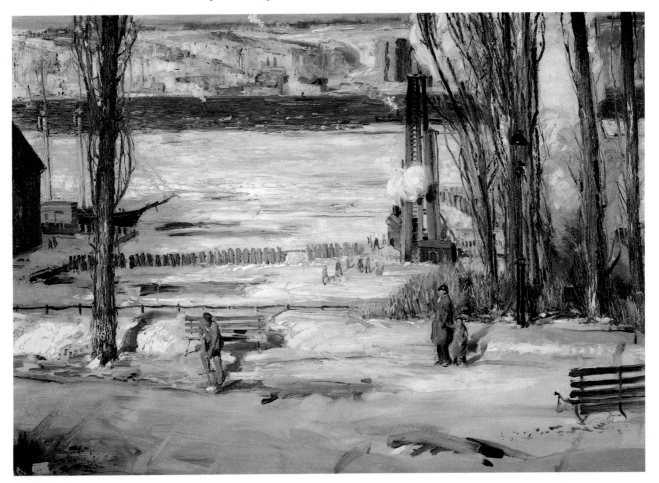

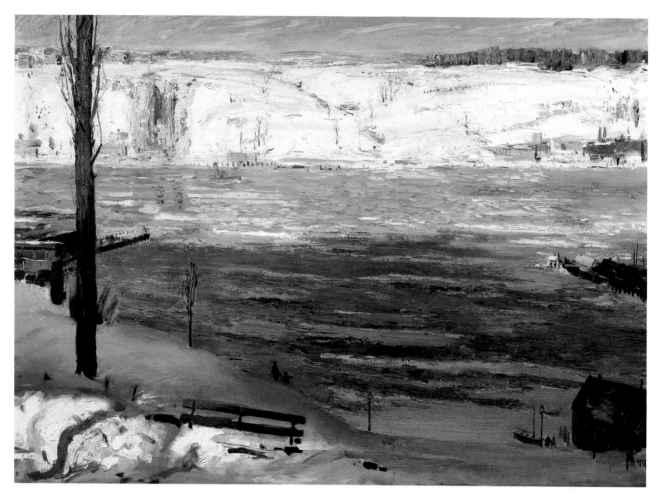

FIGURE 21
George Bellows. *Floating Ice*, 1910. Oil on canvas, 45 x 63 in. Whitney Museum of American Art, New York; gift of Gertrude Vanderbilt Whitney.

It was a natural thing that Bellows should have begun to paint snowy landscapes. The white, winter landscape, which provided material for both those working in an Impressionist style and their philosophical opposites seeking subtle, tonalist harmonies, was just then enjoying its greatest popularity, constituting as much as one painting in fifteen at some annual exhibitions.[22] As Bellows, like some other Henri students, began to use the palette knife more and more, he found in snow the opportunity to create numerous textures in unusually high impastos. Although some shadows naturally occur, these are bright paintings with solid forms. Just six months after the boxing pictures, the dark style of his early period was gone from everything except portraiture. His familiar blue and orange palette continued to work particularly well for snow; in *Floating Ice* it shaded into the blue-green and orange familiar in the work of Ernest Lawson.

A visit to a patron in Lakewood, New Jersey, during April 1910 gave Bellows the opportunity to watch the upper-class sport of polo, which he thoroughly enjoyed. Immediately after his return to New York he painted two versions of the subject, followed by a third in November. The smallest, simplest, and presumably earliest of these is *Polo Game* (fig. 22), followed by *Polo at Lakewood* (fig. 23) and *Crowd, Polo Game* (1910, collection of Mrs. John Hay Whitney). This new subject presented numerous technical challenges, among them lighting, color, and composition. The compositional elements were entirely different: an open field with the horizon itself as the only horizontal, a complete absence of verticals, and chaotic motion. The fact that Bellows imposed a geometrical structure on such unlikely material says a good deal about structure's importance to him. The polo pictures demonstrate his first extensive use of the diagonal—a method that would play a central role in his later work. Bellows divided all sides of his canvas at the usual golden-section intervals, producing at least seven points on each side. Instead of drawing perpendicular lines from

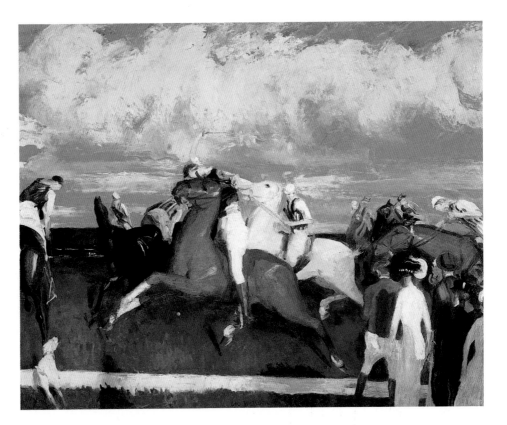

FIGURE 22
George Bellows. *Polo Game*,
1910. Oil on canvas, 38 x 48 in.
Private collection.

FIGURE 23
George Bellows. *Polo at Lakewood*, 1910. Oil on canvas, 45¼ x 63½ in.
Columbus Museum of Art, Ohio; Columbus Art Association Purchase.

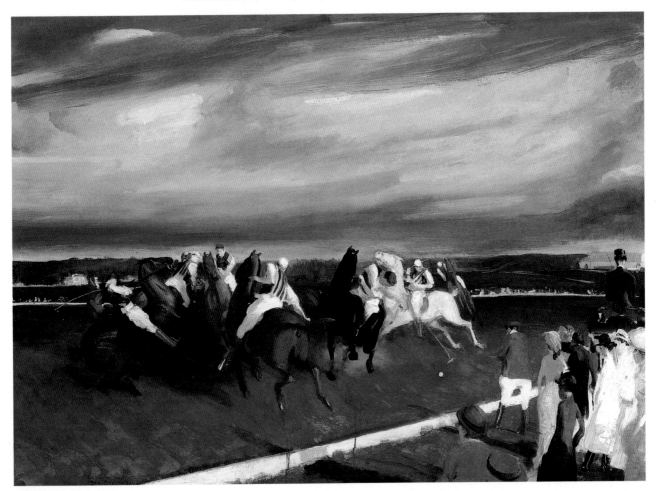

FIGURE 24
Polo Game, showing diagonals to golden-section intervals.

FIGURE 24
Polo Game, showing diagonals to golden-section intervals.

FIGURE 25
Polo at Lakewood, showing diagonals to golden-section intervals.

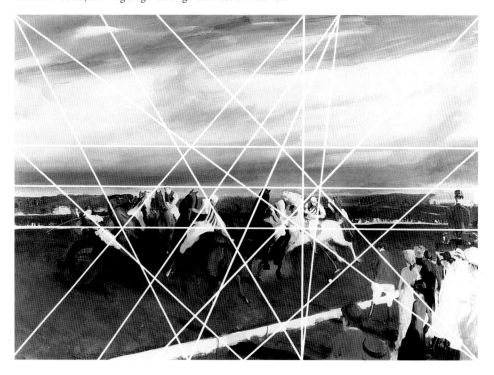

side to opposing side and then aligning horizontal and vertical elements of the design along some of these lines, as he had done in *A Morning Snow—Hudson River*, *Floating Ice*, and other paintings, in the polo paintings Bellows connected the points with diagonal lines and used these to organize the design. Most of the apparently random positions of the turning horses and leaning riders conform to these diagonals between golden-section intervals (figs. 24 and 25). This has the effect of centering the designs and introducing a certain degree of

FIGURE 26
George Bellows. *Snow Capped River*, 1911. Oil on canvas, 45¼ x 63¼ in.
Telfair Academy of Arts and Sciences, Inc., Savannah, Georgia; Museum Purchase, 1911.
Photograph by Daniel L. Grantham, Jr., Graphic Communication.

symmetry and balance.[23] It also imparts a more angular quality, which somehow seems to contribute to a sense of frozen motion. Still, with about a hundred directions possible, the system permitted enough flexibility to keep it from seeming obvious.

The setting required Bellows to include the green of the field as a major element in his palette. In *Polo Game* he added to his favorite blue and orange, found in the sky and the orange-brown of the horses, another pair of complementary colors in the green of the field and the crimson of the uniforms. The lighting of these out-of-doors figures remains the strong, flat, side light of the studio. The paint handling is especially active, like the subject, with bold palette-knife work in the sky and a delightfully summary movement of the brush, working wet into wet.[24]

The following winter Bellows completed three more snow paintings, a landscape, and a major urban landscape. *Snow Capped River* (fig. 26), painted in January of 1911, is virtually a repetition of the motif of *Floating Ice*, painted the previous January. The firm, foreground horizontal enhances the sense of structure in *Snow Capped River*, but the paintings are very much alike in all other ways—the handsomeness of their extensive palette-knife work and the subtlety of their colors of blue, blue-green, orange, yellow, and red into red-purple. If anything, the color in the later painting is richer.

On the other hand, *Blue Snow, the Battery* (fig. 27), painted in December 1910, is an entirely new motif. Distant water recalls the rivers that had been part of all of Bellows's important landscapes, but the flat surface of the park provides quite different visual material. The knee-deep snow that covers the irregularities of the park appears as a perfectly flat, smooth surface, broken only by the paths carved into it and by long, late-afternoon shadows. Brushwork, although not hidden, does not call attention to itself, as it had done in Bellows's previous snow paintings. The range of color also is greatly reduced in this nearly monochromatic picture. The snow is very white, with blue cleverly mixed into it on the canvas for the shadowed areas. The blue tonality is relieved only by a few notes of yellow-orange in the distant buildings, the cupola, the horses' blankets, and the coats. The imagery of smooth, simplified surfaces, stillness, and snow, so unlike Bellows's earlier work, calls to

mind the winter paintings of his friend, Rockwell Kent.[25] *Blue Snow* marks the introduction of both a new manner and a new mood into Bellows's landscapes, as the energy and excitement of his earlier landscapes gave way to a sterner, lonelier, more disciplined world— the imagery of Kent.

In sharp contrast to this flat, empty, snowy landscape is the densely packed *New York* (see page 113), painted in early 1911. Up to this point, the city had been largely absent from Bellows's urban landscapes, which depicted its still half-wild palisades and the ragged terrain of its excavations. In early 1910 he had first painted its tall buildings and traffic in *Upper Broadway* (private collection), looking down on the nearly empty boulevard from a fourth or fifth story, in the manner of the French Impressionists. A large part of the impact of *New York*, in contrast, comes from its low vantage point, looking just over the heads of the hurrying pedestrians, across lanes of traffic, the open square, and more traffic beyond it, to a row of high facades and the dark city canyons narrowing behind them. Allowing just a glimpse of sky and a sliver of open space in the square, the painting is by far the densest and most active that Bellows was ever to attempt. Its subject is the very bustle and confusion of the city, rendered in a somewhat greyed version of Bellows's familiar red and yellow to orange, blue-green, and violet. Although golden-section proportions establish major spatial divisions and organize a few diagonals, imparting a small degree of order, the sheer number

FIGURE 27
George Bellows. *Blue Snow, the Battery*, 1910. Oil on canvas, 34 x 44 in.
Columbus Museum of Art, Ohio; Museum purchase, Howald Fund.

FIGURE 28
George Bellows. *An Island in the Sea*, 1911. Oil on canvas, 34¼ x 44⅛ in. Columbus Museum of Art, Ohio; gift of Howard B. Monett.

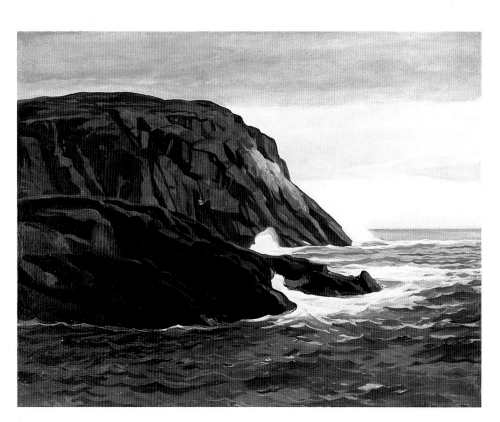

FIGURE 29
Rockwell Kent. *Blackhead, Monhegan*, c. 1909. Oil on canvas, 34 x 44 in. Colby College Museum of Art, Waterville, Maine; gift of the Phillips Collection, Washington, D.C.

of forms, their overlapping, and the energy of the paint application contribute to an image of chaos. The angular quality of the brushwork in the crowd contrasts with the thick paint, laid on and carved with a palette knife, that gives a heavy texture to the windows of the tall buildings. Bellows also struck a note of modernity by cropping the foreground figures.

The following year, by contrast, became Bellows's year of the wild landscape. In January 1911 he painted *Shore House* (see page 138), which betrays the effort of attempting a new subject. Imparting a geometrical scheme to nature produced curious, unsettling relationships. The isolated house is perched on the edge of a cliff, beside a ravine[26]; a curiously tall electric-power pole crowds it on the very edge, while an empty foreground and flat sea stretch all around. Uncertainty about scale contributes to a quality of disquiet, the excessively tall pole (apparently lengthened by the artist) calling into question the scale of the house and the extent of the featureless landscape. Long shadows impart a sense of foreboding. *Shore House*'s haunting quality, depending upon curious juxtapositions, expanses of empty space, and confusion of scale, is an unforgettable image, one that has much in common with the Magic Realist artists of the 1930s and 1940s.

Since its first exhibition, *Shore House* has been compared to the work of Winslow Homer (who had died in 1910), but any influence from Homer would appear to have been mediated by Rockwell Kent. Bellows spent most of August 1911 on Monhegan island, off the coast of Maine, accompanying Robert Henri and one of Henri's slightly younger students, Randall Davey, to this popular summer sketching ground for artists. Bellows had already become an admirer of Rockwell Kent, who had made Monhegan his home for part of every year since 1905 and who had sent powerful images of this stern land back to New York. Especially after 1909 Kent's paintings took on a quality of ominousness and foreboding, which Bellows echoed in the new, darker mood of *Shore House* and a number of his Monhegan paintings of 1911. One of the large pictures he painted while on Monhegan that summer, *Evening Swell* (see page 148), comes closest to Kent's *Toilers of the Sea* (see page 140), with its deep blue water and green sky and the motif of a fishing boat dwarfed by a dark headland. Another of his works, *An Island in the Sea* (1911, fig. 28; see also page 146), recalls Kent's *Blackhead, Monhegan* (ca. 1909, fig. 29); in both paintings, the characteristics of the landscape are subsumed into a general shape, dramatized by silhouetting, that conveys the suggestion of menace. Bellows's painting depicts the view from above the harbor of Monhegan and the even smaller island, called Manana, that protects it. Like *Shore House*, *An Island in the Sea* derives some of its unmistakable mystery from ambiguities of scale: the house in the foreground is too far removed from the island to be a measure of its size and distance.

Despite the striking similarity of mood in *Shore House* and *An Island in the Sea*, however, the paintings are fundamentally different in appearance. This difference reflects a very basic change that Bellows made in his use of color about the time of his departure for Monhegan. He not only started using a different paint, but he began to be fascinated with color theory itself.

THE MARATTA COLOR SYSTEM

Both the new paint and the new theoretical foundation that Bellows adopted in 1911 came from a paint manufacturer and theorist named Hardesty Maratta (1864–1924), who was to have considerable influence on the appearance of American paintings during the teens and early twenties.[27] When Maratta introduced himself to Robert Henri in March 1909, it proved to be a fateful turning point in the careers of Henri and some of his friends. By the fall of 1910 Henri was deeply involved in Maratta's color theories and compositional systems, and by the end of the year he insisted that all the students in his school use Maratta's paints. A number of Henri's students and friends, including John Sloan and Bellows, also became disciples. Henri persuaded Sloan to try the new paints and system during July 1909, and by December Sloan was enthusiastic enough to try to win over a skeptical William Glackens to their use.[28] By November 1910, when Maratta gave public lectures on his colors and systems, the Maratta colors were widely known in the art community of New York.[29]

Although it is not certain precisely when Bellows began to use Maratta's paints, he certainly must have heard about them from Henri about the same time as Sloan did. Bellows's record book does not indicate that he planned paintings according to Maratta's theories until October 1911, but a pamphlet explaining and advertising the Maratta pigments, copyrighted in 1913, contains a testimonial from Bellows that he already had been using the paints for four years.[30] One way to verify whether he used the paints in a given picture is to look for their relative transparency, and hence their lightness and sweetness. Maratta originally manufactured his paints using dyes, in order to be able to mix the colors more abstractly and mathematically.[31] Unfortunately, colors not mixed from earth colors usually lack body. The Maratta paints may already be evident in the transparency of the yellows and oranges in *The Bridge, Blackwell's Island* and *The Lone Tenement*, both painted in December 1909, but the same colors in *Floating Ice*, painted the following year, appear to be earth colors. Thus, even if Bellows had used the Maratta colors to some extent before *Shore House*, he apparently did not fully transfer his allegiance to Maratta's paints and system of color until sometime during the first half of 1911, before his summer on Monhegan. Use of the paints is evident, however, in the muted colors of *An Island in the Sea* and most of Bellows's Monhegan paintings of 1911, which depart from the strong, declarative color of his earlier works. It says something about Bellows's commitment to the Maratta paints and system that he chose these greyed colors to interpret the same loneliness of the place and titanic struggle of sea and land that Rockwell Kent had expressed in much stronger colors. Both color and mood set the Monhegan paintings of 1911 apart from those of 1913 and later.

Maratta's theories were based upon the traditional triangle representing the relationship among the primary subtractive colors, red, blue, and yellow. Every other color was made by combining two or more of these three colors. Orange, for instance, is a mixture of red and yellow; the further addition of blue, orange's complementary color, created an orange of decreased intensity (or "saturation"). Nearly equal mixtures of the primary colors approached a neutral. Maratta had manufacturers mix every one of the primary and secondary colors, as well as precisely greyed shades of each of the twelve, all of which were packaged and numbered separately. With this complete range of already mixed colors, the artist was able to choose combinations of colors that Maratta's theories recognized as harmonious. Like others before him, Maratta assigned to each color a specific musical note; he urged artists to combine colors that were at euphonious intervals of, say, a third or a fifth. Maratta made use of other traditional color theories as well, but always with the difference that the artist could, almost mathematically, use his many colors to establish precise relationships. The initial novelty of Maratta's colors was not their brilliance, which often could be exceeded by the secondary colors of the traditional palette, but rather the wide range of balanced colors in the tertiaries and especially the more neutral shades. Bellows found the atmospheric seacoast to be a motif perfectly suited to the exploration of these blue-greys, green-greys, and blue-purples.

Although he used the summer of 1911 on Monhegan to experiment with the new colors and paints, Bellows's working method remained the traditional one of painting landscape studies to serve as the basis of finished paintings. This system was one he seems to have used just for landscapes. Apparently thinking of his smaller studies as preparatory material, he wrote to his wife in 1911: ". . . I've painted seven little beauts, all of which will make beautiful big canvases. If I succeed in enlarging the idea in size."[32] This trip was oriented toward the production of exhibition pictures; he painted at least a dozen large paintings while on the island and three more—*The Sea* (see page 150), *The Rich Woods* (*Cathedral Woods*) (unlocated), and *Three Rollers* (see page 149)—after his return to New York that fall. This attitude toward sketches as a means to an end, a preliminary step in the creative process, stands in sharp contrast to his use of them on his next trip to Monhegan in 1913. Those landscape sketches have an entirely different character, because Bellows considered them to be an end in themselves: he exhibited a selection of them with his other paintings in his one-man exhibition in January 1914. He did not feel the need to paint more than two or three large exhibition pictures on that trip or from those sketches. The shift from the traditional working method he used in 1911 to the modernist aesthetic of the

sketch he embraced in 1913 is one of the factors that make the character and appearance of the small paintings of those years so fundamentally different.

The very broad, fluid handling, as well as the new, subdued colors of *The Sea* and *Three Rollers*, are in a style unlike Bellows's work before Monhegan. The long, fully inch-wide brushstrokes, uniform and often parallel, give these big paintings the character of oil sketches that have been enlarged rather than reinterpreted. Perhaps Bellows sought to retain the sketches' feeling of immediacy by maintaining the free, independent movement of the brushstrokes and their scale against the motif. Nonetheless, he composed these paintings on a firm structure of horizontals that recalled the stratification of *Floating Ice* and *Snow Capped River*; the striations of *Three Rollers*, for example, conform to golden-section divisions (fig. 30).

Both *The Sea* and *Three Rollers* are painted in a similarly muted palette of very greyed blue, green, and red-purple. Bellows's record-book entry for *The Sea* in October 1911 is the first that includes a notation of the color system he used. He identified it as an analogy in blue-green.[33] The concept of an "analogy" came from Michel Eugène Chevreul's principle of the harmony of sequence, by way of Maratta. According to that theory, the juxtaposition of two closely related colors, such as blue and green, had the effect of intensifying them.

Another of Chevreul's theories, harmony of contrast, is employed in *Snow Dumpers* (fig. 31), painted just after *Three Rollers* in December 1911. This theory, as transmitted by Maratta, holds that juxtaposed complementary colors also intensify each other. The contrast of the complementary colors blue and orange was by no means new to Bellows, but in *Snow Dumpers* he used the color mixtures supplied by Maratta to select a very precise

FIGURE 30
Three Rollers, showing golden-section divisions.

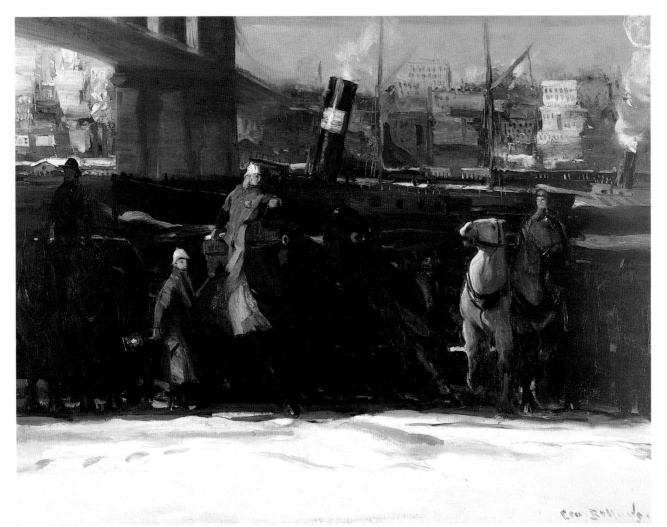

FIGURE 31
George Bellows. *Snow Dumpers*, 1911. Oil on canvas, 36⅛ x 48⅛ in.
Columbus Museum of Art, Ohio; Museum purchase, Howald Fund.

variation of the relationship: a color made of two parts of blue and one of green (blue-blue-green) and its opposite, a color made of two parts of orange and one of red (red-orange-orange), intending the red-orange-orange to be dominant. The way the colors work together both harmoniously and richly in the painting must have seemed to Bellows to prove the new method.

In February 1912, he painted *Men of the Docks* (fig. 32) in the colors red-orange, yellow-green, and blue. This palette applied another of Maratta's theories, that triads of color could avoid the static quality of contrasting, complementary colors. In his first brochure, Maratta happened to use this very triad to describe their use:

> Suppose you chose R-O, Y-G, and B., as the "triad." These are now the three primaries of the Palette to be established. The Secondaries are produced by mixing the R-O with the Y-G; the Y-G with the B; and the B with the R-O.
>
> The development of the HUES [more neutral shades] for this Palette will be the same process as that of the COLORS.
>
> Having established the COLORS and the HUES of this Palette, proceed to paint as though the Palette were normal.[34]

In other words, although the named colors of the triad dominated the painting, the artist did not confine himself to them but supported them with any number of intermixtures. The difference was that the entire palette was shifted away from one based on the normal primary colors, into another key, so to speak. This concept is central to the Maratta system and Bellows's use of it. Not the first to seek the relationship between musical and color

harmony, Maratta had assigned each of his twelve primary, secondary, and tertiary colors to a place on the musical scale of twelve halftones. The artist could use this chart to pick colors that would convey the feeling of a tonic, dominant seventh, or any other chord in any key, major or minor. Bellows chose the triad of colors for *Men of the Docks* in order to reproduce the feeling of the tonic chord in the key of C-sharp major (C-sharp, F, and G-sharp). In fact, these colors are just enough different from his familiar blue and orange to cause a distinctly different impression.

As Bellows worked out Maratta's and Chevreul's color theories in *Snow Dumpers* and *Men of the Docks*, he tried new compositional and thematic developments, as well. In his earlier urban paintings, including excavation subjects, he almost always had placed the subject in the middle ground or background and painted the workers as diminutive figures. In these new paintings, however, the large, powerful worker subjects are arranged in a foreground frieze, separated spatially from the background. The larger, more fluid brushwork first found in the Monhegan paintings also sets these figures apart from the thicker, stiffer palette-knife work of the backgrounds. What is more, in *Men of the Docks*, the smooth, looming shape of the ship dwarfs the humans and lends a new degree of monumentality to Bellows's New York subjects. This new focus, composition, and monumentality may again reflect the influence of Rockwell Kent, who often turned his attention toward the people of Monhegan and sometimes used a frieze-like arrangement in presenting them as heroic, even tragic figures.

FIGURE 32
George Bellows. *Men of the Docks*, 1912. Oil on canvas, 45 x 63½ in.
Maier Museum of Art, Randolph-Macon Woman's College, Lynchburg, Virginia.

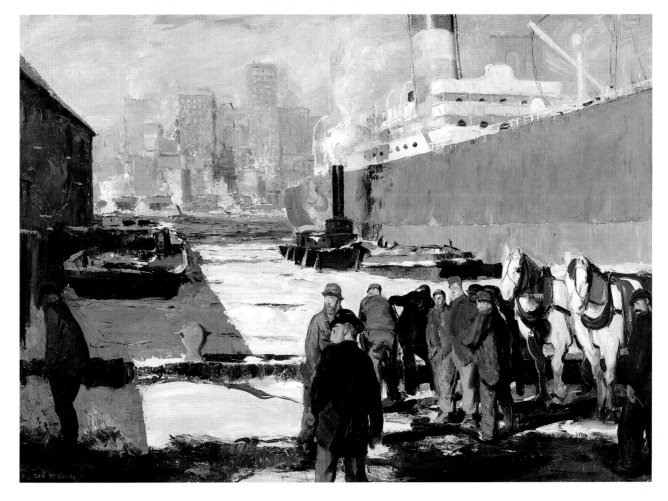

Bellows continued to use Maratta's system to select the palettes of the paintings through 1913, in most cases using simple analogies or triads. *Cliff Dwellers* (see page 117), painted in May 1913, was the exception, representing his most complex exploration of the Maratta color system. It contained three chords: *orange*, red-purple, and green-blue; *blue-purple*, green, and red-orange; and *yellow-green*, red, and blue. Among them, the three chords contain nine of the twelve colors of Maratta's scale—omitting only orange-yellow, yellow, and purple—so there might seem to be little point in specifying a palette at all. But Bellows used the colors of each individual chord together in separate areas of the painting: the first chord in the foreground, the second primarily in the background building (where the complementary colors in green and red-orange cancel each other in mixture and produce a muted yellow), and the third in the red-brick buildings to the left and right (with the addition of white for the building in full light). The color triads are similar enough to produce a harmonious effect, yet varied enough to combine in a very rich color scheme. Bellows must have chosen the chords for their similarities; they do not represent a harmonic progression when translated into musical notes according to Maratta's chart of correspondences.

After his systematic use of Maratta's theory in his color explorations during these two years, from the summer of 1911 to the spring of 1913, Bellows took Maratta's approach in several directions of his own as he worked toward the expressive power of more intense color. Nevertheless, Maratta's basic attitude that color combinations and mixtures should be approached scientifically always remained central to Bellows's method.

THE MARATTA COMPOSITIONAL SYSTEM

Between February 1912 and his departure for Maine and another explosion of painting activity on Monhegan again in the summer of 1913, Bellows's time was largely taken up with work as an illustrator. During this year and a half, Bellows painted only eight portraits, eleven small landscape studies, and five urban or genre scenes. As a guest on an estate in the Catskills during October 1912, Bellows had kept his interest in landscape alive by painting a series of eleven oil sketches in the small format of 11¼ x 15¼-inch panels. Most retain the soft brushwork and muted color of the previous year's work on Monhegan. They give no hint of the new feeling for landscape to appear in Bellows's paintings on his second trip to Monhegan the following year. Indeed, little that had come before predicts the power and lyricism of those remarkable paintings of 1913.

The portraits, of which he had done only a few since 1909,[35] also resembled the dark manner of those first years. Moreover, Bellows accepted the conventions of studio lighting that still were in general use in the very conservative genre of portraiture. Thus his *Portrait of Dr. Walter Quincy Scott* (see page 190), commissioned by Ohio State University to honor its former president, uses strong lighting from the left that leaves one side of the subject's head in deep shadow. However, since the shadow does not merge with the lighter background, the entire figure is thrown into powerful silhouette.

When Bellows returned to Columbus for an exhibition of his work in November 1912, the successful native son continued his rediscovery of portraiture. His portraits of Mrs. Albert M. Miller (see page 191), Mrs. H. B. Arnold (see page 192), and Dr. T. C. Mendenhall share a strong sense of surface design, seen in the way the figures seem to float upon the picture plane. Color harmonies and the way large, flowing brushstrokes somewhat soften the forms add to the Whistlerian quality of the group of portraits. A greater freedom of brushwork and a more fluid paint quality also distinguish these paintings from the earlier portraits. Some appear quite sketchy, even hasty.

Another feature that distinguishes the portrait of Dr. Walter Quincy Scott and others of Bellows's paintings of 1912 and early 1913, is a new compositional system, based on another of Maratta's theories. Bellows's earlier paintings had been carefully organized according to a system of interval and proportion; using the ratio of the golden section, he had divided the sides of the rectangle of most canvases and then aligned parts of the design with the intervals of the sides. But beginning with his portrait of President Scott, Bellows

FIGURE 33
"Rectangle of 54 degrees."
Plate 31 in Samuel Colman,
Nature's Harmonic Unity (1912).

FIGURE 34
*Web of Equilateral Triangles,
Hexagons and Certain Rectangles: For
Designers.* New York: H. G.
Maratta, 1915. Courtesy of
John Sloan Archives, Delaware
Art Museum.

organized his paintings according to an internal geometry, independent of the edges of the canvas. Its composition rests on a large, equilateral triangle—a shape generated among the parts of the design, with little or no reference to the shape of the canvas, aside from a tendency toward centrality and symmetry.

The entry in John Sloan's diary for July 3, 1911, records that on a visit to Henri's home he found him "deep with Maratta in the geometrical problem of rhythm in construction and design of pictures and form."[36] It is likely that Bellows soon would have heard about these theories from Henri. In an article in 1914[37] and a pamphlet published in 1915,[38] Maratta explained that he had discovered the system of geometrical proportion found everywhere in nature, in ancient art and architecture, and in great Renaissance paintings. Like his system of color, it used the equilateral triangle and mathematical proportions to achieve a musical harmony.

Such a belief in a universal, mathematical or geometrical order underlying both nature and beauty was very much in the air at just that moment. In 1910, *The Beautiful Necessity* by Claude Bragdon appeared, describing in theosophical terms an all-pervasive mathematical order. Two years later

THE WEB OF EQILATERAL TRIANGLES, HEXAGONS AND CERTAIN RECTANGLES: FOR DESIGNERS.
COPYRIGHTED 1915. BY H. G. MARATTA, NEW YORK, N. Y.

40

George Bellows

FIGURE 35
George Bellows. *Outside the Big Tent*, 1912. Oil on canvas, 30 x 38 in. Addison Gallery of American Art,
Phillips Academy, Andover, Massachusetts; gift of anonymous donor.

came the publication of *Nature's Harmonic Unity*, an exhaustive and profusely illustrated treatise, by the artist Samuel Colman, on geometrical order in nature and architecture. Some of Colman's diagrams, such as "Plate 31—Rectangle of 54°" (fig. 33), come close to embodying Maratta's concepts. Maratta's web of equilateral triangles (fig. 34) was a grid of frequently connecting horizontal, vertical, and diagonal lines that could be formed into squares, triangles, hexagons, and other geometrical figures. By developing his design over this web and organizing elements in the shape of the geometrical forms, the artist could both incorporate the beauty of nature and achieve an overall harmony of parts. In spite of Maratta's professions of mathematical rigor, there was a mystical quality to his compositional system, as there was to his color theories. As one might expect, it was Arthur B. Davies, the other mystic from among the Henri circle, who joined Bellows in using both Maratta's color theories and his compositional system.[39] To prove the validity of his system, Maratta applied the grid to famous works of art and architecture, demonstrating, for instance, that Michelangelo had used the same method. With such a fine net, it was inevitable that numerous congruences would occur.

For this reason, the superposition of the web upon Bellows's paintings of this period cannot prove that he used Maratta's system. Physical evidence in the canvases, however, does indicate that Bellows used it or a related system as the basis of his designs. This is seen clearly in the paintings *Outside the Big Tent* (fig. 35) and *The Circus* (fig. 36), both painted in June 1912. The surface of each painting bears rows of approximately forty-five small bumps or craters. Because the canvases have not been relined, the reverse of each shows a corresponding pattern of what appear to have been punctures. The pattern appears clearly on the reverse of *Outside the Big Tent*, where six horizontal rows of evenly spaced dots, with every other row offset by one-half interval, establish a diagonal pattern. The intervals between the horizontal rows are less than the interval between the dots in the row, with the result that a pattern of equilateral triangles also occurs. Numerous points in the design of both paintings coincide with this pattern, notably the large triangle of the Ferris wheel in *Outside the Big Tent*. In *The Circus*, the top of the bareback rider's head, at the base of her plume, is the apex of a large equilateral triangle to the near shoulders of the foreground ladies, as well as of a smaller one to the far side of the ring.

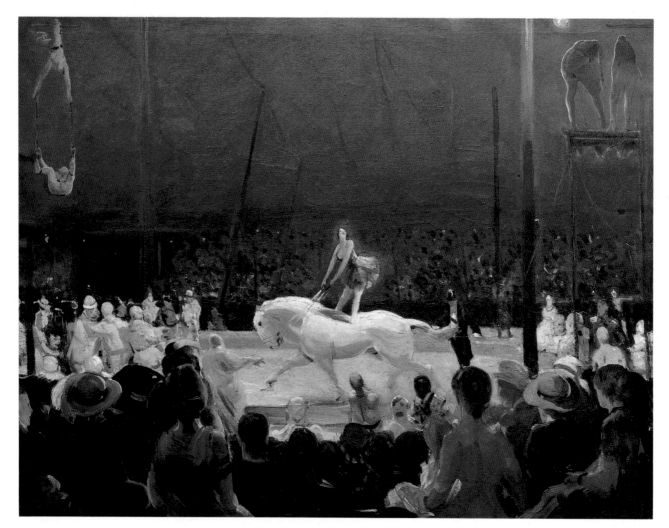

FIGURE 36
George Bellows. *The Circus*, 1912. Oil on canvas, 33⅞ x 43⅞ in. Addison Gallery of American Art,
Phillips Academy, Andover, Massachusetts; gift of Elizabeth Paine Metcalf.

The pattern of bumps or craters and corresponding holes in these canvases can only be explained as the result of pins or tacks having been driven through the canvas. Bellows must have first drawn his grid of horizontal, vertical, and diagonal lines and then inserted the pins, so that the pattern would still be visible as paint began to cover it. Because he painted around the pins and then pulled them out of the tacky paint, they left what appear as small craters in the paint surface. Such bumps are visible in photographs of his *Portrait of Dr. Walter Quincy Scott* of June 1912, and on the surfaces of other paintings of the next twelve months that were examined with them in mind: *Cliff Dwellers* and *Portrait of Dr. T. C. Mendenhall*,[40] both painted in May 1913, and *A Day in June* and *Approach to the Bridge at Night*, both painted in June 1913.

It would be hard to say just how the change from one compositional system to another affected the appearance of Bellows's paintings. On the one hand, he tended to pay more attention to the horizontal and vertical lines than to the diagonal ones, which continued to encourage the stratification of the design that had been such a prominent feature in his paintings composed according to golden-section divisions. On the other hand, the new system encouraged him to think of the entire surface of the canvas as having the potential to carry part of the design. This greater sense of all-over design is especially evident in *Cliff Dwellers*, its entire field dense with incident. With the elimination of the foreground frieze, the designs move smoothly into depth. The paintings also share a strong sense of a repeated, even interval. It is an order that is felt, but unseen.

Continuing a trend already seen in *Snow Dumpers* and *Men of the Docks*, the two circus paintings and the two city paintings of 1912–13 are primarily genre paintings, as opposed

to the empty city scenes of earlier years. Unlike the faceless pedestrians in *New York*, the figures also are large and individual enough to interest the viewer. Different, too, is the festive spirit of the paintings, celebrating the excitement of the midway and the circus, the vigor and color of the life of the city's immigrants, and the grace of an elegant group in a city park.

Although he may have employed the Maratta compositional web again briefly in 1916, Bellows's use of the system was limited almost entirely to the year prior to June 1913, when he was also most intensely involved in the exploration of Maratta's color systems. Following this interlude, Bellows returned to his principal dependence upon golden-section analysis of the painting's rectangle. He used that system with steadily increasing boldness until his conversion to Dynamic Symmetry in late 1917.

On Monhegan in 1913

Some of Bellows's first paintings after his return to Monhegan in July 1913 recall his approach to the landscape during his earlier visit in 1911, particularly in the frieze-like arrangement of the figures in *Cleaning Fish* (reminiscent of the work of Rockwell Kent; see

FIGURE 37
George Bellows. *Hill and Valley*, 1913. Oil on panel, 18 x 22 in.
Colby College Museum of Art, Waterville, Maine.

FIGURE 38
George Bellows. *Wave*, 1913. Oil on panel, 15 x 19½ in.
Private collection. Photograph courtesy of Spanierman Gallery, New York.

page 155) and the muted color of *Evening Sea* (unlocated). But before long Bellows found
a new vision of the island—in the rocks at the water's edge. While views of Monhegan in
1911, for the most part, had been from a fairly distant vantage point that softened forms,
dulled the color with intervening atmosphere, and quieted the raging surf to produce a vision
of monumental grandeur, the studies of 1913 assumed a close-in viewpoint, often on the
rocks and looking directly at the swirling water. Paintings of the land or the pine grove are
exceptions among the summer's work, but even these have a strong sense of point-of-view,
as seen in *Hill and Valley* (fig. 37), which looks down into the curving shapes of the headlands.
If the subject of the paintings of 1911 had been the forms of the island, in 1913 it was the
action of the sea. Again and again Bellows recorded the drama of the crashing waves. These
paintings often have been likened to the late seascapes of Winslow Homer, but their very
energy and immediacy sets them far apart from the balance and stately majesty of Homer's
masterpieces.

Characteristic of many is *Wave* (fig. 38), painted in September 1913. Bellows worked
with the palette of red-orange, yellow, green-blue, and blue-purple—a balanced palette that
was slightly cooler than other variations he used that summer. It is impressive how adept
he was at mixing his more or less standard set of basic colors to suit widely varied effects of
light and weather. He often mixed some colors on his palette, such as red-purple with red-
orange to make a smooth brown for foreground rocks, or, in the case of *Wave*, blue-green
with blue-purple to make the very greyed blue-green that serves as the dominant color of
the wave and, mixed with white, recurs in the sky. Most of the mixing of colors, however,
occurred on the panel, as he deftly mixed color into color, wet into wet, in the vigorous act

FIGURE 39
George Bellows. *Evening Blue*, 1913. Oil on panel, 17½ x 21½ in. Private collection.

of painting. His paint application varies considerably within each painting, from smooth background strokes to angular movements for rocks to agitated tangles in the seething water.

Bellows and his family remained on Monhegan from July until the end of October. It was a period of tremendous productivity, in which he completed nearly a hundred small panels measuring about 15 by 19-1/2 inches. Well into October, he began a series of about thirteen somewhat more ambitious statements in a larger format of eighteen by twenty-two inches. The first of these was *The Big Dory* (see page 154), a heroic image that departed from his earlier landscape work that summer by featuring large figures in strenuous effort. Others from this group, *Monhegan Island* (see page 153) and *Evening Blue* (fig. 39), retain the informal, on-the-spot quality of the smaller sketches, while incorporating the bold color that Bellows began to use toward the end of his long summer on Monhegan.

As he experimented with purer, stronger forms of basically the same colors as before, he wrote to Robert Henri: "I have been working with the colors and not much hue [more neutral color] and find a lot of new discoveries for me in the process."[41] The surf pictures of earlier that summer had an atmospheric, greyed appearance. The later paintings typically are sunnier subjects with warmer light, their strong color replacing the energy of the now calm water.

This new use of color may reflect the influence of Bellows's painting companion that summer, Leon Kroll, whose paintings were rich with blues and expressive color. Perhaps Kroll reinforced Bellows's awareness of trends in European art. Having participated in the organization of the Armory Show of 1913, Bellows had studied the numerous examples of

European modernism that New Yorkers encountered there for the first time. In a letter discussing his summer's work, Bellows drew particular attention to the change in his color: "I am so tired of depending on my past summer for present interest that I hesitate to state for the thousandth time that I painted a great many pictures and arrived at a pure kind of color which I never hit before. And which seems to me cleaner and purer than most of the contemporary effort in that direction."[42]

The changes in Bellows's use of color during the summer on Monhegan marked a turning point in his attitude toward color itself. The doctrine of the Maratta system had been harmony through precise relationships. Color was abstractly considered and artificially adjusted, but with the primary objective of harmony and subtlety. On Monhegan Bellows began to exploit the expressive potential of color, charging areas of the design with stronger color than originally found in the motif, in order to increase the emotional impact. Bellows would develop in this direction through 1917, using Maratta's paints and aspects of his methods but beginning to modify Maratta's concept of color. Having taken Maratta's theories as a point of departure for his work in 1913, Bellows over the course of the summer progressed from methodical restraint to expressive freedom, a pattern seen again and again in his career. It would seem that in the boldest use of color he was most himself. But it was through theory that he found his exceptional talent and own feeling for color.

FIGURE 40
George Bellows. *Love of Winter*, 1914. Oil on canvas, 32½ x 40½ in.
Art Institute of Chicago; Friends of American Art.

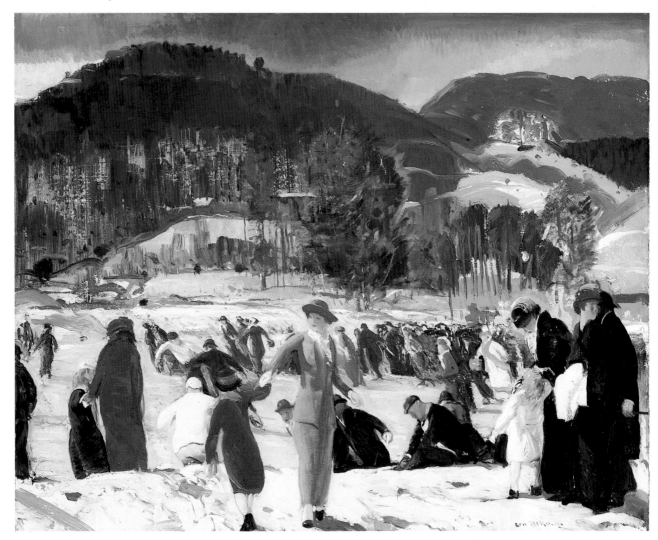

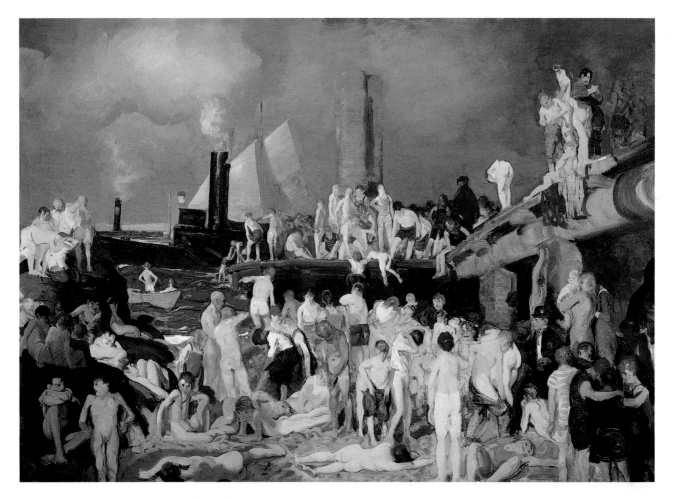

FIGURE 41
George Bellows. *Riverfront, No. 1*, 1915. Oil on canvas, 45⅛ x 63⅛ in.
Columbus Museum of Art, Ohio; Museum purchase, Howald Fund.

FIGURE 42
George Bellows. *Splinter Beach*,
1913. Graphite on paper,
17 x 22½ in. Collection of
Dr. and Mrs. Harold Rifkin.

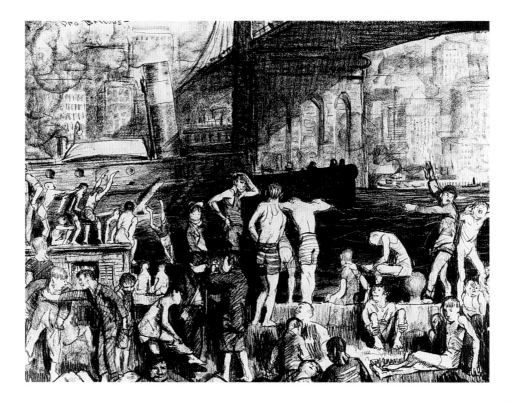

THE SET PALETTES OF DENMAN ROSS

Back in New York in late 1913, Bellows entered a fallow period, framing paintings in preparation for an exhibition of his work in January and producing only seven new paintings during the first half of the new year. He remarked in a letter that January: "There has been none of my favorite snow. I must always paint the snow at least once a year."[43] In February he had his chance and painted *Love of Winter* (fig. 40). *Riverfront No. 1* (fig. 41), his other major painting surviving from that period, was also begun in early 1914 but not completed until January 1915. It developed a theme Bellows had treated in black and white in 1912 and 1913 (fig. 42). The large painting is crammed with an improbable number of nude figures, arranged within a firm structure. Blue and yellow are the dominant colors, contributing a feeling of bright sunlight to the nearly shadowless tableau.

Bellows returned to Monhegan in June 1914, but this time he set upon a course of portrait painting. Through 1916 he brought to that genre the energy and modernist character of his other recent work. Strong light and a new intimacy of presentation gave a distinct character to the portraits of 1914, as did his use of a new color system and a conspicuous, even artificial, geometry in his composition.

Bellows began the summer's work with *Evening Group* (see page 157), portraying himself with his wife and daughter and two other children against the background of Monhegan harbor. The tender, evocative idyll is notable for two stylistic developments. In this painting, the geometry that had played a role in most of Bellows's compositions became apparent and seemingly arbitrary. Pronounced diagonals, the new feature in the Maratta compositional system, are the reason, but in this case they are once again directed toward golden-section divisions of the sides of the canvas (fig. 43). In an important change of intention, during the summer of 1914 geometry began to appear more explicitly, rather than simply providing a firm foundation for the design. Like his use of stronger color the summer

FIGURE 43
Evening Group, showing diagonals to golden-section divisions.

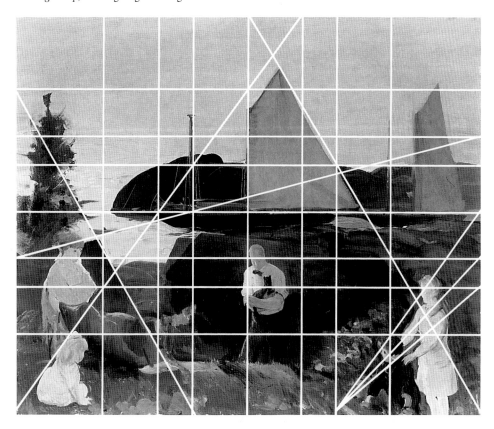

SET–PALETTES

PALETTE 9　　　　　PALETTE 10

before, the visible expression of geometry may have been a response to the modernist works Bellows had seen in the Armory Show.

The other significant development in *Evening Group*, which contains a number of colors in a range of values, is the artist's note in his record book that he painted it with the "Rubens Palette—D. Ross." Denman Ross was a lecturer on aesthetic theory and design, whose book *A Theory of Pure Design* had appeared in 1907. Robert Henri began to recommend it to his students soon after its publication.[44] In 1912 Ross published *On Drawing and Painting*, which contained a more extensive discussion of the use of color.[45] Like Maratta, Ross believed that the artist should work from a limited number of balanced colors, set down in a palette before beginning work on the canvas. Palette number ten in *On Drawing and Painting* (fig. 44) was one of the most complex. Ross named it the Rubens palette, after the colors he had observed in paintings by Rubens and other old masters. The color symbols are arranged in seven registers of value, from lightest at the top to darkest at the bottom of the chart. By specifying value as well as color, Ross introduced another degree of complexity and control to the palettes of Maratta. Most palettes for ordinary work were simply triads, even as basic as the primaries red, yellow, and blue, arranged in gradations of value, with a repeated relative dominance among them. The portrait *Geraldine Lee, No. 2* (see page 198), painted in August of that year, is typical of the simpler and commoner palettes of the Ross system. Red-purple appears in four values—two in the dress, in the hat, and in the curtain on the right; green-blue as five—in three values in the blouse, in the highlight of the curtain on

the left, and in shadows behind the shoulders; blue-purple as a low value in the curtain and shadows; and some red-orange and yellow also appear in mixture. In some of Bellows's early uses of the Ross palettes, the viewer may be strongly conscious of the limitation of the palette, to the exclusion of some colors. (He painted another portrait of the subject, now in the collection of Washington University in Saint Louis, in a strongly bluish palette.)

The portrait also demonstrates an arbitrariness, or artificiality, in its conspicuous geometry: the strong declaration of the horizontal midline, the division of the height into thirds at the belt and the squared-off shoulders, and so on. Only the strong light that falls on the staring, oval face breathes the life of believability into the geometrical forms, making it the arresting portrait that it is.

Some portraits of that summer, such as *Emma at the Piano* (see page 199), with its arrested movement and cropped appearance, have a snapshot quality that suggests informality and immediacy. The strong light also found in the portrait of *Julie* (fig. 45) enhances its cultivated sketchiness and lack of finish to give a similar impression. Bellows's original impetus to use such strong lighting in his portraits that summer may have been his adoption

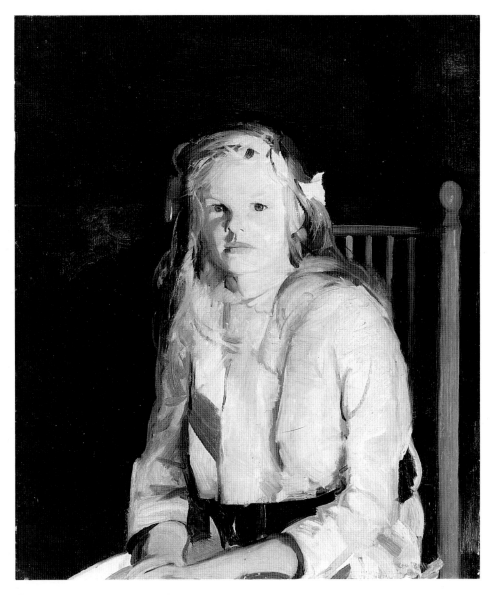

FIGURE 45
George Bellows. *Julie*, 1914. Oil on masonite, 30 x 25 in. Metropolitan Museum of Art, New York; bequest of Miss Adelaide Milton de Groot (1876–1967), 1967.

of Denman Ross's approach to set palettes. The system, by specifying seven levels in a range of values between white and black, placed a new emphasis on precise mixing of white or black into a color. A color has its greatest intensity about the middle of the range and decreases in intensity as increasing amounts of white or black are added. Bellows had been accustomed to using colors at nearly their full intensity or in their more neutral version, without adding a great deal of white or black. In most naturalistic work, an artist can find little use for a very pale shade, full of white. The overly strong lighting of the summer's portraits, which had the effect of blanching color, allowed Bellows to use the higher values of the Ross scales. Its shadows created sharp breaks, allowing the introduction of another step in value. These transitions can seem abrupt, forced, ranging within a single painting from overexposed areas into those of deep shadow.

After his productive July and August on Monhegan, Bellows did not paint again until January 1915, when he resumed work on mainly portraits. A particularly large, developed one is the *Portrait of Anne* (fig. 46). Once again the face and figure are portrayed in an excessively strong light that robs them of all but pale color, but they are set against a

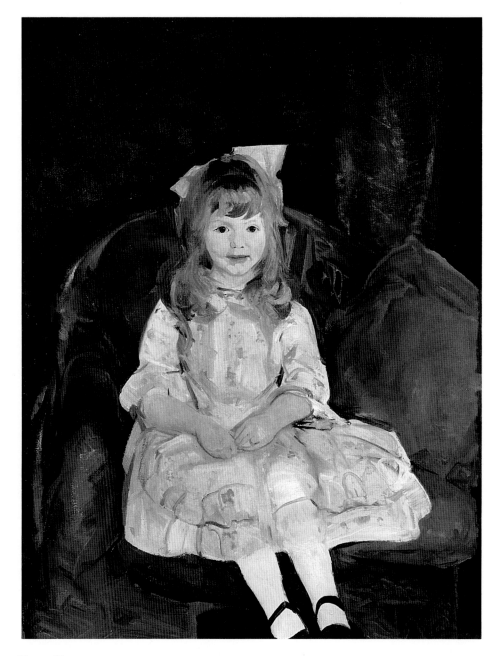

FIGURE 46
George Bellows. *Portrait of Anne*, 1915. Oil on canvas, 48 x 36 in. High Museum of Art, Atlanta, Georgia; Museum purchase, Henry B. Scott Fund.

background of very strong color, predominantly in the blue, blue-green, and blue-purple range. A number of the portraits from that period have a strongly colored background in a dominant hue, as in *Lucie* (fig. 47), a bust portrait Bellows cut down from a size of thirty-eight by thirty inches. The striking blue-green of the painting's background intensifies the pale pinks and purples in the brightly lighted face and also forms the shadows on the side of the sleeves and even the shadowed flesh of the chest. The rich chromaticism of the tints of blue, purple, yellow-orange and green in the presumably white dress even extends to the green eyebrows and blue corneas. The charged color of Bellows's portraits of 1915 drew him into a protracted argument, when the Harvard Club of New York rejected his portrait of Judge Peter Olney (see page 194), a rare commission, because they objected to its strong color.

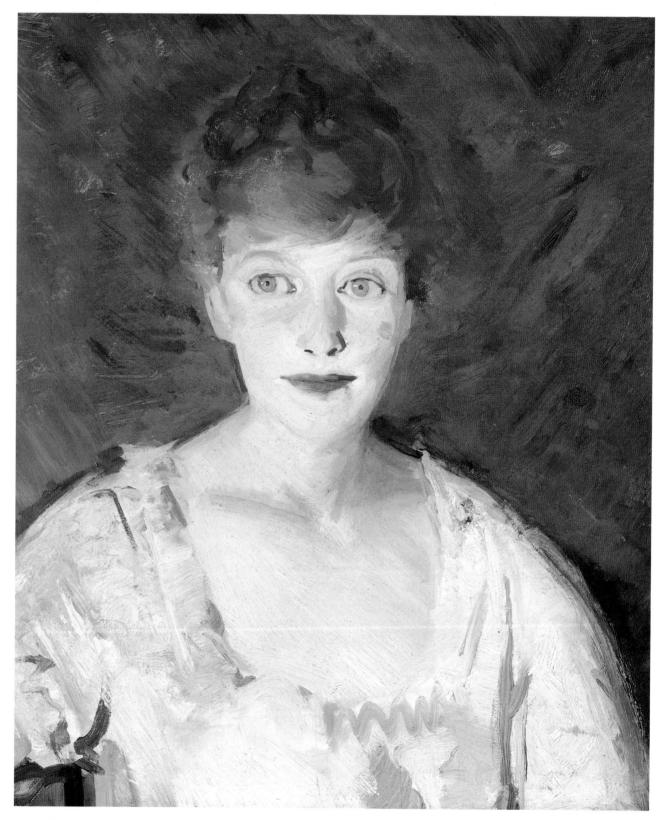

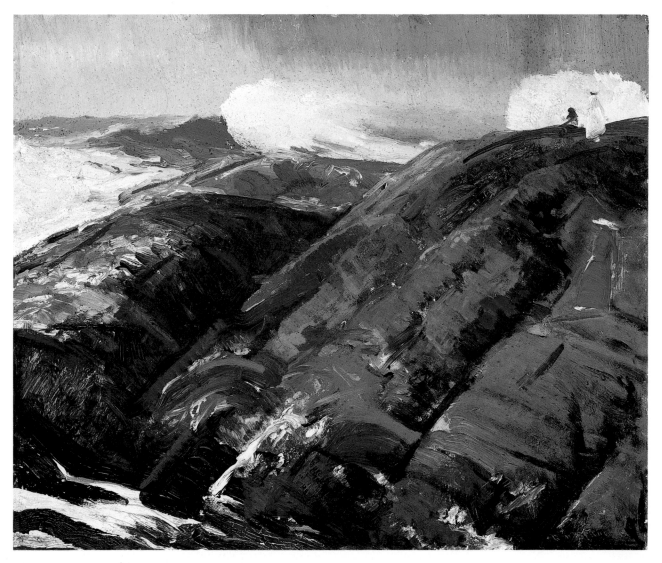

FIGURE 48
George Bellows. *Summer Surf*, 1914. Oil on panel, 18 x 22 in. Delaware Art Museum, Wilmington; gift of the Friends of the Art Center.

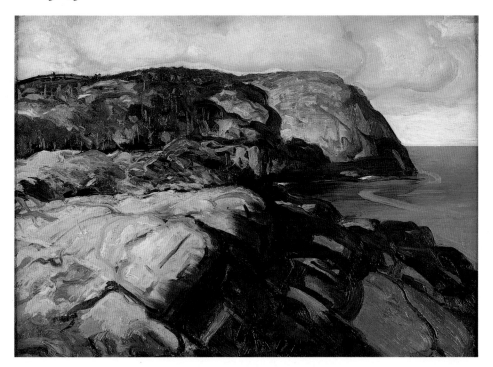

FIGURE 49
George Bellows. *Shaghead*, c.1913. Oil on paperboard, 22 1/16 x 29 5/8 in. Telfair Academy of Arts and Sciences, Inc., Savannah; Museum purchase, 1936.

During the summer of 1914 on Monhegan, Bellows spent very little time on the seascapes that had so dominated his work the year before. Perhaps he had exhausted his interest in landscape; perhaps he had completed more wave paintings than he could ever hope to sell. The weather that summer certainly was poor for landscape painting. Not until the summer of 1916 did he again turn his attention seriously to landscape. As might be expected, the few finished landscapes of 1914–15 show the strong color and the conspicuous geometry that had come to dominate his portraiture. The changes under way in Bellows's style can be seen in the great differences between *Summer Surf* (1914, fig. 48) and the boldest of the earlier shore paintings, such as *Shaghead* (fig. 49), none of which begins to use the geometry of the rock ledges so strongly. Although evidence of salt spray in its paint proves that *Summer Surf* was painted on the spot, its heroic monumentality still seems more conceptual than real. Another notable advance is that the rocks are modeled with color—blue for their darker parts, red-purple for the middle tones, and red-orange for the highlights. With its depiction of summer visitors, new to Bellows's work, and its stern majesty, so unlike previous paintings, *Summer Surf* recalls examples by Winslow Homer. At the same time, this Postimpressionist coloring is the beginning of a new chromaticism that was to reach its full development in 1916, in paintings like *Dock Builders* (see fig. 54) that should entitle Bellows to a place among the more progressive American painters of the period.

Strong color is evident also in a view of Monhegan harbor (fig. 50) that Bellows completed in March 1915 from a painting begun the summer of 1913. The intensity of the blue-purple water is immediately striking. Less apparent, but equally important to the

Figure 50
George Bellows. *Harbor at Monhegan*, 1913-15. Oil on canvas, 26 x 38 in. Jordan-Volpe Gallery, New York.

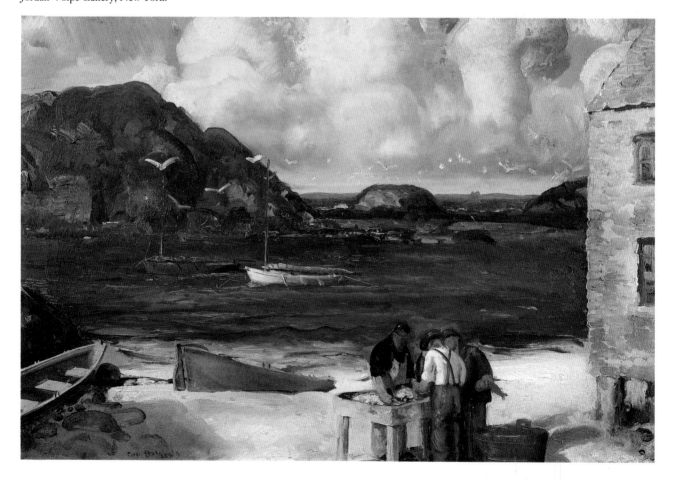

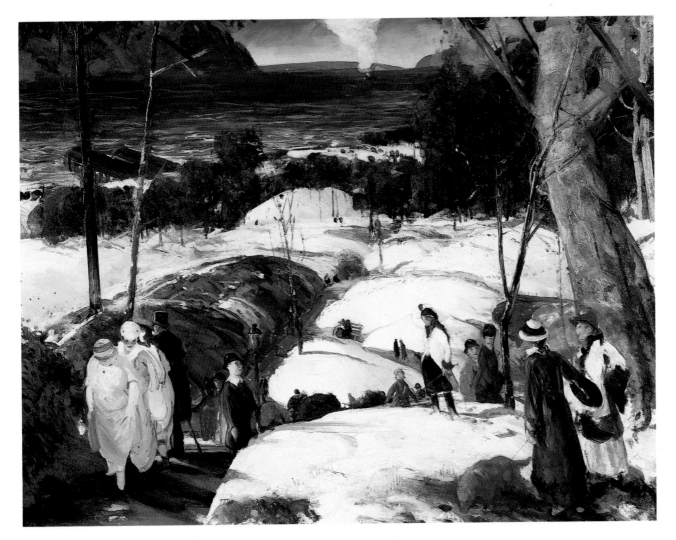

FIGURE 51
George Bellows. *Easter Snow*, 1915. Oil on canvas, 34 x 45 in. IBM Corporation, Armonk, New York.

painting's richness, is the fact that every part of it is filled with color. Bellows relied on only three colors—orange, yellow-green, and blue-purple—which can be found in even nominally colorless materials, such as the sand or the beached boat on the left, which is yellow-green, or the other boat, which is blue-purple in its shadows and orange in the light. Seldom neutralized by mixing, they appear throughout in considerable strength, usually the shadows in blue-purple. Similarly, Bellows painted his annual snow picture, an Easter snowfall, with his recently enriched palette (fig. 51). The painting is full of strong color that makes neutral areas, like the tree trunk on the right, iridescent with unblended hues.

During the summer and fall of 1915 Bellows varied his work on informal portraits only with a pair of nude studies and with a Homer-like painting of figures in a boat by moonlight, which he later destroyed. In early 1916 the beginning of Bellows's intensive activity as a lithographer left him little time for painting. In February, however, he completed *The Sawdust Trail* (see page 120), an image resulting from a trip he made with the journalist, John Reed, to Philadelphia a year earlier, in January 1915, to report on a revival meeting led by the evangelist Billy Sunday. Although Bellows was highly critical of Billy Sunday and included some elements of caricature in the painting, in its composition and iconography the painting is more positive. Its figure reaching downward into another zone recalls images of the Harrowing of Hell. At the same time, the vertical division, with tormented, falling figures on the right and orderly, rising figures on the left, resembles traditional depictions

of the Last Judgement. The technique of *The Sawdust Trail* is a significant departure: much of the thin color appears to be the result of extensive glazing.

The new strength of the color of *Harbor at Monhegan* and *Easter Snow* reflects yet another change of theory that would find full expression in the remarkable paintings Bellows produced when, with the arrival of summer, his season for painting, he left the city and set to work.

A NEW EMPHASIS ON INTENSITY OF COLOR

The summer of 1916, spent at Camden, Maine, and the small islands of Matinicus[46] and Criehaven (Ragged Island) off the coast, was a fruitful one. The artist's new strength of color achieved an especially satisfying balance and complex richness, in paintings that should silence the oft-repeated calumny that Bellows used color systems as crutches because he had no eye for color.[47] The set palettes that he noted in his record book became more extensive, while also becoming quite specific about the intensity, or saturation, of the colors. A new numbering system for the intensity of the colors had resulted from a meeting in 1915 among Bellows, Maratta, and the artists Henri, Sloan, Randall Davey, and Charles Winter, a group that over several years had been collaborating on a manuscript elaborating Maratta's color theories. A chart among Henri's papers (fig. 52) records the results of their efforts to determine the relative intensity of Maratta's twelve colors (marked with a "C") and more neutral "hues" (marked with an "H"). The higher numbers indicate greater intensity, while the lower numbers are more neutral shades. Perhaps as a result of this meeting and the large gap it revealed between the intensities of his colors and hues, by 1916 Maratta also marketed a set of "bi-colors" that were intended to stand halfway between the intensity of each color and that of its "hue."

The chart embodies a new way of thinking about color that turned Denman Ross's set palettes upside down. Ross had emphasized values, placing the high-value, low-intensity colors at the top of the palette. Although Bellows, again in step with Henri, would return in June 1920 to the concept of value in his set palettes, during 1916 and 1917 his attention was on the intensity of the colors he used. His new paintings include few of the pale tints that were a prominent feature of the Ross-influenced paintings of 1914–15; instead, the increased darkness of these new paintings is offset by a much greater intensity of color, giving an impression of equal vividness. The new set palettes often are more elaborate than before, frequently containing nine or ten of Maratta's twelve colors. Sometimes a dominant color appears in a range of intensities, with the rest of the colors in just one or two intensities. For instance, *The Coming Storm* (fig. 53), painted in June 1916, contains the following palette, according to Bellows's record book: yellow-green, 13.9.5.3.1; yellow, 11.7; green, 11; green-blue, 9.1; blue-purple, 9; orange-yellow, 1; red-purple, 5; red-orange, 5. The intensities chosen for yellow-green, yellow, green, and blue-purple are at the top of the range, and that of red-purple next to the top. Thus Bellows began the summer using very intense color that seemed to become even stronger over the next year and a half. As the summer and his experiments with the new color advanced, he came to recognize the potential of a given palette and reuse it for several, or even a number of paintings in a row.

Having used the new approach to color already in paintings earlier in 1916, such as *Easter Snow*, Bellows began his summer in Maine in complete command of his color method, as is demonstrated by the success of his third painting of the season, the beautiful *Dock*

COLOR CHART AS IT WAS ESTABLISHED AT THE MEETING (1915) IN WINTER'S STUDIO. CH. WINTER, HG MARATTA, JOHN SLOAN, G BELLOWS, R.DAVEY, H. The sign + indicates repeat of the color in decreasing intensity. —The HUE USED.

	G	GB	B	BP	P	PR	R	RO	O	OY	Y	YG	G
13												¹³YGᶜ	
11	¹¹Gᶜ	¹¹GBᶜ								¹¹OYᶜ	¹¹Yᶜ	+	¹¹Gᶜ
9	+	+	⁹COBALT M.GBᶜ				⁹Rᶜ	⁹ROᶜ	⁹Oᶜ	+	+	+	+
7	+	+	Bᶜ	⁷BPᶜ		⁷PRᶜ	+	+	+	+	+	+	+
5	+	+	+	+	⁵Pᶜ	+	+	+	+	+	+	+	+
3	+	+	Bᴴ	+	Pᴴ	+	Rᴴ	+	+	+	+	+	+
1	Gᴴ	GBᴴ	Bᴴ Oᶜ	BPᴴ	Pᴴ Yᴴ Yᶜ	PRᴴ	Rᴴ GBᶜ	ROᴴ	Oᴴ	OYᴴ	Yᴴ	YGᴴ	Gᴴ
S	Gᴴ Rᶜ		Bᴴ Oᶜ	BPᴴ OYᶜ	Pᴴ Yᴴ Yᶜ	PRᴴ YGᶜ	Rᴴ GBᶜ	ROᴴ GBᶜ	Oᴴ Pᴴ Pᶜ	OYᴴ BPᶜ	Yᴴ Pᶜ	YGᴴ Pᶜ	Gᴴ Rᶜ

There were some slight changes — but the chart remained practically thus during its life. The mixtures indicated for the 1 and S. lines were those which seemed the most practical. The fixing of the higher intensity of each color was difficult. It was rather surprising that YG should be thought the most "intense." There evidently was some confounding of "value" with "intensity." Evidence of this may be found in the great step between P. and YG. This P. while very dark proved itself to be a very powerful (intense) pigment when mixed with white.

FIGURE 52
Color chart, 1915. Robert Henri Papers, Beinecke Rare Book and Manuscript Library, Yale University.

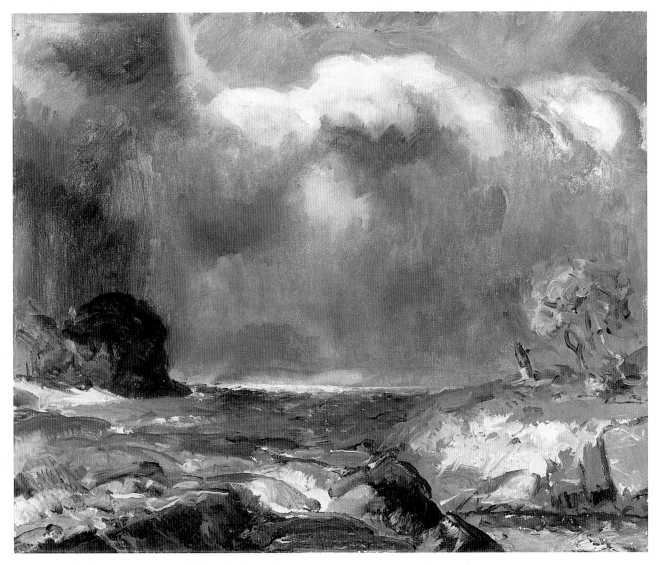

FIGURE 53
George Bellows. *The Coming Storm*, 1916. Oil on canvas, 26¹⁄₁₆ x 32⅛ in. Los Angeles County Museum of Art; Mr. and Mrs. William Preston Harrison Collection.

Builders (fig. 54). Using many, but somewhat less intense, colors with a greater admixture of white, it achieves a convincing effect of bright sunlight on the foreground. Because mixing colors would neutralize them, Bellows only partially blended the rainbows of colors that he used in the foreground rocks and logs. As a general rule, he modeled them from blues in the shadows through reds in the midrange to orange or yellow in the highlights, allowing a shift for local color. This great richness is held in perfect harmony.

The use of color in some passages of *Dock Builders*—for instance, in the veils of blue and purple in the clouds—resembles that in paintings of the same period by Bellows's friend, Leon Kroll, who was summering with him. In fact, Kroll appears, working hard at the oars, in Bellows's painting, *In a Rowboat* (see page 160), painted that July as a record of a perilous moment when the two artists, Emma, and Anne were caught in a sudden storm. The breadth of handling throughout the painting is exceptional, especially in the dark blue and white brushstrokes of the storm. Before completing it, Bellows folded back about an inch of canvas along the bottom, cropping the stern of the boat, no doubt to contribute to the sense of immediacy.

Bellows made four paintings of the shipbuilding wharves at Camden that year. In remarks full of the patriotic romanticism found in these paintings, he later referred to them in terms of his own reverence for the ships and the handiwork of the shipwrights.[48] This attitude is particularly strong in the more complicated paintings, such as *Shipyard Society*

(see page 159), that he apparently made up out of whole cloth, filling it with "types." In another letter to Henri that summer, he wrote, "I have done a number of pictures this summer which have not arrived in my mind from direct impressions but are creations of fancy arising out of my knowledge and experience of the facts employed. The result while in continual danger of becoming either illustration in a bad sense or melodrama has nevertheless evolved into very rare pictures."[49] Apparently Bellows's first imaginary or ideal subjects were on themes of unspoiled, traditional American values.

Along with the paintings of old houses made that summer, the shipbuilding paintings are an early sign of Bellows's interest in identifiably American and traditional subject matter, which would become so important in his paintings of the 1920s. In a letter of June 13, 1916, Bellows urged Henri to come to nearby Rockport, Maine, "a possibly more picturesque place than this and more quaint, a quarry town full of workmen and types . . . I have a corking native kid to paint and have some interesting old farmers from the back country."[50] The inclusion of a plowman and his wife in the left background of *The Rope* (see page 158), painted in August 1916, strikes this note of unspoiled rusticity.

The color of *The Rope*, characteristically, is very rich. In the distant field on the left, for instance, Bellows freely brushed purple over the yellow-green, rather than mixing the colors to dull the yellow-green. A note in Bellows's record book, "built on web [triangle

FIGURE 54
George Bellows. *Dock Builders*, 1916. Oil on canvas, 30 x 38 in.
Antonette and Isaac Arnold, Houston, Texas.

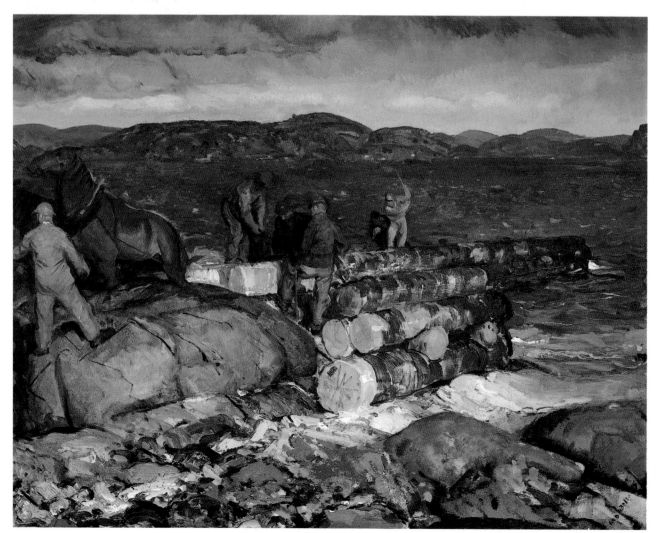

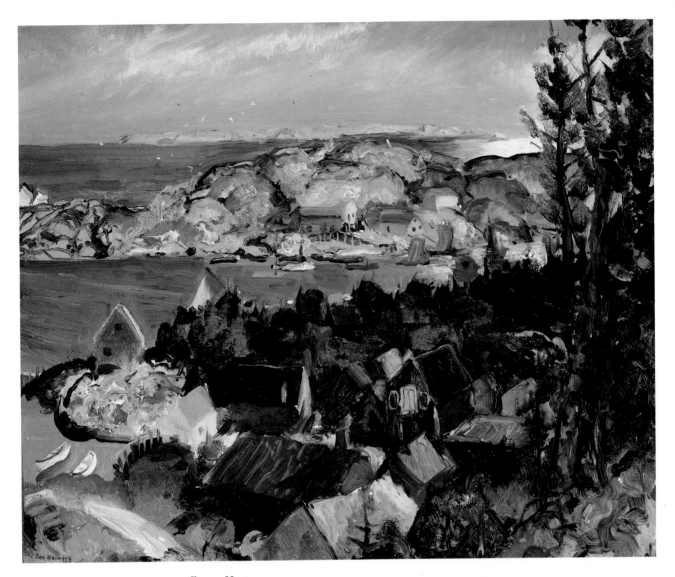

FIGURE 55
George Bellows. *Matinicus from Mt. Ararat*, 1916. Oil on panel, 18 x 22 in.
Portland Museum of Art, Maine; lent by Ellen Williams.

symbol] 12 x 9," suggests that Bellows again used Maratta's compositional systems as the basis for *The Rope*; Maratta had published his web in 1915—after Bellows's use of the system in 1912–13. For the most part, however, Bellows used the golden section to generate compositions that summer. He employed what was called a "golden compass," the proportional compass devised by Manuel Komroff that made it easier to construct the golden section.[51] As Harold Spencer has demonstrated, two works of that period, *Romance of Autumn* (see fig. 58) and *Criehaven, Large* (see fig. 59), share a similar composition based upon golden-section divisions and diagonals.[52] The result was that some of Bellows's paintings of that summer were among his most complex designs based upon the golden section.

In September Bellows and his wife took the boat to the island of Matinicus for about a month. In that time he produced nearly thirty fine paintings of it and the neighboring island sometimes known as Criehaven. Bellows considered them, like Rockport and Camden, to be unspoiled corners of rustic America, free of the summer visitors who flocked to Monhegan. He painted very few pictures of the sea, instead painting informal corners of the island and the farms of its inhabitants. *Matinicus from Mt. Ararat* (fig. 55) and *Ox Team,*

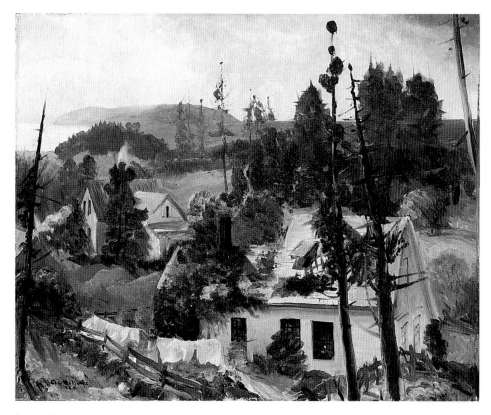

FIGURE 56
George Bellows. *The Red Vine*, 1916. Oil on panel, 22 x 28¼ in. Metropolitan Museum of Art, New York; gift of the Chester Dale Collection, 1954.

FIGURE 57
George Bellows. *Romance of Criehaven*, 1916. Oil on panel, 18 x 22 in. Fine Arts Museums of San Francisco; gift of Mr. and Mrs. W. Robert Phillips in honor of Ian McKibbin White.

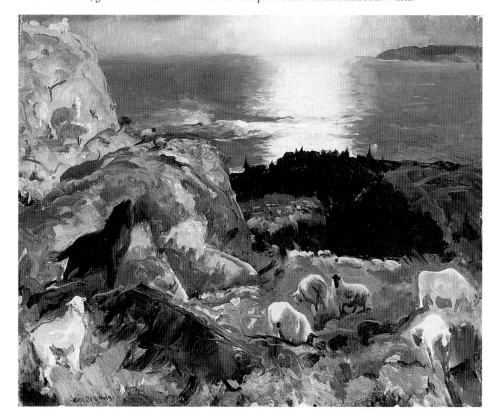

60

George Bellows

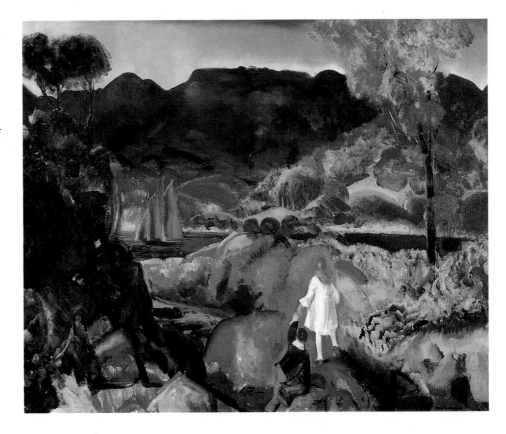

FIGURE 58
George Bellows. *Romance of Autumn*, 1916. Oil on canvas, 32½ x 40 in. William A. Farnsworth Library and Art Museum, Rockland, Maine; gift of Mr. and Mrs. Charles Shipman Payson, 1964.

FIGURE 59
George Bellows. *Criehaven, Large*, 1917. Oil on canvas, 30 x 44⅛ in. William Benton Museum of Art, University of Connecticut; Louise Crombie Beach Memorial Collection.

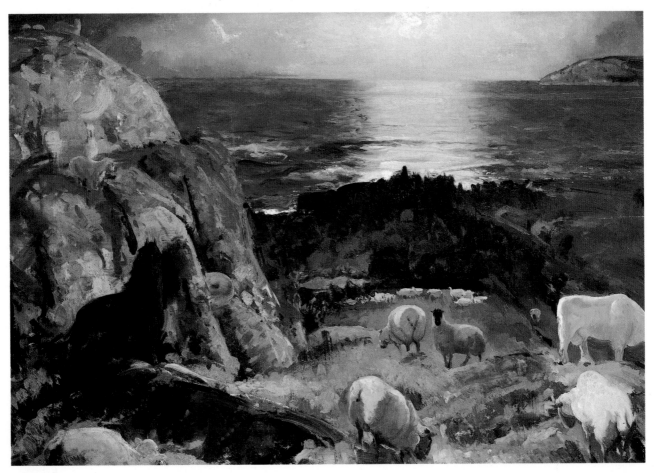

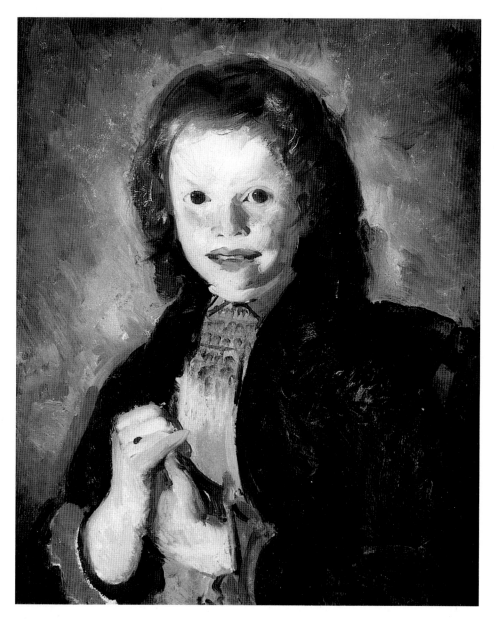

FIGURE 60
George Bellows. *Portrait of Susan Comfort*, 1916. Oil on canvas, 22 x 18 in.
Private collection, Houston, Texas. Photograph courtesy of Meredith Long Gallery.

Wharf at Matinicus (see page 162) are characteristic of the relaxed, snapshot quality of the fresh, brightly colored landscape sketches. The palette he devised for *Ox Team, Wharf at Matinicus* was one Bellows thought particularly successful and used again in a number of paintings, including *The Red Vine* (fig. 56), with the addition of yellow-green for that painting's morning sky.

From sketches (fig. 57) he made in Maine that summer, Bellows painted two large pictures, *Romance of Autumn* (fig. 58) and *Criehaven, Large* (fig. 59). In addition to their underlying similarity of composition, these paintings share strong color, a distinctively loose brushwork, and an ecstatic vision of a natural paradise. In *Romance of Autumn* the exceptional strength of color and gestural brushwork go beyond representation to expressionistic effects. The painting is an extreme case of a general shift in Bellows's use of brushwork and color since the beginning of the summer, when strong color had enhanced a sense of vivid realism in his paintings. Although his theoretical approach remained the same, his objectives

FIGURE 61
George Bellows. *Jewel Coast, California*, 1917. Oil on panel, 20 x 24 in.
Joslyn Art Museum, Omaha, Nebraska.

FIGURE 62
George Bellows. *Well at Quevado*, 1917. Oil on canvas, 38 x 52½. Minnesota Museum of Art, Saint Paul;
Katharine G. Ordway Purchase Fund. Photograph by Jerry Mathiason, Minneapolis.

were changing, and he realized that intense color also could serve those different ends. The new system had enabled him first to see the effects of intense color and later to realize its expressive potential.

Into the fall of 1917 there are more and more cases in which Bellows used excessively strong color in interpreting his subjects in an expressive fashion. This is true not only of landscapes, but also of portraits, such as that of *Susan Comfort* (fig. 60), with its strong color enhanced by juxtapositions—purple shadows to the orange hair and an orange shadow under the green sleeve—and its agitated sketchiness. Bellows's landscapes, made during the summer and fall of 1917 in California and New Mexico, are often drenched in expressive color as well. *Jewel Coast, California* (fig. 61) and *Golf Course, California* (1917, Cincinnati Art Museum) match full color with heavy texture. This trend climaxes in what may be his last painting of October 1917, the powerful *Well at Quevado* (fig. 62), which interprets the Southwest in a visionary splendor of intense color.

The visual and emotional force of their gorgeous color, which achieves a dazzling opulence exceeded in the work of few American painters of the period, makes the paintings of 1916 and 1917 among the most handsome and enjoyable that Bellows ever produced. In the three charmed periods—1913, 1916–17, and 1924—when Bellows painted in his strongest color, its exuberance stands comparison with that of any of the Fauve-inspired American modernists. The delightful paintings of these periods demonstrate not only his exceptional gifts in using color, but also, in the spirit of the modernists, his joy in doing so.

DYNAMIC SYMMETRY

Following his exploration of glorious color in 1916–17, Bellows underwent another of those extreme stylistic shifts that could mark his work from summer to summer. From July 1918 until May 1920, color notations are completely absent from his record books, as though color no longer was of central interest to him. Instead, a new kind of notation briefly appears, expressing the ratio of the sides of the painting as a decimal. These ratios reflect a new interest that was to be a central concern for the rest of his career, a compositional system called Dynamic Symmetry.[53]

Soon after his return to New York from Santa Fe in October 1917, and independently of Henri, Bellows met Jay Hambidge, who conceived the system, and soon became Hambidge's ardent disciple. Having learned its details from Hambidge's public lectures, Bellows by the spring of 1918 was using Dynamic Symmetry in his lithographs inspired by the recently published Bryce report on German atrocities in Belgium.[54] When he repeated those themes on a monumental scale in his paintings that summer, he continued to design in terms of the system.

In fact, Dynamic Symmetry, which divides rectangles into regular parts that bear some proportionate relationship to each other and the whole, gave him the confidence to paint on an entirely new scale. For instance, *Massacre at Dinant* (fig. 63) was created in the size forty-nine by seventy-nine inches, so that the proportion of the sides of the rectangle is 1:1.691. Hambidge described how a rectangle of this shape could be broken down into proportionate parts: if a square is imposed upon the rectangle at either end, the remaining portion of the entire rectangle is equal to a square and a smaller rectangle that he called a root-five rectangle. Figure 64 shows the very first divisions and just one diagonal for *Massacre at Dinant*. Many further divisions and subdivisions are possible, and diagonals of the various squares and rectangles also can be used in the design. In fact, there are so many alternatives for divisions and diagonals that the artist's design can take almost any form. Because the system was so flexible, Hambidge was able to find a variation that would match the design of nearly any Greek vase or temple, thus demonstrating that the beauty of ancient art derived from this system, lost in the Middle Ages.[55] Indeed, all the forms of nature and the human body could be described by the system. Someone like Bellows, who had used golden-section divisions and their diagonals and had been attracted to the mystical proportions of Maratta's system, would be ready to embrace Dynamic Symmetry. But Bellows certainly was not alone in doing so. The system was employed by a substantial

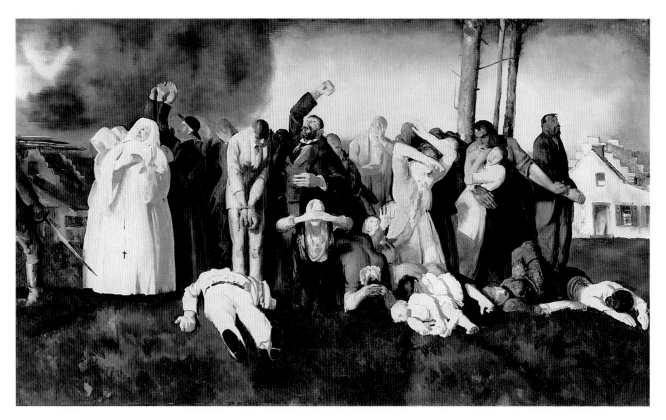

FIGURE 63
George Bellows. *Massacre at Dinant*, 1918. Oil on canvas, 49½ x 83 in.
Greenville County Museum of Art, South Carolina; anonymous loan.

FIGURE 64
Diagram of *Massacre at Dinant*, 1918, showing first divisions according to Dynamic Symmetry.

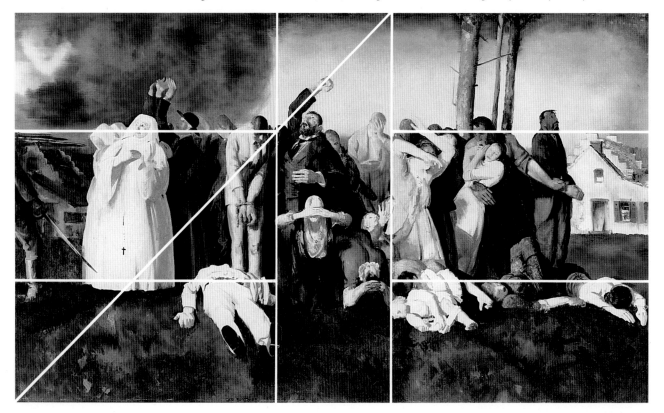

FIGURE 65
George Bellows. *Edith Cavell*, 1918. Oil on canvas, 45 x 63 in. Museum of Fine Arts, Springfield, Massachusetts; James Philip Gray Collection.

number of American architects and artists, both traditional and abstract, and, because Hambidge came from Canada, also by numerous Canadian artists.

Bellows's initial efforts at the new system are highly self-conscious as surface designs. They are extremely planar and shallow, so unlike his recent compositions using golden-section divisions, such as *Criehaven, Large* (see fig. 59), with its leaps into space along the diagonals between divisions. The new paintings also have a strong sense of the demarcation of zones or areas. The figures, obeying the design, have a tableau-like feeling of arrested movement. Although these qualities sometimes can be problems in the action subjects, they curiously have the effect of enhancing the dramatic and emotional effect of *Edith Cavell* (fig. 65), painted midway through the series of war paintings in September 1918.[56] Called before dawn to descend to her execution, the nurse pauses momentarily, partway down the staircase. The large, empty spaces emphasize her isolation, the stillness the epic nature of the moment. The diagonal of the square compels her downward. The result, in its simplicity, emptiness, and quietness, is one of the artist's most powerful paintings.

Dynamic Symmetry continued to fascinate Bellows through the rest of his career. He delved into its theory, becoming an expert to whom Hambidge's widow turned for assistance in readying his manuscripts for publication. It is likely that Bellows used Dynamic Symmetry to plan all but his most modest paintings, drawings, and lithographs. As he continued to work with the system, his compositional schemes became increasingly complex, while he became better at using the designs to move between planes; as a result, his use of the system became less obvious. Nevertheless, a tendency toward bilateral symmetry and a certain stiffness in poses and shapes continued to betray the presence of a geometrical structure.

FIGURE 66
George Bellows. *Children on the Porch*, 1919. Oil on canvas, 30¼ x 44 in.
Columbus Museum of Art, Ohio; Museum purchase, Howald Fund.

INDIRECT PAINTING

While Bellows was exploring the implications of Dynamic Symmetry in his lithography and painting, his paintings took on a much more muted palette. In stark contrast to the richly colored, southwestern scene of *A Well at Quevado* in 1917, his war paintings are very neutral, even limited in color, their brushwork controlled. They give the impression of having been painted tonally in greys, with flat color applied in places. For example, *Edith Cavell* is carried out almost entirely in blue-green and pale yellow and, like the rest of the series, has a monochromatic appearance, almost the effect of a tinted drawing.

This tendency continued into 1919. *The Studio* (see page 170), a Christmas subject completed in March of that year, also has the appearance of clear forms, drawn in light and dark, then tinted with an all-pervasive color. In this case almost the entire picture, aside from areas of local color, is tinted in blue-green, or red- or blue-purple. *Children on the Porch* (fig. 66), painted that July, is even more explicit than *The Studio* in using architecture to articulate the division of the canvas into squares and rectangles. It, likewise, is carried out almost entirely in yellow-green and blue-purple, working as opposites, warm and cool, light and shadow. This pattern of modeling and coloring occurs so frequently in Bellows's paintings of the 1920s that it would appear to represent a new approach, or system, to which he had switched decisively in 1918.

Bellows had known about this system for some time. A passage from his letter to Professor Joseph Taylor in January 1914 may provide a clue as to its nature:

Having got what I can out of the modern movement for fresh, spontaneous pure color, I am now turning my attention to the 'Secrets of the Old Masters.' (To be read with some humor) Hoping that what I have allready done will not loose its freshness with the passage of time. I have come to the realization that permanence demands more care and while I am certain that my pictures are as "stable" as any *modern* technic, I also realize that there are grave dangers in too much spontaneity and haste.

I am glad that most of my good pictures have been on new nearly white canvas and that I have used permanent color and good mediums. But the Old Masters [did not do it this way—crossed out] got different results and I want to know how they did it.

There have been recently published a couple of excellent books on this subject and I expect to change my methods entirely until I learn what I can in a new direction. That direction being the isolation of drawing and coloring into two distinct processes and over a perfectly prepared canvas of pure white. This is the process of Rubens Titian Velásquez & Hals and the rest and the "proof of the pudding etc.

This seems to be an extremely original attitude nowadays. All this is very hopeful of course, and I am not beyond hope.[57]

Bellows's choice of words such as "spontaneous" and the basic concepts mentioned in the letter suggest that he was reading *The Secret of the Old Masters* by the artist Albert Abendschein, which had been published in New York in 1906. This 198-page book was one of several modern explanations of the chemistry of paint and painting technique that first began to appear around this time.[58] The "secret" that Abendschein explained was the principle of indirect painting: he claimed that, using the Venetian "dead color," the great masters from Titian through Rubens to Reynolds had separated the processes of modeling form and of coloring the form. First they modeled the form in the dead color—a cool, silvery color, red, and white—basically in light and dark. After that was thoroughly dry, they returned to the painting, applying veils of oil glazes to give it color. Bellows was only one of numerous artists intrigued by this concept. By the late 1920s and early 1930s, this process was in widespread use among American artists of various schools, who often used tempera for the modeling of form. John Sloan advocated this method in *Gist of Art* (1939), and artists such as Reginald Marsh and Thomas Hart Benton adopted it as well. In fact, the appearance of the tonal underpainting—the modeling abstractly stripped of color—was cultivated in the finished paintings of artists as diverse as Kenneth Hayes Miller and Lorser Feitelson in the 1920s.

Bellows apparently had experimented with this new system of indirect painting before his decisive shift to its use in the war paintings and his further elaboration of the system in the heavily glazed paintings of 1921–23. Already in 1914 he had indicated he was trying it, in a letter to Robert Henri from Monhegan. It was entirely characteristic of both artists to use more than one system at a time, and Bellows wrote: "In following out the principles of Marratta, Abendschein & Ross I have actually surprised myself with the results. It may sound like a little extravagance of boasting but I seem to have happened most naturally on certain results similar in different instances to a number of the old masters." Bellows went on to see resemblances between his paintings of the summer and a number of specific old masters, as well as Cézanne. "Well anyway the thin glaze is a new beauty to me and I have worked it for all its worth."[59] One does not think of Bellows in 1914 using glazes, which often are difficult to identify, especially if one is not looking for them, but certainly the colors in at least the curtains in *Geraldine Lee, No. 2* (see page 198) have the appearance of a transparent layer over a tonal design. Bellows also appears to have used more extensive glazing to color large sections of the design of *The Sawdust Trail* of 1916 (see page 120), but he followed it with directly painted works.

Bellows was not ready to abandon direct painting in 1919, either. This seems clear from the landscapes that occupied most of his time during that summer, the second that he spent in Middletown, Rhode Island, near Newport. A number of them are farm scenes, in which cattle are a prominent new element. The strong color and richly varied paint textures of works such as *Paradise Point* (1919, Berry-Hill Galleries) recall his spirited landscapes of the last extended campaign, in 1916, but other characteristics set most of the

FIGURE 67
George Bellows. *Boy and Calf—Coming Storm*, 1919. Oil on canvas, 26¼ x 38¼.
Columbus Museum of Art, Ohio; gift of Mr. and Mrs. Everett D. Reese.

landscapes of 1919 apart, both from those of 1916 and those to follow during the Woodstock summers of the 1920s. A number of the landscapes display an unusual, dramatizing light effect and a highly geometrical quality. The handsome *Boy and Calf—Coming Storm* (fig. 67) incorporates all the characteristics of that summer's work: the strong color, the numerous paint textures, the dramatic lighting, and the highly designed structure. The strong sense of a very complicated, two-dimensional design suggests that Bellows used Dynamic Symmetry in planning at least some of these landscapes. However, his smaller, simpler landscapes, apparently painted in the field, seem less constrained by planning.

THE NEW PORTRAIT MODE

Theories of color and composition again and again were determining influences upon Bellows's style, but they were not the only influences or always the most important ones. Aware of the history of art and the art around him, Bellows naturally shared the interests of the artists who were his close friends. His portraits of the 1920s, in their scale and complexity, reflect both his own understanding of the history of art and his friends' conception of art. Encouraged by his consciousness of a grander style and more complex images, he more fully explored indirect painting, as he worked toward more sculptural form in an old master manner.

Although by far the largest number of Bellows's works of the 1920s were the informal landscapes of the countryside and farmyards near Woodstock, his major efforts and

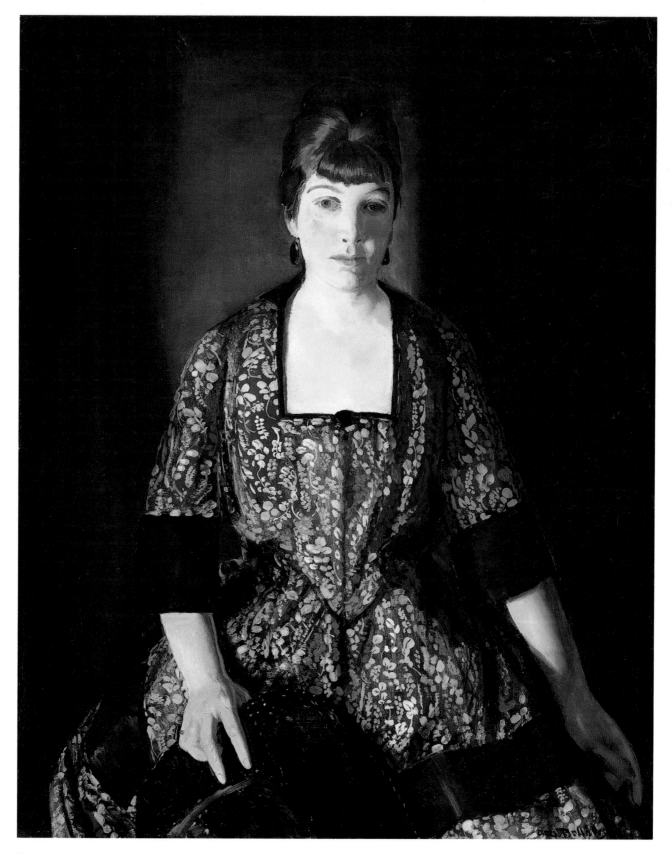

FIGURE 68
George Bellows. *Emma in the Black Print*, 1919. Oil on canvas, 40 x 32 in.
Museum of Fine Arts, Boston; bequest of John T. Spaulding.

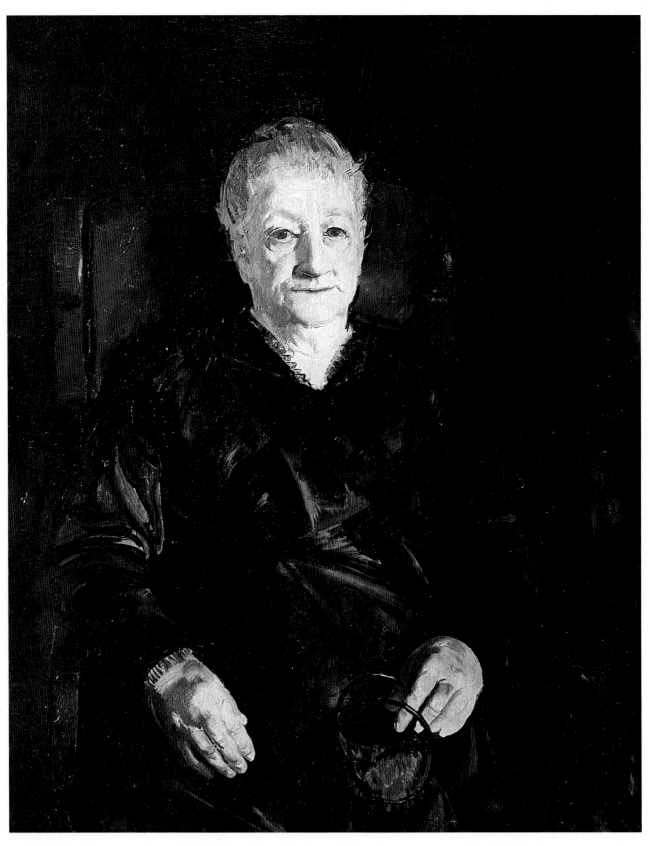

Figure 69
George Bellows. *Grandma Bellows*, 1919. Oil on canvas, 38 x 30 in. Oklahoma City Art Museum.

greatest achievements during the remainder of his career would be principally in the field of portraiture. The few portraits of the summer of 1919 in Newport (aside from the commissioned portrait of Mrs. Chester Dale) established a new direction that was to be extremely fruitful for the artist during the remaining few years of his life. The portraits have an entirely different character, marking a change of intention. *Emma in the Black Print* (fig. 68) and *Grandma Bellows* (fig. 69) exemplify this new approach to portraiture in their extreme seriousness, their severely geometrical composition, their dramatically dark background, and their allusions to a bygone era, all contributing to a sense of poignant loss. Bellows's portraits of the following years are in an elevated mode, partaking, at times, of the heroic and the tragic.

FIGURE 70
Photographer unknown. *Emma Bellows*, n.d. George Bellows Papers, Special Collections Department, Amherst College Library.

Most interpretations of Bellows's work present him as a realist, who simply recorded what he saw. This view of Bellows may be accurate for the earlier part of his career, but it does not describe his paintings after about 1916. During that summer at Camden, Maine, he first had attempted to invent subjects for his genre scenes of the shipyard and apparently felt self-conscious doing so. By the following summer, however, this new, grander conception of genre subjects had produced the truly heroic images of *The Fisherman* (see page 163) and *Well at Quevado* (see fig. 62). By 1919 he began to see the possibilities of portraits likewise conceived as grand inventions that use the resonance of history to achieve a new majesty.

One way that Bellows developed this historical resonance was to dress his sitters in old-fashioned costumes. Sometimes this occurred naturally, as when his mother, an elderly widow, posed in the old-fashioned clothing she customarily wore. On other occasions, as in his paintings of an elderly woman, Mrs. Tyler, he encouraged his aged subject to don the dresses of her youth. In still others, Emma posed in dresses that she had made in historical styles, as costumes for a period piece (fig. 70). Although not correct in all its details, the black print dress of figure 68 has the pinched waist, the distinctive, long, pointed bodice, and very full skirt of a dress of the 1860s, such as the one in *Mrs. T. in Cream Silk, No. 1* (see page 209).

The direct inspiration for all of the distinguishing characteristics of the new portrait style—its solemnity, severity, monumentality, dark manner, and historical costumes—was the powerful experience of the Thomas Eakins memorial exhibition that Bellows had seen at the Metropolitan Museum in November 1917 and unreservedly praised in a letter to Robert Henri: "Thomas Eakins exhibition proves him to be one of the best of all the world's masters. The greatest one man show I've ever seen and some of the very greatest pictures.

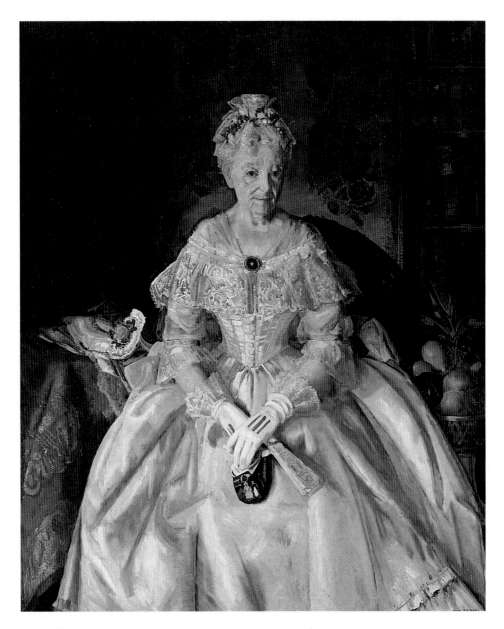

FIGURE 71
George Bellows. *Mrs. T. in Cream Silk, No. 2*, 1920. Oil on canvas, 53 x 44 in.
Minneapolis Institute of Arts; Ethel Morrison van Derlip Fund.

Unfortunately the catalogue reproductions are very bum but otherwise the show seems to be . . . of great importance. The photographer got all the details and none of the values. This is deplorable as I like to keep such things when they're good. 'Mrs. Frishmuth,' the musical instrument collector, is the most monumental work I ever looked at. 'Dr. Gross' must equal 'The Night Watch'. 'Man at Table' good as the best of Renoir and Cezanne. Something here also to remind me of Manet and Titian."[60] Henri's longstanding admiration for Eakins may have predisposed Bellows to such a response to the exhibition.[61] No doubt some of his enthusiasm reflects the fact that Eakins was an American artist who combined the qualities of the most admired European painters. It is notable that a strong American theme runs through Bellows's major portraits from this point on. His response to Eakins's use of Victorian costumes and furniture[62] added a distinctly American nostalgia to his own portraits.

 Not least among Bellows's debts to the example of Eakins is the entirely new degree of concentration on the character and inner life of the sitter. This directness and intense sympathy is most evident in the first and least formal portrait of his mother (see fig. 69), memorable for its intimacy and warmth. In the tradition of Eakins, Bellows was unsparing

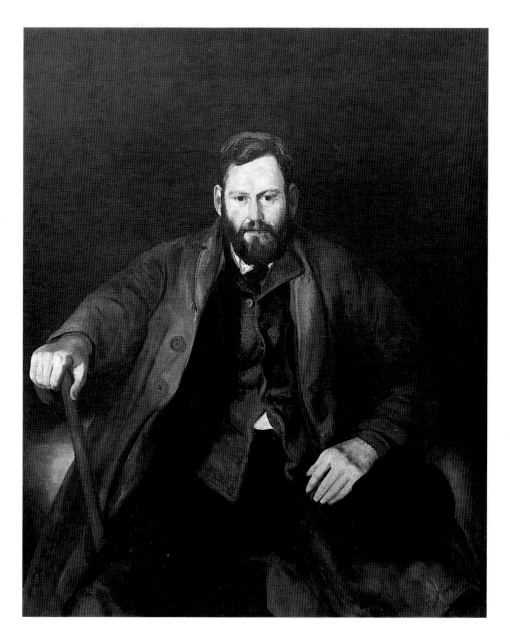

of the evidence of age and weariness in this portrait; the same is true of the series of portraits
of an elderly woman, Mary Brown Tyler, whom he encountered during a brief period of
teaching in Chicago. On December 3, 1919, he wrote to Robert Henri, "Tomorrow I start
work on a little old lady, who is a wonder, eighty years old and in her wedding dress."[63] He
at once began two large, formal portraits of Mrs. Tyler, *Mrs. T. in Wine Silk* (see page 208)
and *Mrs. T. in Cream Silk, No. 1* (see page 209); both dresses are slightly altered originals of
the 1860s and presumably belonged to Mrs. Tyler. Furniture and wallpaper complete the
ensemble of a historical portrait. After returning to New York, in January 1920, he used his
portrait in cream silk to paint another version, *Mrs. T. in Cream Silk, No. 2* (fig. 71). His
record books indicate that Bellows at one point considered titling the second portrait in
cream silk "Portrait of Mrs. Tyler, 1860." The spirit of charm and kindliness that shines
through the portrait in wine silk and the second in cream silk seems insufficient to support
the exceptional monumentality of either portrait. The large figure in its voluminous skirt
is presented in strong, flat light in a frontal, symmetrical, regal pose, but because it is virtually
in the plane of the picture, it has an almost playing-card flatness. (Bellows used the same pose
for his next portrait but gave the figure of his fellow artist, *Waldo Pierce* (fig. 72), a much

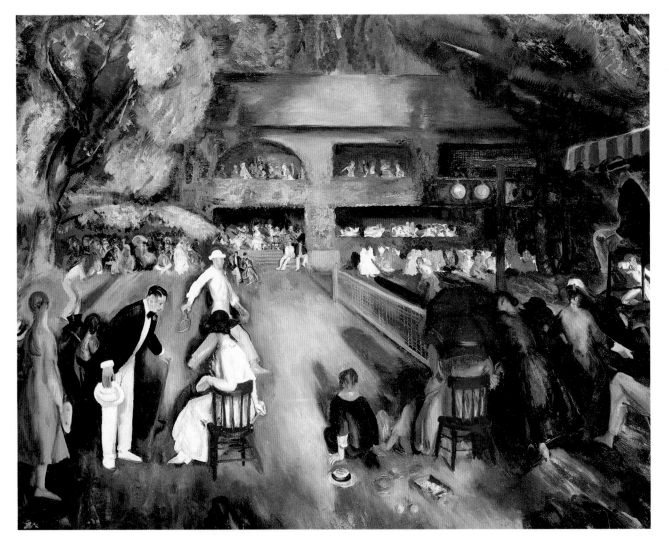

greater plasticity that persuasively carries the heroic monumentality of the format.)
Horizontal folds in Mrs. Tyler's skirt, made by years in a trunk, are evident in the first
portrait in cream silk, but in the second they form a different, radiating pattern of long lines
that trace diagonals to the corners, center of the top, and various subdivisions. The surface
quality of the pattern shows that, even in 1920, Dynamic Symmetry still sometimes
conditioned Bellows to think in terms of only a two-dimensional design in the picture plane.

 Although Bellows worked primarily in landscape and portraiture during this period,
he continued to produce occasional genre subjects of considerable interest. In *Tennis at
Newport* (fig. 73), painted in March 1920, and *Gramercy Park* (fig. 74), painted in May 1920,
Bellows used long, late-afternoon shadows as forceful projections of space, helping to
overcome the two-dimensional quality of his designs based on Dynamic Symmetry. In both
paintings the shadows, which bridge the system's characteristic division of space into
separate registers parallel to the picture plane, give the impression of perspective lines as
they follow the system's diagonals. Because they obey Dynamic Symmetry, rather than the
laws of physics, the shadows sometimes behave illogically, as in the contrariwise-slanting
shadow of the tennis player in the middle distance on the far left. The shadows have one
further function: they lend a greater plasticity to the flat planes by breaking them, giving
them a somewhat corrugated appearance that was to become a prominent feature of many
of the Woodstock landscapes during the 1920s. The long shadow lines also harmonize with
large areas of general shadow that enhance the effect of atmosphere and depth.

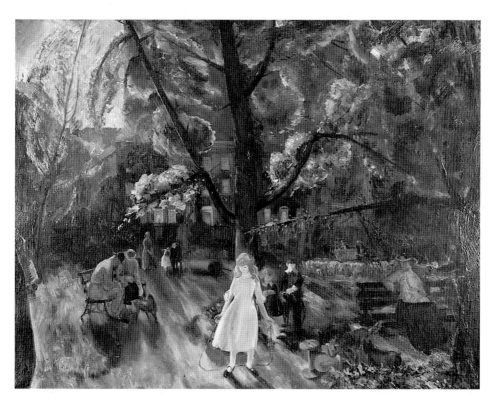

FIGURE 74
George Bellows. *Gramercy Park*, 1920. Oil on canvas, 34 x 44 in. Private collection.

AN EQUAL EMPHASIS ON VALUE AND INTENSITY, IN SUPPORT OF MODELING

Beginning with *Gramercy Park* in May 1920, Bellows's record book entries again contain color notations, for the first time since late 1917. The notations include new initials, expressing both the value and the intensity of each shade. This new approach strikes a balance between the Denman Ross-influenced palettes of 1914–15, with their primary interest in values, and the palettes of 1916–17, based upon the Henri group's chart of color intensities. Bellows's new system for notations followed a change in Robert Henri's color notations, which similarly began to include notations of D[dark]-M[middle]-L[light] by February 1919. These three initials, signifying a greatly simplified scale of values, also were a prominent feature of *The Painter's Palette* (which appeared just at this time, in 1919) by Denman Ross, who continued to consult with Henri. So, once again, the change of approach, reflected in the new symbols in Bellows's notebook, must have resulted from a new consensus among the young color theorists grouped around Henri. Like the symbols for values, the description of color intensities also was greatly simplified in comparison to the color chart of 1914 and represents a break with the consensus it codified. Instead of the chart's thirteen levels of intensity, the new system used just three levels to describe intensity of color. The levels corresponded to the "color," "bi-color," and "hue" paint mixtures supplied by Maratta.

This new concept, which envisioned the use of dark shades within a smooth range of values and considered rich darks as important as lights, seemed to reflect the group's increasing interest in the old masters' careful modeling and resonant darks. Again a shift in theory began to accelerate a change in Bellows's style. The close gradation of values, combined with increasing use of glazing for shadows, would produce a quite Rembrantesque chiaroscuro in Bellows's portraits and figure paintings over the next several years.

During the summer and fall of 1920 Bellows painted three noble portraits of family members, using this softer shadow to enhance a sense of intimacy and great tenderness. In *Anne in White* (see page 216), the expanse of white in his daughter's contemporary summer

FIGURE 75
Diagram of *Aunt Fanny*, from
Jay Hambidge, *Dynamic Symmetry
in Composition* (1923), p. 32.

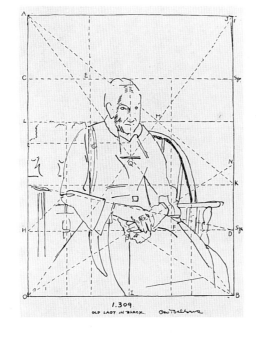

dress greatly lightens not only her figure but also the overall sense of the painting, which actually is darker than it seems. A nominal light enters from the open doorway, but a studio light from the upper right models the figure. Although it shines strongly on the near side of her face, this light leaves portions of the figure in shadow and is insufficient to penetrate the large areas of background shadow, softened by glazes; even the landscape is half in shadow. The strong light that generally flattened the form in Bellows's earlier paintings, now increases the sense of the form's volume. Characteristic of the new style is the way the light rakes across the child's figure, enhancing slight changes of plane in the dress, as in the red-orange and blue shadows of the arm. Although merging with the surrounding shadow, the figure of Anne remains solidly sculptural.

In *Aunt Fanny* (August 1920, see page 212), an active pattern of green highlights and blue-purple shadows describes similar irregularities of shape that establish the bulk and solidity of the black dress. A secondary light separates the figure and table from the background darkness, defining their outlines. The schematic thrusts of the Windsor chair further open up the space around the figure. At the same time, the unmercifully strong light that shines on her face and hands, with their wrinkles painted in as green and brown shadows, conveys an Eakins-like sense of ruthless exposure of the shy, aged widow.

The youthful innocence of *Anne in White* and the aged weariness of *Aunt Fanny* come together in the majestic group portrait, *Elinor, Jean, and Anna* (September 1920, see page 217), portraying Aunt Fanny; the artist's daughter, Jean; and his mother, Anna. The colossal size, which Bellows used first in his war paintings of 1918, shows that it was intended as a monumental statement. Extremely deep in tone, apparently one of his most colorless paintings, it conveys a mood of reserve, solemnity, and stateliness that has invited comparisons to Eakins, Rembrandt, and Hals.

FIGURE 76
Diagram of *Elinor, Jean, and Anna*
from Jay Hambidge, *Dynamic
Symmetry in Composition* (1923),
p. 24.

Another interesting feature of *Aunt Fanny* and *Elinor, Jean, and Anna* is that Bellows allowed his designs for the paintings, with analyses of their geometry, to be published in Jay Hambidge's *Dynamic Symmetry in Composition* (1923).[64] An infrared photograph of *Aunt Fanny* reveals lines, corresponding to some of those in the diagram (fig. 75), that Bellows drew upon the canvas prior to painting; similar examination of other paintings might help to unravel the complexities of their design. The diagram (fig. 76) and analysis of *Elinor, Jean, and Anna* shows just how complex and individual Bellows's designs could be: the individual figures (fig. 77) also have their own, more detailed designs within the general one. It

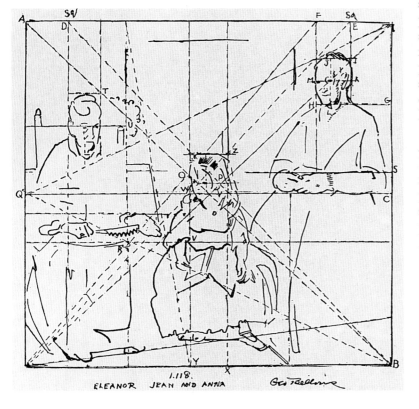

FIGURE 77
George Bellows. *Jean*, c. 1920. Charcoal and graphite on beige paper, 19¾ x 12¼ in. Albright-Knox Art Gallery, Buffalo, New York; gift of A. Conger Goodyear to the Room of Contemporary Art, 1940.

can be assumed that any painting of Bellows's after 1918, except for his informal landscapes,[65] is based upon a design derived from a division of the area according to the methods of Dynamic Symmetry. The shape of *Gramercy Park* (see fig. 74), for example, is the same as that of *Aunt Fanny*, and a roughly similar design is discernable in it. By late 1920, however, Bellows had progressed beyond the self-evident flatness of his earlier use of the system.

FIGURE 78
George Bellows. *Katherine Rosen*, 1921. Oil on canvas, 53 x 43⅛ in. Yale University Art Gallery, New Haven, Connecticut; bequest of Stephen Carlton Clark.

FIGURE 80
Eugene Speicher. *"Red" Moore—Blacksmith*, 1933–34. Oil on canvas, 64⅛ x 52⅛ in.
Los Angeles County Museum of Art; gift of Sid and Diana Avery.

Beginning in 1920, Bellows spent his summers, his season for painting after winters dominated by lithography, in Woodstock, New York, where he purchased land and himself built a house for his family in 1922. He had come at the invitation of his close friend, Eugene Speicher, and while there associated closely with somewhat younger, more modernist painters such as Andrew Dasburg, Henry Lee McFee, and John Carroll. This change of place and associates had two immediate effects upon Bellows's work: often going sketching with Speicher, he experienced another burst of landscape painting; in his figure paintings, he produced fewer, more ambitious works. In 1920 he wrote to Robert Henri, "I am afraid I am getting the Woodstock habit of working a month or more on a 'Masterpiece.' We will see what we will see."[66] During the summer of 1920, Speicher painted a large, fifty-by-sixty-inch portrait of Katherine Rosen, the daughter of Bellows's friend and neighbor, the artist Charles Rosen. Bellows's first painting of the following summer, completed in July 1921, was his own portrait of *Katherine Rosen* (fig. 78), in every sense a "masterpiece." The model, costume, furniture, setting, and lighting all work in a carefully coordinated fashion to contribute to an interpretation. Costumed in a period dress of the 1870s and placed in an

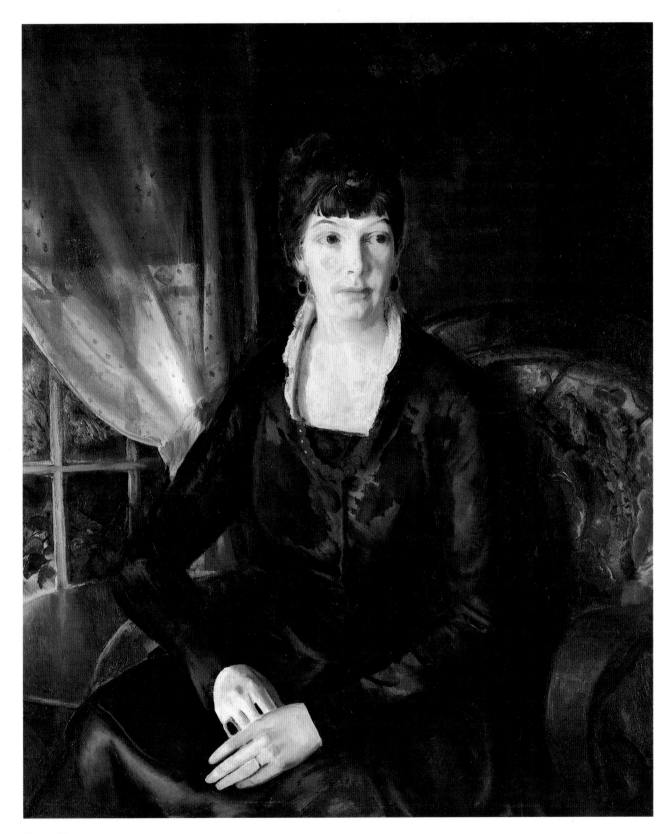

FIGURE 81
George Bellows. *Emma at the Window*, 1920. Oil on canvas, 43 x 34 in.
Phillips Collection, Washington, D.C.

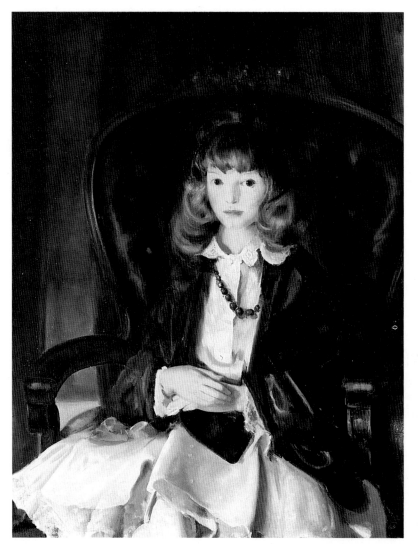

FIGURE 82
George Bellows. *Anne in Purple Wrap*, 1921. Oil on panel, 40 x 32 in. Addison Gallery of American Art, Phillips Academy, Andover, Massachusetts; gift of anonymous donor.

overly large, Victorian armchair in a dim, Victorian interior, Katherine Rosen is the old-fashioned American maiden, beautiful, poised, thoughtful, and very much herself.

Bellows's two full-length portraits of his mother (fig. 79 and page 220), also painted that year, are likewise developed in terms of an elaborate setting that places the subject in an historical period. This method can be compared to the way Eugene Speicher, in his ambitious paintings that are something between a portrait and a genre painting, characterized his model, Red Moore, as a blacksmith (fig. 80) or as a farmer (Dallas Museum of Art). All of these portraits use setting to present the subject as more than just an individual, as a concept or "type" of traditional, American virtue. This is the kind of portrait that Grant Wood would paint in his *American Gothic* (1930, Art Institute of Chicago) and other figure paintings drawn from Americana. It is also akin to the grand-manner portrait that John Neagle had painted a hundred years earlier in his *Pat Lyon at the Forge* (1829, Pennsylvania Academy of the Fine Arts), which characterized the successful businessman in his beginnings, as a hardworking craftsman and patriot.

Two other portraits that Bellows had begun earlier but reworked around 1921[67]— *Mrs. T. in Cream Silk, No. 1* (see page 209), begun in 1919, and *Emma at the Window* (fig. 81), begun in 1920—provide a fuller understanding of his portrait style of 1921, as epitomized in *Katherine Rosen*. A comparison of his two portraits of Mrs. Tyler in cream silk clearly demonstrates the changes in Bellows's style. Identical in subject and setting, the paintings are entirely different in appearance. *No. 2* (actually the first version finished) is crisp, clear, bright, flat, and right at the picture plane. *No. 1* (actually finished two or three years later) is pushed back into depth by intervening veils of red and green glazes that soften detail, dim the light, and suggest atmosphere. The different technique brings about an entirely different interpretation, as well. Although the figure in *No. 1* originally must have looked bright and impressively monumental, like the one in *No. 2*, she ended up not only more three-dimensional but, more importantly, tenderly sympathetic, poignantly vulnerable in the dimness. The painting's much richer color transforms the cream silk into an opalescent, *changeant* fabric and imparts a sensuous quality.

Emma at the Window, like *Katherine Rosen* and another beautiful portrait of that year, *Anne in Purple Wrap* (fig. 82), similarly describes a fully sculptural figure in explicitly dim lighting in terms of similar softness, atmosphere, and rich color to establish a tender intimacy that is deeply affecting. Although modest in format, the hauntingly evocative portrait of *Anne in Purple Wrap* seems to capture his daughter's spirit more completely than any of the other, numerous portraits that Bellows would paint of her. In these paintings Bellows's emulation of old master techniques and styles reaches its fullest expression.

Because he spent from April to September 1922 building his Woodstock home (which he had designed according to the principles of Dynamic Symmetry), Bellows had no time for the large, ambitious figure pieces of the previous summer and those to follow. The few, smaller-scale portraits he produced that year showed a change from the style of the previous summer: they have much less atmosphere but much stronger color. Bellows's painting energy that fall seemed to go into landscapes; in November he wrote to Henri, "Gene

Figure 83
George Bellows. *Farmyard, Toodleums*, 1922. Oil on canvas, 36 x 58 in. Photograph courtesy of Sotheby's, Inc., New York.

Figure 84
George Bellows. *The White Horse*, 1922. Oil on canvas, 34⅛ x 44¹/₁₆ in. Worcester Art Museum, Massachusetts.

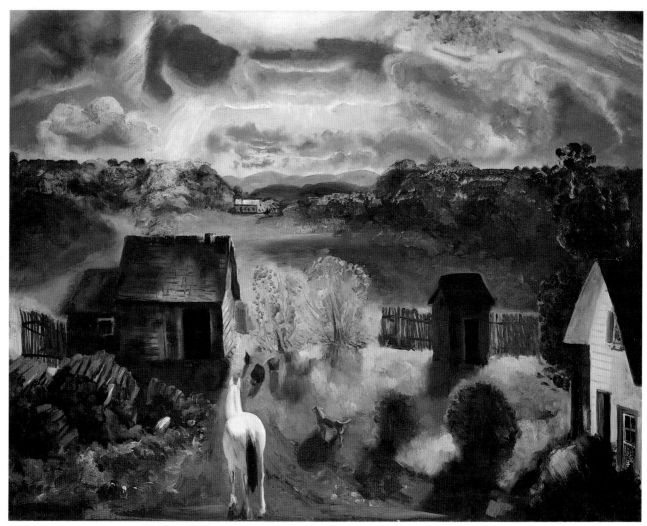

[Speicher] and I and Charlie [Rosen], have been going out every day at 8:30 and coming home at dark with landscapes."[68] The month or so of roaming through the countryside with his friends produced about twenty small panels.

Bellows's two major works of that fall—*Old Farmyard, Toodleums* (fig. 83) and *The White Horse* (fig. 84)—also were landscapes. Although one is a closed view of a farmyard and the other an expansive, open motif, they are alike in the way rapidly alternating areas of light and dark pull and push flat planes, creating a rolling, undulating appearance. Bellows's objective was both greater plasticity and expressive energy. In *The White Horse*, for instance, strongly contrasting bands give the clouds an active appearance, and random shadows falling on the land create a sense of movement there. The result is a turbulent, visionary quality, also found in some of the small landscape panels of the 1920s, that recalls the spiritual landscapes of El Greco, then admired by Bellows and other modernist painters.[69] There is a new energy and drama in these landscapes.

THE FINAL STYLE

In 1923 Bellows again worked on major figure paintings, including two of his family, *Emma and Her Children* (see page 224) and *Fisherman's Family* (see page 165), in which he recast a painting of 1915 that showed Emma, Anne, and himself on a bluff overlooking the harbor at Monhegan. Both of these monumental yet affectionate family portraits are notable for their clever use of just a few colors to give the impression of many—for instance, in the green and purple that make the black of Emma's dress in *Emma and her Children*. These works show a trend in Bellows's thinking about color that was to crystalize in a new theory and style in his painting, *The Crucifixion* (fig. 85).

The new system appears to have been Bellows's own invention, independent of Henri and his collaborating theorists. It grew out of the indirect painting method that Bellows had learned from the book by Albert Abendschein in 1914 and apparently adopted more fully than any of his associates, incorporating it into his style most conspicuously in his paintings of 1921. In 1923, having become comfortable and expert with the methods of indirect painting, he began to take it in a direction of his own. He described the new style—which was to be his final one—in a letter to Robert Henri:

> I have found a remarkable technical fact with to me quite exciting possibilities. I painted the crucifixion complete in two colors, setting mixtures through white of a semi-neutral blue and a semi red orange with the intermixture and useing nothing else until all the picture was finished thus. Then it was easy to sway a cool color a little cooler or warmer with glaze and same for the warm. The result looking not quite full, but rather like a color print although a very good one. Then by Repainting a few things, very easily and holding to the established form with a third color, a perfectly marvelous full coloration was developed strikingly like in texture certain of the best old masters.
>
> The advantages are striking. For the first time I was able to draw very carefully with paint with the kind of freedom I have with a pencil there was no trouble in making alterations, corrections etc. The discoveries in the powers of simplicity in color quite wonderful. The two colors used were calculated to be major notes of the final color scheme and as such enabled the first painting to be done with a feeling of finality, which was never the case in monochrome of which I have now done a lot, and in which glaze didnt count, and the fresh first excitement apt to be lost or somewhat covered. I believe the idea could be used in a one days painting, by adding the third color twards the end of the work. (rather the Final color)
>
> Well that that. I realise that this theory is an old one, known to have been used by Titian, but it is amazing how it has fitted into my practice without any special noviciate.[70]

On January 31, 1924, Henri wrote from Madrid, where he had tacked up a reproduction of *The Crucifixion*, about his own examination of old master paintings: "Tintoretto has a great

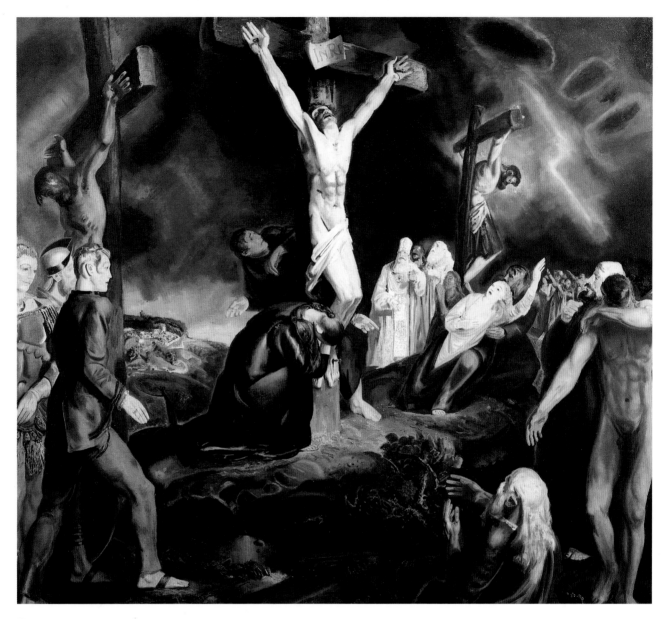

FIGURE 85
George Bellows. *The Crucifixion*, 1923. Oil on canvas, 59½ x 65½ in.
Lutheran Brotherhood, a Fraternal Benefit Society, Minneapolis.

showing. Perhaps if you saw them you would find evidences strong enough that they started their paintings in many instances much as you think they did, i.e. that their two colors were such as to be a close approach to finality—possibly two complements—with the 3d color for a finish, and this not used except where needed."[71]

Once again, adopting a new method caused Bellows to conceive the formal aspects of his works differently and to change his style markedly and abruptly, although he retained such elements of his earlier method and general style as careful modeling of forms, as a process separate from coloring. Bellows's latest approach to color was to have a critical effect upon the paintings of 1924, such as *Dempsey and Firpo* and *Lady Jean*, in which he worked out the application of what might be called his "limited-color method." In *Dempsey and Firpo* (fig. 86), painted in June 1924, the background is a dull grey-green (neutralized partly by the general red underpainting); it is modeled in terms of the addition of white or orange. White is used throughout the painting, within large areas of color, to reduce the intensity of the color and model it by lightening it. The primary method of creating form, however, is through the pairing of the colors green and orange. This basic interaction can be seen most clearly in the way the background figures are modeled. The third color, red-purple, which comes into play in the foreground figures, in isolated patches such as the spectator's jacket,

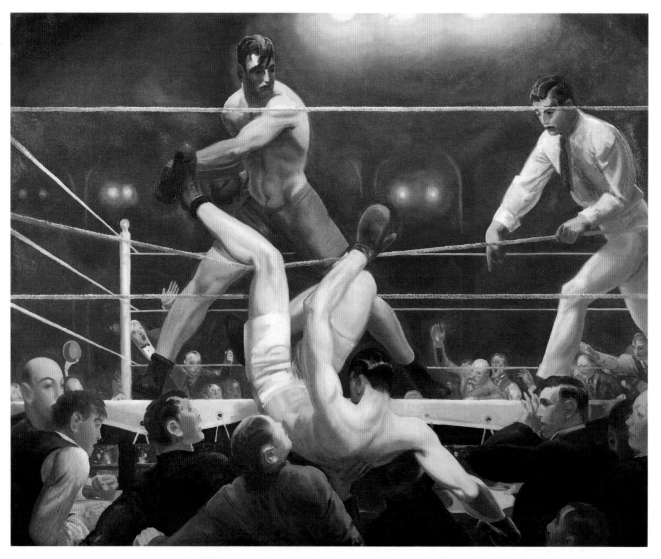

FIGURE 86
George Bellows. *Dempsey and Firpo*, 1924. Oil on canvas, 51 x 63¼ in. Whitney Museum of American Art,
New York; gift of Gertrude Vanderbilt Whitney.

also becomes part of the modeling system: generally speaking, green serves as shadow, red-
purple as mid-tone, and orange as highlight. Among other places, these three colors model
the face of the spectator in the red-purple jacket. There also is a very limited role for the color
yellow—in the referee's trousers, in the forehead of the spectator directly below the referee,
shielding himself, and presumably, in mixture, in some of the flesh passages.

Although Bellows continued to use glazing during 1924, in theory it was not an
essential element in the new system. As a result, he must have conceived of the forms in his
paintings as stripped of the softening, atmospheric veils of glazing that earlier had been
integral to his interpretations. Consequently, his new paintings can have an airless quality.
As part of his ever-greater emphasis on drawing and modeling, Bellows also simplified,
regularized, and slightly geometrized the forms into clearly rounded, sculptural shapes.
How flat, paper-thin, and insubstantial the fighters in *Stag at Sharkey's* (see page 108)
appear, in comparison to the solid, monumental figures of Dempsey and Firpo!

Likewise, the composition of *Dempsey and Firpo* is incomparably more three-dimen-
sional than that of *Stag at Sharkey's*. The rectangles of Dynamic Symmetry are defined in
a number of planes, with diagonals moving easily across several planes into distance,
although the basically planar nature of most of the composition remains. The dramatic
figure of the falling Dempsey is aligned along the diagonal of the square formed by the
rebatment of the left side.[72] As his body crosses the level of the canvas ring, its limbs describe

the logarithmic spiral central to the theory of Dynamic Symmetry. The alignment of Dempsey's body along the diagonal of the square actually is not unlike the use of the fighter's body in *Both Members of This Club* (see fig. 14) to create an image of maximum force; at the beginning of his mature career, Bellows had used the diagonal of the square in a similar manner to create a dramatic movement that also expressed structure and control. The simplicity and directness of those first attempts at geometrical composition, however, stand in contrast to the puzzling complexity of the geometry of *Dempsey and Firpo.* Bellows employed numerous independent procedures of Dynamic Symmetry to specify individual details, such as the precise positioning of the three ropes on the other side of the ring,[73] with the result that a proliferation of geometrical markers, which make the structure explicit, have the contrary effect of dissipating the strength of unity.

FIGURE 87
George Bellows. *Lady Jean,* geometrical plan based on Dynamic Symmetry, 1924. Graphite on paper, 20⅛ x 10⅛ in. Collection of Dr. and Mrs. Harold Rifkin.

Bellows's historical portraits lost much of their period character without the atmospheric glazing of his style of about 1921. *Lady Jean* (see page 225) is full of period detail—the adult dress of the 1880s, the hooked rug, the furniture—but the painting's airless quality and brilliant color give it a modernist, rather than historical, feeling. For one thing, the three colors that Bellows used are the primaries—blue, yellow, and red. Although all other colors could also be made from the intermixture, as in the brown floor, the three colors appear for the most part in a relatively pure form. The fact that they also appear in large, separate areas of uniform color with abrupt transitions between the areas gives the painting something of the character of a print that has been tinted through stencils. It appears that, in this painting, Bellows used glazes for the major areas of yellow and red, painting the yellow, for instance, over shadings of blue and red, then

FIGURE 88
George Bellows. *Nude with Hexagonal Quilt,* 1924. Oil on canvas, 51 x 63 in. National Gallery of Art, Washington, D.C.; Collection of Mr. and Mrs. Paul Mellon.

returning to add some further shadings in opaque blue or mixed paint on top of the yellow glaze. Bellows was correct that his three-color system does give the impression of full coloration; it must rarely occur to those viewing the painting that the color is so limited and so arbitrary. Another unobtrusive manipulation of naturalistic appearances occurs in the angles of the top of the red cabinet and of the rug, which follow the diagonals of rectangles generated by Dynamic Symmetry (fig. 87). (The diagonals of the rug do have the effect of tipping upward the plane of the floor, however.) Other rectangles and diagonals shape the contours of the figure.

Also in July 1924, Bellows painted his magnificent *Nude with Hexagonal Quilt* (fig. 88), the most powerful of the series of nudes that he had painted since 1919, as his interest in modeling sculptural form grew. He followed it in October with the heroic

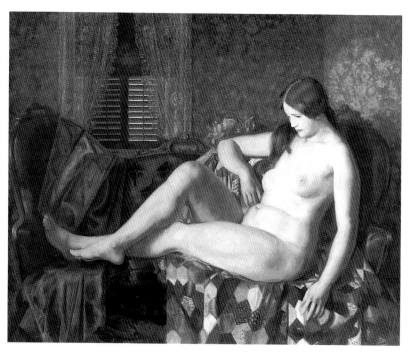

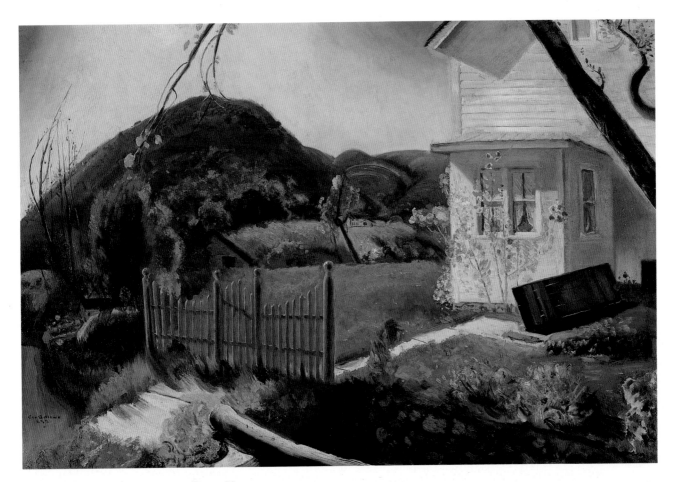

FIGURE 89
George Bellows. *The Picket Fence*, 1924. Oil on canvas, 26 x 38¼ in. Wellesley College Museum;
gift of Mr. and Mrs. Chauncey L. Waddell (Catherine Hughes, Class of 1920).

Two Women (see page 228), which was to be the last of his figure paintings. The painting's original title, *Two Sisters*,[74] does little more to elucidate the enigmatic subject. The unexplained juxtaposition of dissimilar objects, indicating no narrative or interaction between them, imparts a curious, surrealist quality. In this case the Victorian setting adds to the puzzle, rather than providing a context. Titian's *Sacred and Profane Love* is logical as the inspiration for a painting pairing nude and clothed seated figures, of course, but Bellows did not carry out the allegory. Thomas Hart Benton also was to cultivate this dreamlike lack of resolution in his two paintings of monumental nudes unexpectedly encountered in traditional, Americana settings, *Susannah and the Elders* (1938, Fine Arts Museums of San Francisco) and *Persephone* (1938–39, Nelson Atkins Museum).

The figure paintings of 1923 and 1924—Bellows's last two years—gained steadily in power and majesty. His very last paintings, about fifteen landscapes, also give no premonition of the sudden death that came to Bellows from a ruptured appendix on January 8, 1925. Some have the ideal, storybook feeling of *The Picket Fence* (fig. 89), his very last painting (actually finished by Eugene Speicher). All are deliriously happy scenes in brilliant, clear color, like *My House, Woodstock* (fig. 90). Their unbridled color gives them a rapturously fantastic quality, so unlike the tense energy of the landscapes of about 1922. In those earlier landscapes, such as *The White Horse* (see fig. 84), rapid alternation of light and dark passages gave the forms a sense of movement, plasticity, and visionary force. In his last landscapes, painted in 1924, abrupt juxtapositions of strong color achieve some of the same effects. Once again, as in 1913 and 1916-17, when his theories gave him license to paint with the strongest color, he produced some of his most beautiful landscapes.

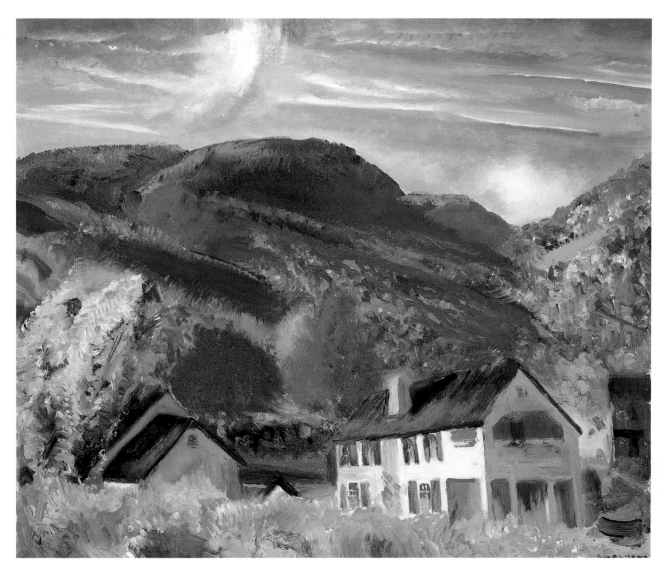

FIGURE 90
George Bellows. *My House, Woodstock*, 1924. Oil on panel, 17¾ x 22 in. Sid and Diana Avery Trust.

At the abrupt end of his truncated career, Bellows was a much more complex artist than he had been when he painted the classic youthful works for which he has been remembered. His skills, sophistication of style, and knowledge of methods were incomparably greater. His growth in these areas, step by step, had been based upon thorough theoretical understanding that led him to constantly new forms of expression. The steadily increasing power of his work, he achieved through knowledge.

Often modern critics and art lovers mistrust the efforts of artists who think too much. They fear that technical knowledge compromises spontaneity, that theoretical correctness can distract the artist from more important goals, such as beauty. Theories of composition and color preoccupied Bellows from about 1910 on, pulling his style in one new direction after another. In his case, however, the theories provided new experiences and insights that led to fresh forms of expression. The clearest demonstration of this pattern is the way color theories enabled him to realize his exceptional gifts for steadily more harmonious and brilliant color. Because artistic strength always was Bellows's ultimate goal, he remained the master of his theories, using them to find the way to fuller interpretive richness. America produced few artists with his range, his steady growth, his consistent quality, and the culminating power of his late masterpieces.

NOTES

[1] The indispensable biography of Bellows remains Charles H. Morgan's *George Bellows: Painter of America* (New York: Reynal and Company, 1965). There are no footnotes, but it sometimes is possible to identify Morgan's sources among his papers, now in the special collections of the Amherst College Library.

[2] In "Twentieth-Century Nostrums: Pseudo-Scientific Theory in American Painting," *Magazine of Art* 41 (March 1948): 98–101, Milton W. Brown takes the position that true modern artists believed in the individual and in intuitive methods, unlike Bellows, Henri, Davies, and others, who mistakenly followed theories and systems of painting supposedly based on scientific principles. It seems to me that theories and systems of painting have been part of most art movements since the Impressionists and well into the beginning of this century. There is no difference between the theory that underlay a major movement and the one that led nowhere—except in retrospect. At the time, all were theories.

[3] See William C. Agee, *Synchromism and Color Principles in American Painting, 1910–1930*, exhibition catalogue (New York: M. Knoedler and Company, Inc., 1965). Tudor-Hart's theories are set forth in his two articles: "A New View of Colour," *Cambridge Magazine* 7 (February 23, 1918): 452–456; and "The Analogy of Sound and Colour," *Cambridge Magazine* 7 (March 2, 1918): 480–486.

[4] In a letter to Robert Henri on October 5, 1916, Bellows wrote about selecting paintings for the exhibition at the Corcoran Gallery of Art: "I am trying to get some of the young fellows invited, McFee, Weber, Halpert, DuBois etc., Kent, Kroll, anybody else?" (Robert Henri Papers, Yale Collection of American Literature, Beinecke Rare Book and Manuscript Library, Yale University.) In early 1920 Bellows joined in protesting the French authorities' refusal to hang the modernist works by Bouche, Gussow, McFee, Maurer, Sheeler, Stella, Weber, and Zorach that he had worked to include in an exhibition of American art to be shown at the Luxembourg Museum.

[5] Henri's interest in art theories is discussed in William Innes Homer, *Robert Henri and His Circle* (Ithaca and London: Cornell University Press, 1969), pp. 184–194.

[6] For information on tonalism, see *Tonalism, an American Experience*, exhibition catalogue (Grand Central Art Galleries Art Education Association, 1982), with essays by William H. Gerdts, Diana Dimodica Sweet, and Robert R. Presto.

[7] For information on Van Dearing Perrine, see Lolita Flockhart, *A Full Life, The Story of Van Dearing Perrine* (Boston: Christopher Publishing House, 1939); John I. H. Baur, "Rediscovery: Van Dearing Perrine," *Art in America* 57 (January 1969): 78; and *Van Dearing Perrine, 1869–1955: First Decade on the Palisades (1902–1912)*, exhibition catalogue (New York: Graham Galleries, 1986).

[8] For a survey of Sloan's genre subjects in his illustrations, prints, and paintings, see the exhibition catalogue, *John Sloan, Spectator of Life* (Wilmington: Delaware Art Museum, 1988).

[9] "Boston Art Shown in Philadelphia," *Boston Herald*, January 26, 1908, Real Estate and Want Section, page 1.

[10] The artificiality of the dim lighting in Bellows's paintings of the period was sometimes ridiculed by reviewers. One wrote of *Forty-Two Kids*, "[the unity of the painting] is obtained by the weird devise of painting these lighted forms against a background of inky darkness, relieved only by a faint tinge." ("Carnegie Institute Exhibition, The Figure Subjects. First Notice," *New York Post*, May 1, 1909, p. 5). The critic "TAD" wrote that "[*Club Night*] by George Bellows is a wonder except that the ring is very shy of light. It looks as though the artist had posed the men and then put a lamp near one fellow's back, as the rest of the ring is as dark as the Kentucky cave. It would be a pipe for the losing man to run in the dark corner and hide. He might stick there for a month unless the other grabbed the lamp and went looking for him." ("TAD Criticized Pictures He Saw at the Art Show," *New York Journal*, January 6, 1908, p. 12).

[11] Reviewing Bellows's exhibition at the Madison Galleries in January 1911, a critic for the *Brooklyn Eagle* [January 31, 1911, p. 9] introduced a comparison with Luks's *Wrestlers*: "the wonder of [Bellows's] work is that he paints all sort of subjects, of the most diverse kind, with equal devotion to fact, to atmosphere and very often to esthetic appeal. Witness the difference between his '[Stag at Sharkey's],' two men sparring in a roped arena, and a 'Wrestler,' painted by George Luks; each is painted in a masterly way, but the Luks work repelled through emphasis on brutality, while in the Bellows work the appeal is to the struggle and the splendid strain of muscles all over the men's bodies." Undated clipping in Bellows's scrapbook, George Bellows Papers, Amherst College Library.

[12] At about the same time, some other young artists of his acquaintance—Henri students—began to use a heavier impasto. An example is Henry Glintenkamp (1887–1946), who by 1910–11 painted entire pictures with the palette knife.

[13] Morgan, *George Bellows: Painter of America*, pp. 85–86. I would like to thank Lucy Belloli, conservator of paintings at the Metropolitan Museum of Art, for kindly sharing with me her examination report on *Up the Hudson*.

[14] The trunk is wide enough to also coincide with a golden-section division of the width. I have chosen the analysis of rebatment because it is by far the simpler system, easily carried out with just a piece of string.

[15] The first such analysis of an American painting that I encountered was Henry Adams's geometrical analysis of John La Farge's *Flowers in a Persian Porcelain Water Bowl* in his essay, "The Mind of John La Farge," *John La Farge*, exhibition catalogue (New York: Abbeville Press, 1987, in conjunction with the Carnegie Museum of Art, Pittsburgh, and National Museum of American Art, Smithsonian Institution, Washington, D.C.), p. 73, n. 51. I am grateful to Henry for recommending other books and articles about geometry in non-American paintings. By far the most useful, as a how-to introduction to different kinds of geometrical analysis, is Charles Bouleau, *The Painter's Secret Geometry, A Study of Composition in Art*, with a preface by Jacques Villon (New York: Hacker Art Books, 1980). My strong impression is that many American artists of the late nineteenth century and through the late 1930s used geometrical compositions. Analysis of that geometry will prove to be important to a full understanding of the paintings.

[16] "Work of Contemporary American Landscape Painters Shown at the National Arts Club," *New York Times*, February 6, 1910, Magazine Section, p. 14.

[17] Newspaper clipping marked "Brooklyn Eagle" [January 31, 1911, p. 9] in Bellows's scrapbook, Bellows Papers, Amherst College Library. It reviews the artist's exhibition at the Madison Gallery, January 21–February 3, 1911.

[18] Newspaper clipping in Bellows's scrapbook, Amherst College Library. It appears to be part of a review of the spring exhibition of the National Academy of Design in 1912. The clipping is marked "Phil Record."

[19] Harold Spencer, "*Criehaven*: A Bellows Pastoral," *Bulletin 1977* (William Benton Museum of Art, University of Connecticut, Storrs), 1 (no. 5): 18–38.

[20] For Gustave Caillebotte's use of the golden section, see Peter Galassi's essay, "Caillebotte's Method," in the exhibition catalogue, *Gustave Caillebotte, A Retrospective Exhibition* (Houston: Museum of Fine Arts, 1976), especially pp. 199–206. The essay was reprinted, essentially unchanged, in Kirk Varnedoe, *Gustave Caillebotte* (New Haven and London: Yale University Press, 1987), pp. 27–40. For Georges Seurat's use of the golden section, see Henri Dorra's essay, "The Evolution of Seurat's Style," in Henri Dorra and John Rewald, *Seurat* (Paris: Éditions d'études et de documents, 1959), pp. LXXIX–CVII. For its use by Juan Gris and for the Salon de "La Section d'Or," see William A. Camfield, "Juan Gris and the Golden Section," *Art Bulletin* 47 (March 1965): 128–134.

[21] Spencer, "Criehaven: A Bellows Pastoral," pp. 26-27.

[22] Charles DeKay, "The Eighty-Seventh Academy," *International Studio* 46 (May 1912): lv–lxii.

[23] Frank Jewett Mather, reviewing the Winter Exhibition of the National Academy of Design ("The Winter Academy," *New York Evening Post*, December 15, 1910, p. 9) remarked on this balanced quality in *Polo Game*: "George Bellows displays a new side of his versatile gift in a polo scene. It has not merely the rattle and rush of the subject, but is also well put together. A swerving horse and dog check and balance up the onrush of the players; a conscious elongation of the figures of the onlookers, a stilting up of pony legs beyond natural proportions show that Mr. Bellows is not merely retinal, but is seeking an expression as well for the elegance as for the animation of his theme."

[24] The later history of *Polo Game* is one of the numerous examples of Bellows's extreme changes of mood and opinion. *Polo Game* is the smallest and first of the three polo subjects that he painted in 1910. When he had just painted *Polo Game*, Bellows wrote of it in a letter to Professor Joseph Taylor, "I've just completed my best picture so far. (So sayeth Robert Henri). A Polo game. Peach of a subject." (George Bellows to Joseph Taylor, undated but probably April 1910, Bellows Papers [Box I, Folder 11], Amherst College Library.) That same year he went on to paint *Polo at Lakewood* and *Crowd, Polo Game*, but even after both these larger pictures were finished, it was still *Polo Game* that he chose to exhibit at the Winter Exhibition of the National Academy of Design in December 1910 and at the Annual Exhibition of the Pennsylvania Academy of the Fine Arts in February 1911. At that point he must have retained his initial, high opinion of *Polo Game*, apparently considering it the best of the series. It attracted considerable notice and admiration at the Winter Academy exhibition, as in the review that appeared in the *New York Sun*: "Let us glance at [the artist Edward Lamson Henry's] artistic antipodes in the way of seeing the world and transferring that vision to canvas. George Bellows is one of the most gifted of our younger men. A pupil of Robert Henri, Mr. Bellows has swum further out in the turbid sea of realism than his master, has developed a more forthright manner. It is one peril of his undoubted cleverness. He does too many things too well. Consider the "Polo Game" (No. 205). Its rhythmic violence, its crash and go, betray not only a close study of Degas but the movement of horses in life. It is a breezy, brilliant picture, full of air, crisp, telling strokes and resounding vitality. How would Mr. Henry have seen the same posture of circumstances? Not Muybridge himself would have equalled in minute details the adventures of those horses and riders—that is, if Mr. Henry would not find it quite impossible to treat such a hullabaloo, such a tohu-bohu. These two artists emphasize in their widely varying work the assertion of MacColl that moderns have discovered a new vision, as well as a new technique for its expression." ("The Winter Academy," *New York Sun*, December 14, 1910, p. 8.) In Philadelphia the painting's "new technique" caused something of a stir because of its bold, sketch-like quality, but this kind of reaction must have been music to Bellows's ears, rather than something that would change his

high opinion of the painting. Nevertheless, by April 1915 Bellows whited out *Polo Game* with a coating of gesso, reversed the painting on its stretcher, and painted his second portrait of Judge Peter Olney on its verso. Thus it joined the considerable list of significant paintings that Bellows later destroyed or drastically cut down, among them paintings like *Portrait of Emma in Night Light* (1914), that he once was proud to exhibit widely. The beautiful portrait of *Lucie* (fig. 47) is an example of a thirty-eight by thirty-inch painting that Bellows cut down. This turning so completely against his favorites may have come in periods of discouragement or perhaps in the moment of his discovery of a new theory, when older work seemed hopelessly wrong. Whether his destruction of a painting always represented his fair judgment of it is hard to say. Fortunately, conservators were able to remove the gesso from *Polo Game* with miraculously little loss of original paint, revealing once again its brilliant brushwork. Ironically, because the portrait was on the other side, *Polo Game* was never relined, which is almost the rule with paintings of this period; its intact impasto retains the exceptional vigor of the act of painting.

[25] Rockwell Kent's influence upon this painting and *Shore House* is suggested by Franklin Kelly in his essay "George Bellows' *Shore House*" in *American Art Around 1900: Lectures in Memory of Daniel Fraad*, ed. by Nicolai Cikovsky, Jr., and Doreen Bolger (Washington, D.C.: National Gallery of Art, 1990), pp. 126–127. Bruce Robertson discusses the influence of Kent upon Bellows's Monhegan paintings in the exhibition catalogue, *Reckoning with Winslow Homer: His Late Paintings and Their Influence* (Cleveland: Cleveland Museum of Art, 1990), pp. 102–110. Both authors, however, see Kent's influence as clearly secondary to the primary influence of Winslow Homer upon Bellows. I am not persuaded by this point of view. It is a compliment to Bellows to think that he was more influenced by the distant example of Homer than he was by the immediate example of Kent and other painters of his generation, but I cannot see Homer's direct influence in many of Bellows's paintings.

Bellows expressed his admiration for the work of Kent in a letter of April 21, 1910, to Professor Joseph Taylor, Bellows Papers (Box I, Folder 11), Amherst College Library.

[26] Rockwell Kent's *Winter—Monhegan Island* (1907, Metropolitan Museum of Art, New York), given by Kent to Robert Henri in 1907 and certainly familiar to Bellows, may have suggested this uncomfortable placement of the house. In *Reckoning with Homer*, pp. 131–132, Bruce Robertson contrasts the feeling of community in Kent's painting with the feeling of isolation in *Shore House*.

[27] The most intensive analysis of Maratta's theories and their influence is Elizabeth Armstrong Handy, "H.G. Maratta's Color Theory and Its Influence on the Painters—Robert Henri, John Sloan, and George Bellows," master's thesis, University of Delaware, 1969.

[28] Bruce St. John, *John Sloan's New York Scene, From the Diaries, Notes and Correspondence 1906–1913* (New York: Harper and Row, 1965), pp. 318, 319, 358.

[29] "Correspondence," *American Art News* 9 (November 19, 1910): 3; "In and Out the Studios," *American Art News* 9 (November 26, 1910): 3.

[30] The four-page brochure carries the heading, "H.G. Maratta Artists' Oil Pigments" and on its third page bears the copyright statement, "Copyrighted 1913 by H.G. Maratta." On its fourth page are printed expert opinions, among them the following statement by Bellows: "Dear Maratta:— I have for four years been an enthusiastic worker with your paint. I have taken every opportunity to let artists know about them. It has always been a matter of surprise to me, that every one has not jumped at the chance of using the most direct and scientific instrument which has ever been placed on the market for the use of the artist. Yours truly, George Bellows."

[31] This information was given to me by Helen Farr Sloan, widow of John Sloan. I am grateful to her for valuable insights into his use of the Maratta system.

[32] George Bellows to Emma Bellows, August 12, 1911, Bellows Papers (Box I, Folder 3), Amherst College Library.

[33] I am grateful to the artist's daughter, Jean Bellows Booth, for her hospitality, when she kindly permitted me to examine a copy of the artist's record books, in her possession. There are three books, identified as Book A, B, and C, which cover the artist's production of paintings, major drawings, and lithographs, from 1905 until his death. In most cases, the books give a page to each painting, including a quick sketch, recording its appearance and listing its month of completion, size, exhibition history, price, and sale. Beginning in 1911, a list of the colors (abbreviated to initials) used in the painting usually is included in the entries. Bellows sometimes wrote or painted the record-book number and the list of colors on the reverse of his paintings. Bellows probably adopted this method of recording his paintings from the example or suggestion of Robert Henri, who used similar record books.

[34] "H. G. Maratta Artists' Oil Pigments," p. 3.

[35] In April 1912, Bellows painted a portrait of Fanny Fry in a large, fifty-six by seventy-two-inch format; he later destroyed it.

[36] St. John, *John Sloan's New York Scene*, p. 548.

[37] Hardesty G. Maratta, "A Rediscovery of the Principles of Form Measurement," *Arts and Decoration* 4 (April 1914): 230–232.

[38] Hardesty G. Maratta, *The Web of Equilateral Triangles* (New York, 1915).

[39] Maratta, "Principles of Form Measurement," p. 231.

[40] I am grateful to Robert A. Tibbetts, Curator of Rare Books and Manuscripts, Ohio State University Library, for kindly examining the *Portrait of Dr. T. C. Mendenhall* and carefully mapping the pattern of punctures visible on its reverse.

　A Day in June is in the Detroit Institute of Arts; *Approach to the Bridge at Night* is at the Elvehjem Museum of Art, University of Wisconsin, Madison.

[41] George Bellows to Robert Henri, 1913, Robert Henri Papers, Beinecke Rare Book and Manuscript Library, Yale University.

[42] George Bellows to Joseph Taylor, January 15, 1914, Bellows Papers (Box I, Folder 12), Amherst College Library.

[43] George Bellows to Joseph Taylor, January 15, 1914.

[44] Letter to the author from Bennard B. Perlman, April 9, 1991.

[45] Ross's *The Painter's Palette*, published in 1919, presented the color theories in a somewhat different way and introduced a discussion of pigments.

[46] Bellows habitually misspelled the names of the islands; Matinicus appears with two "t"s in the titles of his paintings, and Criehaven without the "i."

[47] Typical of this opinion of Bellows are the remarks that appeared in "Comment on the Arts," *Arts 2* (November 1921): 114: "Unfortunately Nature left out of Bellows' make-up some very essential elements which go to the making of a great artist. She left out the artistic instinct. . . . Instead of cultivating the little instinct which he has got he strives to use in its place the theories of Hambidge and Maratta, forgetting that the man who depends too much upon his crutches will in time be quite unable to get along without them. Theories are props for the weak. The strong do not need them. . . . If Bellows had been born with a strong natural instinct for color and arrangement he would have been, I believe, our greatest painter. Alas he has had to seek formulas to prop himself up."

[48] "The Big Idea: George Bellows Talks About Patriotism for Beauty," *Touchstone* 1 (July 1917): 270.

[49] George Bellows to Robert Henri, September 8, 1916, Henri Papers, Beinecke Rare Book and Manuscript Library, Yale University.

[50] George Bellows to Robert Henri, June 13, 1916, Henri Papers, Beinecke Rare Book and Manuscript Library, Yale University.

[51] Bellows wrote, "I have been using the golden compass on nearly everything and believe it does good work for me. I am building a thing now on circles and angles evolved on it but this process is only a slight if any advantage over the web. It is merely curious and interesting. A few points work at least for me just as well." Letter to Robert Henri, August 10, 1916, Henri Papers, Beinecke Rare Book and Manuscript Library, Yale University. The compass is described by William Innes Homer in *Robert Henri and His Circle*, pp. 193–194.

[52] Spencer, "Criehaven: A Bellows Pastoral," pp. 28–34.

[53] *Dynamic Symmetry, A Retrospective Exhibition* (Providence: Museum of Art, Rhode Island School of Design, 1961) contains an apparently complete bibliography of Jay Hambidge's publications and an extensive bibliography of publications by allied writers. Hambidge published relatively little, outside the field of archeology, during his and Bellows's lifetimes. His principal exposition of the theory was as editor of the *Diagonal*, published monthly by Yale University Press from November 1919 to October 1920. In 1923 he published the thin volume, *Dynamic Symmetry in Composition, As Used by the Artists* (Cambridge, Mass.: privately printed, 1923). Because the system is so maddeningly complex, and because it depends upon mathematics and on knowing specific ratios, one has to wonder if Hambidge did not provide some kind of ephemeral handouts at his lectures in 1917. Perhaps Bellows took exhaustive notes at the lectures and remained in close touch with Hambidge during 1918. Otherwise, it is hard to understand how Bellows could have been using the system and some of its more complicated constructions as early as the spring of 1918, before he could turn to any published source.

　Among Bellows's papers in the Amherst College Library are nine mimeographed pages titled *Lecture #10, Primer of Dynamic Symmetry*, but it is copyrighted 1922 by Jay Hambidge. It is possible that Bellows did not have this and other lessons to work with until after Hambidge's death on January 20, 1924, when he and Henri advised Hambidge's widow about publishing her late husband's works.

[54] The Bryce Report on German war crimes during the Belgian invasion of August 1914 had appeared in condensed form in the New York *Times* during February 1915. Bellows seems not to have responded strongly to the grisly accounts at that time, when the United States was determined to remain neutral. The immediate impetus for his campaign of lithographs and paintings came after the country's entry into the war in 1917 and his volunteering for the Tank Corps. In February 1918 *Everybody's Magazine* began to run the series of articles

by Brand Whitlock, "Belgium: The Crowning Crime," and these roused Bellows's determination to undertake a series of war lithographs and paintings, beginning in the spring of 1918. Most were inspired by eyewitness accounts or even brief descriptions in the Bryce Report. The episodes he depicted that occurred after the invasion of Belgium obviously were based upon the Whitlock articles, rather than the Bryce Report. His portrayal of the story of Edith Cavell and his design, *The Return of the Useless*, actually appeared as illustrations to a later installment of the articles.

For a detailed examination of these sources, see the Krystyna Wasserman, "George Wesley Bellows' War Lithographs and Paintings of 1918," master's thesis, University of Maryland, College Park, 1981. Also see the exhibition catalogue, *George Bellows and the War Series of 1918* (New York: Hirschl and Adler Galleries in association with H. V. Allison and Company, 1983).

[55] The authors of geometrical systems for composition liked to demonstrate the validity of their systems by applying them to recognized masterpieces, proceeding then to the conclusion that the beauty of the masterpieces was due to their creators' having used the geometrical system in question. Maratta superimposed his web of equilateral triangles on Renaissance and Baroque paintings, but Hambidge went further, writing at length about Greek vases and even finding demonstrations of Dynamic Symmetry in the proportions of the human body and its members. In 1921 two articles, which happened to have the same title, used different methods to expose the basic fallacy of Hambidge's use of his system on Greek art—that in its more complicated constructions, the system could describe any shape at all. Other analyses, being simpler, were more valid. The two articles are Edwin M. Blake, "Dymanic Symmetry: A Criticism," *Art Bulletin* 3 (March 1921): 107–127; and Rhys Carpenter, "Dynamic Symmetry: A Criticism," *American Journal of Archaeology* 25 (1921): 18–36. Blake's summary represents the force of the opposition that Hambidge aroused: "The rectangles of dynamic symmetry are of themselves inert and lacking of any directive force. They stand ready, as do the rational rectangles, to be selected for such service as the intelligence of the designer may elect. As a method for modern designers, dynamic symmetry has nothing of value to offer, and by imposing false standards and needless restrictions can but hamper the freedom of creative inspiration." (p. 127)

[56] Edith Louisa Cavell (1865–1915) was a British nurse and the first matron of the Berkendael Institute in Brussels, which became a Red Cross hospital after the outbreak of the war. She became involved in an underground group that aided French, Belgian, and British soldiers, caught behind the lines, in reaching the safety of the Dutch border. About two hundred men had been sheltered at the hospital before her arrest on August 5, 1915. Court-martialled and condemned to death on the charge of aiding the enemy (not for espionage), she was imprisoned at St. Gilles and, on the morning of October 12, executed by a firing squad in the Tir National. Bellows's title, calling her death a "murder," reflects the strong reaction to her story among the nonaligned nations. Several books have been written about the heroine.

[57] George Bellows to Joseph Taylor, January 15, 1914, Bellows Papers (Box I, Folder 12), Amherst College Library.

[58] Other important books from this period include W. Ostwald's *Letters to a Painter on the Theory and Practice of Painting*, translated by Morse (New York: Ginn and Company, 1907); Maximilian Toch, *Materials for Permanent Painting* (New York, 1911); Hamilton Easter Field's *The Techniques of Oil Painting and Other Essays*, (Brooklyn, N.Y.: Ardsley House, 1913); A. P. Laurie, *The Pigments and Mediums of the Old Masters* (London: Macmillan, 1914); and Arthur H. Church, *The Chemistry of Paints and Painting* (London: Seeley, Service and Company, 1915).

[59] George Bellows to Robert Henri, August 21, 1914, Henri Papers, Beinecke Rare Book and Manuscript Library, Yale University.

[60] George Bellows to Robert Henri, November 16, 1917, Henri Papers, Beinecke Rare Book and Manuscript Library, Yale University.

[61] See Homer, *Robert Henri and His Circle*, pp. 176–179.

[62] As always, it is tempting to imagine Bellows, or any artist of interest, as deriving inspiration from only the greatest artists, such as Eakins or Homer. As a matter of fact, any number of Bellows's contemporaries exhibited paintings of women in the costumes and interiors of the 1860s and 1870s. The examples of William Paxton and Lydia Field Emmet come readily to mind.

[63] George Bellows to Robert Henri, December 3, 1919, Henri Papers, Beinecke Rare Book and Manuscript Library, Yale University.

[64] (Cambridge, Mass.: Privately printed), pp. 22–38. The chapter includes the account of Bellows's first meeting with the artist. The book elsewhere discusses the use of Dynamic Symmetry by Bellows's friends, Robert Henri and Leon Kroll.

[65] It seems reasonable to assume that Bellows could not have taken the time to adapt a motif to the complex geometry of Dynamic Symmetry when he was in the field, quickly painting whatever promising vista his ramblings discovered. In examining his painting, *Old Barn, Grey Day* (1920, oil on panel, 18 x 22 in., collection of Mrs. Grace Mann), however, I was surprised to discern, through the paint, what appeared to be thin charcoal lines, dividing the panel in half horizontally, and roughly in thirds vertically. Although these lines do not suggest

Dynamic Symmetry, they do establish a framework for a balanced or proportionate treatment of areas of the panel. I have not seen such lines in other paintings, but, having seen them once, I wonder how much geometry of a simpler kind there may be in the Woodstock landscapes. A comparison of those landscapes with similar motifs or vantage points might suggest an answer.

[66] George Bellows to Robert Henri, from Woodstock, N.Y., August 10, 1920, Henri Papers, Beinecke Rare Book and Manuscript Library, Yale University. He reports on work in progress by Speicher, Dasburg, and McFee and remarks, "These fellows are all Kings, and it is great to see them and talk to them when I feel like it."

[67] Bellows's record book indicates that he finally completed *Mrs. T. in Cream Silk, No. 1* in 1923, but much of the work seems to have been done in 1921.

[68] George Bellows to Robert Henri, November 3, 1922, Henri Papers, Beinecke Rare Book and Manuscript Library, Yale University.

[69] In his introduction, "El Greco, The Man and the Myths," in *El Greco of Toledo*, exhibition catalogue (Toledo Museum of Art, 1982), pp. 19-30, Jonathan Brown discusses the rediscovery of El Greco in the late nineteenth and early twentieth centuries by avant-garde artists in France and Germany and by critics who saw resemblances between El Greco, Cézanne, and the Expressionists. Brown quotes the English critic Roger Fry's description of El Greco's "great discovery of the permeation of every part of the design with a uniform and continuous plastic theme" (*Vision and Design* [New York, 1920], pp. 138-139). It was this aspect of El Greco's art (and also that of Albert Pinkham Ryder) that American artists and critics of the 1920s most admired. As Bellows became more concerned with modeling form in his figure paintings, it was natural that he likewise would seek plastic qualities in his landscapes. El Greco showed how that could be done.

Bellows mentioned El Greco in a letter to Robert Henri on September 8, 1916: "One interesting canvas which I have not yet finished and of course may loose, was started from a sketch I made in fancy of the shipyard. I decided to try what would happen if I excluded all vertical and horizontal lines and made everything happen on angles or at least curves. The result was a peculiarly Greco like sensation..." Henri Papers, Beinecke Rare Book and Manuscript Library, Yale University. Critics remarked on the strong El Greco influence in *The Crucifixion*.

[70] George Bellows to Robert Henri, November 1923, Bellows Papers (Box I, Folder 8), Amherst College Library.

[71] Robert Henri to George Bellows from Madrid, Spain, January 31, 1924, Bellows Papers (Box II, Folder 12), Amherst College Library.

[72] The analysis of the geometric structure of the painting given by E. A. Carmean, Jr., in the exhibition catalogue, *Bellows: The Boxing Pictures* (Washington, D.C.: National Gallery of Art, 1982), pp. 43-45, does not follow the principles of Dynamic Symmetry and thus cannot have been the structure that Bellows used. The same can be said for the analysis of *Ringside Seats* on page 39.

[73] This construction is found on page 95 of *Practical Applications of Dynamic Symmetry* by Jay Hambidge (New Haven and London, 1932). The mimeographed manuscript, "Primer of Dynamic Symmetry, Lecture #10," by Jay Hambidge, copyright 1922, among the Bellows papers at Amherst College, contains the same construction on its first page.

[74] Contained in a letter to Walter Munroe Grant, December 15, 1924, Bellows Papers (Box I, Folder 7), Amherst College Library. Bellows felt it prudent to change the title because of a lawsuit concerning a nude sculpture. Morgan, *George Bellows: Painter of America*, p. 278, indicates that the original title was *Sacred and Profane Love*.

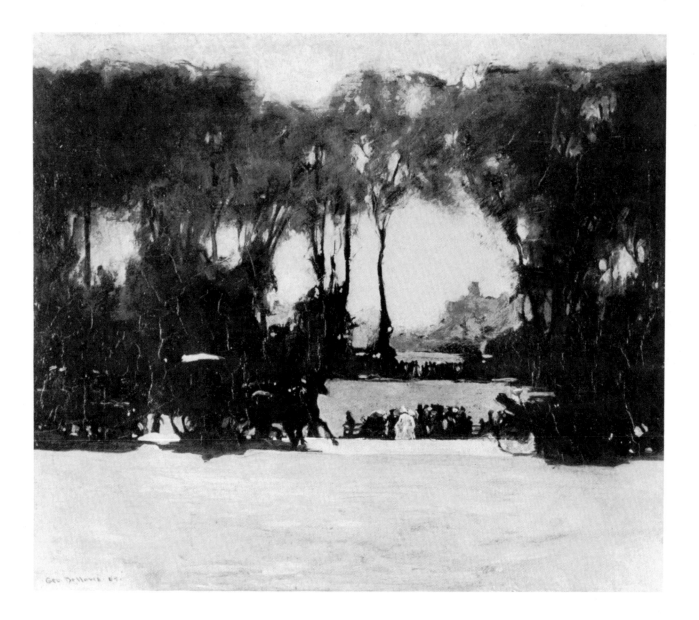

The "Real" New York

MARIANNE DOEZEMA

On seeing nineteen of Bellows's paintings on view at Marshall Field and Company, a critic for the *Chicago Examiner* understood instantly why this Ohioan had become known as "the Gotham personality":

> . . . these pictures palpitate and throb, seethe and roar and reverberate with the stress and drive of the day-turmoil and the night-tonings of a monstrous life set in the midst of the colossal city that fairly overlaps into the Atlantic Sea.[1]

One big canvas in particular appears to have been a focal point of the 1911 show—*New York* (see fig. 12), the critic noted, was packed with "giant architecture, crowds of people, lines of vehicles." To her, this densely painted vision of urban congestion spoke accurately and convincingly of the sights and sounds of the country's most famous metropolis. "This picture rings with sincerity," she wrote.

George Bellows displayed a remarkable talent for recognizing the expressive potential of the urban environment and for ferreting from it particularly potent sights and scenes to paint. The capacity of his pictures to "palpitate" and "seethe" before the eyes of his contemporaries was due, in part, to his choice of peculiarly current motifs—prominent construction projects, the lurid but tantalizing sporting underworld, aspects of working-class street life, and the notorious "baseball evangelist," Billy Sunday. In the early years of this century, such subjects, and Bellows's treatment of them, resonated with emotional and intellectual perceptions, deriving from the dynamic social and economic processes at work in big cities. Reconstructing a dialogue between Bellows's urban subject paintings and their times can help us to understand how and why these images were perceived as truth, as the real thing.

No consideration of Bellows's urban theme paintings could rightly ignore the increasing complexity of the pictures themselves and the artist's changing ideas about making art. This essay, therefore, describes the artist's choice of subject matter as well as his tireless experimentation with compositional schemes. Together these analyses describe the process by which Bellows discovered and came to terms with his adopted city while at the same time emerging as one of the most provocative and highly regarded painters of his era.

FIGURE 1
George Bellows. *Central Park*, 1905. Oil on canvas, 28 x 32 in. The Ohio State University Faculty Club, Columbus; lent in perpetuity to the Ohio State University by Mr. and Mrs. Roy Wildermuth.

When Bellows left Columbus, Ohio, for New York City in 1904, he intended to become a professional illustrator. Already a facile draftsman, he arrived for classes at the New York School of Art and proudly displayed a portfolio of Charles Dana Gibson-inspired drawings to one of the instructors. Robert Henri's tart critique is well-known: "Haven't I seen these before?"[2] Indeed, Bellows had for years been copying magazine illustrations by Gibson and Howard Chandler Christy, and his drawing style was often slavishly imitative. But in a few short months, his method and his notions about art began to change. Henri exerted a profound influence on Bellows during and after his tenure as a student, but Bellows may have changed his mind about a career in illustration because of William Merritt Chase, the famed portrait and still-life painter who in 1904 still presided as dean of the New York School of Art.[3] By 1905, Bellows was painting assiduously, intent on fitting himself to become an artist.

From a small group of early efforts that survive, two paintings, *Central Park* and *Bethesda Fountain* (figs. 1 and 2), provide significant clues to Bellows's rapidly developing skill and his ideas about picture making. First, he was experimenting with a compositional device he probably learned from Chase himself. The empty foreplane in both of these Central Park pictures evokes the dynamic, raking foreground space in a work such as Chase's *Lilliputian Boat Lake, Central Park* (fig. 3). Although the compositional technique derives ultimately from nineteenth-century French prototypes, it became associated with Chase, who employed it conspicuously and with stunning effect in many of his Central Park and Prospect Park pictures of the late 1880s and early 1890s.[4] It seems clear that Bellows intended to animate the foreground space and initiate movement into the middle depth of his own compositions according to Chase's example. He even attempted to create a lively play of sunlight and shadow across the surface of his canvas, as Chase had done in so many of his park paintings. However, while Chase typically suggested spatial tension by a diagonal pathway or the edge of a pond, the horizontal band across the bottom of Bellows's pictures

FIGURE 2
George Bellows. *Bethesda Fountain (Fountain in Central Park)*, c. 1905. Oil on canvas, 20¼ x 24⅜ in. Hirshhorn Museum and Sculpture Garden, Smithsonian Institution, Washington, D.C.; gift of Joseph H. Hirshhorn, 1966.

remains relatively inert. Nonetheless, both of these early paintings, finished after less than two years of training at the New York School, display a surprising level of sophistication with respect to paint handling and the arrangement of elements over the surface. In *Central Park*, for example, movement into depth advances according to regularly spaced intervals—across the open foreground to the carriage path, through a gap between the carriages to a second, lower terrace, and then through a break in the line of trees to yet a third sunlit area. The whole is graceful and balanced, yet animated by judiciously placed spots of bright, near-white paint.

FIGURE 3
William Merritt Chase. *Lilliputian Boat Lake, Central Park*, c. 1890. Oil on canvas, 16 x 24 in. Private collection; photograph courtesy of David Nisinson Fine Art.

In *Bethesda Fountain*, Bellows used a simpler compositional scheme, with fewer elements. The fountain is placed predictably at the center. Yet this modest painting provides a striking demonstration of Bellows's willingness to manipulate observed visual fact in order to suit a particular pictorial scheme. A contemporary etching from a guidebook to New York and Brooklyn, probably based on a photograph, illustrates the typical, and often-repeated, view of the famous fountain (fig. 4). For decades, countless artists and photographers had chosen to present the fountain's "front," the angel facing toward the viewer, seen from a vantage point at the top of three flights of steps leading down to the esplanade. The fountain was usually positioned toward the right of the picture, with the balustrade visible at the left. Bellows eschewed the traditional view and instead chose the perspective obtained by looking across the esplanade and up at the fountain. He reinvented the space to some extent, stretching out the area between his contrived vantage point and the fountain in order to create the open foreground

he admired. Furthermore, he included only the center portion of the circular stone bench that surrounded the fountain's pool, allowing the horizontal line defining it to suggest extension beyond the right and left extremities of the picture. In so doing, he was emulating Chase's method of achieving a sense of limitless space and following the latter's admonition to his students to "let the edges of your picture lose themselves."[5]

Bellows appreciated the subjects and settings of Chase's art as much as his compositional devices. In choosing to locate these precocious landscape studies in Central Park, Bellows not only followed Chase's lead but also his own inclination to seek out decorous and proper, if conventional, motifs. The park's contoured terraces, pathways, and grassy fields had been intended by idealistic, midcentury reformers to promote social betterment while providing verdant green space, in the midst of New York City's congestion, for carriage rides and promenades. Although the park's designer, Frederick Law Olmsted, envisioned serving a wide public, he also assumed members of that public would deport themselves properly within the ordered spaces of his park. As the elegantly posed figures in the guidebook etching illustrate, Central Park continued for some decades to evoke this underlying meaning. During the early twentieth century, the park was still associated with genteel forms of outdoor amusement and with middle- and upper-class codes of public conduct.

FIGURE 4
Artist unknown. *The Bethesda Fountain*. In George F. Smith, *Pictorial New York and Brooklyn: A Guide to the Same* . . . (New York: Smith, Bleakley and Company, 1892), p. 82. Avery Architectural and Fine Arts Library, Columbia University, New York.

F<small>IGURE</small> 5
George Bellows. *River Rats*, 1906. Oil on canvas, 30½ x 38½ in.
Private collection, Washington, D.C.

For a time, however, genteel New York ceased to attract Bellows's attention. By the spring of his second year at the New York School, he was spending time in a very different part of the city. Increasingly under the spell of Robert Henri's dynamic and persuasive personality, Bellows came to think that Central Park was too far from "reality." As a fellow classmate recalled, "Life seemed to the Henri student to flow stronger and fuller in Bowery bars and the riverfront alleys than in the Knickerbocker Hotel or in the fashionable streets of the upper east side."[6] Thus Bellows and his colleagues in Henri's composition class set out to find "real" motifs, most often in New York's tenement districts.

Such activities attracted the attention of a writer for one of the city's most popular papers, the *New York World*. According to a feature article in the *World* Sunday magazine for June 10, 1906, Henri's students were painting "Manhattan everyday life … not idealized and worked up into unnatural 'effect' but truthfully and powerfully and without flattery." To explain the new notion of basing art on life, the writer, Izola Forrester, quoted Henri: "It is not enough to be able to draw correctly, to know the rules of composition and color. One may have all of that, years, perhaps, of training and study in the schools of Europe, and yet not be able to produce a single picture of real life." Instead, Henri sent his students out to immerse themselves in the life of the city, where they "lived in touch with it, studied it face to face." Describing student work on view at the New York School, Forrester divulged her own astonishment: "It takes more than a love of art to see character and meaning and even beauty in a crowd of east side children tagging after a street piano or hanging over garbage cans."[7]

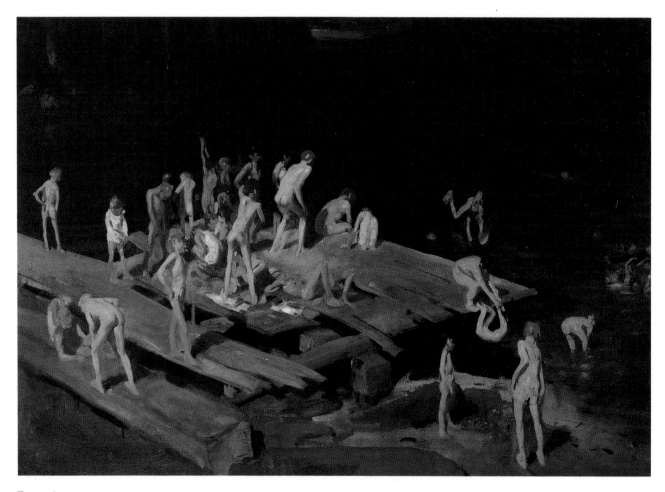

FIGURE 6
George Bellows. *Forty-Two Kids*, 1907. Oil on canvas, 42⅜ x 60¼ in. Corcoran Gallery of Art,
Washington, D.C.; Museum purchase, William A. Clark Fund.

Two months after this article appeared, Bellows painted *River Rats* (fig. 5), one of his
most emphatic early depictions of "real life." Although the painting's title refers to the boys
along the shoreline, their diminutive bodies play a minor role, similar to that of the figures
in the Central Park paintings. They function virtually as part of the setting, helping to
characterize it. Clearly, Bellows intended the scene to be interpreted as a "slum subject."[8]
Although some neighborhoods had access to designated areas for public bathing, swimming
in the dirty water along the shores of the Hudson and East rivers was a daily pastime for many
New York youngsters. The children in Bellows's painting enjoyed no special provisions for
their sport but simply clambered down a rude, dirt bluff to the rotting remains of a wooden
dock at the water's edge, stripped off their clothes, and jumped in.

Very likely, Bellows's contemporaries did not perceive this unsightly scene as an
innocent slice of life. As the title itself suggests, the painting touched upon a complex set of
attitudes. On the one hand, turn-of-the-century, reform-minded urbanites felt sympathy
and concern for the boys of working-class families, who had nowhere to play but at the
grimy shore of the East River, along the wretched tenement neighborhoods of the Lower
East Side. But middle-class New Yorkers also viewed these youthful bathers with a degree
of suspicion: "river rats" or "dock rats" were considered bandits. Helen Campbell described
the cheating, fighting, thieving lives of these children in her urban exposé *Darkness and
Daylight*. In a section called "Homeless Street Boys, Gutter-Snipes and Dock Rats," she
wrote:

> Anywhere along the docks are facilities for petty thieving, and, guard as the policeman
> may, the swarms of small street rovers can circumvent them. A load of wood left on
> the dock diminishes under his very eyes. The sticks are passed from one to another,
> the child nearest the pile being busy apparently playing marbles. If any move of

suspicion is made toward them, they all take off like a swarm of cockroaches, and with about as much sense of responsibility. Children of this order hate school with an inextinguishable hatred. They smash windows, pilfer from apple-stands, build fires of any stray bits of wood they can collect, and warm themselves by them, and, after a day of all the destruction they can cram into it has ended, crawl under steps, into boxes or hallways, and sleep till roused by the policeman on his beat, or by a bigger boy who drives them out.[9]

Bearing in mind some of the contemporary connotations surrounding its title, one can better understand why Frank Fowler characterized the subject of *River Rats* as "sordid." Yet Fowler's review of the 1907 Spring Annual at the National Academy also focused on the way Bellows had "created a work of art" from such unattractive raw material.[10] Indeed, *River Rats* is manifestly a painting—one that proclaims its author to be a bold and talented manipulator of his materials. The spindly bodies of the bathers are indicated with mere gestures of the brush; a jumble of paint strokes in the middle right section of the canvas is barely readable as a dock and other built structures; the hillside that Fowler described as "this unsightly bulk" consists of roughly scumbled slabs of pigment. Streaks of orange/ochre delineate a curving roadway that connects two simply constructed shelves of space, one at the bottom and one at the top of the embankment. But the emphasis of *River Rats* is on surface, on the vertical flatness of that muddy hillside and the massing of building facades above, and on the deft application of the paint itself.

Bellows's second painting of bathing dock rats, *Forty-Two Kids*, again attracted attention, not all of it positive (fig. 6). When it was shown at the National Academy in March 1908, Joseph Edgar Chamberlin, critic for the *New York Evening Mail*, called the painting "a tour de force of absurdity—a graphic impression of a lot of boys diving off a wharf, in which most of the boys look more like maggots than humans." James Gibbons Huneker admired the work and was moved to remark: "A man who has such power in his elbow ought not to stop at the elbow."[11] But Huneker also remembered that the painting had "stirred up" Philadelphia a few months earlier. Indeed, *Forty-Two Kids* achieved a degree of notoriety when it was denied a prize at the Pennsylvania Academy because of its potentially offensive nature.[12]

Such a reactionary move on the part of Academy officials suggests that Bellows had touched a sensitive nerve. Apparently, the "dock rats" posed a threat larger than the illegal escapades that Helen Campbell attributed to their waking hours. In fact, the youngsters of the poor and working classes were the focus of special concern at the turn of the century. They represented the offspring of the most recent wave of immigrants, part of the swelling mass of strange-speaking, alien-featured peoples who were altering irrevocably the social fabric of the nation. The fears of middle-class Americans permeated the literature of the period. For example, a parlor-table guidebook to New York, which promised "life-like views" of all phases of the city, including its "reeking slums," contained a photograph (see fig. 7) of a scene very like the one Bellows painted in *Forty-Two Kids*. The adjacent text presented a frightening scenario:

> There can be but one result from this herding of the poor in non-sanitary tenements; and that is death, both physical and moral. Disease and vice prevail everywhere. The honest children of the honest poor become debauched and go to recruit the army of crime and the denizens of the slums. How can it be otherwise, when conditions of life are such as to violate daily every principle of modesty and decency?[13]

The terms for the street-wise rapscallions in Bellows's painting were all specifically class-based: surely well-to-do Anglo-Saxon children would never have been called "street Arabs," "urchins," or "kids"—or likened to "maggots." Such terminology calls up the darker meanings of Bellows's paintings, meanings that were implicit for at least some segment of his audience. The behavior of these undisciplined youngsters—loafing nude, smoking, even urinating in public—violated codes of accepted conduct and carried connotations of "the social problem" which loomed large during the first decade of this century.

FIGURE 7
Photographer unknown. *Swimming in the Harlem River.* In James W. Shepp and Daniel B. Shepp,
Shepp's New York City Illustrated: Scene and Story in the Metropolis of the Western World (Chicago: Globe Bible
Publishing Company, 1894), p. 194. Avery Architectural and Fine Arts Library, Columbia University,
New York.

Progressive reformers magnanimously blamed the environment for the plight of the unfortunate underclasses, but their real concern was not always for the poor or the children of poverty. Their worries about the present and long-range consequences of this sizeable "foreign-born" presence in American society were often worries for themselves and their own children. "Scientific" findings in biology and sociology seemed to substantiate their fears. For example, one authoritative study, published in 1906, enumerated an increased illiteracy rate, growing numbers of dependent and delinquent populations, and more insanity, disease, and pauperism as some of the effects of immigration, and asserted that "the general criminality of the foreign-born is two and one-half times that of the native-born."[14]

Images of slum children and the immigrant poor had been so incessantly reproduced during the 1890s that reformers worried about the provocative power of reform-style photographs becoming dissipated. But images of poverty at the National Academy of Design were far from commonplace. Some saw these paintings, which brought the daily activities of New York City's largely foreign-born working classes into the rarified realm of fine art, as oppositional gestures.[15] Such subjects implied an explicit rejection of academic idealism and the restrictive tradition of cultural authority allied with it.

But the provocative character of this art was part of its appeal. In a magazine no less prominent than *Harper's Weekly*, Samuel Swift noted the "democratic outlook" of some "Revolutionary Figures in American Art." The school of Robert Henri, Swift reported, presents subjects from all phases of life, ranging "from men and women of prestige to the latest batch of newly landed immigrants, from the work and the play of rich and poor, young and old, down to the worn human aspect of decrepit houses on New York's crumbling East Side."[16] Swift found these "real" life subjects and a "genuinely self-expressive art" to be refreshing alternatives to the moribund production of the academicians, the "dull followers of formula." Henri's band of "revolutionaries" embodied not only the spirit of artistic vitality but also the essential vitality of American life: "They seek what is significant, what is real.... There is virility in what they have done ... a manly strength that worships beauty, an art that is conceivably a true echo of the significant American life about them."

Bellows continued to cultivate his connections with the Henri group and to exploit the press value of painting the "real" New York. Swift had numbered "half-stripped prize-fighters" among the noteworthy subjects associated with the new movement in American art—and Bellows seems to have taken up the suggestion.[17] He made his first boxing pictures, a drawing and a painting, during the summer of 1907 and entered the painting in the

Academy's Winter Exhibition. *Club Night* (fig. 8), then known as *Stag at Sharkey's,* won the jury's approval, and critics noticed it hanging above a doorway. "If the extreme of realism is sought, it may be found over the door of the Vanderbilt Gallery, as if placed there for the benefit of persons accustomed to looking up from ringside. Its title, 'A Stag at Sharkey's,' suggests a recent police problem."[18]

Bellows's big, dark boxing picture, like his paintings of river rats, called up a host of images and associations in the minds of middle-class visitors to the exhibition. For the critic quoted above, blood sports and police raids were indelibly linked. The subject of boxing itself aroused strong reactions: on one hand, pugilism was widely denounced for its brutality; on the other, advocates claimed beneficial effects on, for example, "perception, imagination, judgment, discretion, self-confidence, aggressiveness and will." Theodore Roosevelt himself enjoyed taking on a sparring partner, and he credited the sport for helping to develop not only fitness and agility but also strength of character.[19] But when President Roosevelt promoted participatory sports "which call for the greatest exercise of fine moral qualities," he was not referring to the bloody brawls at neighborhood club/saloons like Sharkey's. Such clubs had been operating on the fringe of the law since 1900, when the Lewis bill made prizefights illegal in New York state. To avoid the prohibition against

FIGURE 8
George Bellows. *Club Night*, 1907. Oil on canvas, 43 x 53 in. National Gallery of Art, Washington, D.C.; John Hay Whitney Collection.

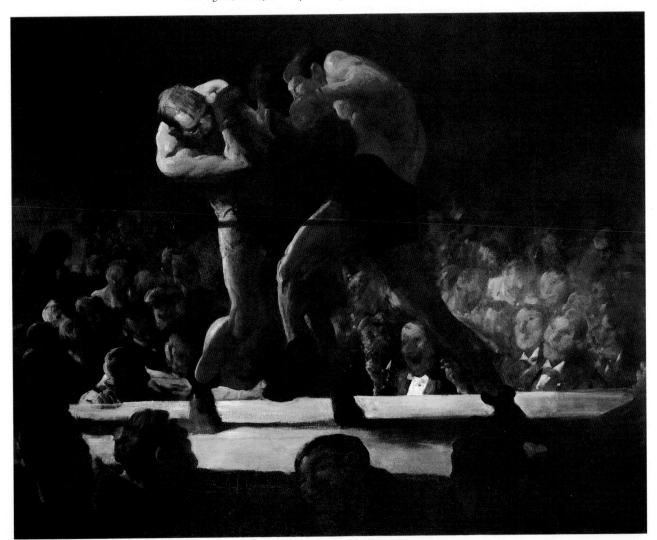

fights where admission was charged and the winner received money or other valuable compensation, "clubs" were organized and "membership fees" replaced admission fees. In spite of these precautions, clubs were continually closed down by police—not always in response to infractions of the law. Referring to the corruption that permeated state and local governments as well as law enforcement, the pro-boxing *Police Gazette* declared baldly: "The police have to get theirs."[20] Thus, it was well known that sleazy athletic clubs sustained connections with machine politicians and catered to payoffs, gambling, and underworld crime.[21]

In addition, professional boxing was generally associated with the underclasses. The boxers themselves usually grew up in the harshest neighborhoods and tended to see prize fighting as a means of escape. The sport drew heavily from recent immigrant groups: Jewish, Italian, and Polish youths often learned to fight as a result of interethnic gang conflicts, but the Irish dominated boxing in this country for several decades. Spectators came from the same working-class neighborhoods as did the fighters. While upper-class and even middle-class males increasingly availed themselves of commodious sport clubs or escaped the city entirely for recreational activities, the poor had fewer options. Open park space was seldom a feature of the urban slum, and transportation to out-of-town facilities was a luxury. Instead, neighborhood saloons became the hub of working-class leisure; diversions included not only drinking but also billiards, bowling, and spectator sports such as rat baiting, cock fighting, and, most commonly, boxing contests.[22]

The company at Sharkey's, as Bellows's painting illustrates, was more diverse than that of the typical neighborhood saloon. In addition to the local clientele, there were a number of conspicuously well-dressed patrons who had ringside seats. The establishment run by ex-fighter Tom Sharkey was on a circuit of gambling halls, taverns, and cheap theaters that were patronized by middle- and upper-class urban men in search of excitement. Slumming was not a new form of diversion in the early years of the twentieth century, but the claustrophobic monotony of city life brought greater numbers to the quest for "real life" experiences. Curious but cautious out-of-towners hired guides or seats on "slumming wagons" in order to see the sites.[23] One such thrill-seeking outing embellished the story line for a 1904 novella called *The Real New York*, in which a Chicagoan poked fun at his new acquaintance from New York City for living in a town with "kindergarten virtues." To prove his boast that "there's still a hot time in the old town every night," the New Yorker included Tom Sharkey's among their evening's entertainments.[24]

Apart from a few such fleeting references, little is known about the real Sharkey's Athletic Club. The artist himself established the basic facts about the place in a letter to the director of the Cleveland Museum of Art. Bellows wrote: "Before I married and became semi-respectable, I lived on Broadway opposite the Sharkey Athletic Club where it was possible under law to become a 'Member' and see the fights for a price." Bellows's roommate at the time, Ed Keefe, reported further that he knew the lightweight champion of Connecticut, Moses King, from school days and brought Bellows to one of King's fights at Sharkey's. This was probably in the early summer of 1907.[25]

Real-life counterparts to the fictional characters from *The Real New York* might very well have been in attendance at Sharkey's the night Bellows purchased his first membership to the club. The row of "gentlemen" included in the painting can be distinguished from the spectators around them in part by their deportment and more obviously by the sharp white triangles of their collars and shirt fronts. A man in evening dress, seated toward the right, has become so fully engaged with the spectacle before him that he has unbuttoned his collar and bawls out a call for more fighting action.

Judging from Bellows's painting, the fight itself took place only a few inches from the faces that lined the ring. The white-shirted figure just behind the outer foot of the left-hand boxer, actually stretches both arms onto the floor of the ring. The depth of the fighting arena is constricted in Bellows's painting to emphasize the pressing closeness of the eager crowd. A bright strip of canvas serves as a too-narrow stage for the towering boxers, their bodies picked out by harsh blue-yellow light from the gloomy, smoky interior of Sharkey's. The configuration of the jousting fighters provides a clue to the brutish nature of this contest. The right-hand boxer is about to deliver a blow with his knee to his opponent's groin. Sports

fans at Sharkey's are unperturbed by such an infraction of the rules. Onlookers appear engrossed, even amused or pleased.

Bellows's brawling boxers loomed, seemingly lifelike, over the heads of visitors to the National Academy of Design. One art critic praised *Club Night* for its you-are-there realism: "It is a brutal boxing match (surely four ounce gloves) about to degenerate into a clinch and a mixup. One pugilist is lunging in the act of delivering a 'soaker' to his adversary. You hear, you feel the dull impact of the blow."[26] The critic felt as if he, too, had dipped into the "real life" world of Sharkey's back room, and he found it "absolutely exciting."

Such remarks reaffirmed what Bellows surely recognized—that paintings of "what is real" attracted attention. Getting in touch with "the real," in fact, was something of a national compulsion. In part, it was a reaction against the inertia of middle-class life and culture. If millions of city dwellers were not sufficiently cognizant of the dull blandness, the meaninglessness of their daily routines, the literary and popular press reminded them of society's spiritual as well as physical decay and of the need for revitalization. There was a widespread perception that materialism was sapping the meaning from modern life and that the new century had brought new cause for ennui. An 1897 article in the *Atlantic Monthly*, for instance, warned against the dangers of "being civilized too much."[27] A lecture by William James entitled "What Makes a Life Significant" was reprinted in 1900 and remained a top seller for more than a decade. In it the great public philosopher, recoiling from a week-long stay at the famous Assembly Grounds at Chautauqua Lake, pondered the bland emptiness he perceived, not just in the thorough-going ideality of the resort itself but in everything it stood for, "all the ideals for which our civilization has been striving." At first seduced by the cultural accoutrements offered by this "middle-class paradise," he soon felt suffocated by its "atrocious harmlessness," its unreality: "Let me take my chances again in the big outside worldly wilderness with all its sins and sufferings."[28]

On a more popular level, the quest for authentic experience was reflected in the new mass-circulation magazines like *McClure's* and *Munsey's*. Exposé articles on graft and corruption in city politics and stories on such titillating subjects as the white slave trade pandered to the taste for what James had termed "strength and strenuousness, intensity and danger." Market-wise editors created series such as "Straight Talk" (*Everybody's*) and "Real Conversation" (*McClure's*) that responded to the demand for authentic information, the "inside" story.[29] On the pages of those same magazines and many daily newspapers as well, a wide assortment of products proffered antidotes to the debilitating conditions of contemporary urban existence. Cigarettes and automobiles, the ads pronounced, would expedite the pursuit of the real. The New England Line railroad promoted "Real Vacations" in the "Real Out-of-Doors," and Victor Records promised to "Make Christmas a Real Christmas." An advertisement for Coca-Cola enticed consumers with an even less tangible invitation: "Get the genuine."[30]

Bellows's *Club Night* was perceived as something singularly genuine amidst what one critic called the "weary waste of canvases" at the National Academy's 1907 Winter Exhibition. Nilsen Laurvik concluded his meandering and perfunctory review of its paintings and sculpture with high praise for the "manly, uncompromising" Bellows and a plea for the opportunity to see more work by "the younger men, the leaven of to-day and the hope of the future."[31] The plea seemed in vain, for many of the insurgent realists were rejected from the exhibition. With Henri no longer on the National Academy's jury, work by his colleagues and protégés had been excluded almost totally. Henri himself, as an academician, still enjoyed the privilege of hanging one entry jury-free and thus was represented by a single portrait, but the other seven participants in the forthcoming exhibition at the Macbeth Galleries appeared in the academy's catalogue only because Macbeth had placed a full-page announcement of their February show.

Bellows, who was not among the eight artists in the Macbeth Galleries exhibition, managed to get a pair of his big, brash paintings past the jury—an early portrayal of the Pennsylvania Station excavation and *Club Night*. They must, indeed, have stood out among the scenes of proper gentility on display all around them. A rude construction scene and a brutal prizefight constituted palpably, aggressively real events—a marked departure from the artificiality and passivity that characterized the majority of American figure paintings

occupying a sizeable share of wall space. Additionally, prize fighting, especially in its twentieth-century, urban manifestation, stood for resistance to the revered moral and social values associated with the academic figure tradition. But again, in some circles, resistance to convention assumed a positive cultural value during this period—especially if it was delimited and carefully contained, so that the implied rebellion did not seriously threaten the established social order. Within the parameters of the picture frame, for example, the gritty sporting underworld could provide gallery-goers with the sought-after revitalizing contact with reality, while at the same time it remained safely distant from their antiseptic daily lives. Furthermore, although Sharkey's represented an aspect of boxing that was decidedly sordid, the monumentalized fighters in Bellows's painting could also be seen as exemplars of individual achievement, of masculine hardiness. In the first decade of the twentieth century, such qualities were commonly considered in short supply.

The engagement of Henri protégés with the real life of the city was part of a larger revolt against an older artistic and cultural tradition. In his February 9 review of the "Eight Painters," James Gibbons Huneker compared their enterprise to that of the literary realists, Frank Norris and Theodore Dreiser, who were challenging the traditionally defined materials of fiction: "They are realists inasmuch as they paint what they see, let it be ugly, sordid or commonplace. . . . They invest the commonest attitudes and gestures of life with the dignity of earnest art. . . . They are often raw, crude, harsh. But they deal in actualities."[32]

Indeed, these writers and painters shared much in common, though for the most part they worked in isolation from one another. Norris, for example, seems to prefigure Henri in an 1897 appeal to young writers: "It's the life that we want, the vigorous, real thing, not the curious weaving of words and literary polish."[33] Only a few years after that article was published, Henri was actively advocating an art based on individual response to personal experience. In his own teaching, he eschewed technical proficiency: "It is my theory that years of precious youth are wasted in learning to draw, and by the time we are finished draughtsmen we have lost individuality, our minds are threadbare of ideas. We can draw to perfection, but the results are lifeless, without individuality."[34]

Just as Henri rejected the display of technique in and of itself or the mechanical exposition of facts, he reviled any art created for its own sake. Instead, he pronounced: "If art is real it must come to affect every action in our lives. . . . It is not learning how to do something which people will call art, but rather investing something that is absolutely necessary for the progress of our existence."[35]

The art of Henri's star pupil, George Bellows, seemed to convey this sense of necessity. The young artist's confrontation with what was perceived as the vital pith of real life assured him a place on center stage in the art world, and his brilliant facility won plaudits from the critics. Even a fairly conventional though spirited urban landscape in the Academy's 1908 Winter Exhibition elicited this from critic Arthur Hoeber:

> One of the snappy, wholesome, original and daring performances of the display was George Bellows's *Up the Hudson*, a somewhat large canvas showing the stream and the surrounding country, all portrayed with zest, with life, in a frank almost brutal manner, bubbling over, nevertheless, with animation and life. One was conscious the work was a joy in the rendering, that the man worked with an enthusiasm fairly contagious and caught a verisimilitude most convincing.[36]

The early months of 1909 brought Bellows professional recognition, with his election to the Academy as an associate, and the tangible rewards of success, with his first two sales. The confidence that must have been bred by such accolades came together fortuitously with Bellows's full realization of his artistic resources. Before the year 1909 was out, he completed some of the greatest paintings of his career, among them two more boxing pictures.

Though in subject, setting, and arrangement *Stag at Sharkey's* (fig. 9) closely resembles *Club Night* of 1907, there are remarkable differences between the two paintings that have to do largely with Bellows's rapidly maturing abilities. In the later work, his application of the paint is looser and bolder. It was as if Bellows developed a working method in direct response to his mentor's admonition to "paint with great speed," to communicate the

immediate sensations elicited by the subject at hand. While in the earlier *Club Night*
Bellows carefully molded the bodies of the fighters with built-up pigment, allowing strong
theatrical light to articulate their muscled shoulders, in the second painting he applied paint
more aggressively, with slashing strokes that seem to intensify the fevered pitch of action,
the charged emotions portrayed.

Though inspired by the vividly real life of the city, *Stag at Sharkey's* is a finely crafted
artwork of enormous formal as well as expressive power. The composition derives from the
earlier *Club Night* but reflects a greater sense of assurance, especially in its more definitive
arrangement of elements. The scheme is at once artlessly simple and shrewdly complex,
explosive and controlled. The figures of the boxers appear larger in relation to the entire
painting, although they occupy similar proportions of the height and width of the canvas.
Brightly lit, they project themselves forcibly toward the surface plane, and the commanding,
centrally placed triangle comprised of the fighters and the referee assertively dominates
the picture. The stability of the triangle serves to marshal the demonic forces set loose in
this savage encounter, locking them firmly in place in the grid of ropes, canvas floor, and
corner post.

The application of paint on the surface of the canvas similarly combines spontaneity
with intentionality. A few areas appear unfinished. The front fighter's right glove, for
example, is indicated with only a thin layer of blue/green underpainting, a glaze used to block

in shapes at the initial stage of work on the canvas. This lack of definition creates an impression of movement, as if the punch is about to be hurled. Other passages show built-up layers of impasto; in some areas wet pigment was painted into wet and in others a wet brush was dragged over drier paint. One broadly applied stroke of flesh-colored pigment at the side of the left fighter's torso intrudes onto the green of his trunks, as if the frenzied action of the painting was for an instant totally unbridled. Flesh overspills the outlines in other areas, too—at the left fighter's kneecap, for example. Consciously unaltered, these marks of pure paint serve as reminders of the artist's brush, his creative presence.

When shown in the Exhibition of Independent Artists in April 1910, *Stag at Sharkey's* quickly became a focal point of the galleries. Certainly it was the most-often-reproduced painting in the show. And, on more than one occasion, critics used Bellows's prizefight pictures to stand for the entire Independents' movement—for the quality of "assertiveness," the "vigor and sincerity" perceived in their work, and their protest against the Academy's system of privilege. A full-page article in the *New York World* exploited the sensationalism of the boxing pictures in its subtitle: "How the 'Art Rebels' of America Are Shocking the Older Schools by Actually Putting Prize Fights on Canvas and Picturing Up-to-Date Life As It Really Is Here and Now." Royal Cortissoz noted in his conservative column in the *Daily Tribune*:

> One may reasonably attribute to everybody in this crowded gallery a distaste for conventional methods, and by the same token, a desire to paint life rather than subjects built up in the studio. The themes drawn from the prize ring by Mr. Bellows or from the movement of our city streets by more than one of the painters represented may be taken as significant of a broadly diffused interest in what is free and contemporaneous.[37]

The highly visible boxing pictures came to stand as Bellows's trademark. Early in 1911, a critic for the *World* enlisted pugilist terminology to describe collectively the twenty-four paintings in his one-person exhibition at the Madison Art Galleries: "The strong arm method of painting is what George goes in for, and he has got art pounded to a frazzle here in this twenty-four-round contest. Two dozen heavyweight pictures and a knock-out punch in every one!"[38]

By this time, *Stag at Sharkey's* was relatively familiar to reviewers. So, while the prizefight pictures continued to epitomize the believability as well as the boldness of Bellows's art, many commentators turned their attention to other pictures in the exhibition. The diversity and type of subject matter elicited considerable discussion, in fact. Noting Bellows's predilection for painting "the city in undress," the critic for the *New York Daily Tribune* enumerated several examples: "a lonely tenement house in a squalid district, the deep excavation made for the new Pennsylvania Railroad station, or the streets crowded with noise and violent movement and when he strays away from the pavements it is to study the lean little 'River Rats' of our waterfront or the still curiously urban types on the beach at Coney Island." Apparently, painting the "common things," "the rough and raw side of the Metropolis," still attracted notice, as did the insistent forthrightness of Bellows's approach to his chosen motifs.[39] But the critics noticed more than just the prosaic nature of the scenes portrayed and the bravura handling of paint; they also recognized a point of view—the suggestion of significant import. Paintings such as *The Lone Tenement; Blue Snow, the Battery*; and *Steaming Streets* were singled out as ambitious, *serious* pictures—demonstrations of Bellows's particular brand of realism, which Joseph Edgar Chamberlin in the *Evening Mail* characterized as "realism alive, representative, full of significance and therefore of spirit."[40]

For Bellows's contemporaries, as much as for late twentieth-century audiences, the visual aspect of these pictures, their formal qualities, helped to determine the way their content was received. In *The Lone Tenement* (fig. 10), for example, the breadth and boldness of pictorial conception, along with the careful, almost stately pacing of its composition, seem to connote a grave theme or at least the presence of substantive content. The tenement building constitutes the primary vertical element, but trees, ship masts, and other built structures join with it to impose an ordering framework on an otherwise shabby city scene. The deliberate spatial progression from left to right that these elements mark out is arrested

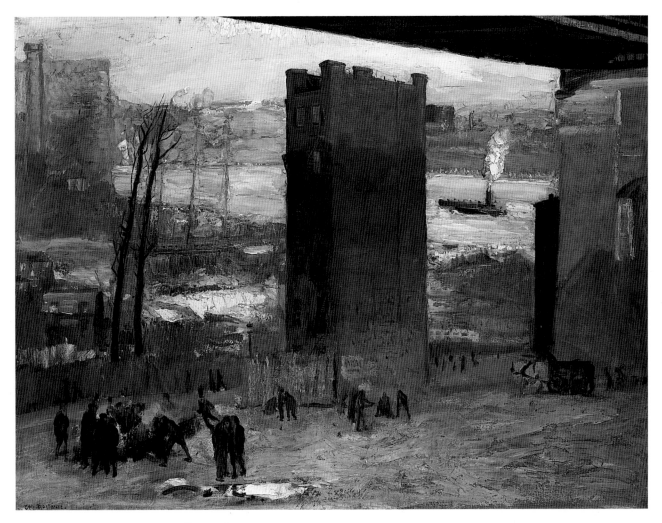

FIGURE 10
George Bellows. *The Lone Tenement*, 1909. Oil on canvas, 36⅛ x 48⅛ in. National Gallery of Art, Washington, D.C.; Chester Dale Collection.

by the central, anchoring lone tenement and then again by the masonry pier of the bridge at the far right. Diagonal movement plays a subtle but critical role in the composition as well. The roadbed of the bridge, moving into depth on a diagonal at the top of the picture, reiterates the line established by a mauve-colored fence that edges the open space of the foreground. In the middle distance, the near edge of the river articulates a second, lesser diagonal that crosses the canvas from right to left. As both of these diagonals intersect the central tenement building, they contribute to the cohesiveness of the composition while describing movement into its depth.

The razed area under the bridge—the recently constructed Blackwell's Island Bridge, now known as the Queensboro Bridge—serves as a gathering place for neighborhood boys as well as men whom bourgeois gallery-goers would have characterized as "idle." The nature of their activities is barely discernable amid the larger forces that dominate the picture (not surprisingly, reviewers of the Madison Galleries exhibition discussed the sunlight and the play of shadows more often than they did the human beings). *The Lone Tenement* is about a place first of all. Bellows intended to describe the contemporary facts about a particular urban environment. According to Henri's dictates, he invested the image with a palpable sense of psychic involvement, "express[ing] by his extract [from nature] the most choice sensation it has made upon him."[41] The eerie emptiness of the huge space that seems left-behind and forgotten and the poignant isolation of the tenement building evoke an unmistakable emotional tenor. But, ultimately, the painting's mood remains open to various

readings, as does the depicted site which represents a confluence of temporal phenomena—the remnants of an old neighborhood now destroyed, a newly built bridge that figures as part of the modern face of New York, and a passing chapter in the dramatic saga of the city's powerless lower classes who made their lives in the spaces left behind by progress.

As *The Lone Tenement* and the other twenty-three paintings on view at the Madison Galleries demonstrated, Bellows painted the banal, quotidian substance of the city and invested it with a palpable sense of felt emotion. Attempting to articulate the sensations they perceived, exhibition reviewers talked about the suggestion of "life and force," about "the spirit of youth, health, vigor, and enthusiasm," and the "energies flow[ing] from his paint brush."[42] Indeed, Bellows had seized on a series of subjects and a mode of pictorial expression that reflected a contact with the real things in American life.

Unlike several other members of the Henri circle, Bellows had never been employed as an artist/journalist, yet his work often conveyed a quality of reportorial realism that was noted by his contemporaries. He not only made paintings that closely correlated with contemporary conceptions of the urban environment but also painted places and subjects that had a sense of here-and-now currency. At times they were, in effect, news stories. The excavation for Pennsylvania Station, for example, frequently occupied the headlines of daily newspapers and nationally circulated magazines during Bellows's first years in New York City. The artist joined the countless onlookers, photographers, and reporters who watched as the entire four-square-block area between Thirty-first and Thirty-third Streets and between Seventh and Ninth Avenues was cleared of building and then a giant hole carved out of the leveled ground. He produced a series of four paintings of the excavation between 1907 and 1909. Though the sites and spectacular statistics of the project were widely familiar, the frankness of Bellows's paintings of the scene took critics aback. J. Nilsen Laurvik saw the earliest excavation painting in 1908 and pronounced it "stunning," but he added that such a "realistic presentation" of the "big hole . . . with its bedraggled snow and slush and mud" was hardly satisfying as an artistic conception. James Huneker, too, remarked on the "candor" in Bellows's treatment of the excavation. Prior to seeing *Excavation at Night* (fig. 11) when it was exhibited at the New York Academy's 1909 Winter Exhibition, Huneker had frequently expressed his high opinion of Bellows and defended his penchant for painting the sooty side of the city. But the "grim ugliness" of the dramatic *Excavation at Night* moved him to wonder if Bellows's "uncompromising" commitment to "hard facts" had interfered with his demonstrated ability to transform raw observed phenomena into a work of art.[43]

In February 1911, immediately following his Madison Art Galleries exhibition, Bellows began work on still another portrait of the city, his most ambitious composition to date. Perhaps the experience of seeing an assembled group of his urban paintings impelled him to make a larger, more grandiose statement, as if to encompass the whole. He called it, simply, *New York*.

In contrast to the separate components of the city he had depicted in various earlier paintings on view in the exhibition, in this canvas he attempted to take it all in. *New York* (fig. 12) presents not just a particular place or a city scene or a passing episode but all of those things, in multiples—its purview embraces a huge slice of modern urban life. A myriad of incidental details seems to confirm its authenticity. Facades with countable windows, signs with visible if not readable text encourage the perception that the painting faithfully describes a particular site. In fact, however, period photographs of some of the busiest sections of New York's commercial center seldom document the sense of densely packed buildings and moving bodies represented in this painting. For example, a wide-angle view of Union Square (fig. 13), from a parlor-table guidebook to the city, shows the same distinctly elliptical shape reflected in the curving trolley track and diagonal sidewalk in the center of Bellows's picture. Union Square's commercial establishments and hotels, the trees surrounding the park at the center of the square, even the statue, all relate to features in *New York*—as does the Sixth Avenue elevated, located two blocks to the west. Other salient elements of the painting, however, clearly do not correspond to Union Square as it looked in 1911. The photograph presents a more open space—indeed, the overall proportions of any such square would be more horizontal than vertical. Bellows's painting emphasizes a

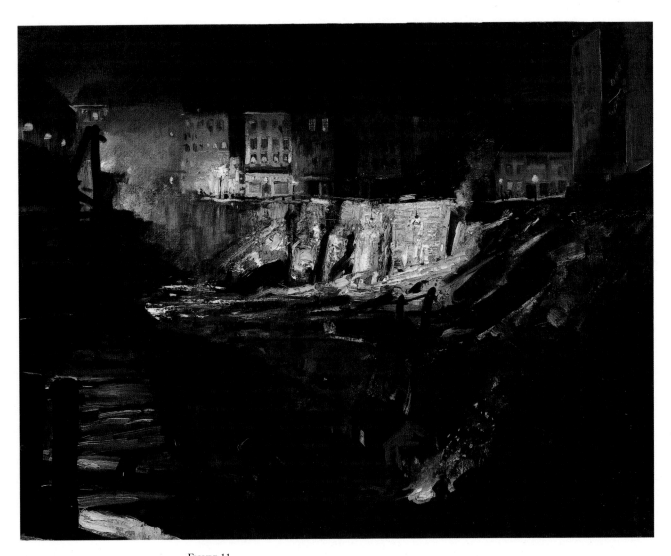

FIGURE 11
George Bellows. *Excavation at Night*, 1908. Oil on canvas, 34 x 44 in. Courtesy of Berry-Hill Galleries, New York.

preponderance of tall, tightly packed buildings which virtually fill the frame and block out the sky. Although buildings of that scale were common farther downtown, none of the open, park-like squares resembling the one in Bellows's picture seems to have been adjacent to such an aggregate of tall structures. Thus, Bellows probably was not portraying a single, precise scene. Rather, he combined the openness of the square and the convergence of vehicular activity that would have occurred there with that most prominent characteristic of New York City, the "canyon" between rows of skyscrapers (see stereograph view, fig. 14).[44] He spliced these two city "parts" together to provide the setting for the turmoil of activity that comprised the real subject of his picture, then crammed the lower half of the composition absolutely full of moving things. This compendium of New York scenes produced a document of life in the city that was more convincing than faithful description.

Painted in the studio, according to Bellows's usual method, *New York* represents an intentional manipulation of spatial elements. As any number of contemporary photographs would demonstrate, Bellows compressed the space of his square and exaggerated the massing of the buildings around it. Both forces tend to enhance the sense of throbbing density, the magnificent heterogeneity of the scene. A number of factors contribute to the effect of compacted space: the depth of the roadway on the far side of the square is completely eclipsed in the painting, while the articulation of the building facades, with brilliant passages

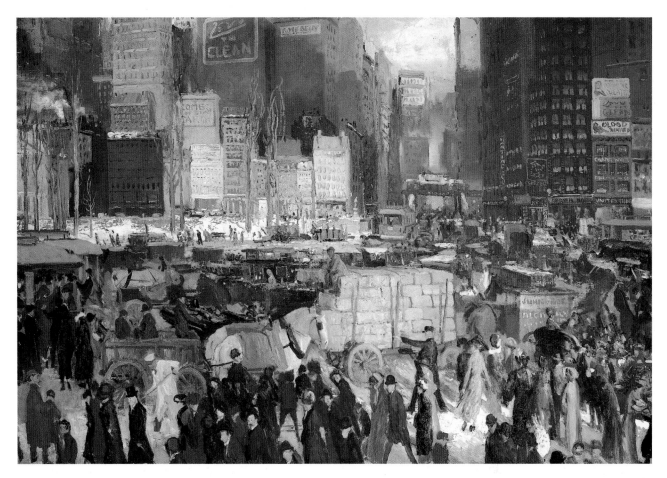

FIGURE 12
George Bellows. *New York*, 1911. Oil on canvas, 42 x 60 in. National Gallery of Art, Washington, D.C.;
Collection of Mr. and Mrs. Paul Mellon.

FIGURE 13
Photographer unknown. *Union Square*. In E. Idell Zeisleft, ed., *The New Metropolis* (New York:
D. Appleton and Company, 1899). Courtesy of Bobst Library, New York University.
Foreground figures were added with a montage technique.

FIGURE 14
Photographer unknown. *Looking up the Deep Canyon at Lower Broadway*, 1915.
Stereograph by Underwood & Underwood. Library of Congress.

of loose and at the same time tightly controlled brushwork, brings those surfaces up close to the picture plane. In the upper right quadrant, a stacked row of windows, atop the building that marks the deepest recession into depth, aligns itself with stacked bundles of hay in the immediate foreground, while the back edge of these bundles corresponds precisely to a strong vertical element, the edge of a building, just above it. Such alignments serve as subtle reminders that the painted background and foreground exist on one and the same surface. But while these devices tend to restrict or deny spatial recession, the very plenitude of elements in the foreground creates an insistent demand for space. The carts, horses, trolleys, and people funnel out from and back into the street that recedes into the distance of the picture. Compression and expansion thus work against each other to create a dynamic tension across the jostling surface of the composition.

When *New York* was displayed in the Academy's Spring Annual, James Huneker called it an "amazing" transcription of New York life—"ugly," "grimy," and "crudely realistic." But after acknowledging its realism, Huneker went on to conclude that Bellows's picture was just too much—"too much portrayed, too much literalism, too little left to the imagination, too harsh an insistence upon the raw facts of a street scene." Voicing the consensus of New York's critics that spring, he called Bellows's painting an "impossible attempt" to envision a "thousand details" and a "jumble of oppositions." Despite these objections, none could deny the remarkable truth they perceived in *New York*. One reviewer remarked: "Some day far in the future it will be pointed out, no doubt, as the best depiction of the casual New York scene left by the reporters of the present day."[45]

Early twentieth-century gallery-goers also recognized truth in Bellows's depictions of street life on the Lower East Side—scenes that often had corollaries in the press. Urban reformers and progressive newspapers and magazines made ongoing efforts to keep the "social problem" of the underclasses on the minds of reading Americans. The persistent media focus on urban poverty, crime, and disease must have added resonance, certainly a heightened sense of topicality, to depictions of tenement-district life on the walls of art galleries.

The critical commentary about a major canvas of 1913, Bellows's *Cliff Dwellers* provides a specific example of the power such an image might possess to summon up current

FIGURE 15
George Bellows. *Why Don't They Go to the Country for a Vacation?*, 1913. Transfer lithograph reworked
with pen, 25 x 22½ in. Los Angeles County Museum of Art; Los Angeles County Funds.

issues associated with urban reform. When the painting garnered third prize at the Annual
Exhibition of the Carnegie Institute, the reviewer for the *Fine Arts Journal* was provoked to
remark that the artist "frequently causes the smug to feel conscious of the brutal facts of life;
thus is Mr. Bellows, perhaps unintentionally, a worker for social betterment."[46]

Bellows's original interest in the Lower East Side was piqued by Henri, not the urban
reform movement or the press; at the same time, however, printed illustrations and reform-
style photographs comprised a prominent part of his visual environment. It seems likely that
the mass media may have stimulated ideas for Bellows's art, at least from time to time. Such
may have been the case in April 1913 when Bellows made the drawing (fig. 15) which he
subsequently used as a study for *Cliff Dwellers*.[47]

Having been persuaded by John Sloan to become involved with the radical magazine
The Masses, Bellows spent much of April and May 1913 producing a series of drawings that
he contributed to the periodical, free of charge. The second of these, which he titled *Why
Don't They Go to the Country?*, may have been made only days after the publication, on April
10, of an article in the socialist *New York Call* describing conditions similar to those depicted
in the drawing. The lengthy article had examined the fate of underclass families who suffered
the stifling summer heat and crowded conditions of their tenement neighborhoods with-
out relief. "Sample Sunday Pleasures," as the article was ironically titled, lamented the
inadequate provisions for recreation in the congested urban environment of New York
City. While thousands of well-off New Yorkers had the means to escape to seaside resorts

Courtesy of the New York "Sun."

A SUNDAY SCENE IN A CONGESTED EAST SIDE DISTRICT.

FIGURE 16
Photographer unknown. *A Sunday Scene in a Congested East Side District.* In "Sample Sunday Pleasures," *Literary Digest* 46 (May 17, 1913): 1129.

or into the country, the author pointed out, four million of the less affluent remained confined to the city on Sundays, where they "listlessly prowl about the street, or continue to breathe the stench of the tenements. . . . Some of them rush the can or the equally pernicious ice cream soda growler."

That Bellows produced a drawing of a crowded tenement street scene and called it *Why Don't They Go to the Country?* in mid-April, invites speculation that he noticed the article. In fact, he may even have turned to the *Call* for reference as he ventured into magazine illustration, still a fairly new outlet for him.[48] Sloan himself, Bellows's initial contact at *The Masses,* had been contributing drawings and cartoons to the *Call* since 1909, and Bellows always held Sloan in high esteem. His interest in teaming up with Sloan at *The Masses* would suggest that he was at least sympathetic to his colleague's political ideas; although Bellows was not a socialist (he professed only a commitment to personal and artistic freedom), he surely recognized that any association with *The Masses* implied an interest in cultural iconoclasm, if not political anarchism.

However, the conditions enumerated in "Sample Sunday Pleasures" apparently drew attention beyond the *Call* itself. The author's provocative analysis of the "curious and illogical blending of puritanism and license" that accounted for New York's "demoralizing Sunday" was picked up by the *Literary Digest* and summarized with collaborating photographs in its May 17 issue (see fig. 16).[49] Thus, whether Bellows saw the *Call*'s original article matters less, ultimately, than the fact that the issues it raised were "in the air." The brutal living conditions of the urban poor were constantly discussed in the socialist, progressive, and popular press.

As a "slum" subject, *Cliff Dwellers* (fig. 17) was associated, broadly speaking, with heightened awareness of rising immigration and the pernicious effects of urbanization and industrialization. For example, one of the overriding impressions created by the scene, as Bellows depicted it both in the drawing and in the final painting, is its crowded atmosphere. Very likely that impression would have been even more striking for those who saw either of these images in 1913. Cleanliness and orderliness were highly prized, bourgeois virtues, hallmarks of civilized life, and class-conscious urbanites exhibited particular sensitivity to the issue of space versus congestion. In 1907 one prominent settlement house actually organized a Congestion Committee, which directed its efforts to fostering greater aware-

FIGURE 17
George Bellows. *Cliff Dwellers*, 1913. Oil on canvas, 40³⁄₁₆ x 42¹⁄₁₆ in. Los Angeles County Museum of Art; Los Angeles County Fund.

ness of the problems associated with overcrowding in the tenements and to "drive home to the general public the evils from which New York should emancipate itself."[50] To this end, the committee presented an exhibition at the American Museum of Natural History that relied, in part, on photographs to arouse interest in their cause. One can safely assume that several of the images on view in this exhibition also resembled figure 16, the photograph selected to illustrate the *Literary Digest*'s summary of "Sample Sunday Pleasures." Much of the evocative power of this genre of reform-style photography depended on well-established expectations for spaciousness in the public as well as in the domestic environment.[51] Bellows exploited these same expectations in many of his tenement-district pictures.

 Cliff Dwellers may very well have evoked additional, particular concerns in the minds of reform-conscious members of Bellows's audience. The children in the foreground, for instance, are involved with various forms of undisciplined play; furthermore, they cavort and pass their time in the street. During the Progressive Era, a vocal group of conscientious,

primarily middle-class citizens, spearheaded by agencies such as the New York Society for Parks and Playgrounds for Children, determined that the street was an inappropriate and unsafe setting for play. These reformers were mindful not only that the streets were dirty and dangerous but also that the boisterous street life they observed in immigrant neighborhoods seemed contrary to their view of orderly social behavior. They organized supervised play facilities, gymnasiums, and vacation schools, as distant as possible from the "vulgarity and all the unspeakable sights and sounds of the streets."[52] In this way, the "children of the toiling masses"[53] could be lured from the odious influences of their raucous home life and taught proper values and behavior. A February 1913 article in the *New York Times* emphasized the imperative of recognizing the "dreadfully injurious" effects of "improper play," pointing ominously to a ruinous future that would result for "old Manhattan and the nation." An extended statement by a child development expert testified, however, to the fact that these dangerous trends were reversible, since even "little thugs" and "mean little cads" from the tenements respond to "every wholesome influence."[54]

The children in Bellows's *Cliff Dwellers*, innocent as they appear, exhibited no effects of the requisite "Americanizing" process that urban reformers considered crucial to the maintenance of social order. Some of the youngsters stand around idly; others play leapfrog, a game not considered conducive to developing healthy minds and bodies.[55] Bellows also included in this painting an additional sign of the irregular social patterns of the children's background. The teenager in the central foreground, who holds a baby at her shoulder, would have reminded middle-class audiences of the "little mother" problem. School-age girls from many working-class families assumed a large share of the responsibility for rearing their infant brothers and sisters, particularly during times of the day when the real mothers were otherwise occupied. The babies as well as the substitute mothers, contemporary reformers would charge, were victims of this unhealthy, un-American practice.

Cliff Dwellers might in fact be described as a catalogue of the social ills that characterized life "at the bottom."[56] In addition to children playing unruly street games and a "little mother" caring for her infant sibling, a female figure conspicuously isolated at the middle right of the picture is depicted "rushing the growler." Women were seldom permitted in respectable neighborhood saloons during this period, especially if unaccompanied, so they purchased beer in buckets to drink at home. That the woman in Bellows's painting exchanges words with an otherwise unoccupied man enhances the suggestion of unseemliness. Above and below her, several other female figures would appear to demonstrate the effects of the "inherent and subtle evil of overcrowding" in the tenement districts, as described by urban reform advocate Lilian Brandt: "There are always women to be seen gazing out of the windows, sitting on the steps, and standing on the sidewalks," who display the "inertia," the "'indifferentism,' which germinates among the tenements."[57]

Singly and collectively the series of vignettes presented in *Cliff Dwellers* spoke of a place abhorrent to the sensibilities of genteel Americans—and those aspiring to gentility. At the same time, many middle- and upper-class urbanites found such a scene strangely fascinating. Francis Hopkinson Smith betrayed this typical mixture of attraction and distaste as he described a well-known tenement neighborhood for his parlor-table volume *Charcoals of New and Old New York*:

> Elizabeth Street, between Prince and Houston, is an ill-smelling thoroughfare, its two gutters chocked with crawling lines of push-carts piled high with the things most popular among the inhabitants,—from a yesterday's fish to a third-hand suit of clothes.
>
> About these portable junk-shops swear and jabber samples of all the nationalities of the globe, and in as many different tongues, fighting every inch of the way from five cents down to three,—their women and children blocking the doorways, or watching the conflict from the windows and fire escapes above.
>
> It is the Rialto of the Impoverished, the alien and the stranded. It is also enormously picturesque.[58]

When *Cliff Dwellers* went on exhibition for the first time in October 1913, Henry McBride, critic for the *New York Sun*, lamented its brutal frankness. Undoubtedly he would

have preferred the distancing effect of a more picturesque point of view:

> George Bellows' "Cliff Dwellers" is appalling. Can New York really be like that in summer? The dreadful people crowding the street, like naked urchins, the vendors of unhygienic lollypops, the battalion of mothers nursing their infants near the footlights where you have to see them, the street car clanging its mad way through the throng, the gentlemen on the fire escapes doing their toilets and the housewives hanging out the wash, can anything in Bedlam or Hogarth's prints equal this?[59]

Doubting the veracity of the picture, McBride wondered whether "Mr. Bellows will swear he hasn't exaggerated."

In fact, the truthfulness of *Cliff Dwellers* emerged as an issue for critics who reviewed the exhibition of paintings by fifteen "young Americans" at the Montross Gallery that October. For the *Times* reviewer, "reality" was the picture's "particular merit," and he devoted considerable column space to a detailed description, concluding: "The scene is innocent of make-up, just a bit of life outside the theatre, and Mr. Bellows has loved it because it was real and has seen his way to expressing its quality without affectation." Guy Pène du Bois had a different view, that Bellows "has built a crowd of people in which not one single person exists; a crowd that loses its reality the moment that it is dissected." Du Bois went on to point out particular figures that defied all rules of naturalistic representation, including "a young girl who bends stiffly, at right angles like a jack-knife, a brute boy whose bare back does not suggest flesh, a horrible bit of blown-up surface feeding an infant."[60]

This debate underlines the point that during this period "reality" had come to be associated with depictions of the lower class. *Cliff Dwellers* seemed convincing to some members of its first audience in part because it served to reaffirm commonly held conceptions of tenement-district life—that its inhabitants were alien and inferior. But to late-twentieth-century eyes, the painting's departures from the "real" seem obvious. It is first and foremost a pictorial construction, in which spatial manipulations enhance the evocative character of the scene—most prominently the sense of chaotic and oppressive crowding. In addition, the bony, angular bodies of the children in the foreground and their exaggerated, awkward postures were part of a visual language that signified the "real life" nature of the subject. Such distortions derived from established conventions especially prevalent in the mass media. Bellows himself no longer copied printed illustrations from periodicals as he had during his high school and college days, but the images he saw in the media helped to produce his knowledge of "reality." In searching for ways to create meaningful representations of his social environment, he borrowed elements from a visual language widely familiar from the mass-circulation press. A cartoon (fig. 18) published in *Puck's Library* in 1902, when Bellows was still studying magazine images assiduously, provides an example of the formulaic figure type that was common in "middle-brow" magazines and newspapers. The spindly bodies that bend at sharp angles appeared regularly in Bellows's own "real life" subjects.

Cliff Dwellers was exhibited a second time, during January 1914, in a one-person exhibition of twenty-seven paintings at the Montross Galleries. Forbes Watson, art critic for the *New York Evening Post*, meted out high praise when he remarked that the assembled paintings afforded "an opportunity to study the development of one of the most powerful

A "RINGER."

FIRST BETTOR.— Look out for dat "Goo-Goo!" He's a "ringer." Dat's de same goat dat run a mile in ten minutes at de Newtown Creek track last year; dey've simply blacked his face, trimmed his whiskers and changed his name from "Brass-Knuckles" to "Goo-Goo." I knowed him in a minute.

FIGURE 18
Artist unknown. *A Ringer,* ©1899 by Keppler and Schwarzmann. In *Puck's Library,* no. 183 (October 1902), [p. 19]. Library of Congress.

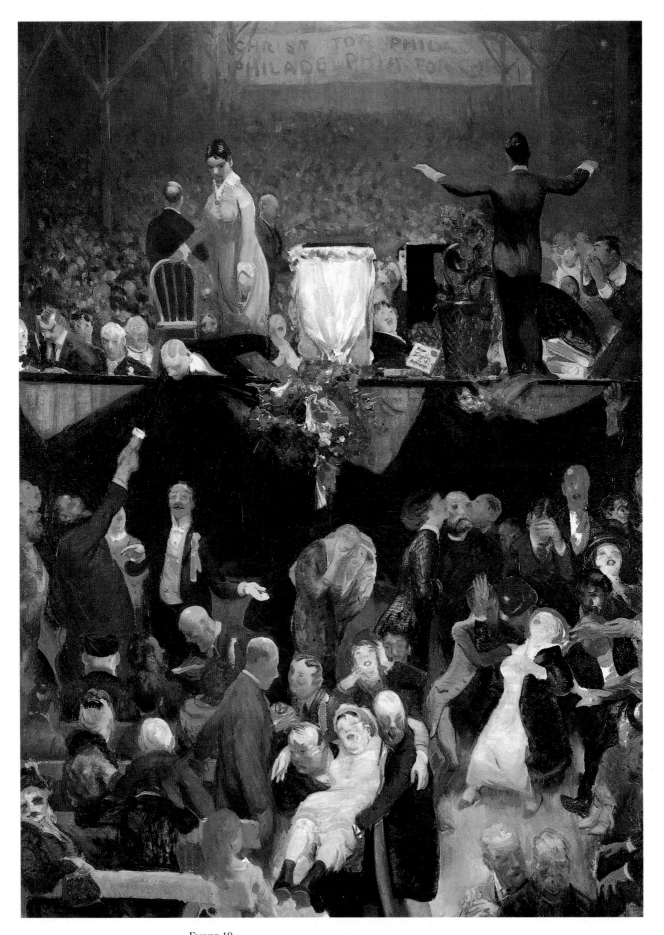

FIGURE 19
George Bellows. *The Sawdust Trail*, 1916. Oil on canvas, 63 x 45⅛ in.
Milwaukee Art Museum; Layton Art Collection.

personalities in American art." On this occasion, Watson was less interested in the realism issue than in evidence he perceived of a new direction in the artist's work. Bellows himself had confirmed that, indeed, he was absorbed with a "deep interest in what might be called the geometrical logic of painting." As this critic explained:

> Believing ardently in the rediscovery of laws common to all great art, he is attempting to master them and build accordingly. Bellows has begun more than ever before to subject his joy in creating to the guidance of his mind. These paintings represent a period of experimenting and some of them betray a hint of mechanical color organization which often mars to some degree even Bellows' great pictures, but also a more mechanical design.[61]

Bellows's new-found interests might have been stimulated, or at least reinforced, by the great art event of the season, the Armory Show. That exhibition and its aftermath had significant ramifications for all the artists in the Henri circle, who for several years had enjoyed a center-stage position in the New York art scene. The Armory Show reconfigured that stage, leaving Henri and his protégés no longer at the vanguard of artistic trends. During the months, indeed the years, following that seminal event, Bellows seems to have repeatedly reassessed and reevaluated his own position in relation to the art world as he perceived it. It is not surprising that Bellows would seek to affirm the validity of his own work in response to the influx of new ideas associated with Cubism, Fauvism, and other European modernist styles—ideas that were attracting so much attention among artists, critics, and a sizeable segment of the art audience. By asserting his interest in certain "fundamental laws of design,"[62] Bellows was establishing a connection with venerable tradition, with great art of the past, and at the same time confirming the intellectual content of his work.

Bellows hoped that *Cliff Dwellers* would serve as a demonstration of technical facility as well as compositional complexity. The paint surface itself displays a virtuoso performance, but not in the manner of his impulsive slashing style of the previous decade; instead, his paint strokes were assiduously nurtured into a tightly woven, lattice-like screen, each mark subscribing to the configuration of some visual detail—a windowpane, a line of bricks. The checkered blanket hanging on a clothesline just above and to the left of the picture's center presents itself as a tour de force, an artful combination of painterly fluidity and control.

The central figural group—bracketed at the right by a young mother who bends at a sharp right angle to discipline her cowering child and at the left by the "little mother"— announces, or echoes, the compositional unit of the entire picture, the square. The canvas itself is close to square (forty by forty-two inches), and a series of concentric and overlapping rectilinear shapes comprise a dense, almost architectural structure within it. Subtle but explicit diagonals not only provide counterpoints to the dominant pattern of horizontals and verticals but also direct attention to the central, focal group. The angled slats of a pushcart loaded with fruit establish the diagonal on the left; its counterpart on the right is defined by the railing, which additionally focuses attention on the woman "rushing the growler." The physical reality of that railing, interestingly, is not permitted to interfere with a significant component of the painting's iconographic scheme: one vertical member of the railing gives way rather than conceal the bucket of beer.

Bellows exhibited *Cliff Dwellers* several times throughout the country before its next New York outing, a one-person exhibition at the newly opened Whitney-Richards Galleries in December 1915. The *New York Sun* marked the event with a half-page feature: "George Bellows, N.A., Paints 'The Call of the City.'" At the head of the article two large reproductions—*Cliff Dwellers* and a boxing drawing, *The Knock-Out*—exemplified the artist's fascination with New York. Bellows himself, who was interviewed for the article, explained: "I paint New York because I live in it and because the most essential thing for me to paint is the life about me, the things I feel to-day and that are part of the life of to-day."[63]

The first paragraph of the *Sun*'s laudatory article listed a catalogue of Bellows's New York subjects, which included "all phases of city life"—East Side tenements, the North River docks, prizefights, Central Park, and Billy Sunday (fig. 19). This last was not, strictly speaking, a New York picture. Earlier that year, Bellows had travelled to Philadel-

FIGURE 20
George Bellows. *Deponent Testifies That He Is No Longer a Sinner.* In *Harper's Weekly* 58 (January 3, 1914): 16–17.

phia to see the renowned evangelist at his largest and most sensational revival. Two large-scale, highly finished drawings produced as a result of his trip were among the twenty-one works in Bellows's Whitney-Richards show. At least one critic, surprised that the small group of drawings was not overpowered by the paintings shown with them, confessed that "Mr. Bellows' drawings show another phase of him and are as big as anything he has done."[64]

Bellows aspired to deal with "the tremendous, vital things" of his time,[65] and with Billy Sunday he could do just that. Sunday had become a national phenomenon by 1915, a news story that was truly larger than any one city. Reports of his notorious activities often rivalled coverage of World War One. In March of that year, at the height of his highly publicized Philadelphia revival, the *Metropolitan Magazine* commissioned Bellows to illustrate an exposé article on Sunday, to be written by journalist John Reed.

The "baseball evangelist" had been generating nationwide publicity since 1907, when the *American Magazine* published a feature article about a revival in Fairfield, Iowa.[66] In the beginning, his revivals were carried out largely in the West and Midwest. But his distinctive style, coupled with his remarkable success in attracting great throngs in city after city, increasingly drew the attention of the media and the nation. By the 1910s a large number of reading Americans were probably familiar with the Sunday method: he organized revivals only in response to an invitation that represented the support of all evangelical ministers of a given city; those who invited him had to build a wooden tabernacle, complete with inches of sawdust on the floor to muffle noise; and his sponsors had to provide financial guarantees in advance.[67]

Bellows had Billy Sunday on his mind as early as January 1914, when he mentioned him in a letter to a friend. Referring to the recent publication of his satirical drawing of a prayer meeting, "Deponent Testifies That He Is No Longer a Sinner" (fig. 19) in *Harper's Weekly*, Bellows remarked: "That's what I wanted to do to Billy Sunday and did not get a look. This I will always regret."[68] The following April, Sunday actually made an appearance in New York, opening the annual campaign of the city's Evangelistic Committee. But it was the Philadelphia campaign that brought unprecedented attention to the "salvation circus." As usual, Billy Sunday's advance team had been making preparations and building up publicity for months. Many observers considered this particular campaign special. Philadelphia, it was thought, differed from Sunday's previous host cities, the "more impressionable communities of the Middle West."[69] But apparently, even savvy easterners were susceptible to Sunday's magnetism. The first service filled the fifteen-thousand-seat tabernacle, an additional five thousand people stood, and extra police had to restrain thousands more who were turned away.

Newspaper editors and journalists examined the remarkable Philadelphia phenomenon from every conceivable angle. Sunday's baseball background, his slangy, down-to-earth preaching style, his athletic poses on stage, all provided fodder for the press. Philadelphia papers, it was said, had agreed to present Sunday in a positive light, at least during the campaign. In New York, on the other hand, writers tended to be more skeptical about the reasons for the evangelist's extraordinary success, his ability to incite a state of emotional religious excitement in an entire city. Some openly accused him of using crowd psychology rather than preaching "real" religion.

The high point of any revival was the call for converts. Titillating accounts of the procedure found their way into almost every story about the Philadelphia campaign. Sunday always delayed the initial call until well into the first week of the campaign. No one knew when it might happen. When it did, inevitably, hundreds would "hit the sawdust trail." As

the choirmaster led the eighteen-hundred-voice choir in repeated renditions of "Stand Up for Jesus," "We're Marching to Zion," and "Jesus, I Am Coming Home Today," Sunday would lift up a trapdoor at the front of the platform and step down into a hole from where he could reach over the edge and shake the hand of every "trail hitter" who approached him. The ushers, carefully rehearsed, directed all movement, especially near the platform where they cleared the front rows of seats to make way for converts as needed. After the first call proved successful, "hitting the sawdust trail" became a regular feature of services for the remainder of the campaign.

FIGURE 21
George Bellows. *The Sawdust Trail,* 1915. Graphite, black crayon, pen and ink, and ink wash on paper, 28⅛ x 22⅛ in. Boston Public Library, Print Department; gift of Albert Henry Wiggin.

This was the event Bellows elected to depict in the more spectacular of his two illustrations for the *Metropolitan* magazine article (fig. 21). A diagram reproduced opposite the drawing pointed out the principals—Billy Sunday, his wife "Ma" Sunday, the choirmaster, a few others—and the directional flow of converts along the sawdust trail (fig. 22). The presence of this diagram reinforced the factual, reportorial nature of Bellows's drawing, which presented itself as a visual record of the interior of the tabernacle and the disposition of the people participating in an historical event. This calculated aura of realism depended on the expectations of the picture's intended audience. Some accounts, for example, suggest that Bellows overstated the level of hysteria among the "trail hitters," but this was precisely the aspect of revivalism that attracted the sharpest criticism from religious conservatives, as well as the largest share of

Showing dramatis personae in big picture opposite

FIGURE 22
Showing Dramatis Personae in Big Picture Opposite. In John Reed, "Back of Billy Sunday," *Metropolitan* 42 (May 1915): 10. Courtesy of Indiana University Library, Bloomington.

voyeuristic curiosity. Newspapers often revelled in evocative descriptions of the melodramatics of conversion—weeping, sobbing, trembling, and occasionally fainting. The *New York Times* maintained its usual reserve in reporting on the Philadelphia campaign, but one typical account reflects the paper's plainly condescending attitude toward the hoards of converts:

> Eight torrents of men and women surged down the eight "sawdust trails" in the Billy Sunday Tabernacle and joined in a weeping, singing, and shouting crowd at the feet of the evangelist this afternoon and tonight. . . . Row after row, the hard pine benches in the front of the immense structure filled with the swaying, sobbing throng.

By invoking terms that connoted mob action and weak-minded excitability, the *Times* journalist asserted the otherness of those who responded to the Billy Sunday phenomenon. Reports published throughout the Philadelphia campaign presumed that the notorious, public displays of emotion on the part of converts constituted a breach of accepted standards of social behavior, standards cherished by the paper's readership. The *Times* also made implicit references to the social class of the average "trail hitter," on one occasion, for example, describing a group of 174 converts as "practically all poorly dressed."[70]

Bellows's drawing catered to a similar audience. *Billy Sunday on the Job,* as the picture was titled in the *Metropolitan* magazine, reassured readers that the "trail hitters" in

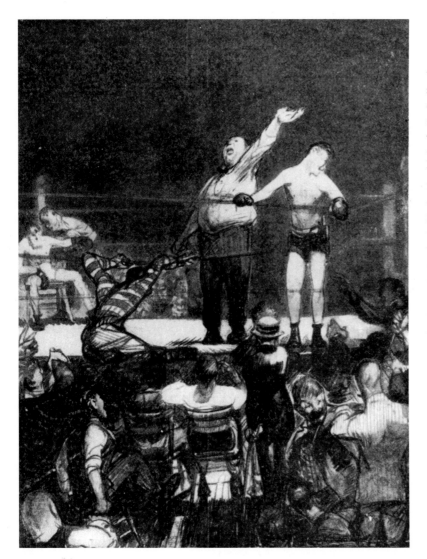

FIGURE 23
George Bellows. *Introducing the Champion.* In "The Last Ounce," *American Magazine* (April 1913): 72. Courtesy of Fort Worth Public Library.

the foreground were different from themselves. The most dynamic area of the composition, the lower register, focuses attention on the swooning, weeping converts. At first glance, the lower half of the picture appears chaotic, but in fact an undergirding V-shape provides a framework for the tangle of movements, gestures, and outstretched limbs. Loosely defined diagonals converge at the bottom of the composition, at the point where two ushers carry an unconscious and disheveled "trail hitter" down the central aisle of the tabernacle, offering a view of her indecorously exposed ankles to all assembled viewers. The arm of the usher supporting her from the left initiates movement along the right-hand diagonal, up and through the figure of an earnest usher, depicted in Daumieresque caricature, who attends another woman overcome with religious excitement. Just above this woman's uplifted hand, a hapless male "trail hitter" seems dumbly perplexed by the attentions of a female usher who has grasped his arm and prays into his ear.

Despite the marshalling of shapes into a discernable if subtle pattern, the composition of the drawing is elaborate and difficult. Bellows elected to use a vertical format with two distinct registers, stacked on top of each other. The upper realm, peopled by Sunday and his company and the choir farther in the distance, is separated from the excited crowd by the draped front of the raised platform. The two realms are connected, somewhat tenuously, by the evangelist's arm reaching down to clasp hands with a scruffy convert at the left of the picture. Bellows had worked out a similar composition format three years earlier for a boxing subject, an illustration for a short story that was published in the *American Magazine* (fig. 23).[71] In this drawing, entitled *Introducing the Champion,* he connected the upper and lower registers by linking outstretched arms. Though the referee's hand and the upper arm of a fan who climbs onto the ropes never actually touch, their arms are clearly and explicitly aligned. They mark a primary diagonal that traverses the drawing, establishing one side of a ninety-degree triangle that provides the organizing framework for the composition.

Encompassing the drama, scope, and complexity of Billy Sunday's tabernacle scene presented a more formidable challenge. Many more elements are involved in the latter drawing, and the multiple foci of attention scattered throughout tend to destabilize any overall unifying scheme. In developing a composition that would respond effectively to these demands, Bellows undoubtedly returned to some of his own earlier work but, in addition, he may very well have drawn on his knowledge of past art. In fact, a recent showing of works by El Greco and Goya at the Knoedler Galleries might have revivified his long-time admiration for Spanish art, based in large part on reproductions.[72] Henri had admonished his students to "study reproductions and pictures you like in this matter of rhythm, organization, concentration, balance, dominance," and he had called particular attention to the compositions of El Greco:

> His work is an illustration of what a composition should be, that is, he puts together forces and makes . . . a great unit. Continuity is carried through the canvas with a positive control, a coordination. His work overlays and interplays like a brook. The

rising movement in it is like a flame, and he makes much of the movement of light.[73]

One of the most famous masterworks of Spanish art was El Greco's *The Burial of the Count of Orgaz*, a monumental altarpiece with a vertical format (fig. 24).[74] Most significantly, the painting would have offered a conspicuous prototype for the use of distinct upper and lower registers. El Greco's ingenious solution to the problem of establishing overall unity within such a composition was to connect its celestial realm to the earthly sphere by the Virgin's beneficent gaze and the gesture of her hand.

A comparison of *The Burial of the Count of Orgaz* with Bellows's Billy Sunday drawing quickly reveals a number of correspondences among figures as well as figure groupings. This is not to imply that Bellows consciously borrowed from the famous El Greco painting, element by element. Rather, the similarities suggest that he knew the El Greco well and that, when he created one of the most complex compositions of his oeuvre, he drew on that memory. The most significant correspondence between Bellows's drawing and *The Burial of the Count of Orgaz* has to do with the way the compositions function. In both cases, many figures and incidental details are subsumed within a larger scheme. Dynamic elements of each composition create a lively pattern of movement that swirls around the circumference of the picture, leaving the center essentially vacant.

FIGURE 24
El Greco. *The Burial of the Count of Orgaz*, 1586. Oil on canvas, 16 ft. x 11 ft. 10 in. San Tomé, Toledo, Spain. Photograph courtesy of Alinari/Art Resource.

In the Bellows drawing, the diagonal line linking the two swooning women in the foreground continues backward and up through a series of stacked faces at the right. Bellows surely intended that the single uplifted arm at the far right would establish a connection to the half-crouched figure on the platform above. The upper half of this figure turns the line inward, toward the choir director, who points toward "Ma" Sunday, whose outstretched left arm continues the line of movement to her husband, and so forth. In spite of this underlying cohesion, very little about the drawing's composition serves to stabilize it. Even if the circular pattern described above is interpreted as a triangle, its inverted orientation works against qualities of fixture or permanent equilibrium. The overall composition, in fact, remains unsteady, even restless. The fact that its dynamic elements are distributed around a vacuous center, traditionally the focal point of a compositional or iconographic program, only adds to the sense of unease that pervades Bellows's picture.

In February 1916, Bellows used his carefully contrived drawing as the basis for a painting, transcribing the image virtually figure by figure. He titled it *The Sawdust Trail* after Billy Sunday's famous call for converts (see fig. 19). In a 1917 interview for *Touchstone* magazine, the artist commented on this work and its subject, immediately after making reference to "those wise old guys in Italy and Spain." He wanted to reaffirm explicitly, and for the historical record, his relationship to the past and tradition. He also wanted to make clear that his artistic enterprise was of real consequence and that he was concerned with meaning (significantly, the article was titled "The Big Idea"): "I like to paint Billy Sunday, not because I like him, but because I want to show the world what I do think of him. . . . I believe Billy Sunday is the worst thing that ever happened to America. He is death to imagination, to spirituality, to art."[75]

Inasmuch as the painting is relatively faithful to the original drawing, the iconography remains the same. In one specific instance, however, Bellows used color to reinforce his characterization of the crowd. The woman at the extreme lower left of the picture, who turns in her seat to glance back behind her, displays ruby-red cheeks. For self-righteous middle-class audiences, such an obvious overuse of facial makeup indicated the woman's lack of refinement and low social status. For art critic W. H. de B. Nelson, the entire scene comprised an "amusing burlesque," in which "the lemon-coloured ladies in different stages of religious fervour being propped up or ambulanced out by male enthusiasts helped to make up a very entertaining canvas full of clever painting and observation."[76]

The Sawdust Trail is a highly self-conscious, ambitious painting, a document of a real, contemporary event and a work of art that laid claim to a venerable heritage. It also marked a new stage in Bellows's interest in design principles. In fact, he had invoked one of the "fundamental laws of design" in his original drawing. He established the placement of the floor of Sunday's platform according to a mathematical proportion used by artists and architects since the Greeks. The point at which the platform divides the two sectors of the drawing is precisely the golden section of its height. The painting explicitly retains that proportion; furthermore, Bellows made slight adjustments in the overall dimensions of the composition when he transferred it to canvas. The shape of the painting conforms to a particular kind of rectangle, a $\sqrt{2}$ rectangle, in which the sides bear a 1:2 mathematical relation to each other (that is, the diagonal of a square whose sides are equal to the rectangle's width is used to determine the length of the longer side.)

Bellows's interest in pictorial organization attracted him to a series of Jay Hambidge's lectures during the fall of 1917, and he promptly began to apply Hambidge's principles to his own work. Increasingly, during and after 1918, Bellows relied on geometric relationships to provide the "constructive armature" for his compositional schemes.[77] The new rigor of his attention to design was most noticeable in his late boxing paintings, which are also his last treatments of an urban theme.

Bellows completed one of these works, *Introducing John L. Sullivan*, in June 1923 and two more, *Ringside Seats* (1924, Hirshhorn Museum and Sculpture Garden) and *Dempsey and Firpo* (see page 80), during the spring and early summer of 1924. All were included in one public exhibition, in Chicago, prior to the artist's death. The critical response to this exhibition reflects the perception of seriousness, of the profound, in Bellows's work. In the *Chicago Daily News*, Marguerite Williams called the roomful of paintings "startling" and "disconcerting"—a distinct departure from "the era of sunshine and trifles in art." Bellows's real concern, in her view, was not the putative subjects of his pictures, "what the eye sees in a scene or a person"; rather, his paintings were about "the intangible psychic thing back of the material thing."[78]

Of the three late boxing paintings, *Dempsey and Firpo* attracted the most attention, in part because the protagonists were real fighters, engaged in an actual, indeed, highly prominent fight. The painting, in fact, records the most dramatic moment in one of the most famous prizefights in the history of boxing—the September 14, 1923, bout between the unlikely American hero, Jack Dempsey, and his Argentinian challenger, Luis Angel Firpo. Extraordinary media hype had drawn the nation's attention to the fight, although neither fighter had a reputation for technical skill or finesse. Dempsey was known for flailing punches with reckless abandon, and the Argentinian was not even well trained, but both men incited passion in a crowd. More important, a promotion campaign that exploited racial and national partisanship had elevated the fight to a far larger significance than that of the heavyweight championship itself. One contemporary observer recounted the mixture of nationalist and primordial sentiments that flared at ringside: "We are here to see the Nordic race defend itself against the Latin; or if you read Sporting Expert B instead of Sporting Expert A it is white man against Indian. At the very least, it is Grizzly Bear Jack against Wild Luis, the Pampas Bull."[79] Thus, thousands gathered at the Polo Grounds to watch the vindication of a race, its mettle to be tested by brute force.

Bellows witnessed the melee at the Polo Grounds firsthand. Having been commissioned by the *New York Evening Journal* to produce a drawing of the fight for publication, he viewed the proceedings from the press box. The very presence of structured provisions

for journalists demonstrates that boxing had changed since Bellows had painted the fights and the rowdy mob at Sharkey's more than a decade earlier. The sport no longer bore the onus of illegality; in fact, attendance at major boxing events became chic in some circles, and women regularly attended fights. During the preliminaries to the Dempsey-Firpo battle, ushers escorted innumerable members of the social elite to their seats. The rich and famous included A. J. Drexel Biddle, Sr. and Jr., Elihu Root, W. K. Vanderbilt, George Gould, Forbes Morgan, William A. Brady, Henry Payne Whitney, Florenz Zeigfeld, John Ringling, and Babe Ruth.[80]

The fight itself lasted only four minutes. In a frenzied exchange, Firpo went down ten times and Dempsey twice before the latter was declared the victor. One visual image that was printed and reprinted in the media encapsulated the entire, action-packed encounter—that of Dempsey knocked through the ropes and out of the ring by Firpo's blow to his jaw (fig. 25). Like the fight itself, which generated interest far beyond the usual sporting audience, the image of Dempsey toppling out of the ring became a commonplace for literate Americans. It was coined for a variety of purposes in disparate contexts (see fig. 26).

FIGURE 25
Photographer unknown.
In William Cunningham,
"No Wonder They Want
to Fight!" *Collier's* 74
(September 13, 1924): 14.

Bellows recorded that signal instant in his drawing, which presents Firpo standing defiantly over the upended figure of Dempsey (fig. 27).[81] For all the movement, the unleashing of powerful energies that are contained in the subject, Bellows's picture conveys less motion or dynamism than it does a strong sense of stability and balance. To be sure, activating diagonals dominate the composition. The falling figure of Dempsey crosses virtually the entire expanse of the drawing along one diagonal axis, his outstretched right arm reaching into the extreme lower right corner of the picture and his raised left leg pointing at the opposite corner. Intersecting that diagonal at a 90-degree angle is a secondary line formed by the referee's right arm and Dempsey's own bent right leg. The shoulder of a figure at the bottom left of the picture carries the second diagonal all the way into the lower-left corner. Firpo's spread legs and swinging arm reiterate the criss-crossing lines and establish the apex of a triangle that rests firmly on the bottom edge of the drawing. Thus, the dynamic forces inherent in the central X shape, articulated by flying limbs, are subdued by the carefully ordered and contrived nature of the composition. All of its elements are so strictly marshalled into position that they seem incapable of dislodging themselves. Furthermore, the diagonal lines are pinned down by a series of horizontal bands. In addition to the ropes that surround the fighting arena, two primary horizontals divide the height of the composition into thirds—the floor of the ring and the row of lights with which both of Firpo's gloves and Dempsey's left foot are aligned. Dempsey's left glove falling away from that line provides one of the few areas of dynamic tension in the composition. The highly finished surface of the drawing further distinguishes it from the spontaneity and immediacy often associated with the sketches of an artist/journalist. Thus, while Bellows was participating quite explicitly in the tradition of reportorial realism, he also took care to clarify his changing relation to it by creating a meticulously considered work of art.

Indeed, by the date of this drawing, September 1923, Bellows's conception of himself as an artist had transcended notions of spontaneity and intuitive response that were hallmarks of his earlier work. His pictorial documentation of the famous boxing bout was intended to reveal not only the operation of the artist's alert eye and skilled hand but also of his analytical mind. His drawing offered a self-consciously calculated interpretation of an historic moment that came to stand for the entire Dempsey-Firpo phenomenon.

FIGURE 26
John A. Knott. *A Little Outside Assistance Might Help Him Come Back*. In *Literary Digest* 79 (October 13, 1924): 14.

FIGURE 27
Dempsey Through the Ropes, 1923. Black crayon on paper, 21½ x 19⅝ in. Metropolitan Museum of Art, New York; Rogers Fund, 1925.

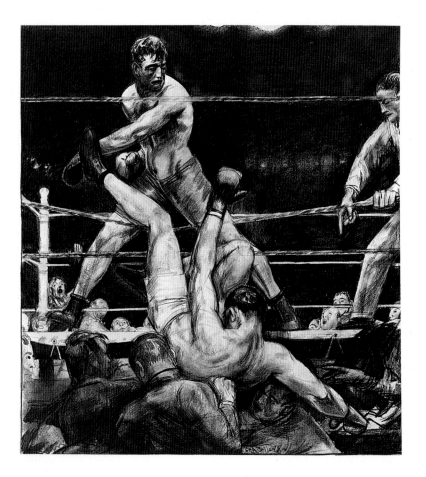

Bellows continued to work out his compositional ideas in two lithographs—*Dempsey Through the Ropes* in the nearly square format of the drawing and another, *Dempsey and Firpo*, in a horizontal format. When the latter was exhibited early in 1924, Henry McBride found the "likenesses" of the principals disappointing but conceded: "in the startling moment he chose to represent—that moment in which the fistic idol of Americans went crashing through the ropes—there was no time to observe eyelashes." McBride was more disturbed, however, that Bellows adhered so resolutely to Hambidge's system of Dynamic Symmetry and "refused to allow his imagination to work in order to apply his rules for composing."[82]

Undaunted by such criticism, Bellows produced a painted version of *Dempsey and Firpo* on a monumental scale (see page 80), retaining the arrangement of the horizontal-format lithograph, with some adjustments. For example, the figure at the bottom of the painting, who supports the falling Dempsey with his right hand while bracing himself with his left, now looks up and toward the action rather than down and away from it as he had done in the print, thus defining a more regular triangle echoing that of Dempsey directly above him. As if to defy McBride's objection that "there are too many lines curving in the same direction in just that part of the picture,"[83] Bellows reworked that area of the painting, regimenting the lines even more rigorously. As a result of such manipulations, Bellows imposed a regulating order onto the confusion of the fighting ring, onto the chaos of the "real."

Throughout the final years of his career, Bellows continued to believe that contemporary reality would provide the basis for the greatest, most significant art of his age. It was his ambition to deal with the "intensity" and "danger" that James had preferred rather than the "culture" and "kindness" that stifled modern society. Bellows wanted to portray the "sight of the struggle going on" that made life significant.[84] On the other hand, he reserved an appreciation for the ordered spaces of Central Park and the cultural values revered in the Victorian household of his upbringing.

In his personal copy of Robert Henri's *The Art Spirit*, published in 1923, Bellows marked out the following sentences:

> Although all fundamental principles of nature are orderly, humanity needs a fine, sure freedom to express these principles. When they are expressed freely, we find grace, wisdom, joy.[85]

These sentiments must have seemed familiar to Bellows. The profession of faith in human freedom had been a frequent theme in Henri's classroom. The particular passage that moved Bellows to make a pencil mark for future reference and rereading also reflects an almost reverential attitude toward the ordered harmony of nature's processes. Bellows, too, spoke about knowing the laws of nature and selecting from them to discover the "social, ethical, mechanical and artistic orders which ought to be." In a letter that was found among his papers and published after his death, he had continued: "As a matter of fact, all the acts of life are the reordering, recognised or not, of phenomena, and the search for a finer reordering."[86]

Bellows's interest in the pictorial structure of a painting was related, in his own mind, to his understanding of the harmony and balance expressed in natural phenomena and then, ultimately, with the

meaning and significance of his art. Dynamic Symmetry provided Bellows with a series of proportions that could be applied directly to the process of composing a picture, conveying on it the "finer reordering" that he saw as connected to the "profoundest and simplest truths."[87] Critics occasionally lamented his adherence to Hambidge's design system, but the majority of art commentators were prepared to recognize a new breadth and monumentality in the artist's last paintings. When an exhibition of work from the summer of 1924 opened at the Durand-Ruel Galleries, shortly after Bellows's death, reviewers used superlatives in their praise—that he "seems to have been just entering upon his best period" or was "at the very top of his powers."[88]

Helen Appleton Read, devoting considerable attention to the posthumous show, interpreted Bellows's experimentation with color and design as part of a broader, only partially realized development in his work. The artist's ambition, she reported, was to encompass contemporary themes in his art and to present them in the form of "great wall decorations"—Bellows himself had invoked the name of Puvis de Chavannes—that would "sing out at people." Thus, Read suggested, while Bellows continued to the very end to be an observer of "our national spectacle," his interest in "larger, more synthetic designs" reflected his desire to produce a truly monumental art—an art that had its roots in the past and was also timely, relevant, meaningful.[89]

Read's article and many other reviews of the Durand-Ruel exhibition tended toward grandiose, eulogistic approbation. But the basic issues they discussed in relation to Bellows's art were not new ones. His first one-person exhibitions, more than a decade earlier in 1911, had demonstrated the catholicity of his vision—he painted "all sorts of subjects," "with equal devotion to fact," it was said. From early on, critics talked about his personal and professional ambition: "That there is a big intention in George Bellows' art no one can deny. It is the bigness that comes from the brush of a man who sees and feels intensely the sensation that prompts his work and which creates an enthusiasm that makes him try for big results."[90] And contemporary art commentary continued to suggest that Bellows was concerned with substantial content, as in a 1915 *New York Times* review: "Mr. Bellows is never more completely himself that when he has something important and moving to say."[91]

Thus, Bellows's contemporaries repeatedly testified to the potency, the expressive power, and the significance of his work. Though such attributions were clichés of the time, to some extent, many of the accounts transcribed here convey a sense that such pictures as *The Lone Tenement*, *Stag at Sharkey's*, and *Cliff Dwellers* did, indeed, present themselves as vital, relevant cultural events. They were recognized as vivid reflections of the artist's experience of urban culture, his attempt to comprehend it. But his pictures represented more than a single artist's view or demonstration of technical skill; they served as collective visions of a shared cultural experience. Early twentieth-century New Yorkers saw in these pictures their changing urban environment, an awareness of class difference and social transformation, and reflections of an emerging mass culture. By virtue of such evocative and highly current connotations, Bellows's urban scene paintings were perceived as accurate, and important, documents of the time. For many members of his first audience, Bellows's art was about "real life" and "big ideas."

NOTES

I am indebted to Jean Bellows Booth for responding tirelessly and carefully to my questions about her father's life and work. I would also like to thank Doreen Bolger and Glenn Peck for reading this manuscript and for making suggestions that contributed to its final form.

[1] H. Effa Webster, "Nineteen Paintings of City Life," *Chicago Examiner*, undated clipping in Bellows's scrapbook, George Bellows Papers, Special Collections Department, Amherst College Library.

[2] Quoted in Charles H. Morgan, *George Bellows: Painter of America* (New York: Reynal and Company, 1965; reprint, Millwood, N.Y.: Kraus Reprint Company, 1979), p. 40.

[3] Bellows's interest in illustration was recalled by individuals who knew him before and after his move to New York City. See accounts of interviews with Charles Chubb, a faculty member in the department of architecture

at Ohio State University, and Edward Keefe, the artist's roommate from 1904 to 1909, in Frank A. Seiberling, "George Bellows, 1882–1925: His Life and Development as an Artist," Ph.D. dissertation, University of Chicago, 1948, pp. 183, 204. Chubb reported to Seiberling that Chase persuaded Bellows to abandon commercial art. This has not been corroborated specifically, but other students have noted Chase's disdain for commercial illustration. See Ronald G. Pisano, *The Students of William Merritt Chase*, exhibition catalogue (Huntington, N.Y.: Heckscher Museum, 1972), p. 13.

4 Bellows may have had an opportunity to see examples of Chase's Central Park paintings in an exhibition in Philadelphia. Forty-one works by Chase were included in a show at the McClees Gallery in March 1905.

5 Chase lecture notes, Shinnecock, July 17, 1894, William Merritt Chase Papers, Archives of American Art, Smithsonian Institution, Washington, D.C.; quoted in Charles C. Eldredge, "William Merritt Chase and the Shinnecock Landscape," *Register of the Museum of Art, University of Kansas* 5 (no. 3, 1976): 18.

6 Helen Appleton Read, *Robert Henri and Five of His Pupils* (New York: Century Association, 1946), n. p.

7 Quotations from Izola Forrester, "New York's Art Anarchists: Here is the Revolutionary Creed of Robert Henri and His Followers," *New York World*, June 10, 1906, magazine section, p. 6.

8 "Slum subject" is the term Helen Appleton Read used to describe the subject matter preferred by Henri and members of his circle, in her "Introduction" to *New York Realists, 1900–1914* (New York: Whitney Museum of American Art, 1937), p. 8.

9 Helen Campbell, Thomas W. Knox, and Thomas Byrnes, *Darkness and Daylight; Or, Lights and Shadows of New York Life* (Hartford, Conn.: Hartford Publishing Company, 1899), p. 153.

10 Frank Fowler, "Impressions of the Spring Academy," *Nation* 84 (March 28, 1907): 298.

11 Joseph Edgar Chamberlin, "An Excellent Academy Show," *New York Evening Mail*, March 14, 1908, p. 8; James Gibbons Huneker, "The Spring Academy," *New York Sun*, March 21, 1908, p. 6.

12 The jury for the Pennsylvania Academy's Annual Exhibition voted eight to two in favor of awarding the Lippincott Prize to Bellows for *Forty-Two Kids*. That decision was changed to avoid the possibility of offending the donor. Robert Henri indicated in his diary account (entry for January 23, 1908) that the title as well as the subject aroused concern. (Henri Papers, Archives of American Art, Smithsonian Institution.) In February, Bellows was asked by a reporter for the *New York Herald* whether, in his opinion, museum administrators had feared that Mr. Lippincott might object to the naked children: "'No,' said the artist, 'it was the naked painting that they feared." ("Those Who Paint What They See," *New York Herald*, February 23, 1908, Literary and Art Section, p. 4).

13 James W. Shepp and Daniel B. Shepp, *Shepp's New York City Illustrated: Scene and Story in the Metropolis of the Western World* (Chicago, Ill.: Globe Bible Publishing Co, 1894), p. 194.

14 Prescott F. Hall, *Immigration and Its Effects Upon the United States* (New York: Henry Holt and Co., 1906), p. 156.

15 It has frequently been pointed out that members of the Henri circle tended to present sanitized images of healthy innocence and the joys of a simple childhood and failed to portray the real filth and misery of daily existence in the slums. The rosy cheeks and youthful exuberance of the majority of their subjects notwithstanding, the decision to paint tenement-district scenes was often interpreted as a political act. Helen Appleton Read, looking back on the decade of The Eight's Macbeth Galleries exhibition, recalled that paintings by Henri's followers were perceived in political terms, particularly those by George Bellows: "It was the unprecedented realism of these portrayals of tense moments in the prize ring and the early paintings of riverfronts and crowded tenement districts which did more to establish the Henri group's reputation for hard-hitting realism and radicalism than any other single factor." *Robert Henri and Five of His Pupils*, n. p.

16 Samuel Swift, "Revolutionary Figures in American Art," *Harper's Weekly* 51 (April 13, 1907): 534. Swift's article must be contextualized. It was occasioned by Robert Henri's dispute with the Academy's jury for the eighty-second Spring Annual Exhibition. He had complained when entries by members of his circle were rejected, and finally withdrew two of his own paintings and went to the press with a story about the Academy's "penalization of originality or self-expression in art."

17 Of course, Henri had also suggested the idea of making boxing an art subject. He urged his students at the New York School to make drawings and paintings based on such "real life" environs as the Bowery, Child's Restaurant, the Matteawan Asylum, and on sporting events of all kinds including boxing. See Eugene Speicher's "A Personal Reminiscence," *George Bellows: Paintings, Drawings, and Prints* (Chicago: Art Institute of Chicago, 1946), p. 5.

18 "National Academy's Exhibition Opened," *New York Herald*, December 14, 1907, p. 3. Bellows's *Pennsylvania Excavation* was also shown in the Academy's Winter Exhibition.

19 Quotations from W. R. C. Latson, "The Moral Effects of Athletics," *Outing* 49 (December 1906): 391; Theodore Roosevelt, "Value of an Athletic Training," *Harper's Weekly* 37 (December 23, 1893): 1236.

20 Sam C. Austin, "Trouble for New York Boxing Clubs," *Police Gazette* 91 (July 13, 1907): 10.

[21] On the connections between urban politicians and professional spectator sports, see Steven A. Reiss, *City Games: The Evolution of American Urban Society and the Rise of Sports* (Urbana: University of Illinois Press, 1989). Information on boxing during this period is also from Reiss's "In the Ring and Out: Professional Boxing in New York, 1896–1920," *Sport in America: New Historical Perspectives*, ed. Donald Spivey (Westport, Conn.: Greenwood Press, 1985); Elliot J. Gorn, *The Manly Art: Bare-Knuckle Prize Fighting in America* (Ithaca, N.Y.: Cornell University Press, 1986); Michael T. Isenberg, *John L. Sullivan and His America* (Urbana: University of Illinois Press, 1988); Jeffrey T. Sammons, *Beyond the Ring: The Role of Boxing in American Society* (Urbana and Chicago: University of Illinois Press, 1988).

[22] See Jon M. Kingsdale, "The 'Poor Man's Club': Social Functions of the Urban Working-Class Saloon," *American Quarterly* 25 (October 1973): 472–489.

[23] See, for example, Roy L. McCardell, "Broadway's 'Reckless Mile' New Thrill for Students of 'Life As It Is,'" *New York World*, April 3, 1910, Metropolitan section, p. 1.

[24] Rupert Hughes, *The Real New York* (New York: Smart Set Publishing Company, 1904), chapter 4.

[25] George Bellows to William Milliken, June 10, 1922, Curators' file, Cleveland Museum of Art; and Morgan, *George Bellows: Painter of America*, p. 69.

[26] James Gibbons Huneker, "Academy Exhibition—Second Notice," *New York Sun*, December 23, 1907, p.4.

[27] Henry Childs Merwin, "On Being Civilized Too Much," *Atlantic Monthly* 79 (June 1897): 883–846. T. J. Jackson Lears discusses various responses to the artificial, overcivilized qualities of modern existence in *No Place of Grace: Antimodernism and the Transformation of American Culture, 1880–1920* (New York: Pantheon Books, 1981).

[28] William James, "What Makes a Life Significant," in *Talks to Teachers on Psychology; and to Students on Some of Life's Ideals* (Cambridge: Harvard University Press, 1983). See also George Cotkin, *William James, Public Philosopher* (Baltimore: Johns Hopkins University Press, 1990).

[29] On the mass circulation magazine's version of real life as "a carefully managed credibility," see Christopher P. Wilson, "The Rhetoric of Consumption: Mass-Market Magazines and the Demise of the Gentle Reader, 1880–1920," in *The Culture of Consumption: Critical Essays in American History, 1880–1980*, ed. by Richard Wightman Fox and T. J. Jackson Lears (New York: Pantheon Books, 1983).

[30] See Miles Orvell's provocative analysis of the notion of authenticity and how it affected the arts in America in *The Real Thing: Imitation and Authenticity in American Culture* (Chapel Hill: University of North Carolina Press, 1989). His discussion of early twentieth-century advertisements, including that of Coca-Cola (p. 144), reminded me of several additional examples. The Victor Records ad appeared in *Collier's* 40 (December 1907): 2. The New England Lines advertised in many of New York's daily newspapers.

[31] Quotations from J. Nilsen Laurvik, "The Winter Exhibition of the National Academy of Design," *International Studio* 33 (February 1908): cxxxix–cxlii.

[32] James Gibbons Huneker, "Eight Painters," *New York Sun*, February 9, 1908, p. 8.

[33] Frank Norris, "An Opening for Novelists: Great Opportunities for Fiction Writers in San Francisco," *Wave* (May 22, 1897), quoted in Orvell, *The Real Thing*, p. 115.

[34] Quoted in Guy Pène du Bois, "What is Art Anyhow?" *New York American*, December 1, 1907, p. 8.

[35] Robert Henri, "The New York Exhibition of Independent Artists," *Craftsman* 18 (May 1910): 161. On Henri's method and philosophy of teaching, see also William Innes Homer, *Robert Henri and His Circle* (Ithaca, N.Y.: Cornell University Press, 1969; reprint, New York: Hacker Art Books, 1988).

[36] Arthur Hoeber, "The Winter Exhibition of the National Academy of Design," *International Studio* 36 (February 1909): cxxxvi.

[37] Henry Tyrrell, "The Battle of Artists: How the 'Art Rebels' of America . . . ," *New York World*, June 5, 1910, magazine section, p. 6; Royal Cortissoz, "Independent Art: Some Reflections on Its Claims and Obligations," *New York Daily Tribune*, April 10, 1910, part 2, p. 2. Short quotations also from Cortissoz and "Young Artists' Work Shown," *New York Times*, April 2, 1910, p. 9.

[38] Undated clipping, probably from *New York World*, January 1911, in Bellows's scrapbook, Bellows Papers, Amherst College Library.

[39] "Matters of Art," *New York Daily Tribune*, January 29, 1911, part 2, p. 7.

[40] Joseph Edgar Chamberlin, "Good Work by Bellows," *New York Evening Mail*, undated review of the exhibition at the Madison Art Galleries in Bellows's scrapbook, Bellows Papers, Amherst College Library.

[41] Robert Henri, *The Art Spirit*, compiled by Margery Ryerson (New York: J.B. Lippincott Company, 1923; paperback ed., New York: Harper and Row, Publishers, Inc., 1984), p. 83.

[42] "News and Notes of the Art World," *New York Times*, January 29, 1911, section 5, p. 15; "Art and Artists," *New York Globe and Commercial Advertiser*, January 27, 1911, p. 8.

[43] J. Nilsen Laurvik, "Significance of the Exhibition of the Pennsylvania Academy...," *New York Times*, January 26, 1908, section x, p. 8; James Gibbons Huneker, "The Winter Academy," *New York Sun*, December 21, 1909, p. 8.

[44] Bellows may very well have been referring to his recently exhibited *New York* when he described his approach to urban landscape subjects in a 1911 interview with Florence Barlow Ruthrauff. *New York* was undoubtedly on view in the studio, along with other paintings. Following her conversation with the artist, Ruthrauff reported: "His sketches are made with notebook and pencil, but which he seldom uses in painting the picture, so graphically is it photographed on his memory. And then, too, while he paints parts of the city he generalizes it so that there will not be a localization. For instance, his Palisades are not of any one spot on the Hudson, but might be any place. So it is with his streets of New York, which portray the life and actuality without being any particular spot." See Ruthrauff's "His Art Shows 'The Big Intention,'" *New York Telegraph*, April 2, 1911, magazine section, p. 2.

[45] "The Spring Academy," *New York Sun*, March 17, 1911, p. 6; "Academicians and Associates Show Excellent Pictures at the Spring Exhibition," *New York Times*, March 19, 1911, magazine section, p. 15.

[46] "Annual Exhibition Carnegie Institute," *Fine Arts Journal* 30 (June 1914), p. 291.

[47] The drawing is listed in Bellows's Record Book, p. 158, as the second of three drawings "for 'Masses.'" Immediately beneath the title, *Why Don't They Go to the Country*, Bellows added the note: "Study for 'Cliff Dwellers' p. 157."

[48] Bellows's first illustrations (since the drawings he made in 1902–03 for the Ohio State University yearbook, *Makio*) appeared in John A. Moroso, "Uncle Bung," *American Magazine* 74 (August 1912): 396–403.

[49] "Sample Sunday Pleasures," *New York Call*, April 20, 1913, p. 8; "New York's Demoralizing Sunday," *Literary Digest* 46 (May 17, 1913): 1129–1130.

[50] Mary Kingbury Simkhovitch, *Neighborhood: My Story of Greenwich House* (New York: W. W. Norton and Company, Inc., 1938), p. 160.

[51] See Peter S. Hales, *Silver Cities: The Photography of American Urbanization, 1839–1915* (Philadelphia: Temple University Press, 1984), especially pp. 192–213, 254–260. Also see Maren Stange, *Symbols of Ideal Life: Social Documentary Photography in America, 1890–1950* (Cambridge and New York: Cambridge University Press, 1989), chapter 1.

[52] Frederick A. King, "Influences in Street Life," *Yearbook of the University Settlement Society of New York, 1900* (New York: Winthrop Press, 1900), 29.

[53] Jacob Riis, *Children of the Tenements* (New York: Macmillan Co., 1903), p. 1.

[54] "The City Child is Handicapped by Restricted Play," *New York Times*, February 23, 1913, section VI, p. 13.

[55] See Cary Goodman, *Choosing Sides: Playground and Street Life on the Lower East Side* (New York: Schoken Books, 1979), p. 16.

[56] From the title of Miriam Finn Scott's article, "At the Bottom," *Everybody's* 27 (October 1912): 536–545.

[57] Lilian Brandt, "In Behalf of the Overcrowded," *Charities* 12 (June 4, 1904): 585.

[58] Francis Hopkinson Smith, *Charcoals of New and Old New York* (Garden City, N.Y.: Doubleday, Page and Company, 1912), p. 43.

[59] Henry McBride, "What's Doing in World of Art, Artists and Art Dealers," *New York Sun*, October 26, 1913, section VII, p. 2.

[60] "The Younger Generation," *New York Times*, October 26, 1913, magazine section, p. 15; Guy Pène du Bois, "Fifteen Young Americans at the Montross Gallery," *Arts and Decoration* 4 (December 1913): 71.

[61] Forbes Watson, "Art Notes," *New York Evening Post*, January 24, 1914, p. 8.

[62] Ibid.

[63] "George Bellows, N.A., Paints 'The Call of the City,'" *New York Sun*, December 26, 1915, section V, p. 7.

[64] "George Bellows' Art Shown at New Gallery," *New York Herald*, December 16, 1915, p. 11.

[65] "The Big Idea: George Bellows Talks About Patriotism for Beauty," *Touchstone* 1 (July 1917): 275.

[66] See Lindsay Denison, "The Rev. Billy Sunday and His War on the Devil," *American Magazine* 64 (September 1907): 450–468. Other prominent nationally circulated stories include: Bruce Barton, "Billy Sunday—Baseball Evangelist," *Collier's* 51 (July 26, 1913): 7–8, 30; "Religion With a Punch," *Nation* 98 (March 19, 1914): 287–288; "Billy Sunday in Big Cities," *Literary Digest* 48 (April 4, 1914): 761–762; Joseph H. Odell, "The Mechanics of Revivalism," *Atlantic Monthly* 115 (May 1915): 585–92; George Creel, "Salvation Circus: An Estimate of Billy Sunday," *Harper's Weekly* 60 (June 19, 1915): 580–582; S. K. Ratcliffe, "The Man Who Is Sunday," *Living Age*

286 (July 3, 1915): 50–54; Francis Hackett, "Billy Sunday, Salesman," *New Republic* 10 (April 28, 1917): 370–372.

[67] On Billy Sunday, see William T. Ellis, *"Billy" Sunday: The Man and His Message* (Philadelphia: John C. Winston Company, 1914); William G. McLoughlin, *Billy Sunday Was His Real Name* (Chicago: University of Chicago Press, 1955); Robert A. Allen, *Billy Sunday: Home Run to Heaven* (Milford, Mich.: Mott Media, 1985).

[68] George Bellows to Joseph Taylor, January 15, 1914, in George Bellows Papers (Box I, Folder 12), Amherst College Library.

[69] "'Billy' Sunday Hits Philadelphia," *Literary Digest* 50 (January 23, 1915): 152.

[70] Quotations from "Sunday's Appeals Win 1,300 Converts," *New York Times*, January 11, 1915, p. 11; "Shouting, Kicking, Slangy 'Billy' Sunday in Action," *New York Times*, January 17, 1915, section V, p. 3.

[71] *Introducing the Champion* was one of four illustrations by Bellows for the story, "The Last Ounce." The drawings were executed in September 1912; they appeared in *American Magazine* in April 1913. See the catalogue, entry 11, by Linda Ayres and Deborah Chotner, in *Bellows: The Boxing Pictures*, exhibition catalogue (Washington, D.C.: National Gallery of Art, 1982), pp. 85–86.

[72] On the exhibition, see "Art Notes: Loan Exhibition of Paintings by El Greco and Goya at Knoedlers," *New York Times*, January 13, 1915, p. 8; "Works of Great Spanish Painters on Exhibition: Remarkable Collection of Masterpieces by El Greco and Goya on View at the Knoedler Galleries for Benefit of War Relief," *New York Times*, January 17, 1915, p. 11. One of the paintings from this exhibition, El Greco's *Christ Driving the Money Changers from the Temple*, was reproduced in Guy Pène du Bois, "Greco, Goya and Velasquez," *Art and Decoration* 5 (March 1915): 181.

[73] Henri, *The Art Spirit*, pp. 100, 267.

[74] The painting was widely reproduced. It was included, for example, in Meier-Graefe's *Spanische Reise*, a book that might have been brought to Bellows's attention by Walter Pach, one of his colleagues and former classmates. Pach called *Spanische Reise* "one of the best books published in 1910" in "New York as an Art Centre," *Harper's Weekly* 54 (February 26, 1910), p. 12.

[75] "The Big Idea," p. 270.

[76] W. H. de B. Nelson, "Springtime at the Academy," *International Studio* 58 (May 1916): xc.

[77] Quotation from "What Dynamic Symmetry Means To Me," *American Art Student* 3 (June 1921): 5.

[78] Marguerite B. Williams, "Bellows' Paintings Prove Startling," *Chicago Daily News*, December 24, 1925, p. 4.

[79] Bruce Bliven, "Arc Lights and Blood: Ringside Notes at the Dempsey-Firpo Fight," *New Republic* 36 (September 26, 1923): 125.

[80] See Randy Roberts, *Jack Dempsey: The Manassa Mauler* (Baton Rouge: Louisiana State University Press, 1979), p. 183. My discussion of Dempsey and boxing in the 1920s draws on Roberts's account and on Sammons, *Beyond the Ring*, chapter 3.

[81] According to the catalogue by Linda Ayres and Deborah Chotner, in *Bellows: The Boxing Pictures*, p. 93, the drawing was never published because of a printers' strike.

[82] Henry McBride, "Dempsey-Firpo Lithograph Attracts Art Collectors," *New York Herald*, February 17, 1924, section 7, p. 13.

[83] Ibid.

[84] James, "What Makes Life Significant," pp. 151, 153.

[85] Henri, *The Art Spirit*, p. 145. I would like to thank Bellows's daughter, Jean Bellows Booth, for permitting me to examine the contents of her father's library.

[86] Bellows's letter published in Emma Bellows, *The Paintings of George Bellows* (New York: Alfred A. Knopf, 1929), p. ix.

[87] "The Big Idea," p. 270; George Bellows, "What Dynamic Symmetry Means to Me," p. 5.

[88] Henry McBride, "George Bellows's Paintings at Durand-Ruel's," *New York Sun*, February 7, 1925, p. 14; H. C., "Last Canvases by Bellows on View," *Art News* 23 (February 7, 1925): 3.

[89] Helen Appleton Read, "Bellows' Last Year's Work; Review of His Career," *Brooklyn Daily Eagle*, February 8, 1925, p. B2.

[90] "Mr. Bellows' Virile Works," *Brooklyn Daily Eagle*, January 31, 1911, p. 9; Ruthrauff, "His Art Shows 'The Big Intention,'" p. 2.

[91] "Art Notes: George Bellows's Paintings in the Whitney-Richards Gallery," *New York Times*, December 21, 1915, p. 12.

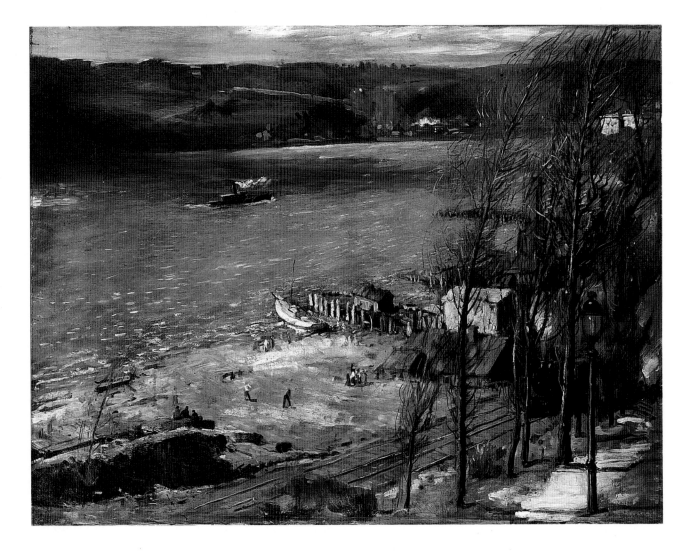

"So Clean and Cold": Bellows and the Sea

FRANKLIN KELLY

If you were with me we could tramp the wild places all day and be alone together again; and sit by the sea in the night wind; and watch the moon lay a silver carpet over the ocean. We could slip over the velvet rocks down at the sea's brink and watch the waves reach for us, and you could laugh at me for being timid and afraid of those crystal green hands . . . which are so clean and cold. And everything I spoke of to you would be about Love and beauty and love again and the greatness of this nature which is in us. We two and the great sea and the mighty rocks greater than the sea and we two greater than the rocks and the sea. Four eternities.

—Bellows to his wife Emma from Monhegan Island, Maine

George Bellows was fascinated by the sea, but he was also frightened of it; at times inescapably attracted to it, he was also repelled by it. With its timeless mystery and power the sea inspired him to create some of his most moving and evocative paintings, but it also frustrated him, reminding him of his own inadequacies as he struggled to capture its essential nature on canvas. Often invigorated by watching the relentless energy of great ocean surges, he could equally be daunted by the sea's vastness, finding his thoughts turned back upon himself and upon doubts and insecurities. Like Melville's Ishmael, who understood that "meditation and water are wedded forever," Bellows came to know the sea as "the image of the ungraspable phantom of life; . . . the key to it all."[1]

That Bellows should be drawn to the sea was not altogether unexpected. Although born in Columbus, Ohio, far from either the Atlantic or the Pacific, he was not, as one early commentator put it, "in a true sense, a product of that state, his people having derived from the Montauk end of Long Island, where his grandfather had been a whaler of renown."[2] Bellows and his family often made summer trips to Sag Harbor, Long Island, where relatives of both his mother and his father still lived, and the boy enjoyed crabbing, swimming, sailing, and other water activities while there.[3] Among his first known artistic efforts were copies of pictures of sailing ships, made when he was ten.[4] Although it would be almost two decades before he would fully grapple with portraying the sea in his art, the seeds that led him to the subject with such energy and tenaciousness were clearly sown in his temperament early on.

When Bellows arrived in New York at the age of twenty-two, resolute in his intentions to succeed as a painter, he quickly embraced the vitality of the city as inspiration for his art. In the early twentieth century the city was, far more than now, closely wedded to the water; Manhattan was, after all, an island, and its commerce largely depended on the ships that called regularly at its docks and piers. The great numbers of European immigrants who so fundamentally transformed the very nature of the city arrived by ship. Although the city had certainly changed from the days of the mid-nineteenth century, Melville's description of it in *Moby-Dick* remained accurate: an "insular city . . . belted round by wharves as Indian isles by coral reefs—commerce surrounds it with her surf. Right and left the streets take you waterward. Its extreme down-town is the Battery, where that noble mole is washed by waves, and cooled by breezes, which a few hours previous were out of sight of land. Look at the crowds of water-gazers there."[5]

As Bellows wandered the streets of New York, keeping in mind his mentor Robert Henri's dictum that "there is beauty in everything if it looks beautiful in your eyes," he found

FIGURE 1
George Bellows. *Up the Hudson*, 1908. Oil on canvas, 35⅞ x 48⅛ in. Metropolitan Museum of Art; gift of Hugo Reisinger, 1911.

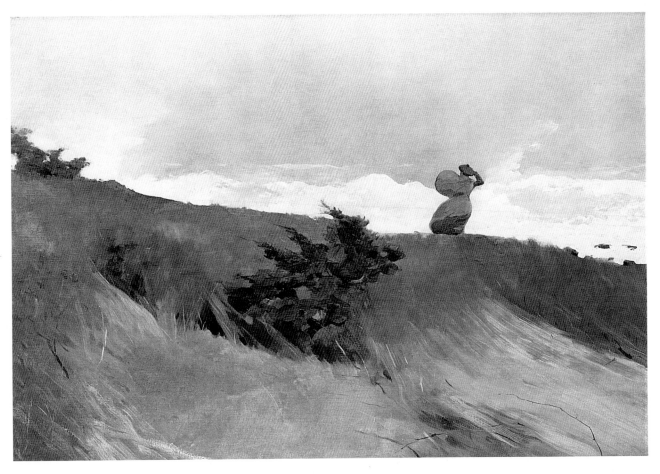

FIGURE 2
Winslow Homer. *The West Wind*, 1891. Oil on canvas, 30 x 44 in. Addison Gallery of American Art,
Phillips Academy, Andover, Massachusetts; gift of anonymous donor.

ample subjects for paintings.[6] Among them were the great excavation at the site of
Pennsylvania Station, the urchins who animated the streets with their innocent and not-
so-innocent games, and the smoky rooms of boxing clubs. But again and again Bellows
found that the streets took him "waterward," and over and over one finds in his early works
the assertive presence of water. In works such as *River Rats* of 1906 and *Forty-Two Kids* of
the following year, he showed children frolicking in the waters of New York's rivers. For
the next few years Bellows found ample inspiration in the rugged river banks of the city,
painting the scene in snow (*North River* [see page 14] and *Up the Hudson* [fig. 1] of 1908), in
rain (*Rain on the River* [1908, see page 16]), and on one memorable occasion (*Floating Ice*
[1910, see page 27]) showing the great river clogged with ice floes.

 The artistic progress revealed in Bellows's early New York pictures was astonishing.
He had quickly absorbed Henri's slashing brushstroke and transformed it into a handling
all his own, one characterized by stronger colors and greater compositional energy and
dynamism. And although the young painter had not yet tried his hand at painting the
sea, he had already begun to look at and understand the works of Winslow Homer. Critics
were soon commenting on the similarities between the two artists. In 1908 Bellows's *North
River* was on view at the National Academy of Design, as was Homer's *The West Wind* of
1891 (fig. 2), and the critic for the *Times* compared the two. Noting in Homer's painting
"force and freshness driven home in an unexpectedly exhilarating fashion," he found in
Bellows's canvas a comparably "rugged and almost startling reality" and concluded, "In its
truthfulness of observation and in its painter-like qualities, this is the best piece of work
produced by this young man so far."[7] Two years later the English critic C. Lewis Hind,
reviewing an exhibition of American paintings in Germany, found "signs of a national
American art" in the works of Homer and Bellows.[8] After discussing Homer's paintings,
which he found "characteristically, spiritually as well as physically, American," he turned to

Bellows's *The Bridge, Blackwell's Island* (see page 25). Hind wrote: "Something of Winslow Homer's force I find in the work of George Bellows, in his *Bridge* arching the indigo water, rough, frank, original, true, a large sketch, a quick impression that has been left as seen, not worried into an exhibition picture."[9]

It is important to understand just what these observers found similar in the works of Homer and Bellows in order to appreciate the latter's full achievements as a painter of the sea. Both were praised for their "truthfulness" and "freshness," for their ability to be "exhilarating" and "startling," for being "rough, frank, original," and, perhaps most importantly, for portraying "force."[10] Yet both men combined with their skills at depicting the world a strong feeling for abstract design and painterliness (or what the *Times* critic called "painter-like qualities"). Their paintings were assertive not only because they depicted scenes brimming with natural and man-made energy, but also because the canvases themselves were alive with artistic energy and purpose. No one looking at a picture like Homer's *West Point, Prout's Neck* (fig. 3) or, even more, at one of Bellows's dynamic works of 1908–10, such as *Polo at Lakewood* (see page 28), could fail to be reminded by the aggressive compositional rhythms and richly applied paint that these were records of artistic process as much as they were records of external reality. And it is that underlying awareness of powerful artistic personality—on the one hand of an aging, reclusive "old master" and, on the other, of a gifted and brashly confident young painter—that ultimately binds the works of the two men together most profoundly. Homer was a nineteenth-century artist who managed, as very few of his generation did, to paint pictures in the twentieth century that both summed up what had gone before and embraced the future with a spirit of innovation. Bellows was a twentieth-century artist who, like equally few of his generation, managed to absorb the lessons of the past and transform them into a personal and fully modern idiom.

Homer died on September 29, 1910. The papers were full of notices lamenting the loss of the man many considered America's greatest painter, and his passing was the subject of much discussion in artistic circles. Surely Bellows was aware of Homer's death, for we know he greatly admired the painter he once called his "particular pet."[11] But we have no record of what he might have said, or felt, at the time, and his mind was undoubtedly preoccupied with another, more personal, matter. The previous spring, after years of frustrating courtship, Bellows had finally convinced Emma Story to marry him. He had also

FIGURE 3
Winslow Homer. *West Point, Prout's Neck*, 1900. Oil on canvas, 30 1/16 x 48 1/8 in. Sterling and Francine Clark Art Institute, Williamstown, Massachusetts.

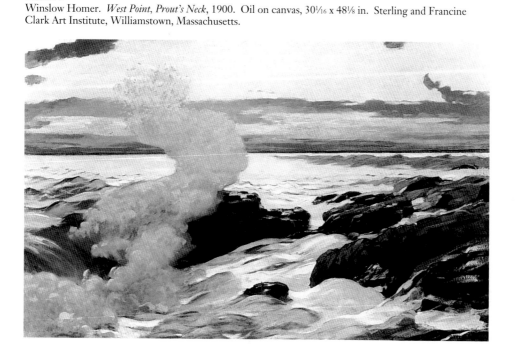

accepted a new appointment as life class instructor at the Art Students League for a salary of one thousand dollars a year. He and Emma were busy during the summer of 1910 preparing for their life together, and on September 23, they were married. That night they took a train to Montauk, Long Island, the former haunts of Bellows's grandfather the whaler. It would be there that Bellows, in addition to beginning life as a married man, at last took up the challenge of painting the sea.

In 1910 Montauk was still a remote and isolated place, with some of the most rugged and dramatic landscapes and coastal views anywhere within a day of New York City. As one visitor noted: "tourists . . . find especial charms in its seclusion, and in the bold and picturesque scenery of its defiant promontory, upon which the wild Atlantic incessantly beats, and sometimes with tremendous violence."[12] While there the newlyweds stayed in a boardinghouse and toured the area by day. Bellows sketched and painted at least one small oil, *Montauk Light and Point* (private collection) during the time they stayed at Montauk.[13]

FIGURE 4
George Bellows. *Shore House*, 1911. Oil on canvas, 40 x 42 in. Collection of Rita and Daniel Fraad.

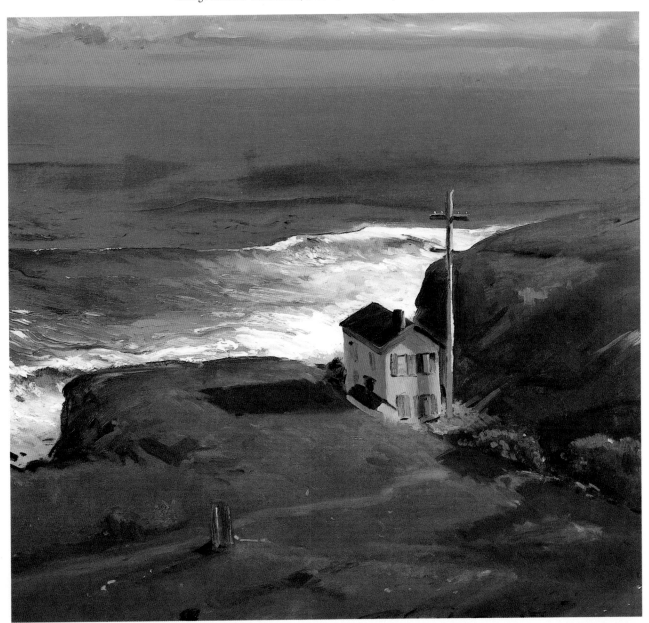

But the most important painting to result from the experience, and Bellows's first great painting of the sea, was *Shore House* (fig. 4), which would not be completed until several months later.

According to Bellows's record book, *Shore House* was "Painted from Montauk sketch Jan. 1911."[14] Compared to earlier paintings, with their generally dynamic and energetic compositions, *Shore House* has a remarkable quality of calm and reductive monumentality. Even paintings that immediately preceded it are much more visually active, although the composition of one of these, *Blue Snow, the Battery* (see page 31) does offer some comparison to *Shore House*. It would seem, then, that as Bellows turned to painting the sea, he realized that the compositional schemes he had employed so successfully in capturing the rhythms of New York would not necessarily serve these new ends. Bellows constantly experimented with his paintings; as he once said, "There is no new thing proposed, relating to my art as a painter of easel pictures, that I will not consider."[15] In coming to terms with painting the sea, it is clear that Bellows turned to the art of other men for guidance and inspiration.

There were, of course, many potential sources of inspiration for anyone interested in painting the sea. Painters had been portraying the sea for centuries, and in America a rich tradition of marine painting had developed during the nineteenth century.[16] Bellows, although doubtless aware of earlier renderings of the sea, was most influenced by more immediate sources. His teacher, Robert Henri, had been to Monhegan Island, Maine, in the summer of 1903 and painted a number of impressive seascapes. In April 1910 Bellows had seen and admired one of the older man's paintings: "Henri . . . has an ocean which has the wonder of the sea in it. The Terror and what is the sea if it isn't terrible."[17] Henri, in turn, openly admitted his admiration for Winslow Homer. As he once wrote: "Look at a Homer seascape. There is order in it and grand formation. It produces on your mind the whole vastness of the sea, a vastness as impressive and uncontrollable as the sea itself. You are made to feel the force of the sea, the resistance of the rock; the whole thing is an integrity of nature."[18] If one compares a Henri seascape such as *Marine—Storm Sea* (fig. 5) to Homer's *On a Lee Shore* (fig. 6), Henri's attempt to emulate the older artist is obvious, even if not altogether successful. Although Homer's grasp of the "integrity of nature" was powerfully inspiring to Henri, the latter was not, in the end, much disposed toward painting the sea. Instead, his pupil would most directly learn from Homer's example and use those lessons to create his own powerful marine paintings.

Critics were quick to recognize that in *Shore House* Bellows had achieved something well worthy of comparison with

FIGURE 5
Robert Henri. *Marine—Storm Sea*, 1911. Oil on panel, 11¾ x 15 in. Collection of Bernard G. Roer.

FIGURE 6
Winslow Homer. *On a Lee Shore*, 1900. Oil on canvas, 39 x 39 in. Museum of Art, Rhode Island School of Design, Providence; Jesse Metcalf Fund.

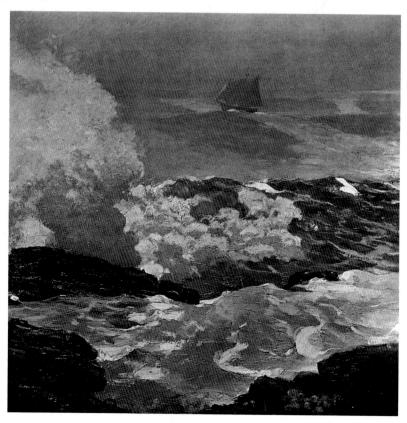

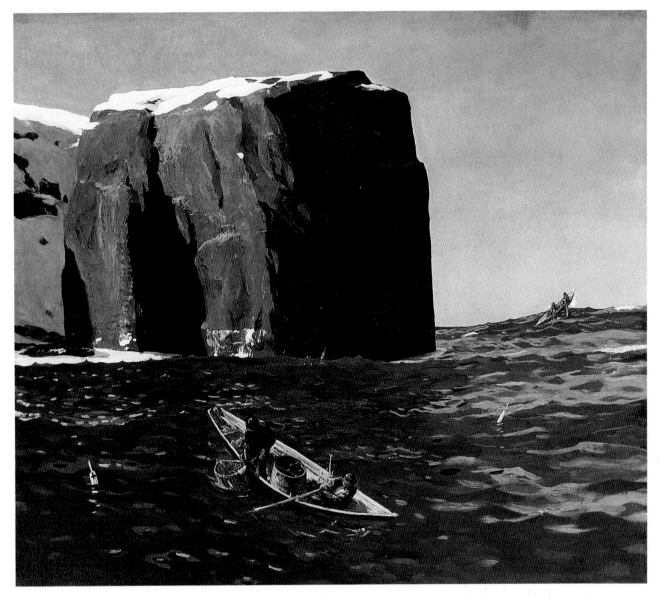

FIGURE 7
Rockwell Kent. *Toilers of the Sea*, 1907. Oil on canvas, 38 x 44 in. New Britain Museum of American Art, Connecticut; Charles F. Smith Fund. Photograph by E. Irving Blomstrann.

Homer. As one observed, he had arrived "at mastery by simple means in the 'Shore House,' a square house . . . with a massive blue sea beyond as gaunt and dignified in arrangement as a Winslow Homer."[19] Another critic writing later was even more complimentary: "'Shore House' . . . strikes a note of stark maritime beauty. This seems a sea more stirringly real than most of the seas (in oil) from Homer's brush."[20] The overall conception of *Shore House* reveals that Bellows had learned far more from Homer than just how to paint the ocean. In his late seascapes such as *On a Lee Shore*, Homer had reduced his compositional elements to a minimum, concentrating their effect powerfully. *Shore House* essentially reinterprets Homer's pictorial language, with broadly simplified planes of land and sea, the single motif of the house, and the flattening of space. Bellows also used a nearly square format, as had Homer in a few works such as *On a Lee Shore* and *Cannon Rock* (1895, Metropolitan Museum of Art). In American art of the late nineteenth and early twentieth centuries, the square format, with its compositional dynamics tending to work against illusionism and drawing the viewer's eye to the flatness of the picture plane, represented a conscious expression of aesthetic modernism.[21] Thus Bellows, far more than Henri, had grasped the full aesthetic implications of Homer's art and used them to help give his sea paintings a currency of modernism appropriate to his own day.

Homer was not, however, the only source of inspiration for Bellows, who also learned much from the work of his former classmate Rockwell Kent.[22] Kent was equally devoted to the works of Homer, as he had demonstrated in a series of powerful landscapes and seascapes of Monhegan, including *Toilers of the Sea* (fig. 7) and *Winter – Monhegan Island* (fig. 8), which were shown in New York in 1907. Kent's starkly simplified paintings portrayed the dramatic and rugged natural scenery of the island with bold, large forms and strong contrasts of light and dark.[23] Bellows saw the exhibition and "feasted his eyes long and enviously on these pictures, vowing that someday he would go to Monhegan himself and do better ones."[24] Even before Bellows made good on that vow, he demonstrated in paintings such as *Blue Snow, the Battery* and *Shore House* that he had grasped the potential Kent's art held for his own work.

These various sources of influence may tell us something about Bellows's pictorial achievement in *Shore House*, but the far more challenging question of meaning remains. Bellows has often been dismissed as little more than a pure painter, a realist who captured the essence and appearance of his subjects but did little to reveal any deeper meaning or significance. A work such as *Shore House* suggests that such assertions are not, in fact, valid, for it has an undeniable mood of evocative mystery that hints at meanings beyond the obvious. Bellows himself believed that learning to draw or paint was "an easy matter," but

FIGURE 8
Rockwell Kent. *Winter – Monhegan Island*, 1907. Oil on canvas, 33⅞ x 44 in. Metropolitan Museum of Art, New York; George A. Hearn Fund, 1917.

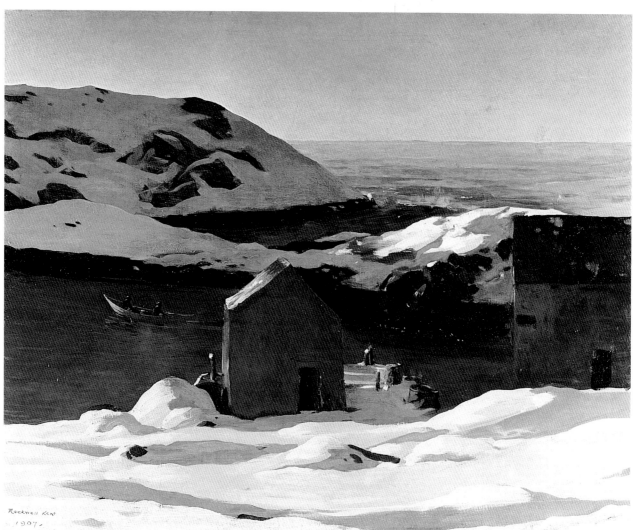

"to say anything you must have ideas." "Drawing and painting," he observed, "is a language. You can be great or small, glad or sad, in its use according to what you have to say."[25] To understand what Bellows had to say in *Shore House*, and in many subsequent images of the sea, we must keep in mind his admonition that "a picture is a human document of the artist."[26] In the intersection of the broad associations evoked by the sea—one of the great archetypal images in mankind's consciousness—with the personal meanings it held for Bellows himself, lie the most profound levels of meaning in his marine paintings.

Over the centuries the attitude of Western man towards the sea has shifted and changed many times.[27] Although these changes and shifts were the result of complex and sometimes conflicting events and circumstances that cannot be subjected to generalization, certain broad observations are useful. For much of antiquity and into the Middle Ages the sea represented chaos, and the land, inhabited and settled by man, represented stability and order. Gradually there evolved an image of the sea as the embodiment of purity in contrast to the corruption of life on land, a concept that fully emerged in the romantic era. Although a lingering fear of the sea recurs, the theme of redemption at sea and the voyage to knowledge led to more positive connotations. As W. H. Auden has observed: "The sea is where the decisive events, the moments of eternal choice, of temptation, fall, and redemption occur. The shore life is always trivial."[28]

In America the close association of national character and the sea was most clearly expressed in sea fiction, which saw its greatest flowering in the middle of the nineteenth century.[29] With the passing of the great age of sail and the growth of industrialism there was a waning of literary interest in the sea, but it had by no means died out in the late nineteenth and early twentieth centuries. Indeed, those years saw the creation of some of the masterpieces of the genre, such as Stephen Crane's "The Open Boat" and Jack London's *The Sea Wolf*—dramas that revealed personal meaning through individual confrontation with the elements. The sea no longer was seen as holding clear or certain meaning, but rather as embodying a host of possibilities, many of them ambiguous. Like so much else in the modern era, it had taken on an elusive and enigmatic character that changed according to the personality and condition of the person observing it. As Bellows painted the sea over the course of the teens, his greatest challenge would be to capture the way it expressed some of his strongest and most powerful feelings and sensations in paintings that transcended mere personal interest.

As we have seen, the circumstances behind Bellows's creation of *Shore House* were his marriage and honeymoon, events that surely colored his perception of the sea and, in turn, his portrayal of it in this particular "human document."[30] As he entered the state of matrimony and began to face the prospects of beginning a family, Bellows had come to a turning point in his life. Gradually he would face the inevitable process of emotional separation from his parents, especially from his adored and adoring mother. Although he had not lived with his parents for almost a decade, he also had not, during his years as a bachelor artist, established anything approaching domesticity. Now, however, he and Emma had purchased a house in New York (with money given to them as a wedding present by Bellows's father), and he had worked busily in the time before the wedding to ready it. Although the house in *Shore House* was remote in place and spirit from their New York home, its simple monumentality and quiet expression of strength and stability as it sits at the edge of the sea suggest that, for Bellows, it may have been a personal symbol of his union with Emma and of their future together.[31] This was, after all, a house situated in the very land of his own forefathers, a reminder of his own origins.

In finding this kind of meaning for *Shore House*, in associating it with the artist's feelings about home and family, past, present, and future, we must also not overlook the fact that the painting contains an underlying current of mystery, uncertainty, and even loneliness. Bellows, although undoubtedly happy about his marriage and unquestionably in love with Emma, must also have been beset by the doubts and questions that face anyone about to begin a new and a very different life. *Shore House* was created by an artist who knew that he had come to a crossroads in his life and who was fully aware of the ultimate uncertainty of life itself. And it is of particular significance in this context that he chose to express those concerns in an image of the sea. In this first great painting of the sea Bellows presented no

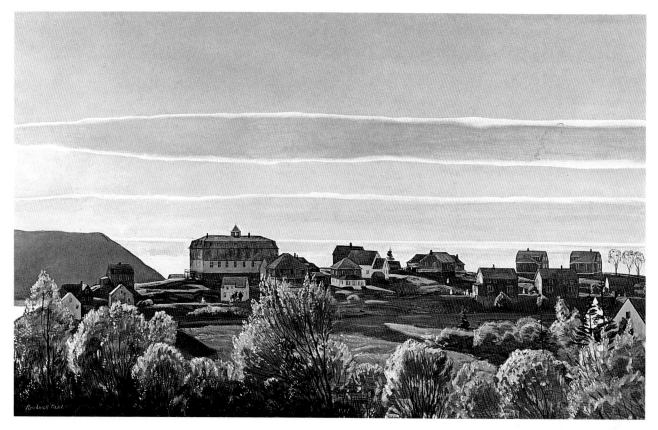

FIGURE 9
Rockwell Kent. *Monhegan, Maine*, c. 1907. Oil on canvas, 28 x 44 in. Colby College Museum of Art, Waterville, Maine; gift of Mr. Corliss Lamont.

single, clear-cut, and easily definable meaning. Instead, he brought forth something profoundly and deeply evocative. Similar elements of mystery, uncertainty, and ambiguity would resonate in many of Bellows's greatest images of the sea over the course of the next few years, and in perhaps no other area of his art would he so consistently, and so movingly, express complex and multilayered levels of meaning.

In July 1911, with Emma expecting their first child, Bellows found himself concerned about her health, generally worried—and unable to paint.[32] When Henri suggested that Bellows join him and another young painter, Randall Davey, on Monhegan Island, Bellows (with Emma's blessing) immediately agreed. It was his first sustained encounter with painting the sea. Over the next four weeks he worked with tremendous energy, painting during the day and writing to Emma almost every night. These letters are important keys to understanding him and his work; as his biographer has noted (perhaps unconsciously putting it in a way that evokes the sea), they are "penetrating documents for the study of the emotional tides that govern an artist's life."[33] Even though often preoccupied by how much he missed his wife, and worried about her and the coming baby, Bellows exulted in the dramatic scenery on the island. Lying about twenty miles off the mainland, Monhegan is about two and a half miles long and one mile wide. In 1911 it was only sparsely populated, with a small fishing village located beside a natural harbor (fig. 9). Most of the locals fished for their livelihood, and they were generally hospitable to the artists who came to paint the island's scenery.

Bellows's letters to Emma are full of enthusiasm for the sites he was visiting and painting. As he wrote soon after arriving: "This is the most wonderful country ever modeled by the hand of the master architect."[34] He marvelled that an island so small could contain such extraordinary terrain that it seemed as large as the Rocky Mountains and three times as high as Montauk.[35] At one point he suggested that Emma accompany him back to the island the following summer for a second honeymoon "to beat number one."[36] But often loneliness and depression entered his thoughts; contemplating the sea filled him with moodiness and led to speculations about the eternal mysteries of life (as in the quote at the

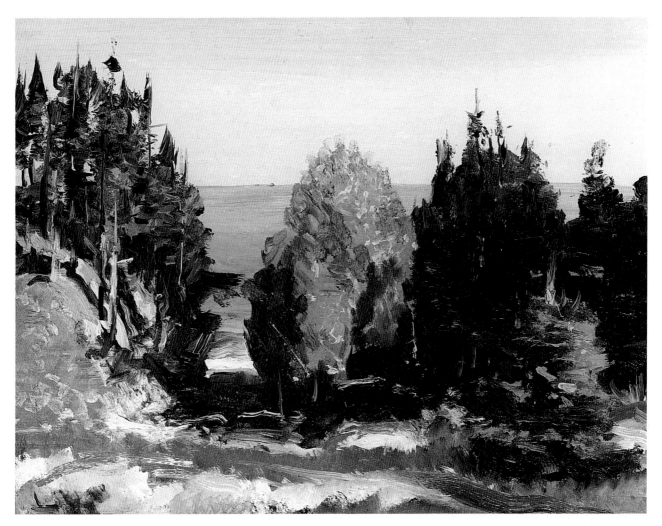

FIGURE 10
George Bellows. *The Grove – Monhegan*, 1911. Oil on panel, 14¼ x 18⅞ in. Museum of Fine Arts, Houston; Wintermann Collection of American Art, gift of Mr. and Mrs. David R. Wintermann.

beginning of this essay). One letter was so despondent that Emma refused to keep it.[37] In another he mentioned "feeling a wild spirit of adventure, but with thoughtful care of myself. … When I remembered my wife and child I got none too close to the edge of the precipitous precipice."[38] The edge of the precipice was very close indeed, and his mind turned to dangerous musing: "I climbed into the Lair of the sea eagle where human foot had never trod, and then what do you think happened? I lay on the ledge for a while in some soft long grass watching the clouds above and the mighty sea far below, when suddenly the thought got into my head: suppose that—and just as suddenly I arose and clim[b]ed out again."

In spite of his fluctuating mood, Bellows maintained a remarkable pace of painting. "I feel a great pride in working so hard in getting strong and stronger," he wrote; "Im being browned by the sun and hardened by work. And it all has such a wonderful meaning."[39] Once, using a word with double meaning, he wrote that he was "drowned in work."[40] He kept Emma posted on his progress, and by the end he could proudly report his achievements: "12 pictures, 30 panels now in 3 weeks. Not mentioning what I scraped out."[41] As Bellows's tally indicates, most of his works executed on Monhegan were small panels, but only a few of these (such as *The Grove – Monhegan*, fig. 10) are securely identified today. Many of his larger paintings, such as *Gorge and Sea* (fig. 11), are characterized by a free and vigorous handling that suggests they were executed quickly, much like a sketch. But, as he told Emma, "Don't imagine that because I am painting so much that they are only slight sketches. They are beauts and complete or will be made so easily."[42]

On one occasion Bellows painted a work that he recognized immediately as different and special, and he gave Emma his unqualified opinion of it: "Well Dear Sweetheart. I

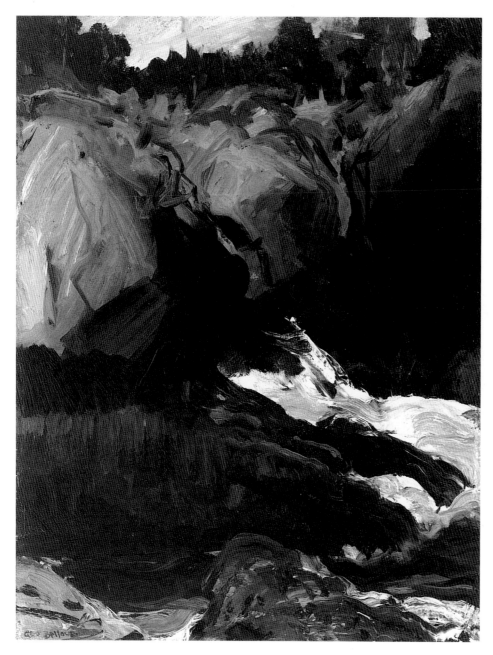

painted a real sure enough masterpiece today which walks up to The Shore House and says Hello Kid. I'm with you. It's 'An Island in the Sea.' Mrs. H[enri] . . . called it the 'picture of the year.' Bob is with his wife on the subject."[43] Emma replied: "Such a wonderful and poetic name that I long to see the picture that is such a corker."[44] The picture in question is one of Bellows's most remarkable creations.

 An Island in the Sea (fig. 12) shows the islet of Manana, which lies immediately adjacent to Monhegan. Similar in appearance to Monhegan, Manana is clearly visible in the background of Rockwell Kent's *Winter – Monhegan Island* (see fig. 8); it may also be seen in the distance of Bellows's *Harbor at Monhegan* (see page 53). *An Island in the Sea*, however, shows little of its everyday reality. It looms dark and large in an undefined space, seemingly adrift somewhere between the greenish-grey sea and an overcast sky. A broad band of white light radiates from the sky and reflects on the water but does not illuminate the dark recesses of the island itself. Man's presence is only minimally suggested by a small house and two boats. A mood of mysterious loneliness permeates the scene, and the island seems almost to exist outside of time.[45]

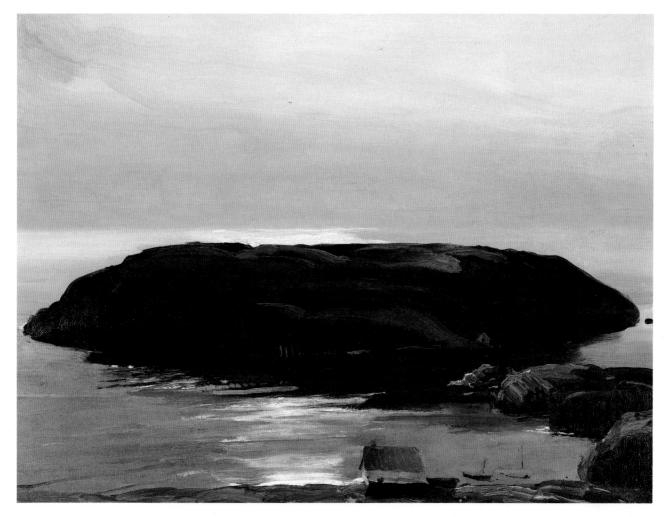

Figure 12
George Bellows. *An Island in the Sea*, 1911. Oil on canvas, 34¼ x 44⅜ in. Columbus Museum of Art, Ohio; gift of Howard B. Monett.

An Island in the Sea is such an unusual work in Bellows's oeuvre that it might seem altogether anomalous. We should, however, keep in mind that Bellows was particularly pleased with this painting and considered it closely related to at least one other work, *Shore House*. Clearly, he was once again exploring the themes he had presented in the earlier painting; even the title, as Emma sensed, gave it an evocative resonance. If it is correct to read *Shore House* as expressive of life's mysteries and uncertainties and indicative of Bellows's state of mind, then similar content may be discerned in *An Island in the Sea*. As we have seen, while on Monhegan Bellows's mind was full of thoughts about life and death, love and eternity. Studying the ocean excited and energized him on some occasions and frightened him on others. Reading his letters, one gains a clear impression of an artist who did not simply paint what he saw with detached realism (if there could indeed be such a thing). He thought deeply and profoundly about what he was capturing in paint and was often struck by its "wonderful meaning." And more than once, contemplating that "wonderful meaning" led his thoughts to the fundamental uncertainties of life; he imagined himself with Emma staring out at the sea, and willfully stated that the two of them, even though tiny and insignificant compared to the sea and rocks, were equally "eternities" because of their love. But repeatedly, as Bellows sought to fix himself and his life in eternity, he would once more be cast adrift. He spent one "cold grey day . . . walking around in a dream doing nothing . . . [it was] deadly."[46] Or, staring at "the clouds above and the mighty sea below" from the edge of a dangerous precipice, he was so overcome that for a moment he contemplated the unthinkable. If the experience of his honeymoon and the sight of a desolate house perched by the wild Atlantic had earlier moved him to introspective contemplation, the intensity of

FIGURE 13
Rockwell Kent. *Afternoon on the Sea, Monhegan*, 1907. Oil on canvas, 34 x 44 in. Private collection.
Photograph courtesy of the Fine Arts Museums of San Francisco.

his experiences on Monhegan turned his thoughts even more profoundly inward. *An Island in the Sea*, more than any other single work in Bellows's art, gives us the mystery of the sea, the sea as "the image of the ungraspable phantom of life."

 There are few obvious precedents in American art for this painting. Bellows probably knew Kent's *Afternoon on the Sea, Monhegan* (fig. 13), which is similar in composition but utterly different in feeling. Closer in spirit is Homer's *Cape Trinity, Saguenay River* (fig. 14), which has been described as "less a view than a vision, saturated by its ominous forms and

FIGURE 14
Winslow Homer. *Cape Trinity, Saguenay River*, c. 1904–07. Oil on canvas, 28½ x 48 in.
Regis Collection, Minneapolis, Minnesota.

FIGURE 15
Arnold Böcklin. *Island of the Dead*,
1880. Oil on panel, 29 x 48 in.
Metropolitan Museum of Art,
New York; Reisinger Fund, 1926.

eery blackness with the immanence and imminence of death."[47] Both Homer's and Bellows's visions bring to mind the Swiss-German painter Arnold Böcklin's famous series of paintings depicting *Island of the Dead* (fig. 15), one of which was described by its creator as "a picture for dreaming about."[48] Although we cannot say with certainty that Bellows knew such paintings, he was surely aware of the Symbolist themes that informed so many European and American paintings of the late nineteenth and early twentieth centuries. To be sure, seascape (and landscape) was a relatively limited part of Symbolist painting,[49] but the mysterious sea was a recurrent subject for many artists who worked within the Symbolist vocabulary. Bellows had no need of supernatural figures like mermaids; such was the power of his imaginative vision that the facts of the scene that lay before him were transformed on canvas into something of great beauty and evocativeness.

FIGURE 16
George Bellows. *Evening Swell*, 1911. Oil on canvas, 30 x 38 in. Berry-Hill Galleries, New York.

In the end, no easily or precisely identifiable meaning is asserted. Perhaps, when we recall the ebb and flow of the "emotional tides" of Bellows's life while on Monhegan, we should not expect the image to be completely decipherable. Instead, there is, to use Melville's words, "one knows not what sweet mystery about this sea, whose gently awful stirrings seem to speak of some hidden soul beneath for here, millions of mixed shades and shadows, drowned dreams, somnambulisms, reveries; all that we call lives and souls, lie dreaming"[50]

Bellows returned to New York and to Emma just in time for the birth of their first child, Anne, on September 8, 1911. During the fall he used his Monhegan sketches as the inspiration for four large canvases: *Evening Swell*, *The Sea*, *Three Rollers*, and *The Rich Woods*. These four canvases were summaries of the different types of scenery that had so enthralled him on the island. *Evening Swell*

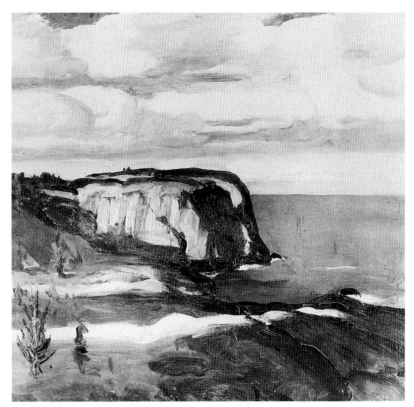

FIGURE 17
George Bellows. *Three Rollers*, 1911. Oil on canvas, 39⅝ x 41¾ in. National Academy of Design, New York.

(fig. 16), which strongly recalls Kent's *Toilers of the Sea* (see fig. 7),[51] presents a view from low on the shoreline, looking across waves toward a massive dark cliff that rises almost to the very top of the picture. Two watermen are seen in a small boat just cresting a wave. *Three Rollers* (fig. 17) shows a similar scene from a different vantage point, with the artist/viewer now on a hill looking across a much greater expanse of land and sea. Reminiscent of Homer's *Summer Squall* (fig. 18),[52] *The Sea* (fig. 19) takes a smaller central motif, a dark rock just rising above the sea with waves breaking over it, and sets it against a vast backdrop of ocean and a brooding sky. In the far left distance smoke rises from the tiny funnel of a ship, which, like the sailboat in Homer's *Summer Squall*, helps establish the immensity of the scene. But Bellows's painting is darker and more brooding, a vision of primeval power and force that is subtly yet undeniably threatening. In contrast, *The Rich Woods* (unlocated) portrays the majestic beauty of Monhegan's forests (see fig. 10), where Bellows had sketched with Henri and Davey on several occasions.[53]

These paintings, or at least the three that we may judge today, are remarkable for their powerful compositions, dramatic juxtapositions of light and dark, and boldly expressive brushwork. Although a work such as *Three Rollers* might recall Henri's advice to use large and simple forms, or seem to capture the majesty of the scene in a way that suggests Homer, it is unmistakably Bellows's creation. Once again employing a square format (as in *Shore House*), he used great, rough sweeps of a loaded brush to lay in the contours of hills, rocks, waves, and clouds. Even though intelligible to the viewer as a depiction of a place, *Three Rollers* is ultimately just as much about the application of pigment to canvas and about the artistic personality that lay behind it.[54] *Evening Swell* and *The Sea* are equally impressive for their seemingly unrestrained, but in fact perfectly controlled handling.[55] In no other

FIGURE 18
Winslow Homer. *Summer Squall*, 1904. Oil on canvas, 24¼ x 30¼ in. Sterling and Francine Clark Art Institute, Williamstown, Massachusetts.

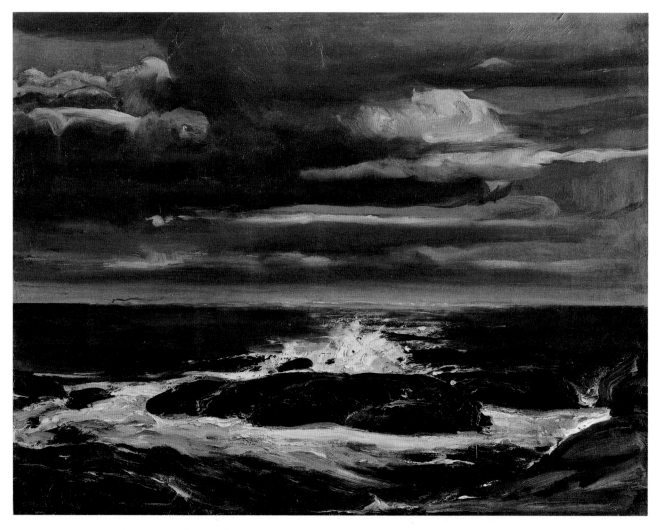

FIGURE 19
George Bellows. *The Sea*, 1911. Oil on canvas, 34 x 44⅛ in. Hirshhorn Museum and Sculpture Garden, Smithsonian Institution, Washington, D.C.; Joseph H. Hirshhorn Foundation.

subject at this point in his career had Bellows pushed the possibilities of the medium so far and with such success. His confrontation with the sea had led him to move beyond his earlier style to something that was potentially even more powerfully effective.

In the winter of 1911–12 Bellows returned to painting familiar subjects drawn from city life. Works such as *Snow Dumpers* (see page 36), while recalling earlier prototypes such as *The Bridge, Blackwell's Island* (see page 25), are also informed by the powerful pictorial structure first evident in his finished Monhegan pictures. Bellows also once again found himself drawn to the New York waterfront, which provided the subject for one of his greatest paintings, *Men of the Docks* (see page 37). The urban characters of the foreground and buildings in the distance clearly establish that this is a city scene far removed from the coast of Maine, but the pronounced contrasts of light and dark, emphatic brushwork, and bold juxtapositions of forms speak once again of the lessons Bellows had learned from painting the sea. And the looming shape of the great ocean-going freighter that closes the right side of the composition reminds us that the sea was never, after all, very far away from Bellows's experience.

Bellows wanted to return to Monhegan during the summer of 1912, but his wife balked at the idea. No doubt she had many reasons for not wanting to go, but one of them seems to have been a fear of the water, perhaps intensified by the sinking of the *Titanic*, with the loss of over fifteen hundred lives, in April 1912.[56] Emma had never learned how to swim, even though Bellows, himself a strong swimmer, had offered to teach her.[57] So part of that summer was spent far from the sea in the Catskill Mountains. Bellows, not greatly

moved by the scenery that had inspired
so many other painters, only managed to
complete ten small landscapes. When they
returned to the city he was busy during
the fall and winter helping with plans for
the Armory Show. Five of his paintings—
including *Crowd, Polo Game* (1910, collec-
tion of Mrs. John Hay Whitney), *The Circus*
(see page 41), and *Mrs. Albert M. Miller* (see
page 191)—and eight drawings were to be
included. When the exhibition opened in
February 1913, Bellows, like virtually every
other American artist who saw the works of
the European modernists, was profoundly
affected.

Unlike many of his older or more
conservative colleagues, Bellows did not
dismiss outright the innovative works of
such artists as Picasso and Matisse. Seeing

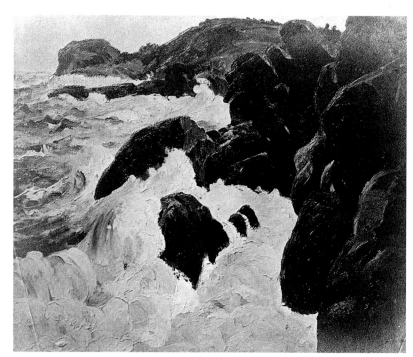

the works of Renoir (whom he especially admired) and the Fauve canvases of such painters
as Matisse and André Derain was a startling revelation, even though Bellows already had a
love of strong colors.[58] He was eager to integrate the lessons from the Armory Show into
his own work and wanted to return to familiar territory for inspiration.

This time he convinced Emma to go to Monhegan with him for the summer and fall
of 1913. It would be one of the most creative and energetic periods of his career, with a final
tally of well over one hundred works.[59] As in 1911, Bellows roamed throughout the island,

FIGURE 20
Leon Kroll. *Maine, Rocks and Sea*,
1913. Oil on canvas, 25 x 30 in.
Location unknown. In *Leon Kroll,
A Spoken Memoir*, edited by
Nancy Hale and Fredson Bowers
(Charlottesville: University Press
of Virginia for the University of
Virginia Art Museum, 1983).

FIGURE 21
George Bellows. *Churn and Break*, 1913. Oil on panel, 17¾ x 22 in. Columbus Museum of Art, Ohio;
gift of Mrs. Edward Powell.

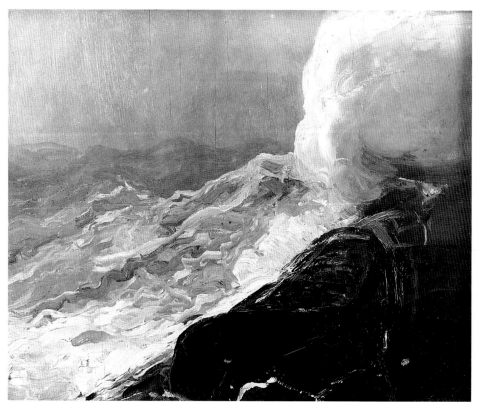

and on one occasion he and Emma visited the nearby island of Matinicus and spent the night in a fisherman's house.[60] At times Bellows's painting even outpaced his ability to obtain supplies, and he had to borrow paints from Leon Kroll, who was also on the island that summer and spent much of his time with the Bellows family. Kroll had been equally inspired by the Armory Show (fig. 20), and he encouraged Bellows in his new experiments with color.

Although we lack any documentation comparable to the letters Bellows wrote his wife from Monhegan in 1911, there is some evidence that in 1913 he had not fully resolved his conflicting feelings about the sea. At one point, in a letter to Henri, he complained about "that hag of a sea" and its "insidious feminine seductions."[61] Generally, however, Bellows seems to have been pleased with what he was accomplishing that summer. Just before leaving the island at the end of October, he wrote to Henri: "I have taken a peculiar pleasure in the contemplation of trotting out all my pictures for your inspection."[62] He was also contemplating "trotting out" his pictures for public inspection, and he wrote to William Macbeth from the island suggesting an exhibition. "I am painting on panels 15 x 20 and getting some very complete pictures which are a decided departure on my part in color. I am delighted with some of them. . . . These panels are twice as big as the old ones and a long way removed from quick sketches."[63] The exhibition at Macbeth's did not materialize, but Bellows did have a one-man show of twenty-seven paintings, mostly Monhegan subjects, at the Montross Gallery in January of 1914.[64]

FIGURE 22
George Bellows. *Beating Out to Sea*, 1913. Oil on panel, 15½ x 20 in.
William A. Farnsworth Library and Art Museum, Rockland, Maine.

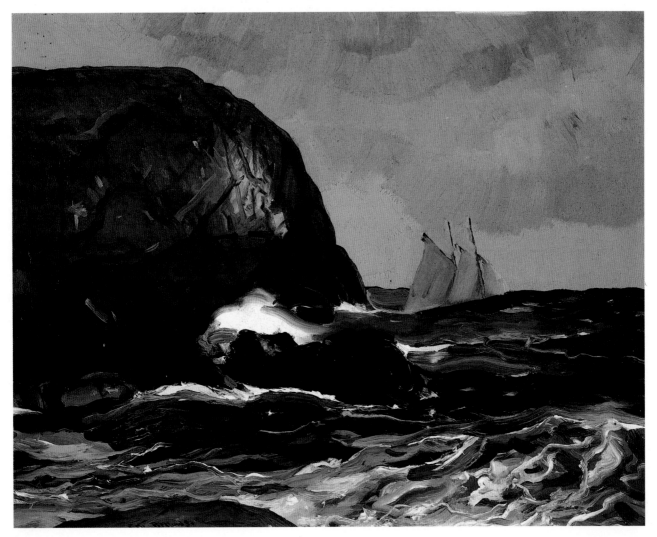

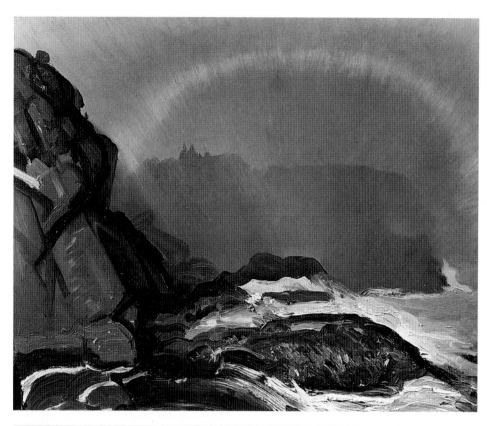

FIGURE 23
George Bellows. *Fog Rainbow*,
1913. Oil on panel, 18 x 22 in.
Berry-Hill Galleries, New York.

FIGURE 24
George Bellows. *Monhegan Island*,
1913. Oil on panel, 18 x 22 in.
Worcester Art Museum; gift of
Mrs. Janet Morgan and her
children in memory of Charles H.
Morgan.

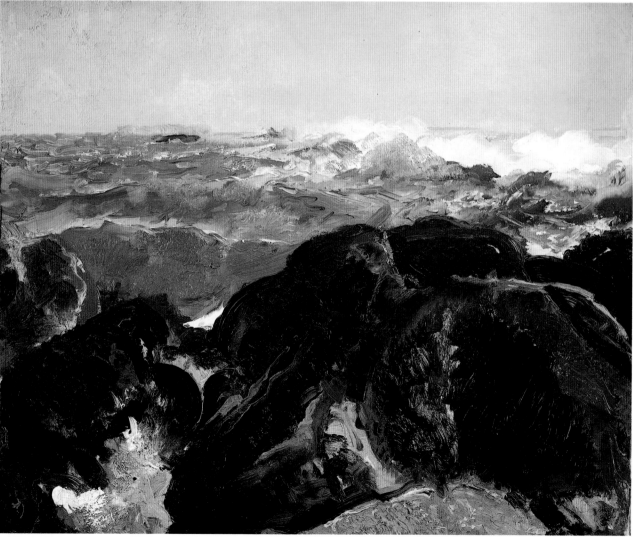

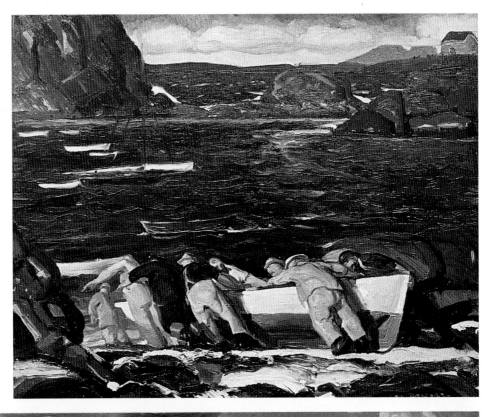

Figure 25
George Bellows. *Launching*, 1913.
Oil on panel, 18 x 22 in. Reading
Public Museum and Art Gallery,
Reading, Pennsylvania; Mengel
Memorial Fund purchase.

Figure 26
George Bellows. *The Big Dory*,
1913. Oil on panel, 18 x 22 in.
New Britain Museum of American
Art, New Britain, Connecticut;
Harriet R. Stanley Fund.

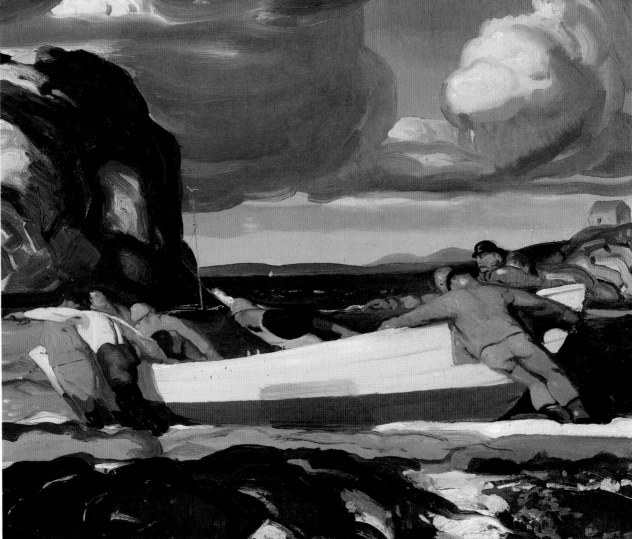

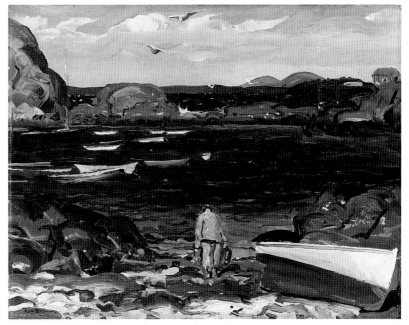

FIGURE 27
George Bellows. *The Harbor,
Monhegan Coast, Maine*, 1913.
Oil on panel, 15 x 19½ in.
Minneapolis Institute of Arts;
William Hood Dunwoody Fund.

Bellows's 1913 Monhegan paintings are markedly different from those of just two years earlier. The evocative mood of mystery and uncertainty found in *Shore House* and *An Island in the Sea* is gone, replaced by an exuberant celebration of the ocean's boundless, primal energy. Generally painted with great, bold strokes, the works of 1913 obtain a new dramatic force and power. Works such as *Churn and Break* (fig. 21) and *Beating Out to Sea* (fig. 22), while still much indebted to Homer (compare figs. 3 and 6), have aggressive, animated surfaces that go well beyond anything the older artist attempted. Other panels, such as the remarkable *Fog Rainbow* (fig. 23) or *Monhegan Island* (fig. 24), show Bellows's new and highly expressive use of color. On one sunny day Emma put on her straw hat and went out onto the cliffs above the sea. Bellows painted a panel of her lying on the grass with only the rocks and the sea beyond, and gave it the suggestive title *The Dreamer* (private collection).[65] As one critic wrote: "The romance of the place, the weight and power of the sea, the massive architecture of the ledges, the domination of the sky, and the relation of these elements to each other, have evidently appealed strongly to Bellows, and he conveys his feeling for them in a simple, large, and striking manner."[66] Or, as another observed: "He surely gets the deep color of [Maine's] waters, the thunderous surge of its breaking seas, and the hard life of its fisherfolk. . . . There is a 'gripping' quality in these coast scenes and marines."[67]

Among the most appealing of Bellows's 1913 paintings of Monhegan are several closely related views showing fishermen at work at the harbor, including *Launching* (fig. 25), *The Big Dory* (fig. 26), and *The Harbor, Monhegan Coast, Maine* (fig. 27). Painted with broad brushstrokes and bold colors, these paintings are organized with strong diagonal and horizontal lines. Writing of another harbor view, *Cleaning Fish* (fig. 28), one critic described "how far from literal" was Bellows's depiction of the scene: "the promontory that projects across the picture . . . has most obviously been made to conform to the artist's design. The man leaning on the boat and the shadow cast by him have been made, admittedly, to continue the outline of the cliff." He concluded:

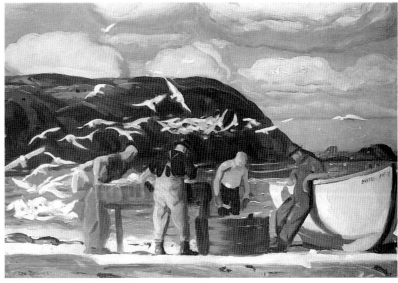

FIGURE 28
George Bellows. *Cleaning Fish*,
1913. Oil on panel, 13¼ x 19¾ in.
Nelson-Atkins Museum of Art,
Kansas City, Missouri; gift of
Mrs. Logan Clendening.

"it is apparent that the painter has been thinking much of the principles of design . . . [and] what might be called the geometrical logic of painting."[68] Such "geometrical logic" also informs a larger picture, *Harbor at Monhegan* (see page 53), that Bellows began on the island but did not complete until 1915.[69]

The steady pace on Monhegan in the summer and fall of 1913 seems to have temporarily exhausted Bellows's creativity when he returned to New York, and for three months he found himself unable to paint. He also began to worry that his summer excursions to Maine could not provide him with fresh material and inspiration indefinitely. "I am so tired," he wrote his friend Joseph Taylor in January 1914, "of depending on my past summers for present interest"[70] But by spring he was again thinking of Monhegan, apparently convinced it could indeed inspire him once more. Upon his return to the sea

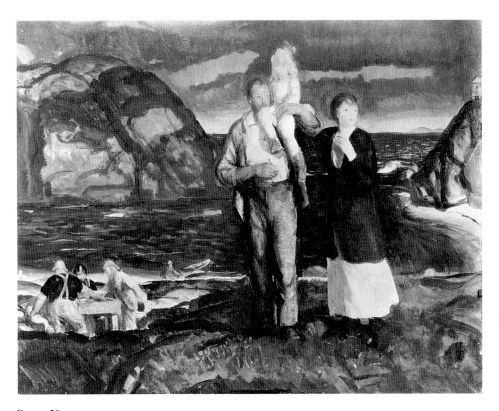

FIGURE 29
George Bellows. *Fisherman's Family*, 1914–15. Oil on panel, 30 x 38 in. Photograph courtesy of Allison Gallery, New York.

he began what would be one of his most memorable creations, a large painting called *Fisherman's Family* (fig. 29).

Fisherman's Family shows Bellows, Anne, and Emma standing on a hill above a harbor enclosed by steep bluffs. A pronounced S-curve of water leads from a group of fishermen working at a table at the lower left along a stretch of beach and out to the sea. A solitary house, reminiscent of the one in *Shore House*, is perched above the sea on the hill in the right background. The great, dark headland that closes the composition at the rear left was apparently painted with expressive brushstrokes that recall the handling of *Three Rollers*, although this is impossible to verify from the painting itself, which was destroyed sometime after 1919. As a photograph of the painting shows, Bellows's "geometrical logic" here had the triangle as its basis, for each major element of the composition—the family, the fishermen, the hills—forms a triangular mass with its base parallel to the picture's lower edge. Numerous smaller triangles, such as those formed by Bellows's right arm, the sailboat and its mast, the roof of the house, and the suspenders of a fisherman's overalls, are scattered throughout the composition, each adding its own measure of stability and order. As for the painting's color scheme, we know from a contemporary description that it was "strongly colored and broadly treated. . . . Bellows in his unmistakeable deep slate greys, emerald greens, ultra marine blues and strange reds, achieves the ominous feeling of the dangerous sea."[71]

It has been said that this scene is purely an imaginary one,[72] but it is in fact the same harbor view seen in Bellows's 1913 paintings such as *Launching* and *The Harbor, Monhegan Coast, Maine*. The shapes of the hills and the curve of the harbor itself have obviously been exaggerated, but its Monhegan origins are nonetheless clear. In *Fisherman's Family* Bellows envisioned his return to this place of artistic inspiration not only in terms of actually being present on the island; he also imagined merging himself and his family into the very identity of the place. One detects here a powerful longing to do more than just paint the world he had come to know on Monhegan. Bellows now wanted to become part of that world, blurring the distinction between the artist and his subject, the sense of the two as separate identities.

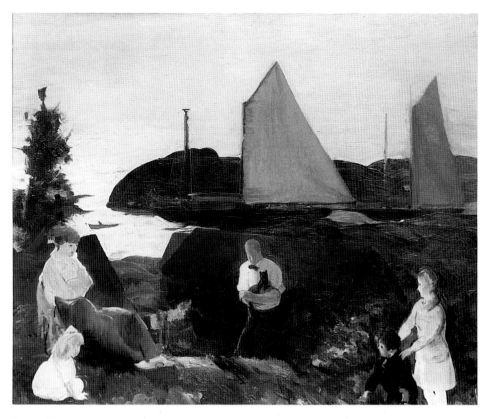

FIGURE 30
George Bellows. *Evening Group*, 1914. Oil on composition board, 25 x 30 in. Memorial Art Gallery of the University of Rochester; Marion Stratton Gould Fund, 1947.

In essence, this picture forcibly asserted that Bellows and his life formed, in some undeniably fundamental way, the very focus of his art. One could hardly conceive of more explicit evidence in support of autobiographical meaning in his images of the sea than this painting. In *Fisherman's Family* Bellows created an ideal vision, one that defined his life with clarity, order, and security. He imagined himself in the guise of a type of man he admired, the hard-working Maine fisherman. He showed himself as husband and father, physically and emotionally linked to his wife and child. His form bisects the painting vertically, separating the two spheres of his existence—family and home on the right, fishermen and boats on the left. It is he who mediates between these two worlds, who on the one hand sails on a boat out into the wide sea to gather food and on the other hand is master of house and home. To confirm the meaning of his own existence, Bellows has once again placed himself in the context of the natural world, giving vivid pictorial expression to the words he wrote to Emma in 1911: "the great sea and the mighty rocks greater than the sea, and we greater than the rocks and the sea . . . eternities."[73] The mood of doubt and alienation that made *Shore House* and *An Island in the Sea* so evocatively mysterious is here replaced with a greater expression of certainty. Significantly, Bellows and his family do not face the "ominous and dangerous sea" but turn their backs to it, safe for the moment from the danger that it will divide them.

Bellows's hopes that his return to Monhegan in the summer of 1914 would revitalize him and his art were not to be realized. The island was foggy that summer, and he was only able to paint a few panels of its familiar sights (e.g., *Summer Surf*; see page 52). The island no longer worked its magic on him, and he spent much of his time painting portraits. He attempted a kind of sequel to *Fisherman's Family* with *Evening Group* (fig. 30), but the result was something curiously different. Painted from behind the cottage where they were staying, *Evening Group* shows Anne, Emma, and Bellows with two other children; the harbor and the islet of Manana lie beyond. Yet the confidence and certainty of *Fisherman's Family* and the convincing integration of the figures into the natural world seem absent. Here each figure seems detached, and only the two children at the right are in contact. Emma stares

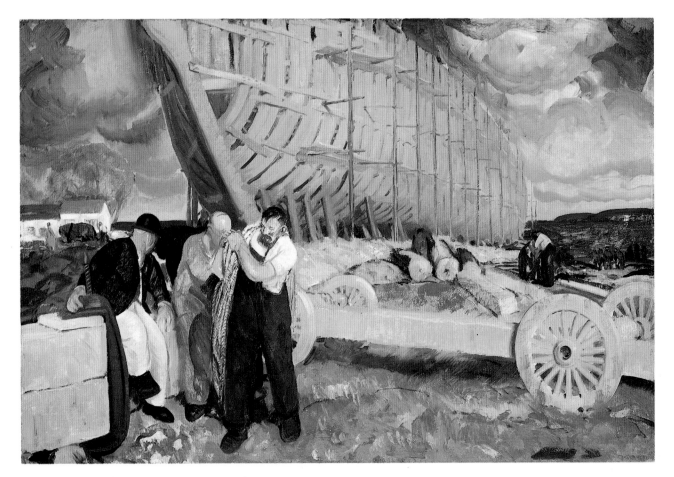

FIGURE 31
George Bellows. *The Rope* (*Builders of Ships*), 1916. Oil on canvas, 30 x 44 in. Yale University Art Gallery; gift in memory of Chauncey K. Hubbard.

FIGURE 32
George Bellows. *The Skeleton*, 1916. Oil on canvas, 30¼ x 44¼ in. Wichita Art Museum, Wichita, Kansas. Photograph by Henry Nelson.

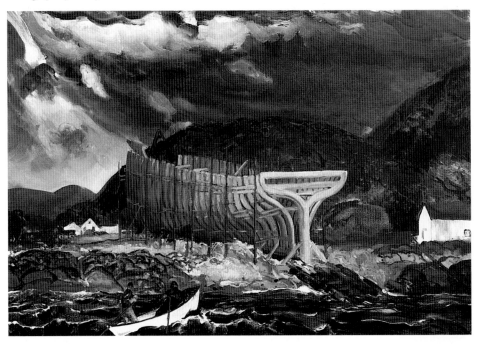

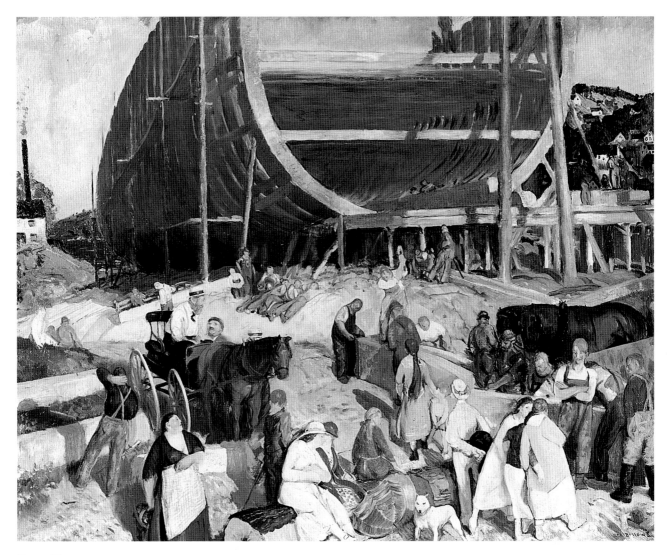

FIGURE 33
George Bellows. *Shipyard Society*, 1916. Oil on panel, 30 x 38 in. Virginia Museum of Fine Arts,
Richmond; Adolph D. and Wilkins C. Williams Fund.

off to the right and Bellows seems to stare at the ground; they are no longer united in their
gazes as they were in *Fisherman's Family*. And although Bellows's use of "geometrical logic"
is again obvious in the way each of the figures is echoed by a shape in the background (sails
and a tree), the pictorial stability this logic creates is not echoed by a comparable clarity of
meaning. The order and certainty for his art and his life that Bellows had predicted in
Fisherman's Family was not to be found that summer on Monhegan.

 During the fall and winter of 1914–15 Bellows painted relatively little; "depending on
past summers for present interest" was not possible now. Europe was at war, and with the
torpedoing of the *Lusitania* in May 1915, the United States moved closer to joining the
conflict. Bellows did manage to complete *Harbor at Monhegan* in March 1915, but other than
reworking two of his 1913 Monhegan sketches, he accomplished little else.[74] In spite of the
frustrations of the previous summer, Bellows longed to go to Monhegan again, but Emma
refused. She did agree to return to Maine, but this time the family—including an infant
daughter, Jean, born that April—went to Ogunquit, a small, quiet fishing village on the
mainland. It was a poor summer for the artist; he accomplished little work and painted not
a single important picture of the sea.

 The following summer the Bellows family went to Camden, Maine, where the painter
found a new subject, the shipyard, that resulted in several major paintings (figs. 31–33).
There Bellows watched, with fascination, the construction of a large wooden vessel. In each

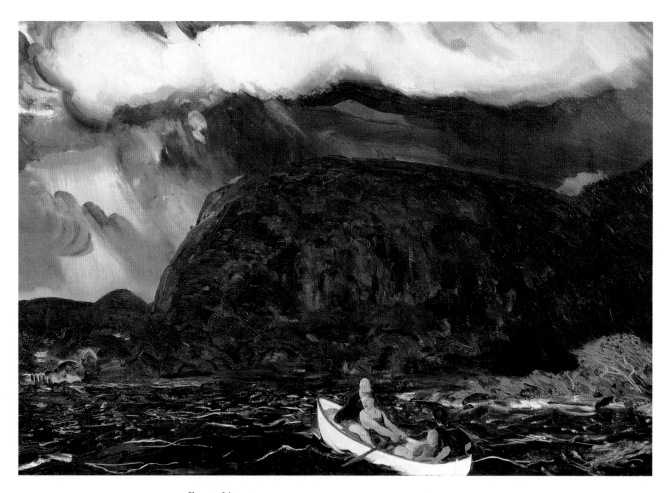

painting the uncompleted hull of the great ship looms at the center of the composition, dominating the scene. Bellows described the feelings he wanted these paintings to convey in an article written in 1917: "When I paint the great beginning of a ship at Camden, I feel the reverence the ship-builder has for his handiwork. He is creating something splendid, to master wind and wave, something as fine and powerful as Nature's own forces. I get it from him that he is impressed with his own struggle to accomplish this, and when I paint the colossal frame of the skeleton of his ship I want to put his wonder and his power into my canvas, and I love to do it. I have no criticism to make of what he does, I am filled with awe, and I am trying to paint as well as he builds, to paint my emotion about him."[75] Bellows was pleased with these pictures and felt that their powerful forms and compositional energies were worthy of comparison with the works of two of his favorite old masters, El Greco and Rembrandt.[76] Similar feeling for large and powerful forms and dynamic compositional rhythms animates *Dock Builders* (see page 57), another canvas painted at Camden in the summer of 1916.

Bellows found the inspiration for one of his most dramatic images of the sea, *In a Rowboat* (fig. 34), in a frightening incident that occurred that summer. Bellows, Emma, and Anne had gone one day with Leon Kroll in a small rowboat to a club that lay across Camden Harbor. As they were returning a sudden squall caught them. Leon Kroll recalled:

> there was a desperately serious moment, not at all funny at the time. . . . Emma and Anne were seated in the stern, George at the Bow and I was rowing. We all watched

with awe, a wonderful dark cloud coming over the hill behind our houses. Suddenly the squall hit us, pushing the boat toward the sea, despite my rowing as powerfully as I could. I kept the bow pointed straight into the wind, realizing that the worst thing that could happen was to be driven up[on] a small Island between us and the open sea. George however was quite worried and whispered to me to take Anne and he would take Emma in case we capsized. Neither of them could swim. The only real danger was water being shipped into the boat. Emma, serene as ever, was efficiently scooping up water with a rather good-sized pot I kept in the boat. The wind stopped as suddenly as it had started. The only result was the handsome and dramatic picture George painted the next day."[77]

According to Bellows, his painting was "an epic of terrific nature and tried to express the fear of it all."[78] Anyone who has ever been caught by a squall on open water in a small boat can understand what he meant and appreciate his attempt to capture such feelings on canvas. *In a Rowboat* reduces the elements of the story to a minimum in order to maximize the dramatic effect. There is only the sea, the sky, the undetailed mass of the land, and the boat with its four occupants. A strong diagonal line moves through the composition, running from the storm clouds at the upper left to the boat and off the bottom of the picture. The boat, caught by the energies of wind and water, is perilously close to being driven backwards out of the picture and, by implication, into disaster. Kroll, straining against the oars, has the boat safe for the moment, but one can only wonder at the ultimate outcome. Bellows, Emma, and Anne tensely look off in different directions; again the family is divided by separate visions.

Some observers contend that *In a Rowboat* fails in conveying "the fear of it all" and falls short of Homer's great dramas of the sea such as *The Fog Warning* (fig. 35).[79] Such judgments are, of course, invariably subjective, but seeing the painting in a context larger than the specific incident depicted may perhaps help to augment its meaning. Stephen Crane's "The Open Boat," one of the best-known works of fiction in Bellows's time, offers a striking verbal complement to the painting. Indeed, Bellows's image seems virtually to illustrate the opening passage of Crane's story of four men in a small boat: "Their eyes glanced level, and were fastened upon the waves that swept toward them. The waves were of the hue of slate, save for the tops, which were foaming white. . . . These waves were most wrongfully and barbarously abrupt and tall, and each froth-top was a problem in small-boat navigation."[80] Most of its action takes place within sight of land, but the water is far too rough for the characters to attempt landing on the shore. The occupants of Crane's boat, like those in Bellows's painting, thus cannot take comfort from the sight of land and its promise of safety, for though it lies close at hand, it is for the moment utterly beyond their reach. Crane's seamen cannot risk the pounding surf; Kroll must struggle to keep from being driven onto the island. The sea, then, is both the source of the danger and, paradoxically, for the moment the only safe haven. And it is that irony, that reminder of just how narrowly separated are life and death, that gives both works so much of their dramatic power. At the end of Crane's story it is the strongest of the four men, the one who guided the boat to safety, who perishes. With Bellows's painting, unless we are privy to the specific details of the incident (which Bellows's audience was not), the outcome of this drama of the sea remains unresolved.

In September 1916 Anne and Jean returned to New York while Bellows and Emma remained in Maine. They made a repeat visit to Matinicus, where they had first gone in the summer of 1913, and also went to the nearby island of Criehaven. Bellows wrote to Henri that he was doing "extra fine work" and continuing his experi-

FIGURE 35
Winslow Homer. *The Fog Warning*, 1885. Oil on canvas, 30 x 48 in. Museum of Fine Arts, Boston; Otis Norcross Fund.

FIGURE 36
George Bellows. *Ox Team, Wharf at Matinicus*, 1916. Oil on canvas, 22 x 28 in. Metropolitan Museum of Art, New York; gift of Mr. and Mrs. Raymond Horowitz, 1974.

ments with color.[81] Such works as *Ox Team, Wharf at Matinicus* (fig. 36); *Matinicus from Mt. Ararat* (see page 58); and *Romance of Criehaven* (see page 59), which was translated into *Criehaven, Large* (see page 60) the following year, are notable for their bold colors and expressive brushwork. Even more strikingly colored are the paintings of Sherman's Point, such as *Romance of Autumn* (see page 60), which Bellows painted after he returned to Camden. Yet in all of these works it is landscape that predominates, suggesting that Bellows's desire to paint the sea was now on the wane. The Atlantic had held his fascination for over five years, but by the end of 1916 he had painted his last significant pictures of the great ocean.

Bellows's interest in painting the sea was briefly revived by a trip to California in the summer of 1917. He and his family settled in Carmel and made excursions to nearby sites such as Point Lobos and Pebble Beach. Bellows was fascinated by the colors and light of the California landscape, which seemed so different from what he knew in the East. The sea, too, looked different, with a warmer and deeper tone than the Atlantic.[82] One can see him attempting to capture the character of the Pacific in one of his last important oils of the sea, *The Fisherman* (fig. 37). The waves are painted with striking blues, greens, and purples,

colors that are echoed in the rocks beneath the fisherman's feet. Still, though Bellows's use of color here was novel, the basic format of the painting, with its diagonal opposition of rocks and foaming water, harkens back to such prototypes as *Churn and Break* of 1913 (fig. 21).

The Bellows family spent the summers of 1918 and 1919 in Middletown, Rhode Island, where Bellows occasionally painted small pictures of the shore. Although Anne and Jean had not yet learned to swim, they were fond of playing in the waves. As their father wrote in 1919 in response to an invitation to visit Kansas City: "It is very difficult to get my family away from the sea. It would take some propaganda and some wonderful advertising to pull this off. If we could tell them that the bathing was verry wonderful in Kansas City we might succeed."[83] The following year Bellows did succeed in getting his family to spend their summers inland, in Woodstock, New York, where he eventually realized his lifelong dream of building a house. Anne and Jean had to be content with swimming in a pool constructed for them in a stream on the property. The sounds of the sea and the smell of salt air that had been part of Bellows's summers (and so crucial to his artistic inspiration) for so many years were replaced by the quiet of the New York countryside. And feelings of loneliness and uncertainty that contemplating the ocean might bring on were replaced by the pleasures of rural life and domestic bliss.

The sea made its final appearances in Bellows's art in 1922–23. In 1922 *Century Magazine* commissioned him to produce fifteen drawings as illustrations to the novel *The Wind Bloweth*, by the popular Irish writer Donn Byrne.[84] Bellows loved the book and was inspired to produce some of his finest graphic images. In two of these works the sea plays

FIGURE 37
George Bellows. *The Fisherman*, 1917. Oil on canvas, 30 x 44 in. Berry-Hill Galleries, New York

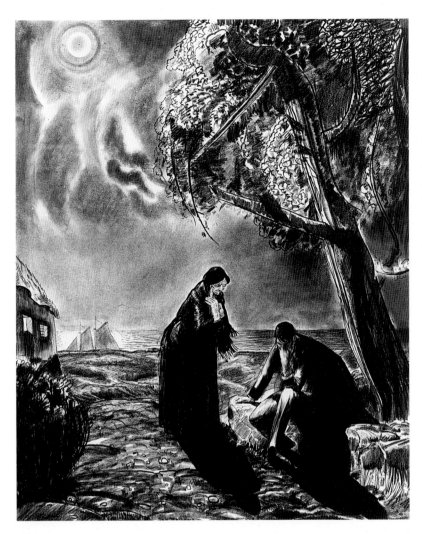

FIGURE 38
George Bellows. *The Hag and the Young Man*, 1922. Black crayon, 18 x 14½ in.
Cleveland Museum of Art; gift of Leonard C. Hanna, Jr.

FIGURE 39
George Bellows. *Alan Donn Puts to Sea*, 1922. Crayon and pencil, 17½ x 21.
Albright-Knox Gallery, Buffalo, New York; gift of A. Conger Goodyear, 1954.

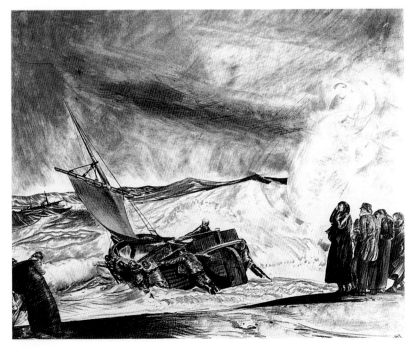

an important role. *The Hag and the Young Man* (fig. 38) shows the story's hero, Shane Campbell, seated outside a thatched cottage at night. Campbell had returned from sea to find his young wife dead; her wake is being held in the cottage. As he sits brooding under a tree his wife's elderly mother, drunk on whisky, approaches him to ask what he will be leaving her. Seemingly unconcerned by her daughter's death, she nags the young man to promise her more and more of his possessions, even the house. In visualizing the scene, Bellows added a view of the ocean in the background. Silhouetted against the silvery reflection of the moonlight in the water are the sails of a ghostly ship, which the artist must certainly have intended as not only a reminder of Campbell's life on the sea, but also as an emblem of the departed soul of his wife. This dark sea, then, provided a physical and spiritual passageway leading away from the corruptions of the land.

Death also informs *Alan Donn Puts to Sea* (fig. 39), which illustrates a later chapter in the story. Campbell, once again back on land, learns that his uncle Alan Donn has died. When he asks the circumstances he learns that his uncle had drowned while trying to assist a wrecked schooner. Bellows's picture shows the highly charged moment when Donn, refusing to allow anyone else to accompany him, is pushed off shore: "We pushed with the water up to our waists. The keel ground. The sand sucked. We pushed with the water up to our shoulders. Then the trisail caught the wind. And Alan Donn was off." As the crowd watched anxiously Donn worked his way out to the schooner: "And then he came to the ninth wave . . . the drowning wave. . . . There was the crippled schooner, and Alan Donn, and the great sea. And the wave curled and broke. And then was only the schooner and the great sea."[85] This is a vision of the sea that recalls Bellows's words of 1910: "The Terror and what is the sea if it isn't terrible."

In 1923 Bellows decided to repaint his 1914 *Fisherman's Family*, making only minor changes to the original design (fig. 40). Emma is now older and appears more mature and elegant, but Anne is still a young girl. Although his last visit to the Maine coast was seven years in the past, the image still held meaning for him. As he painted this new version, he endowed it with an even greater feeling of monumentality, making

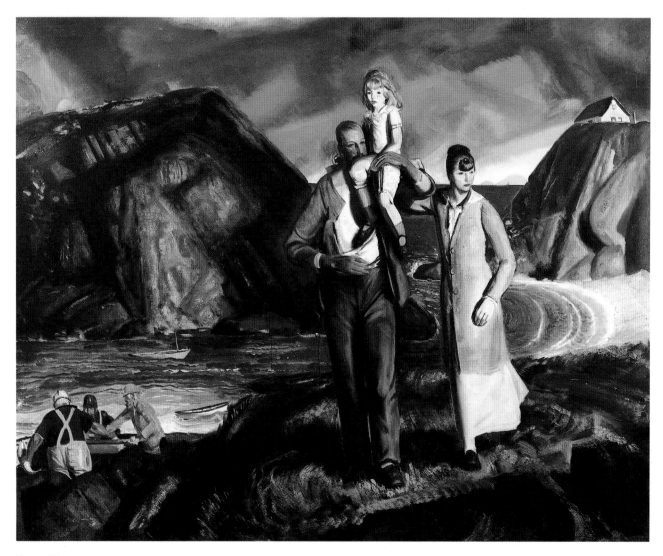

FIGURE 40
George Bellows. *Fisherman's Family*, 1923. Oil on canvas, 38½ x 48¼ in. Private collection; photograph courtesy of Kennedy Galleries.

the heroic figures dominate the scene more convincingly. The space behind them now seems secure and closed, with the hills more dominant and the harbor correspondingly diminished. The triangular forms that stabilize the composition are even more assertive, and Emma's arm, which before was held rather uncertainly to her breast, now hangs relaxed at her side, closing the group of figures. Even the house at the upper right is larger and more comfortably situated on its hill. In his illustrations for *The Wind Bloweth*, the sea had been inextricably associated with the end of life, but Bellows now reaffirmed his belief that he and his family were "eternities" at one with nature. *Fisherman's Family* was the creation of a man who, for one more time in his art, had reckoned the shape of his own existence against the timeless and boundless sea. And this time he expressed no uncertainty, no doubt, and no fears that "those crystal green hands" might reach up from the sea to claim him.

We can only wonder what images of the sea Bellows might have painted after this confident and assured statement and whether that confidence would have been maintained, for he died less than two years later. For over a decade he had painted the sea, matching the energy of its great waves with his own surges of energetic creativity, and tracing on canvas its mysterious moods that mirrored the tides of his own feelings. Perhaps for Bellows, as for Ishmael, the "clean and cold" sea had indeed been "the key to it all," for in attempting to unlock its mysteries, and those of his own life, he brought forth some of his most profound and evocatively beautiful creations.

NOTES

Many people helped by providing information and assistance as I was preparing this essay. In particular I am grateful to Doreen Bolger, Jean Bellows Booth, Karen Hinson, Jane Myers, Glenn Peck, Jane Posey, Franklin Riehlman, Bruce Robertson, and Nancy Stevens.

[1] Herman Melville, *Moby-Dick; or, The Whale* (1851; reprint ed., New York: W. W. Norton, 1967), pp. 13, 14. Ishmael's well-known words are found in chapter 1, "Loomings."

[2] Frank Crowninshield, "Introduction," in *Memorial Exhibition of the Works of George Bellows* (New York: Metropolitan Museum of Art, 1925), p. 12.

[3] Charles H. Morgan, *George Bellows: Painter of America* (New York: Reynal and Company, 1965), p. 25. Morgan's book remains the essential biography on the artist. Even after moving to New York as an art student Bellows continued to visit his Long Island relatives on vacations; see p. 59.

[4] Morgan, *George Bellows*, p. 21.

[5] Melville, *Moby-Dick*, p. 12.

[6] Quoted in Morgan, *George Bellows*, p. 40.

[7] Quoted in Morgan, *George Bellows*, pp. 82–83.

[8] "American Paintings in Germany," *International Studio* 41 (September 1910): 189–190. Homer was represented by three oils: *The Gulf Stream* (1899, Metropolitan Museum of Art), *The Lookout—"All's Well"* (1896, Museum of Fine Arts, Boston) and *Driftwood* (1909, private collection).

[9] One could cite many other examples of critics linking Bellows and Homer at this time; for an excellent discussion of the early relationship between the two painters, see Bruce Robertson, *Reckoning with Winslow Homer: His Late Paintings and Their Influence* (Cleveland: Cleveland Museum of Art, 1990), pp. 93–97. I am much indebted to Robertson's stimulating catalogue and to the conversations about Homer and his influence that we have had in recent years.

[10] Robertson (*Reckoning with Homer*, pp. 95–96) believes the "key word is *force*. The single most important point of similarity was Bellows' vigor and interest in dynamic action."

[11] Letter to Dr. S. C. G. Watkins, February 25, 1924, George Bellows Papers (Box I, Folder 15), Special Collections Department, Amherst College Library; quoted in Morgan, *George Bellows*, p. 272, and Robertson, *Reckoning with Homer*, p. 88. Bellows also noted his admiration for Thomas Eakins and James A. M. Whistler in this letter.

[12] Charles Parsons, "Montauk Point, Long Island," *Harper's New Monthly Magazine* 43 (September 1871): 481. For more on Montauk and Bellows's visit, see my "George Bellows' *Shore House*," in Nicolai Cikovsky, Jr., and Doreen Bolger, eds., *American Art Around 1900: Lectures in Memory of Daniel Fraad* (New York and Washington, D.C.: National Gallery of Art, 1990), pp. 122–123.

[13] George Bellows, Record Book A, p. 84.

[14] I am grateful to Glenn Peck of Allison Gallery, New York, for this information; see Record Book A, p. 89.

[15] Quoted in "The Relationship of Painting to Architecture: An Interview with George Bellows, N. A., in Which Certain Characteristics of the Truly Original Artist Are Shown to Have a Vital Relationship to the Architect and His Profession," *American Architect* 118 (December 29, 1920): 848.

[16] See John Wilmerding, *A History of American Marine Painting* (Salem and Boston: Peabody Museum and Little, Brown and Company, 1968; revised ed., New York: Harry N. Abrams, Inc., 1988), especially chapters IV–XIII.

[17] Letter to Joseph Taylor, April 21, 1910, Bellows Papers (Box I, Folder 11), Amherst College Library. I am very grateful to Jane Myers for sharing with me transcripts of Bellows's letters and for making available a great deal of other material and information that aided me enormously as I prepared this essay.

[18] Robert Henri, *The Art Spirit* (Philadelphia: J. B. Lippincott Company, 1923), p. 115, quoted in Robertson, *Reckoning with Homer*, p. 99.

[19] "News and Notes of the Art World," *New York Times*, January 29, 1911, sec. 5, p. 15.

[20] Edward Alden Jewell, untitled review of Bellows exhibition at H. V. Allison Galleries, *New York Times*, October 25, 1942, sec. 8, p. 9.

[21] See William H. Gerdts, "The Square Format and Proto-Modernism in American Painting," *Arts Magazine* 50 (June 1976): 70–75. Gerdts considers *Cannon Rock* "the most significant of Homer's square paintings" and "one of Homer's most flattened and design-conscious paintings."

[22] On Kent see Richard V. West, *"An Enkindled Eye": The Paintings of Rockwell Kent*, exhibition catalogue (Santa Barbara, Calif.: Santa Barbara Museum of Art, 1985).

23 Robertson, *Reckoning with Homer*, pp. 101–106.

24 Morgan, *George Bellows*, p. 68.

25 From an interview in the *New York Herald*, quoted in Morgan, *George Bellows*, p. 158.

26 "Relationship of Painting to Architecture," p. 849.

27 My remarks here follow those of Michael Osborn in "The Evolution of the Archetypal Sea in Rhetoric and Poetic," *Quarterly Journal of Speech* 63 (December 1977): 347–363.

28 *The Enchanted Flood: The Romantic Iconography of the Sea* (New York: Random House, 1950), p. 14; quoted in Osborn, "Evolution of the Archetypal Sea," p. 351.

29 See Thomas Philbrick, *James Fenimore Cooper and the Development of American Sea Fiction* (Cambridge: Harvard University Press, 1961), and Bert Bender, *Sea-Brothers: The Tradition of American Sea Fiction from Moby-Dick to the Present* (Philadelphia: University of Pennsylvania Press, 1988).

30 I have speculated about the meanings of *Shore House* at greater length in "Bellows' *Shore House*," in Cikovsky and Bolger, *American Art Around 1900*, pp. 130–134. One aspect of the painting that I did not consider in that context was the possibility that its title might have held personal meaning for Bellows and his wife. At least twice, once in October 1906 and then again in December the following year, Emma travelled from her home in Montclair, New Jersey, into New York to see Bellows and stayed overnight in an apartment building named "The Shorehouse." (Letters from Emma Story to George Bellows, October 16, 1906, and December 2, 1907, Bellows Papers [Box I, Folder 15 and Box II, Folder 3], Amherst College Library). Emma was careful to give Bellows the address on both occasions, so he must have gone there to meet her. It seems inescapable that in calling his painting *Shore House* Bellows was making reference to the building where Emma had sometimes stayed during their courtship. Whether this was merely a lighthearted allusion, or whether it held some deeper, and possibly private, meaning for the couple remains to be discovered.

31 Ronald G. Pisano has read the painting as "an image of strength and endurance, an appropriate and hopeful symbol for a marriage"; see *Long Island Landscape Painting, 1820–1920* (Boston: Little, Brown and Company, 1985), p. 158.

32 Morgan, *George Bellows*, p. 133.

33 Morgan, *George Bellows*, p. 134.

34 George Bellows to Emma Bellows, August 9, 1911, Bellows Papers (Box I, Folder 3), Amherst College Library.

35 George Bellows to Emma Bellows, August 12, 1911, Bellows Papers (Box I, Folder 3), Amherst College Library.

36 George Bellows to Emma Bellows, August 14, 1911, Bellows Papers (Box I, Folder 3), Amherst College Library.

37 Morgan, *George Bellows*, p. 139.

38 George Bellows to Emma Bellows, August 21, 1911, Bellows Papers (Box I, Folder 4), Amherst College Library; quoted in Morgan, *George Bellows*, pp. 139–140.

39 George Bellows to Emma Bellows, August 14, 1911.

40 George Bellows to Emma Bellows, August 14, 1911, quoted in Morgan, *Bellows*, p. 137; this is the same letter that includes the quote at the beginning of this essay.

41 George Bellows to Emma Bellows, August 28, 1911, Bellows Papers (Box I, Folder 4), Amherst College Library.

42 George Bellows to Emma Bellows, August 15, 1911, Bellows Papers (Box I, Folder 3), Amherst College Library.

43 George Bellows to Emma Bellows, undated, Bellows Papers (Box I, Folder 3), Amherst College Library; see also Morgan, *George Bellows*, p. 137.

44 Emma Bellows to George Bellows, August 18, 1911, Bellows Papers (Box I, Folder 9), Amherst College Library. Emma's characterization of the title as "poetic" is interesting, but whether Bellows was inspired by a specific literary source is not known. Edgar Allen Poe's "To One in Paradise" (1834) contains the following lines which, if not literally the inspiration for Bellows's painting, are nevertheless strongly suggestive of it:

> Thou wast all to me love,
> For which my soul did pine—
> A green isle in the sea love,
> A fountain and a shrine. . . .

[45] It was widely believed that the Norsemen had visited Manana around 1000 A.D., and unusual scratches, four feet long and six inches wide, found on its rock ledges were cited as evidence of their presence. See *Maine: A Guide "Down East"* (Boston: Houghton Mifflin Company, 1937), p. 396.

[46] Morgan, *George Bellows*, p. 141.

[47] Nicolai Cikovsky, Jr., *Winslow Homer* (New York: Harry N. Abrams, Inc., 1990), p. 143.

[48] Quoted in William Vaughan, *German Romantic Painting* (New Haven and London: Yale University Press, 1980), p. 239. Cikovsky has perceptively compared *Cape Trinity* with Böcklin's 1880 version of *Island of the Dead* in *Homer*, p. 143.

[49] Roald Nasgaard, *The Mystic North: Symbolist Landscape Painting in Northern Europe and North American, 1890–1940* (Toronto: Art Gallery of Ontario, 1984), p. 4. See also Charles C. Eldredge, *American Imagination and Symbolist Painting* (New York: Grey Art Gallery, 1979), especially "From Sea to Shining Sea: Submarine Fantasies in American Art," pp. 62–67.

[50] "The Pacific," *Moby-Dick*, p. 399.

[51] Robertson, *Reckoning with Homer*, p. 111.

[52] Robertson, *Reckoning with Homer*, p. 111.

[53] See, e.g., his letter to Emma of August 21, 1911: "We painted today in what is called Cathedral Forrest and it is a majestic place. Gothic spires everywhere...." According to his Record Book, *The Rich Woods* was twenty-six by thirty-four inches and was also known as *The Cathedral Woods*. I am grateful to Franklin Riehlman of Allison Gallery for this information.

[54] That Bellows chose *Three Rollers* as his diploma presentation to the National Academy of Design, upon his election to full membership on December 1, 1913, is perhaps indicative of his satisfaction with the work.

[55] Bellows was clearly concentrating on the expressive possibilities of his medium in these paintings, and he even chose Whistlerian names for two of them. In his record book he called *The Sea* "Analogy in Blue Green" and *The Rich Woods* "Pyramid in Yellow Green." See Morgan, *George Bellows*, p. 146. Neither *Three Rollers* nor *Evening Swell* was similarly annotated.

[56] Morgan, *George Bellows*, p. 156.

[57] See, e.g., his letter to Emma of 26 August 1906, Bellows Papers (Box I, Folder 2), Amherst College Library, which discusses the possibility of teaching her to swim.

[58] "When George Wesley Bellows saw for the first time the painting of Pierre August Renoir, he was thrilled and praised his work to artists and art dealers. I feel very strongly that the success of Renoir's painting in this country is due to George Bellows." Victor Salvatore, quoted in *Armory Show Fiftieth Anniversary Exhibition* (Utica, N.Y.: Munson-Williams-Proctor Institute, 1963), p. 97.

[59] Morgan, *George Bellows*, p. 171, gives a total of 117 paintings; Bellows, in a letter to Robert Henri of October 25, 1913 (Henri Papers, Yale Collection of American Literature, Beinecke Rare Book and Manuscript Library, Yale University), mentions 125 works completed and says he expects to paint a few more before leaving. See also Record Book A, pp. 163–274.

[60] See Morgan, *George Bellows*, p. 172. The fisherman had argued to Bellows that his island was smaller and more attractive than Monhegan and invited the painter to see for himself. They made the trip over rough water in a small boat and Emma, as Morgan observes, "earned her passport to heroism."

[61] George Bellows to Robert Henri, September 15, 1913, Henri Papers, Beinecke Rare Book and Manuscript Library, Yale University; quoted in Robertson, *Reckoning with Homer*, p. 109.

[62] George Bellows to Robert Henri, October 25, 1913.

[63] George Bellows to William Macbeth, date unknown (probably late August 1913), Macbeth Papers, Archives of American Art, Smithsonian Institution, Washington, D.C.

[64] The exhibition at Montross Gallery must have been something of a disappointment, for none of his recent pictures found a buyer. Morgan, *George Bellows*, p. 177.

[65] For a reproduction, see *American Impressionism* (New York: Coe Kerr Gallery, 1985), unpaginated, where the painting is correctly dated July 1913 but is discussed as if it had actually been painted the following summer.

[66] From a review of the exhibition at Montross Gallery, *New York Post*, January 24, 1914.

[67] "George Bellows at Montross's," *American Art News*, January 24, 1914, p. 3.

[68] Both quotations are from the *New York Post*, January 24, 1914.

[69] Record Book B, p. 14.

[70] George Bellows to Joseph Taylor, January 15, 1914, Bellows Papers (Box I, Folder 12), Amherst College Library.

[71] Evelyn Marie Stuart, "The Twenty-Ninth Annual Exhibition at the Art Institute," *Fine Art Journal* 34 (December 1916): 623–624.

[72] Morgan, *George Bellows*, p. 180.

[73] George Bellows to Emma Bellows, August 15, 1911.

[74] Morgan, *George Bellows*, p. 187. According to Glenn Peck, Bellows also created three portraits and three drawings during this period.

[75] "The Big Idea: George Bellows Talks About Patriotism For Beauty," *Touchstone* 1 (July 1917): 270. In the first sentence the text actually says "Gloucester" rather than "Camden," but the shipbuilding pictures all depict the latter town.

[76] Bellows specifically invoked the two artists when describing a shipyard picture in a letter to Henri of September 8, 1916, Henri Papers, Beinecke Rare Book and Manuscript Library, Yale University.

[77] Leon Kroll to Charles Morgan, March 24, 1965; Morgan Papers (Box VI, Folder 17), Special Collections Department, Amherst College Library.

[78] George Bellows to Robert Henri, September 8, 1916.

[79] See, e.g., Robertson, *Reckoning with Homer*, p. 112: "Bellows has pulled his punches, skirting the danger to his family . . . the certainty of the shore holds the boat comfortably in its visual field."

[80] *Great Short Works of Stephen Crane* (New York, 1965), p. 277. "The Open Boat" was first published in *Scribner's Magazine* in June 1897.

[81] George Bellows to Robert Henri, October 5, 1916, Henri Papers, Beinecke Rare Book and Manuscript Library, Yale University.

[82] Morgan, *George Bellows*, p. 210.

[83] George Bellows to Shirley MacMahan, November 4, 1919, in scrapbook in possession of Charles Wesley Nash.

[84] The novel was published in serial form in the magazine in 1922 and released as a book the same year. In 1924 Bellows mentioned a book called *Mysteries of Sea and Land* that he found particularly useful in his work as an illustrator. George Bellows to A. O. Foote, March 10, 1924, Bellows Papers (Box I, Folder 7), Amherst College Library. No book of that title can be identified today.

[85] *The Wind Bloweth* (New York: Century Company, 1922), p. 267. As has been noted, the central motif of Bellows's illustration strongly recalls his 1913 paintings *The Big Dory* and *Launching*; see *George Bellows: Works from the Permanent Collection of the Albright-Knox Art Gallery* (Buffalo: Albright-Knox Art Gallery, 1981), p. 21, and Jane Myers and Linda Ayres, *George Bellows: The Artist and His Lithographs* (Fort Worth: Amon Carter Museum, 1988), pp. 113–116.

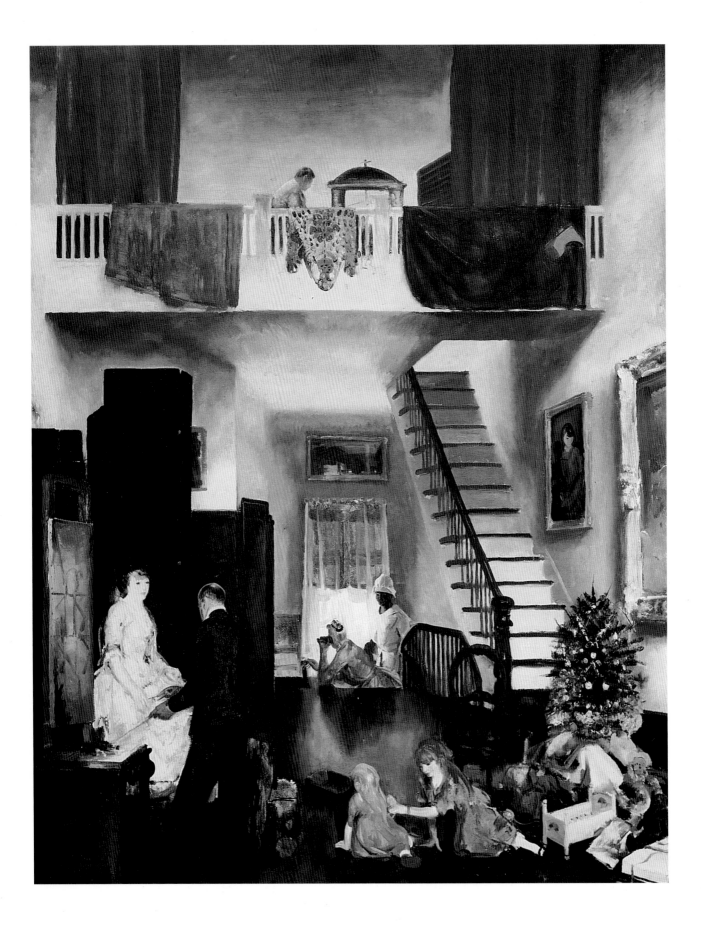

"The Most Searching Place in the World": Bellows and Portraiture

JANE MYERS

FIGURE 1
George Bellows. *The Studio*, 1919. Oil on canvas, 48 x 38 in. Collection of Rita and Daniel Fraad.

Portraiture was central to George Bellows's ambition to become a great artist. Whether he was creating formal portraits of individual family members, friends, and patrons, or portraying identifiable figures in another context, such as landscape, he treated the human form as a repository for intangible values, for essential common qualities of human existence. That portraiture played a significant role in Bellows's personal and professional life is evident in *The Studio* (fig. 1), completed in March 1919, which enlarges a scene he had lithographed as a Christmas card in 1916 and summarizes some of his primary concerns in treating the human figure.

The unity of the multi-generational family mirrored in this harmonious domestic scene was a dominant theme in much of Bellows's figural work. The inviting, enclosed environment of the artist's living and working space contains his wife, Emma—the object of her husband's artistic labors as well as his affection—enthroned on the model stand, and their daughters, Anne, age seven, and Jean, age three, playing nearby beneath the family Christmas tree. Emma's mother, Catherine Anderson Story, is silhouetted against the window in the center of the composition as she talks on the telephone, and the inclusion of family's maid, standing next to her, reinforces the informality of the scene. The man on the upper landing, working at the artist's printing press, presumably is George Miller, Bellows's lithographic printer, whose presence underscores the continuity that Bellows found between his professional and private concerns. Completing the group is the artist himself, the foremost participant in the life of this family. A provider who, here, literally offers the gifts of Christmas, Bellows also figuratively served as the conduit through whom profound sentiments could be transferred to canvas.

Just as an ordinary family holiday could carry multilayered connotations for Bellows, so too could the task of transcribing the human visage. His portraiture, which he worked on continuously from his student days until a few months before his death, is especially telling about the artist. He painted at least 140 portraits—about one-fifth of the total number of canvases he produced in his relatively brief, twenty-year career—and this large body of work illustrates the paradoxes of his artistic personality. An activist in the progressive circle that had gathered around artist Robert Henri (1865–1929), Bellows earned wide acclaim early in his career for his vigorous oils, drawings, and lithographs of the boxing ring, the teeming life of the Lower East Side, and New York City's recreation and commerce. His depictions of his life and times were both autobiographical and editorial, and many of

his early portrait subjects also were drawn from the city's lower classes. The portraits did not, however, attract similar notice in his early exhibitions. Working within an essentially conservative genre and taking his artistic models from time-honored traditions, Bellows nonetheless tried to approach portraiture creatively, as an integral part of his own artistic program. His figural work often reveals unexpected nuances of meaning and the tenderness of the human condition. Although he felt personally challenged to be unique in his portraiture, Bellows also wished to compete for portrait commissions with other contemporary portraitists; keenly sensitive to the dominance of society portraiture, he measured his own work against the commercial successes of the foreign and foreign-trained artists who enjoyed a thriving patronage in early twentieth-century America.[1]

Portraiture was often the genre in which Bellows investigated style and content, beginning with his incisive portrayals of urban youth during his student years and ending in the 1920s with an elaborate series of solemn, monumental portraits whose complex iconography and expressive power surpassed the work of any contemporary. After the Armory Show, where he was inspired by the European and American modernists, Bellows, during a three-month period in the summer of 1914, induced friends and neighbors to pose for his imaginative formal concerns. But his most constant portrait subjects, as *The Studio* so explicitly described, were members of his family; almost one-third of his portraits depict relatives. In Bellows's later career these portraits became typological constructs, with many depictions of Emma, Anne, or Jean also representing broader issues of age and gender. Even his commissioned portraits contain hints about his art in general; because their very nature required the artist to adhere to a more traditional path, he used them as touchstones for judging himself against popular portraitists. Finally, in works that could not be classified as portraiture, genre, or landscape, Bellows incorporated figural elements into a more symbolic narrative where the interrelation of man and nature conveys a painting's meaning.

Because Bellows primarily selected subjects himself, his portraiture increasingly became an intimate endeavor. There were diverse motives for painting individuals from his own family. Working with familiar (and accessible) subjects somewhat mitigated the continual uncertainty of rendering an apt likeness. Moreover, Bellows's family members readily conformed to his mature understanding of the portrait as a vehicle to express ennobling sentiments. While the preponderance of female relatives probably ensured that few men would figure in the artist's portraiture,[2] his attention to female models nonetheless recalls the work of Thomas Eakins, whom he greatly admired; Eakins also favored women as subjects and left probing records of his wife, sisters, niece, and female acquaintances.

Bellows's reliance upon family and friends for portrait subjects indicates an underlying autobiographical theme, often enigmatic, that became more intense in his later career. He captured their likenesses not so much for their individual physical appearances but because their personal endowments represented a larger concept transcending literal fact. For example, *Elinor, Jean, and Anna* of 1920 (see fig. 44) says much about life's journey and generational bonds through its sober depiction of Bellows's mother, aunt, and daughter. This codification did not preclude a sensitivity to individual personality, however, and Bellows's highest achievements came when he shared a psychological empathy for his subjects, whether family members such as his wife and daughters or street urchins like the one in *Paddy Flannigan* (see fig. 14).

The impetus for taking portrait subjects from the realm of personal experience arose, at least in part, from the powerful influence of Robert Henri, who over the course of his own career chose figural subjects broadly, from a range of economic groups, vocations, and nationalities. After a fortuitous encounter with Henri's commanding personality at the New York School of Art, where he enrolled upon his arrival in the East, Bellows promptly abandoned light-hearted illustration and began seriously portraying the human figure. Bellows was an ideal protégé; innately self-confident, idealistic, and industrious, he was predisposed to Henri's liberal philosophy, which had the laudable ability to inspire enthusiasm for great artists while encouraging students to cultivate their own singular abilities.

By his own admission, Bellows was a rube: "I found my precious title of 'the Artist' quite a shoddy distinction. I had every equipement [sic] except all the essentials. My brains

were as innocent as a college could make them. My life begins at this point."[3] In addition to life classes and Henri's portraiture class, the young artist also studied with William Merritt Chase, founder of the New York School of Art, who excelled in high-style portraits (the so-called international style) at the turn of the century (fig. 2). Although Chase's art-for-art's-sake philosophy stood in opposition to Henri's desire to make art a corollary for life, both highly influential teachers turned to similar artistic models, holding the Spanish and Dutch realists and, more immediately, Edouard Manet in high regard. Bellows diligently studied the old master portraits Henri endorsed, filling his studio (figs. 3 and 4), which doubled as an apartment, with a multitude of framed old master reproductions, predominantly portraits, which he displayed side by side with his and his roommates' own artistic aspirations.[4]

The august associations of art history appealed to Bellows's lofty sensibilities, and the traditions of portraiture provided him with a way to express his individuality. Bellows admired the traditions of such masters as Rembrandt and Eakins, and he may well have been paying homage to Velázquez's *Las Meninas* in his composition of *The Studio*. Art history merely provided a set of guideposts for his own individual perspective, however. He believed that "the student of art is continually at work both on art and on life. He gathers from the first what other fine minds have found, from the second he searches for new experience."[5] He evaluated his figural work against this standard and asked others to do the same; in the summer of 1917 he solicited his wife's opinion of a commissioned portrait "with reference not only to art but also in regard to likeness."[6]

That Henri himself influenced Bellows's portraiture is evident in the similarities between Henri's striking portrait of John Sloan (fig. 5) and Bellows's *Robin, Portrait of Clifton Webb*. Drawing from the romanticism of seventeenth-century Spanish portraiture, Henri set Sloan's dramatically lit visage against a shadowed backdrop and relegated his figure to secondary importance, barely allowing it to emerge from the shadows. Quick to learn Henri's method, Bellows applied the informality of this portrait type to his own depiction of a teen-aged Clifton Webb (fig. 6), a fellow student at the New York School of Art, where the painting probably was made.[7] Bellows used a three-quarter-length view seen in near profile, and the disposition of light and dark

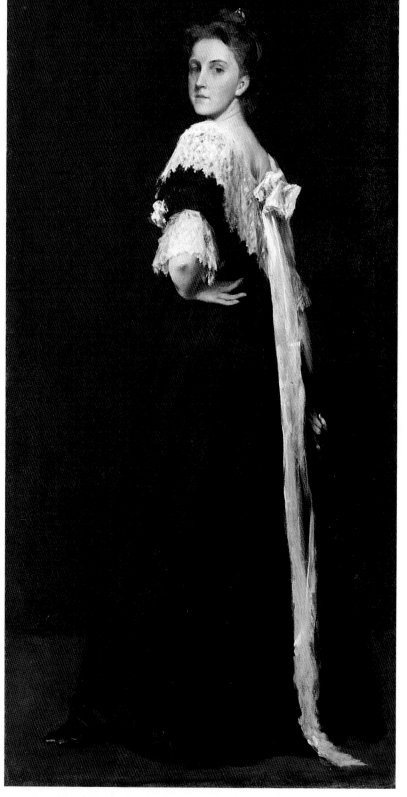

Figure 2
William Merritt Chase. *Portrait of Miss E. (Portrait of Lydia Field Emmet)*, c. 1892. Oil on canvas, 71⅞ x 36¼ in. Brooklyn Museum; gift of the artist.

FIGURE 3
Charles Grant. *Edward Keefe and George Bellows in Their Studio, New York*, 1908.
Photograph. Collection of Charles Wesley Nash.

FIGURE 4
Charles Grant. *George Bellows and Edward Keefe in Their Studio, New York*, 1908.
Photograph. Collection of Charles Wesley Nash.

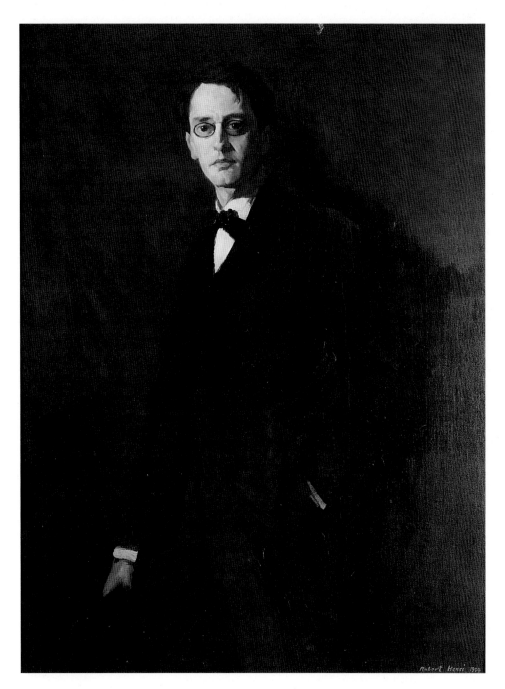

Figure 5
Robert Henri. *Portrait of John Sloan*, 1904. Oil on canvas, 56⅝ x 41⅛ in. Corcoran Gallery of Art, Washington, D.C.; gift of Mr. and Mrs. John Sloan.

passages corresponds to Henri's portrait. But more importantly, he adopted Henri's view that portraiture was a means to express the artist's unique perception of some inherent quality of the sitter—what Henri referred to as the "true subject"[8]—rather than a reworking of staid artistic formulas.

Bellows's own affability, uninhibited good humor, and gift for banter probably helped in making this portrait, for he had an easy rapport with Webb, whom he christened Robin Red Nose for his "expectant, early morning, worm-hunting look." Already taking a leadership role in the school by his second year, Bellows had rescued Webb from acute embarrassment on his first day in the Men's Life Class, where the neophyte experienced

FIGURE 6
George Bellows. *Robin, Portrait of Clifton Webb*, 1905. Oil on canvas, 44½ x 30½ in. Mr. and Mrs. Richard D. Zanuck.

"considerable inner confusion" while drawing the nude model. Soon after, as Webb was called upon to make a speech before the boisterous and irreverent students, he heard Bellows call out: "Don't worry, kid. Come and sit by me, I'll look out for you." In his plight, Webb touched that compassionate and benevolent part in Bellows that was to be incisively reflected in his early portraits.[9] The genuine and easygoing nature of their friendship comes across in this rendering of an uncertain youth with a quizzical smile.

The informal portraits that Bellows produced in the years following his move to New York bear little resemblance to the grand manner portraits of his day, with their sleek sophistication and elegant refinement. Throughout Bellows's lifetime, popular portraitists, including Chase, prospered by painting flatteringly chic portraits for wealthy patrons. Even John Singer Sargent (1856–1925), their standard-bearer, who ceased portrait production in 1909 following a glamorous international career, continued to show his older works along with other society portraitists at prominent national exhibitions.[10] Despite its popular successes, high-style portraiture came under fire after the turn of the century for its homogeneous cosmopolitanism and conventionality and, in a climate of rising chauvinism, for failing to capture an innately American idiom. Critics decried the society portraitist's reliance on the refinements of eighteenth-century English painters, who had "refashioned life according to their ideals."[11] In 1905, Sadakichi Hartmann called for a new American school in the tradition of Hals, Velázquez, and Manet, "to paint things just as they are, without the addition of any aesthetic formulae whatsoever—the most unassuming pose will do."[12]

For his part, Bellows would summarily dismiss the pyrotechnics of his more popular colleagues: "Did you ever notice how like a society portrait painter is the undertaker. He too tries to get a good likeness."[13] With a keen conception of form and personality and a spirited independence that conspicuously distinguished his work from fashionable portraits, Bellows strove for a portrayal truly representative of the sitter. His early figural work garnered only limited critical attention, however; although some works, such as *Prosper Invernizzi* (see page 12) and *Little Girl in White* (see fig. 10), began to draw more notice when they were exhibited in 1910, several years after their execution, he was not at first "known as a figure painter."[14] Some critics perceived portraiture as one genre where he demonstrated uncharacteristic restraint. Only around 1914, when portraits had become a significant proportion of his artistic production, did he gain widespread recognition for his skills in rendering the human form.

Rejecting "the constant and foolish demand that pictures be 'beautiful'[,] As if Shakespeare had allways gone around writing love sonnets,"[15] Bellows instead favored a more perceptive approach, uninhibited by the dictates of fashion. Writing in 1910 to Joseph Taylor, his former professor at Ohio State, he singled out John Sloan's portrayal of a clown, probably *Clown Making Up* (1910, fig. 7), for its disclosure of the pathos inherent in the human condition:

> It is a picture to dream over. It's funny how when you look at this picture you think of all the human sensations a clown must have in his life. You catch yourself wondering whether he has a wife and some kids, and how much money he makes. Sloan is wonderful this way. In all his things you find yourself dreaming about the lives of the people he paints. Big and broad & simple; rough in color and without polish. These pictures have a distinction as human documents which in my experience of painting I believe to be the quality of all the rarest."[16]

This emphasis on the humanity of the subject and rejection of a beautiful exterior appearance coincided with the call among some progressive critics for American alternatives to high-style, cosmopolitan portraiture.[17] Henri asserted that by virtue of their common nationality, the realists would inevitably reflect a native school. Like the nineteenth-century French realists, he and his followers focused on the human drama of the lower classes, using the quotidian details of life to disclose the essential character of contemporary society. In choosing subjects drawn from the poorer classes of New York's teeming Lower East Side, Bellows adhered to Henri's dictum to paint the life around him, as did Henri himself in character studies of individuals he encountered both in New York and during numerous

FIGURE 7
John Sloan. *Clown Making Up*, 1910. Oil on canvas, 32 x 26 in. Phillips Collection, Washington, D.C.

later trips to Spain, Ireland, and Holland.[18] Conditioning Bellows's portraits of these unnamed individuals was the belief that he was expressing a dynamic and more universal American nationalism by depicting indigenous and commonplace American types: "a lumberman," "ragged children," and "tawdry women."[19] Such works by Henri and his protégés earned praise for their forthrightness, although critics sometimes complained: "If earlier artists went to the extreme of prettiness and sentimentality, these, at times, certainly go to the extreme of ugliness. Most of their portraits are interesting because of their character of expression rather than because of their expression of character."[20]

Of course, the realism of Henri and the aestheticism of Chase were not mutually exclusive or even very distinct. Given the professional and financial attractiveness of portrait commissions, artists had a practical as well as an artistic impetus for making portraits. Henri's portraits invoked enough aspects of the prevailing mode to satisfy his patrons[21] and to compare favorably with Sargent's. He even used this style occasionally for works that

FIGURE 8
Robert Henri. *Young Woman
in White*, 1904. Oil on canvas,
78¼ x 38⅛ in. National Gallery
of Art, Washington, D.C.;
gift of Violet Organ.

FIGURE 9
William Merritt Chase. *Girl in
White*, c. 1898–1901. Oil on
canvas, 84⅜ x 40 in. Akron Art
Museum, Akron, Ohio; bequest
of Edwin C. Shaw.

were not commissioned (fig. 8). When his painting *Ballet Dancer in White* was exhibited in 1910 at the Pennsylvania Academy of the Fine Arts, a reviewer noted that it "drew larger audiences than either of the John Sargent portraits. The brilliance of the technique, the sincerity of the pose and large simplicity of Mr. Henri's handling seemed to infatuate group after group of lookers on."[22]

On a few occasions the conceits of popular portrait painting served as a foil for Bellows's realistic portrayals. Chase, a master of fashionable portraiture—and a one-time friend of James Abbott McNeill Whistler (1834–1903), a leading exponent of the Aesthetic Movement—used such titles as *Girl in White* for his portraits (fig. 9). When Bellows's portrayal of the coquettish laundry girl, Queenie Burnett (fig. 10), was first exhibited in 1910, it bore a similarly "artistic" title, *Little Girl in White*.[23] Both Chase and Bellows employed a format that Whistler had derived from Velázquez and Manet, setting a solitary figure against a schematically realized background. Each heightened the contrast between the white attire of the sitter and the dark backdrop, but Bellows flattened the figure to reinforce the artifice of his design. Unlike Chase's patrician child, who is more representative of social caste than of childhood innocence, Bellows's subject is charmingly unassuming and informal. Her long brown hair falls loosely on her shoulders and her spindly legs, clad in black stockings, terminate in oversized shoes. The child's tilted head and shy gaze eloquently evoke her character; belying her apparent youthful innocence are hollowed eyes, which give her a gaunt intensity reminiscent of Goya's models. Although the suggestion of poverty is a disturbing quality that Bellows would not repeat in later portraits of his own daughters, the painting nonetheless presages, in its simplification and mystery, the emblematic nature of Bellows's mature studies of girlhood.

180

George Bellows

FIGURE 10
George Bellows. *Little Girl in
White* (*Queenie Burnett*), 1907.
Oil on canvas, 62¼ x 34¼ in.
National Gallery of Art,
Washington, D.C.; Collection
of Mr. and Mrs. Paul Mellon.

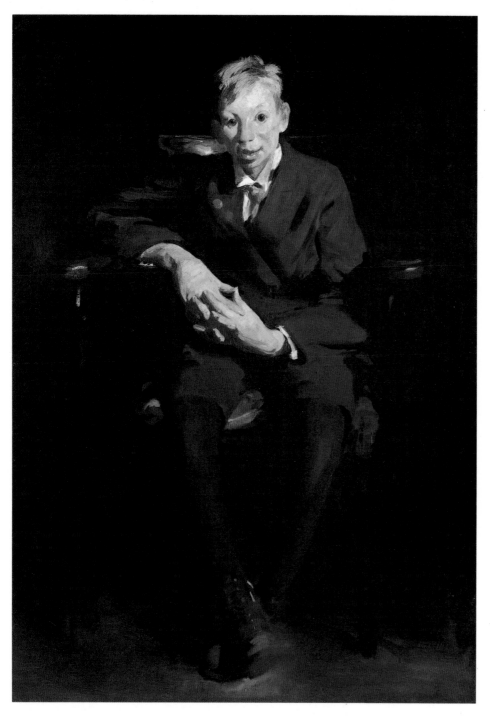

FIGURE 11
George Bellows. *Frankie the Organ Boy*, 1907. Oil on canvas, 48 x 34½ in. Nelson-Atkins Museum of Art, Kansas City, Missouri; acquired through the bequest of Ben and Clara Shlyen.

Bellows, like Henri, had an affinity for his young subjects, whom he treated with compassion and sympathy. His early portrait titled *Frankie the Organ Boy* (fig. 11), for example, compares favorably with Henri's *Portrait of Willie Gee* (fig. 12). The more discerning and ultimately the more empathetic of the two artists, Bellows distilled Frankie's brimming energy and mischievous spirit into a portrait of a distinct individual. The boy's oversized hands, tousled hair, and endearing grin are the kinds of unique, often quirky, details that Bellows sought in his early portraits. Henri, on the other hand, liked to portray anonymous "types" as representatives of a particular nation or a race, emphasizing communal, universal predispositions over the specifics of the individual and "looking to

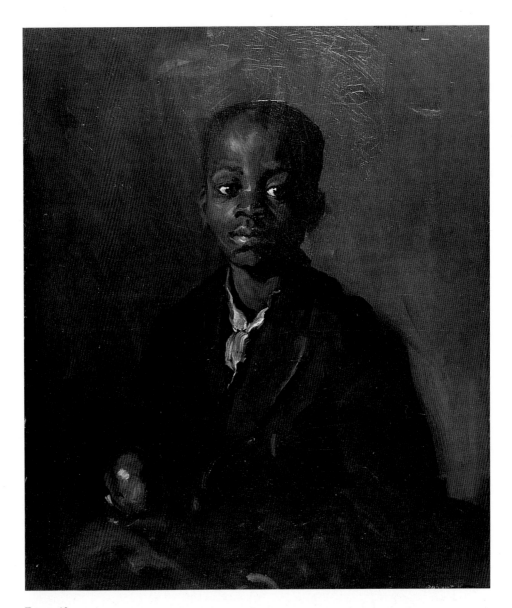

each individual with the eager hope of finding there something of the dignity of life, the humor, the humanity, the kindness, something of the order that will rescue the race and the nation."[24] For example, his subject for *Gypsy with a Bandurria* (fig. 13), whom he encountered in 1906 on a trip to Spain, has the "typical" qualities he rhapsodized about: "very large handsome eyes" and a "good easy nature."[25] Henri continued throughout his career to render common "types" deemed quaint and appealing, but Bellows eventually abandoned this approach and surpassed his mentor by seeking diversity of expression and the nuances of individual character.

Bellows's facility in capturing and even exaggerating personalities had its genesis in his experimentation with caricature in high school and college and was enhanced by commissions that he received for magazine illustrations.[26] In large paintings, such as *Kids* (1906, collection of Rita and Daniel Fraad), and *Forty-Two Kids* (see page 101), he graphically, yet poetically, rendered the carefree pastimes and communal play of urban children from the lower classes. He carried over the exaggerated quality of these pictures to his portraits of individual children, predominantly boys, whose idiosyncracies are so finely delineated that they resemble *dramatis personae*. The sitter's slightly askew gaze in *Cross-Eyed Boy* (1906, Mead Art Museum) and the buck teeth and saucy gaze of Paddy Flannigan are

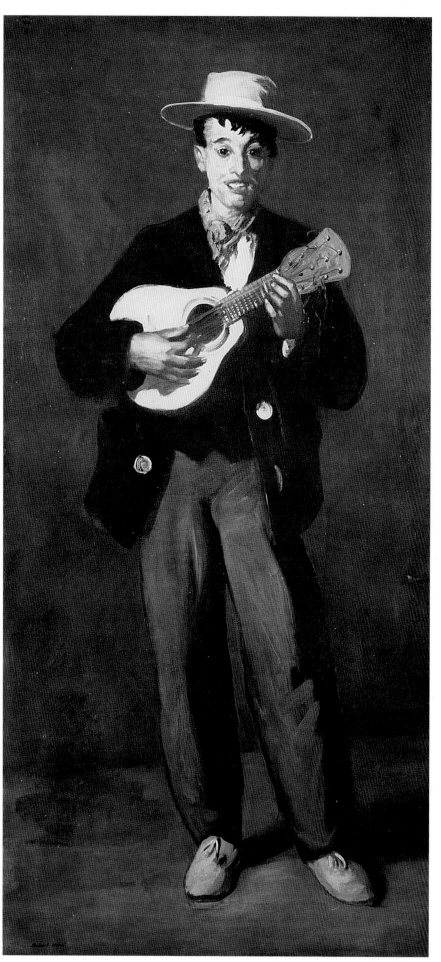

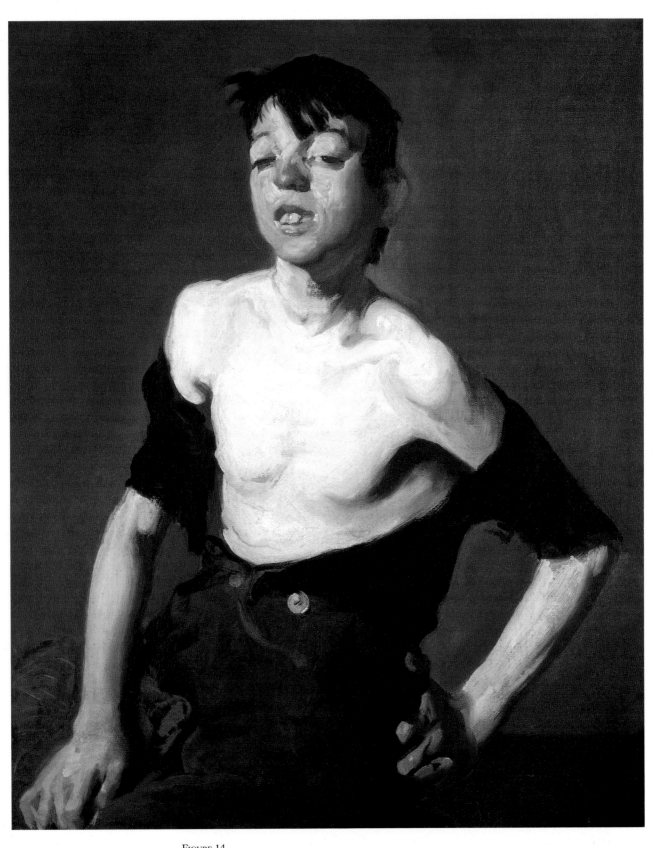

FIGURE 14
George Bellows. *Paddy Flannigan*, 1908. Oil on canvas, 30¼ x 25¼ in. Erving and Joyce Wolf Collection. Photograph courtesy of Christie's, New York.

revealing qualities that bring the subjects to life. The last of Bellows's portraits of ragamuffin children, *Paddy Flannigan* (fig. 14) represented Bellows's most complex figural composition to date. The broadly expressive brushwork, the tilt of the boy's head, and the juxtaposition of his partially nude torso against an indeterminate background suggest sources as diverse as Hals and Caravaggio—masters who, through Henri's earnest guidance, animated the brush of the emerging artist. The boy's awkward and apparently uncomfortable stance, with his hand placed emphatically on his hip, apparently was dictated by the artist searching for novel poses to introduce the sitter's "state of being . . . manifest[ing] itself . . . through form, color, and gesture."[27] The veiled look created by the boy's half-closed eyes and his slight smile baring prominent teeth exude an impudent and disarming sexual overtness, under-scored by the threadbare shirt that slips from his shoulders.

These carefree and candid celebrations of childhood distinguished Bellows as a young artist of perceptive depth within the Henri circle. Bellows would also capture the childlike spirit in portraits of his daughters, but these later works unfolded along more formal and intensely personal lines. The ambitious presentations of his late career—with their tight, controlled brushwork; fanciful colors; and complex, mannered composition—would be far removed in conception from these early endeavors.

Despite Bellows's rapid assimilation of Henri's teachings, which accelerated his own artistic development, and the stylistic and compositional parallels between their portraits of the same period, the younger artist never drew slavishly from his teacher. As his *Portrait of My Father* (fig. 15) reveals, very early in his career Bellows's profound sensitivity to characterization already set him apart. The portrait, a moving testimony to filial devotion, was executed during the Christmas holidays in 1906, when Bellows made his first visit to Columbus since his departure for New York two years earlier. George Bellows, Senior, a widower when he married the artist's mother, was in his fifties when his only son was born. Conservative and strong-willed, he represented a Victorian sensibility deemed obsolete by New York's artistic, social, and political thinkers, who were now influencing his son's intellectual growth. The older man had initially opposed young George's decision to become an artist, a career that seemed fraught with uncertainty. Now in his seventies, he was entrenched in an outmoded moral stance and his son equally dedicated to a more progressive one.[28] These generational differences were temporarily transcended, however, in this sympathetic and sensitive portrayal of the frailty of age and its attendant wisdom. Bellows's lively characterization renders the wizened features in small, relatively tight brushstrokes that reflect the controlled quality of the sitter's personality as they give him form and volume. The artist's father is calm and contemplative, his hands gently resting on his cane, his gaze averted, and his body slightly turned; the spatial complexity that results from this subtle shift of weight anticipates Bellows's more ambitious figural compositions of the following year, such as *Frankie the Organ Boy* and *Little Girl in White*.

Bellows may have chosen this format, strongly reminiscent of works by American adherents of the Munich School (popular in the 1870s and 1880s), as a tour de force to impress his father.[29] It is also conceivable that, having asserted his independence by leaving Ohio, he found that the distance from his family and his father's subsequent support of his career had mitigated his own rebellion, enabling the son to objectify the artistic possibilities suggested by his father's advanced age. As Bellows wrote his wife in 1912, the year before his father's death, "Father is too weak to travel but spruces up now and then. He has a wonderful old head."[30] Despite his fond regard for both his parents, Bellows reserved further exploration of familial interrelationships until he started his own family five years later.

Around the time of his marriage in 1910, he began more seriously to consider the critical and financial repercussions of portraiture. Like Henri, who had made full-length portraits of the American social elite while Bellows was his student, Bellows investigated portraiture as a commercially viable activity. He had received his first portrait commission, to paint Ohio State University's Professor James Canfield (Ohio State University Libraries), in 1909, the same year he became an associate member of the National Academy of Design. At this point his portraiture entered the artistic mainstream; he put aside his candid and richly drawn portrayals of urban children and moved toward a more conventional realiza-tion of portrait subjects.

George Bellows

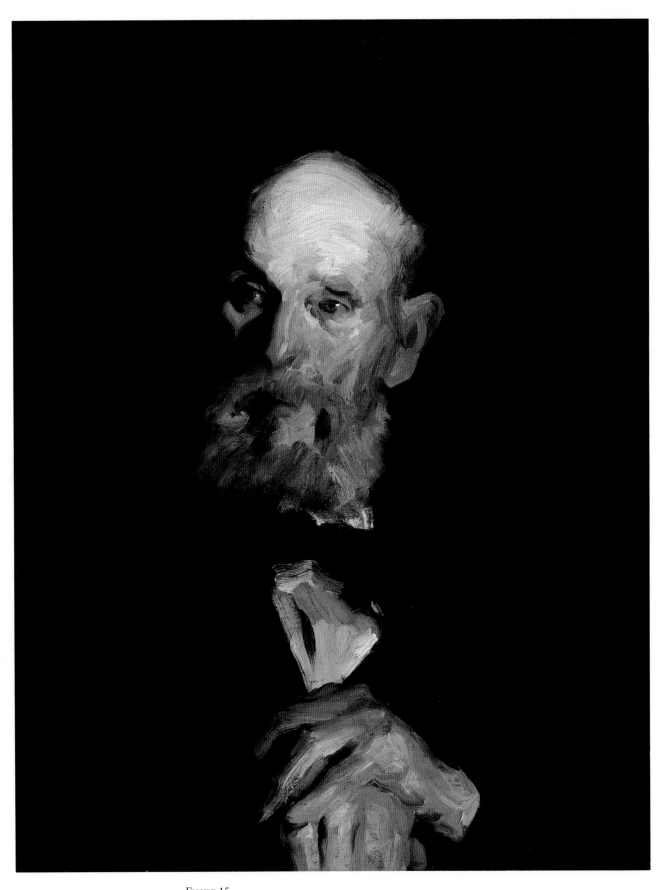

FIGURE 15
George Bellows. *Portrait of My Father*, 1906. Oil on canvas, 28⅜ x 22 in.
Columbus Museum of Art, Ohio; gift of Emma S. Bellows.

Nonetheless, the portraits that Bellows completed between 1909 and 1912 must be considered experimental, at least in retrospect; of the sixteen he noted in his record book for those years, he later destroyed seven, including some he had initially liked enough to exhibit. His bride became one of his principal portrait subjects and Edouard Manet, famous for his sensual depictions of women, became his principal artistic model. Writing to Joseph Taylor in 1910, Bellows cited Walter Pach's recent article on Manet, which contended that, like their French predecessor, Americans could freely draw upon the traditions of other countries yet maintain an essentially nationalistic vision: "Through their achievement we see a new people, with attributes, activities and needs apart from those of other nations."[31] Manet's spirit of rebellion, of quiet defiance and persistence in the face of adverse criticism, undoubtedly also sparked Bellows, the idealist, who was already forming the strong opinions that he freely expressed throughout his career.[32]

FIGURE 16
George Bellows. *Girl on Couch (Portrait of Emma on the Divan)*. Reproduced in *New York Tribune*, December 17, 1911. George Bellows Papers, Special Collections Department, Amherst College Library.

Bellows's infatuation with his wife is richly documented in the correspondence they conducted during the summer of 1911, when he made his first trip to Maine and Emma, expecting their first child, remained with her parents in New Jersey. His letters from that summer's sojourn fluctuated from one emotional extreme to another: from passionate longing and despair at leaving his new bride to a heady preoccupation with his craft, from wonderment at nature's majesty and power to uncertainty that he would ever be able to express this magnificent subject adequately. His two renderings of his new bride, *Candlelight*, painted in November 1910, and *Girl on Couch (Portrait of Emma on Divan)*, painted the following June, were Bellows's most ambitious portraits to date. *Candlelight*, according to a reviewer, depicted a young girl seated before a table spread with white dishes, fruit, and candles, holding an apple in her hand. *Girl on Couch*, known only through a newspaper reproduction (fig. 16), drew an inevitable comparison with Manet because it showed Emma reclining in a pose that is the mirror image of Manet's celebrated painting of a nude Parisian courtesan, *Olympia* (1863, Musée d'Orsay, Paris).[33]

Some reviews of *Girl on Couch* were less than enthusiastic. While admiring Bellows's innovative spirit and his ability to offer a refreshing alternative to the staid and predictable Academy exhibitions, most critics saw him as a yet undeveloped portraitist. One complained that *Girl on Couch* "strongly suggests Manet and does not suggest any knowledge of a standard work known as *Gray's Anatomy*."[34]　Another commented on its "Frenchified artificiality . . . [it] is as ugly a portraiture as one could find in a short winter day. If the chief purpose of the picture be to prove that the lady wears white shoes, its purpose is realized."[35] While the portrait did receive some favorable criticism, the artist's two major figural works of 1910–11 were ambivalently received, and his portraiture career was faltering. The results were apparently not entirely gratifying for Bellows, either; at some point following the last exhibition of *Candlelight* in 1912 and *Girl on Couch* in 1914, both paintings were destroyed. His artistic satisfactions had to come from another source: Hugo Reisinger, a German-American merchant and art collector, purchased Bellows's landscape *Up the Hudson* (see page 134) in 1910 and presented it to the Metropolitan Museum of Art.

The responsibility of a growing family—daughter Anne was born the year after he and Emma were married—and perhaps the mixed reception of his recent portraits were likely factors in Bellows's shift to a more popular portrait type and his concentration on portrait commissions in 1912. He was never complacent about commissioned work; the psychological insight he had pursued in his earlier work seemed frustratingly intangible and elusive in such endeavors. He recognized that depicting the human condition was not a simple matter

of technical facility: successful portraits also had to render more elusive qualities without seeming to contain "more knowledge than romance."[36]

Bellows initially believed that he could transmit his sitters successfully just by virtue of knowing them and that many portrait commissions would be forthcoming. His youthful confidence was shaken, however, by the practical realities of acceding to the sitter's objectives. Sensitive to the demands of patronage, Bellows was willing to employ orthodox portrait modes in an effort to distinguish himself by prominent commissions—a compromising posture that he would not countenance in the rest of his work. In his commissioned portraits of Columbus citizens from high society and academia, he investigated the established standards of society portraiture as embodied by Whistler, Sargent, Chase, and their adherents. Yet his commissioned portraits rarely proved successful in terms of emotional veracity, even though he clearly made attempts to adapt his realist viewpoint to the egotism of his sitters. Confronted with the difficult task of achieving both a sympathetic likeness and a technical masterpiece—a fortuitous union that he rarely achieved— he increasingly found portrait commissions of meager satisfaction. More often than not, they represented frustrating nadirs in his career. The interlude in Columbus in 1912–13 is indicative of a lifelong pattern of executing commissioned portraits only sporadically. After 1913, Bellows would never again seek commissions as earnestly or consider them a significant source of income.[37] His relative failure as a commissioned portraitist had no bearing on his popularity, however, and his prominence in the art community, including his participation in the annuals of such leading institutions as the National Academy of Design and the Carnegie Institute, insured that his portraits would receive widespread recognition, both nationally and internationally.

The Columbus commissions, which occupied him until the opening of the Armory Show in 1913, gave Bellows the opportunity to show his hometown how far he had come from his early days when, as a high school and college student, he had been celebrated for his caricatures and genteel drawings of statuesque and imperious women— the type popularized by illustrator Charles Dana Gibson. As early as 1909, when the University Alumni Association hired him to paint former University president James

Canfield—who died before his portrait could be completed in the artist's New York studio[38]—Bellows had envisioned a series portraying prominent faculty members of Ohio State University. Still hoping that a series of academic portraits might be viable in January 1912, he undertook on speculation a full-length portrait of Dr. William Oxley Thompson, who had been president of the university since Bellows's student days (fig. 17). As he explained to Joseph Taylor a decade later, Bellows had expected that through his "kindly, even . . . great affection" for Thompson he might be able to paint "a very fine thing." However, "when the occasion arose, . . . the romance seemed to have fled," leading Bellows to assert that "the model stand is the most searching place in the world."[39] His unremitting self-doubts and long labor over the work continued until May 1913, when he announced the painting's completion to Joseph Taylor. Even then, he observed that "there is not a square inch that hasn't bothered me to death."[40] Bellows's perseverance seemed justified when the painting won the Maynard Portrait Prize at the 1914 National Academy annual,[41] but the university never purchased the painting, and the positive critical response to the painting was meager vindication for the artist.

Ohio State University did, however, commission him to paint two other portraits, one of Dr. T. C. Mendenhall (see page 243) and the other of Walter Quincy Scott, the second president of the university (fig. 18).[42] Bellows's conception for the latter painting was grandiose: he filled the large canvas with Scott's imposing form, rendered almost monochromatically but enlivened by a bright red sash and by flesh tones in a cheerful palette of pink and yellow. Although respectful of his midwestern roots, Bellows was nonetheless critical of the provincialism he found in Columbus and was bitterly disappointed that the university did not commission a larger series of portraits as an integral part of the community's overall cultural betterment.[43] The passage of time did not lessen his disappointment, and he remained sensitive about the university's lack of support.

Further portrait projects in Columbus marked Bellows's final excursion into a sanctioned portrait style during this period. Following the portrait commissions from Ohio State, Bellows was emboldened to offer his skills to a few members of Columbus society during the Christmas holidays in 1912.[44] Upon his return to New York, he executed nearly full-length portraits of two socially prominent women, Mrs. H. B. Arnold and Mrs. Albert M. Miller (figs. 19 and 20). Marking a personal and public departure for Bellows, these works audaciously reflected the current mode. Their format is telling; whereas the portraits of the university's male dignitaries are circumspect and commanding, in keeping with their intellectual prowess, the women's portraits draw upon an equally fashionable but more painterly style, with parallels in grand-manner portraiture.

For these aspirants to high society, the unpretentious intimacy that the artist had employed in his earlier portraits of urban children was altogether inappropriate. In Mrs. Arnold's portrait, Bellows selected a restricted palette, dominated by a single russet hue, and exploited the decorative possibilities of the sitter's gown, utilizing a Whistlerian conceit of turning the figure slightly to reveal the gown's embellishments. Mrs. Miller, too, projects a sophisticated reserve. Her portrait is an amalgam of mannerisms drawn from eighteenth-century British portraiture: bravura brushwork, an artificial stage lighting effect, and a dainty foot gracefully turned away from the picture plane.[45] Despite these stylish features, Bellows never aggrandized the sitters entirely; more in the spirit of Eakins, he gave the women's countenances an animated and honest appraisal.

Demonstrating his confidence in these portraits, Bellows exhibited them in New York early in 1913. Despite his adroit handling of paint and his ability to capture a likeness, as well as the fact that the portraits had just been shown in January among a group of more progressive American paintings (primarily works by Henri and his coterie) at the MacDowell Club, his painting of Mrs. Miller must have seemed hopelessly retardataire when it appeared among the avant-garde European pictures in the Armory Show. Critics in New York were more positive about the Miller and Arnold portraits than were Bellows's patrons.[46] After *Portrait of Mrs. Albert Miller* was returned to Columbus following the Armory Show, Bellows fretted to his friend Professor Taylor, "Burt Miller wrote me that there is still some trouble with Mrs. M's portrait around the mouth." The family of Mrs. Arnold apparently rejected her portrait entirely, for upon the artist's death, the painting remained in his estate.[47]

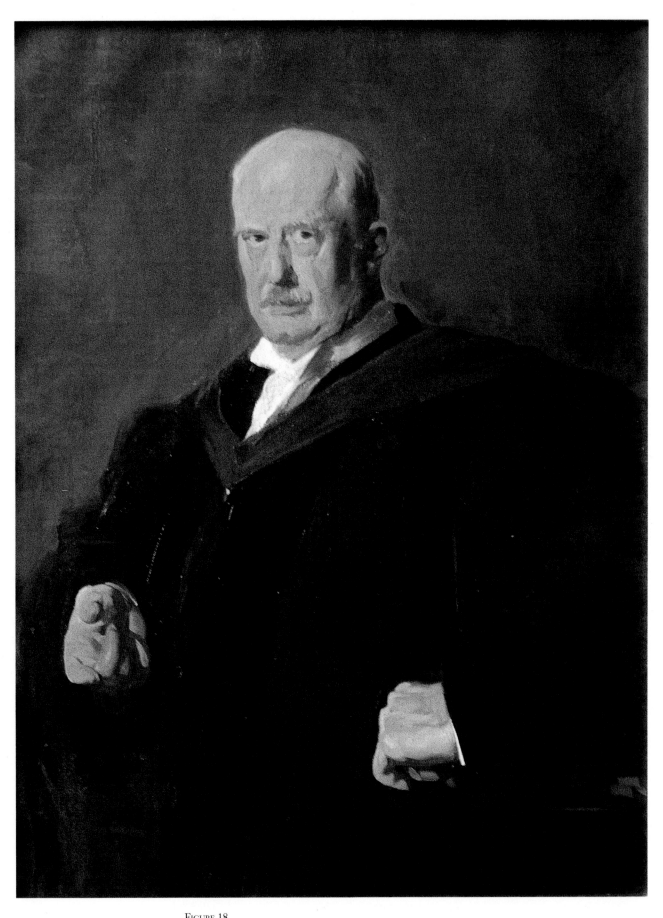

FIGURE 18
George Bellows. *Portrait of Dr. Walter Quincy Scott*, 1912. Oil on canvas, 44 x 34 in.
Ohio State University Libraries.

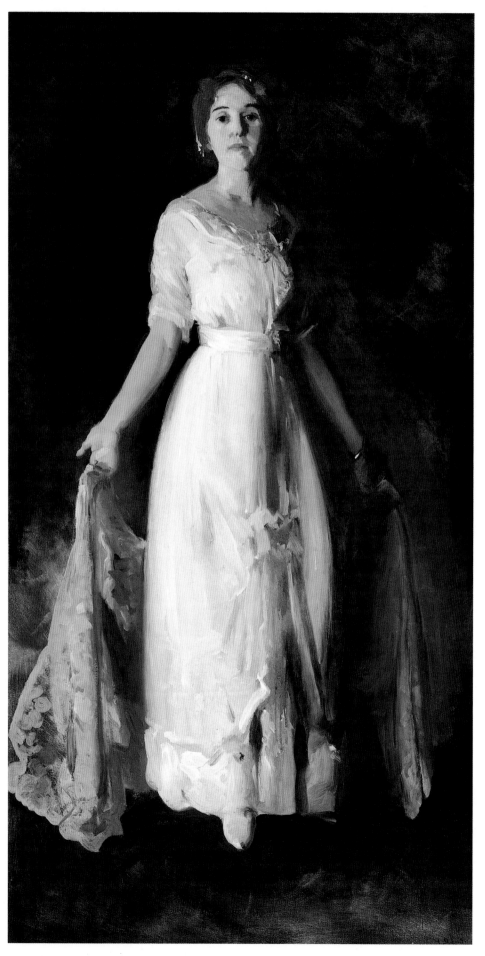

FIGURE 19
George Bellows. *Mrs. Albert M. Miller*, 1912. Oil on canvas, 77 x 40¼ in. Columbus Museum of Art, Ohio; gift of Mrs. H. Bartley Arnold.

192

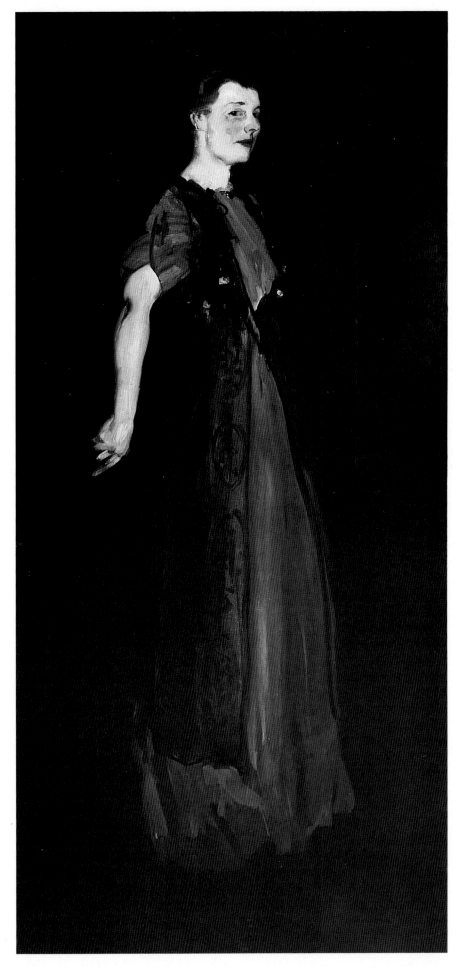

Figure 20
George Bellows. *Mrs. H. B. Arnold*,
1913. Oil on canvas, 77½ x 37 in.
Columbus Museum of Art, Ohio;
gift of H. Bartley Arnold.

The Armory Show of February 1913 marked a turning point in Bellows's career, although he never fully embraced the tenets of modernism that he first discovered there. Having already gauged his portraiture against the work of old masters like Hals and Velázquez and contemporaries as diverse as Henri and Cecilia Beaux, Bellows considered it against the work of the modernists, as well. It is somewhat ironic that this group helped the ardent "realist" find his métier as a portraitist. It was as if the bold and imaginative distortions of modernism had given him free license to render ordinary portrait subjects in a creative and exhilarating manner.[48] While the rhetoric that the Armory Show engendered was not specifically of concern to him, the exhibition served as a catalyst for a period of experimentation. Perceiving that the breach between the realists and modernists was not absolute, Bellows arrived at a distinctive blend of modernist experimentation and truthful portrayal. He and members of the Henri circle held a moderate position between the academic status quo and the disruption of modernism, and that gave them an edge in attracting portrait commissions.[49]

For Bellows, color, which he had already brilliantly employed to dramatic pictorial effect in his seascapes of 1913, had become an adjunct to the expressive potential of figural subjects. He could appreciate that the modernists "try to get the same emotional reflexes from paint and canvas placed in harmonic orders or relations, without regard to representations, that the musical composer tries for in harmonic proportions of sound and tune."[50] His attempts to paint a prominent judge, Peter Butler Olney, according to these new theories provoked considerable controversy, however. The Harvard Club retained Bellows to paint Judge Olney's portrait in the summer of 1914, and he completed two versions by the following spring; after rejecting both paintings, the Club balked at paying Bellows his commission. The second Olney portrait (fig. 21) was rendered in a brilliant palette of green, purple, and yellow which, contrasted with the narrow range of color employed in his recent portraits of society women, underscores how thoroughly Bellows had assimilated bold color contrasts following the Armory Show.[51] He audaciously featured the painting in two exhibitions devoted to contemporary portraiture, and it excited considerable commentary, both positive and negative.[52] One reviewer saw in it "a new set of faculties, those of sensuous emotion, rather than those of intellect. . . .The portrait is of secondary interest in the violent appeal of colour."[53] Yet Bellows's ego was bruised by negative reactions to it. Reacting to the criticism of Forbes Watson, he observed that "the critic should realize that he is not competent to teach the artist. He may be competent to teach the public."[54]

This debate reflects the broader ambitions that Bellows had begun to ascribe to portraiture. Beginning in the summer of 1914, his pursuit of the human form began to play a significantly expanded role in his oeuvre. Responding to the impact of the Armory Show, to the problematic nature of commissions, and perhaps to the incessant, often detrimental parallels that critics drew between his work and that of such important predecessors as the esteemed Manet, Bellows turned to new concerns in his portraiture—brilliant color, in particular. He began to concentrate much of his painting into the summer months, which he spent away from New York City. Beginning with his trip to Maine in 1911, Bellows had been stirred by the opportunities for concentrated study that he found in summers of relative isolation. Although he regretted the disconnected nature of these intensely productive periods, relegated as they were to a few months each year,[55] his portraiture, now evolving into a protracted undertaking, benefitted from these sojourns beyond the demands of urban life. From the summer of 1914 through the summer of 1919, Bellows explored the figural themes that would become his chief concern during his five remaining summers.[56]

Heeding Henri's insistence on the development of an individualized pictorial language and renewed by his encounter with modernism, Bellows during the summer of 1914 committed himself to portraiture with a fresh intensity, painting over fifteen canvases, most a uniform thirty by thirty-eight inches in size. All depicted female subjects: his wife, friends, and residents of Monhegan Island. In contrast to the sitters in his Ohio State University and Columbus society portraits, his Monhegan subjects were individuals he had freely selected. Emancipated from the vagaries of commissioned work, Bellows employed an array of dramatic devices and imparted vitality to a genre that did not, by its traditionally conservative nature, readily lend itself to inventive compositions. He used theatrical lighting; broad,

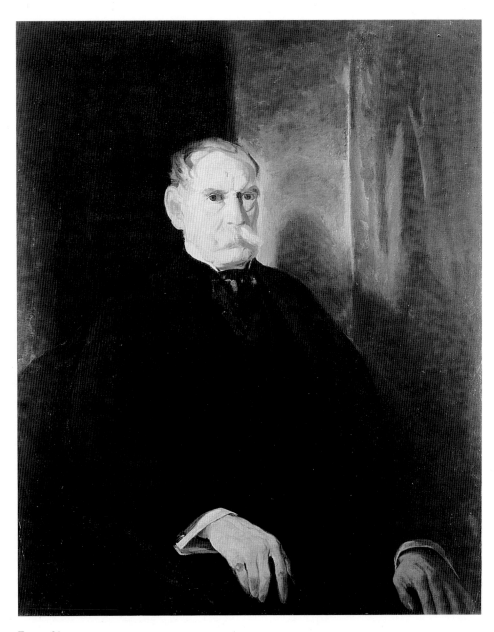

FIGURE 21
George Bellows. *Judge Peter Butler Olney*, 1915. Oil on canvas, 48 x 38 in.;
verso of *Polo Game* (see page 28). Private collection.

localized shadows; bold coloration; richly applied brushwork; and flesh tones rendered in
unflattering pallid hues—elements later assailed in the second Olney portrait. These
resulted in strident delineations that sometimes belied gentle characterizations. In his
portrait of Florence Davey (fig. 22), for example, the harsh lighting of the figure and the
heightened colors, such as turquoise in the background, contribute a sense of vitality to the
elegant subject.

Bellows experienced a surge of creativity that summer and reveled in the variety of
effects he was achieving. He wrote Henri in August that, upon his departure from
Monhegan, he would have twenty paintings, each portrait in a different light.[57] This delight
in experimentation is evident in his two portrayals of Geraldine Lee Nott, the daughter of
a local fisherman. Among the first portraits executed that summer, the Geraldine Lee
paintings (figs. 23 and 25) exhibit a characteristic format: they are vertical compositions with
the sitter's head set against a suggestion of a geometrically demarcated background. The

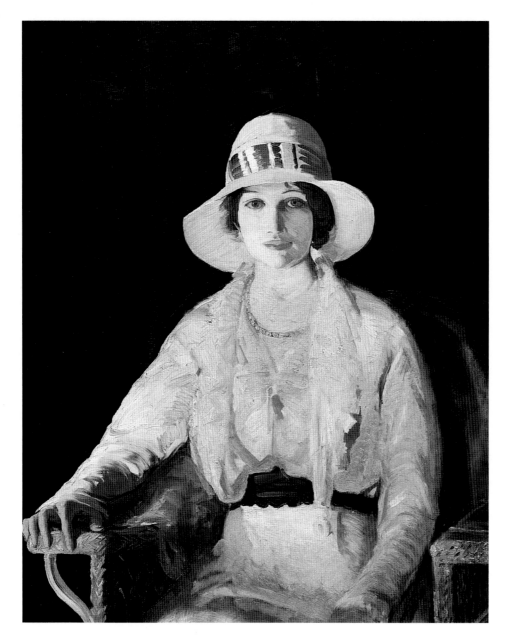

FIGURE 22
George Bellows. *Florence Davey*, 1914. Oil on panel, 38 x 30 in. National Gallery of Art,
Washington, D.C.; gift of Florence S. McCormick.

first version was painted as a three-quarter-length view of a girl, slightly turned from the
viewer, and her dog; it was subsequently cut down to a portrait bust.[58] In the second view,
the sitter is presented in a more naturalistic fashion; slouched in her chair, she confronts the
viewer with a direct gaze as her gracefully extended left arm rests on her chair in an unfeigned
and relaxed manner. Like *Young Brittany Woman, "Lammerche"* (fig. 24) by Bellows's
acquaintance, Cecilia Beaux, the *Geraldine Lee* paintings exhibit a spirit of tentative
awakening and dreamy repose animated through brushwork, color, and shifting light.
Glowing illumination from an undetermined source deftly imparts a momentary quality to
the second version.[59] Heightened color and controlled, sure brushstrokes enliven *Geraldine
Lee, No. 2* (fig. 25), but the portrait lacks the good-humored liveliness and salient quirks
evident in Bellows's earlier studies of children. Instead a quality of feminine reflection,
popular in turn-of-the century painting, and a modern forthrightness characterize the

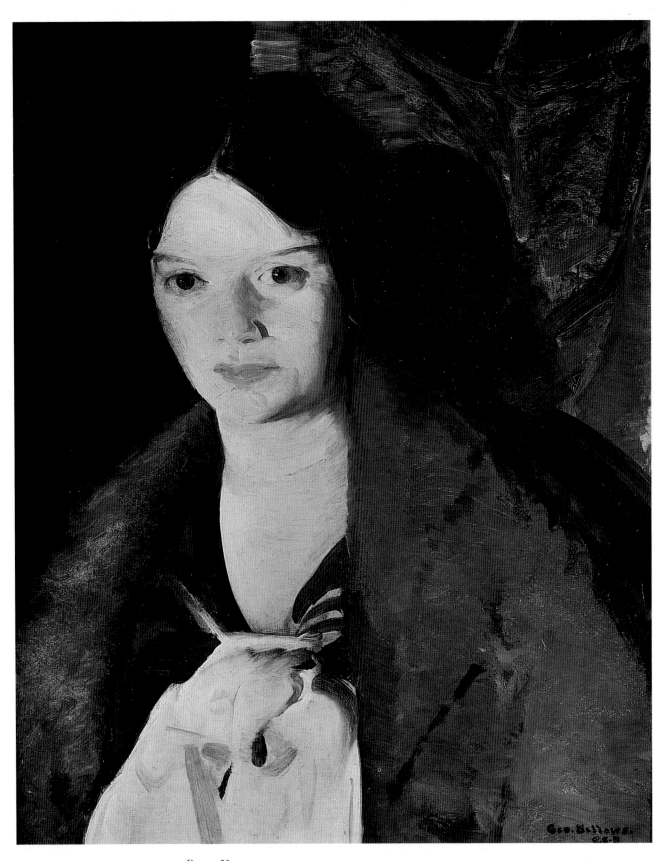

FIGURE 23
George Bellows. *Geraldine Lee, No. 1*, 1914. Oil on panel, 22 x 18 in.
Washington University Gallery of Art, Saint Louis, Missouri.

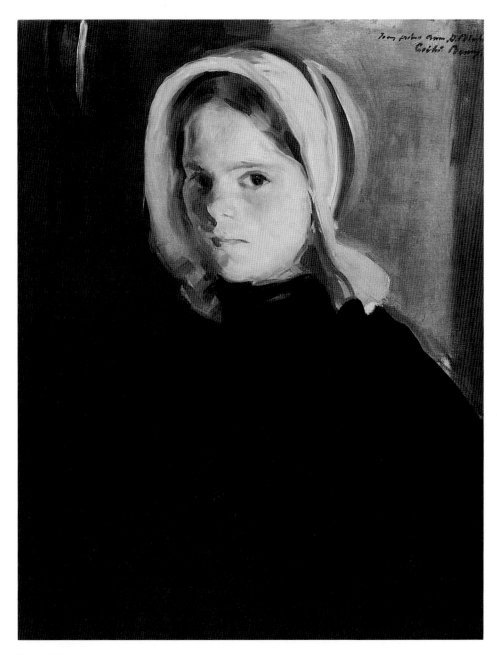

F IGURE 24
Cecilia Beaux. *Young Brittany Woman, "Lammerche,"* c. 1902. Oil on canvas, 24 x 19 in.
Fine Arts Museums of San Francisco; gift of Mr. and Mrs. John D. Rockefeller 3rd.

young woman. She projects an assertive demeanor, perhaps reflecting the artist's sympa-
thies with progressive thought and with the women's suffrage movement.[60]

Bellows was gradually coming to the belief that profound artistic achievement
involved synthesizing the ordinary aspects of the sitter with the greater themes of human
existence. Patiently responding to a young girl in Texas, who was intrigued by the painterly
effects of the first version of *Geraldine Lee*, he wrote:

> To tell you why I painted Geraldine Lee would necessitate an essay on my philosophy
> of life and of art. The reasons for painting her were not different than the reasons for
> painting anything else. She offered me a subject or a "point of departure" as we say,
> or a "motif" or lets just say some ideas for the play of my creative fancy.[61]

Although the expressive power of Bellows's 1914 portraits marked a turning point
within his own work, these paintings, like works by the Realists in general, seemed prosaic
when compared to the examples of American and European modernism featured in the

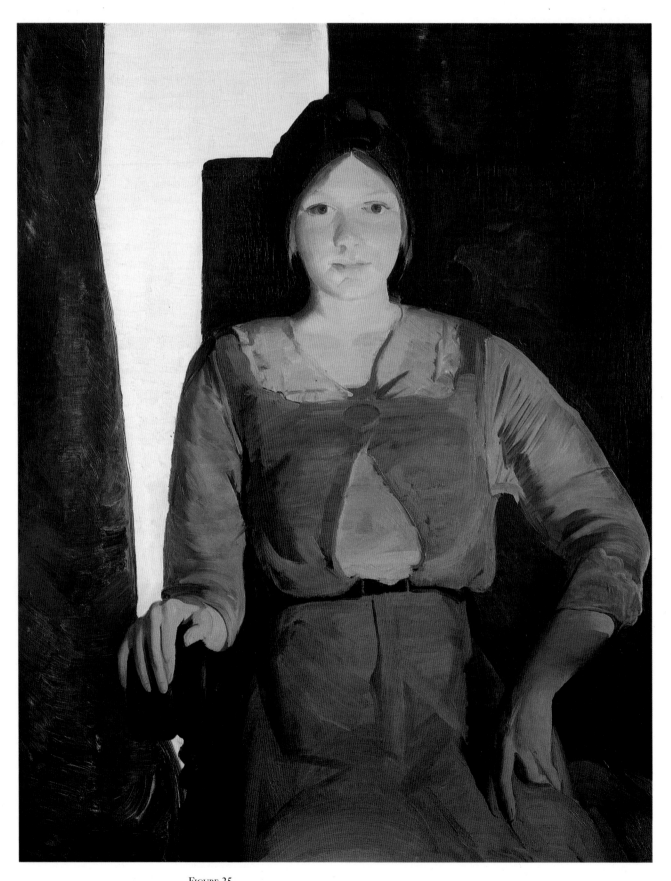

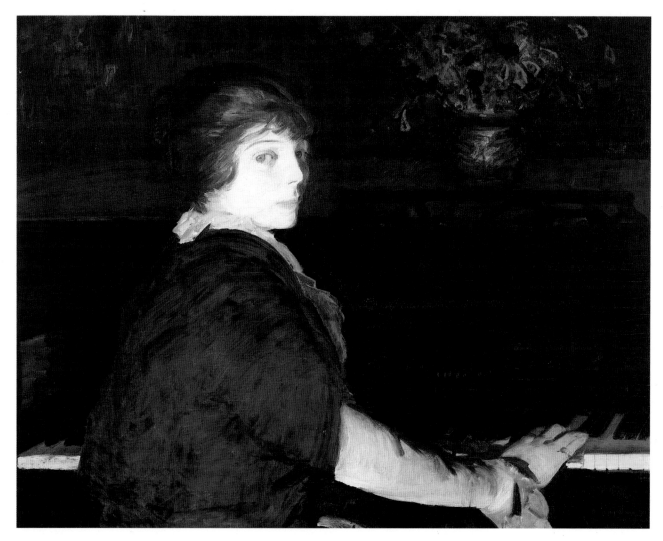

FIGURE 26
George Bellows. *Emma at the Piano*, 1914. Oil on panel, 30 x 38¼ in.
Chrysler Museum, Norfolk, Virginia.

Armory Show. As a result, the portraits made little impact at the time. When *Geraldine Lee, No. 2* was exhibited at Montross Gallery in 1914, critic Henry McBride, a champion of modernism who admired the formal qualities of Bellows's painting, noted that the work would not "provoke discussion" because its style was familiar as a Manet, and facile in contrast with the sensational offerings of the Armory Show.[62]

Bellows never distanced himself from the actual appearance of his subject, as was the tendency of abstract painters. Yet modernism encouraged his experimentation with emotive content conveyed through color and line. It also reinforced his idea that the artist's own emotions impacted the work of art. He never forgot Henri's philosophy that design elements must bespeak the content: "It is one of the mistakes, one of the big mistakes that is made, this idea of regarding color in itself as beauty. Color is no more beautiful than a line is, and the face of a woman is beautiful because of what it expresses. If it does not express a thing that we greatly like, then it is not beautiful."[63]

While Bellows's portraiture remained representational, it began to take on a grander thematic purpose and symbolic realism. For his most important treatments of the human figure, he turned to his family, where he often was successful in merging reportage and sentiment. Although, in its depiction of a simultaneously frank and compliant woman, *Emma at the Piano* (fig. 26) resembles other portraits painted during the summer of 1914, this painting represents a greater psychological interaction with the artist than others from the period. In a compositional format redolent of numerous art historical antecedents,[64] the artist captures his wife in a private moment of suspended action; her hand still lingering on

the piano keys, she provocatively turns her head to engage the viewer as a privileged participant in this exchange. Informing this serene portrayal is the mannered "japonisme" associated with Whistler and the Aesthetic Movement, expressed through the emphatic horizontal divisions of the piano's surfaces and a flat, decorative aspect extending to the sitter's barely modulated arm. Bellows employed a selective palette with vivid accents: Emma's rich blue dress and luminous white ruffled blouse are balanced by identical tonalities in the piano's ivory keys. Rhythmic color harmonies carried out by other coloristic touches—the red applied in the corner of Emma's eye, pink in her mouth and cheeks—are echoed in the broadly rendered still life, which sits atop the piano and serves as a graceful counterpoint to the sitter.

Few portraits of this period had the emotional intimacy of *Emma at the Piano*. As part of a broader iconographic program, Bellows began increasingly to distance himself from intimate psychological interaction with his subjects. Instead of portraying them on an immediate level, reflecting only their individual personalities and their familial relationships to the artist (as husband and wife or father and child), he began to give his subjects universal, archetypal connotations as well. Bellows perceived intangible qualities of character and beauty that surpassed mere comeliness in his female sitters. They began to personify larger themes, which would expand late in his career, and the artist's style became more exacting as he searched for thematic and formal abstractions.

This more intellectual approach to his work soon prompted critics to take notice. Some took exception to the preoccupation with technique and the aesthetic sacrifices he made for theme and subject. As one critic concluded: "*Geraldine Lee No. 1* was as interesting for lighting and pattern of mass and colour as it was for Geraldine Lee."[65] Although Bellows may have altered his style to suit his new painting concerns, some critics saw his style hardening into something superficial and formulaic (the same charges, ironically, that were being leveled against high-style portraits). Guy Pène du Bois wrote: "In [Bellows's portraits] we see only technical expertness before which the flicker of admiration must soon die."[66]

During the summer of 1914, the autobiographical element of Bellows's portraits began to merge with his developing interest in the fisherfolk of Maine. Fascinated by the lives of the local inhabitants, Bellows painted the fishermen's offspring in Monhegan (1914) and Ogunquit (1915) and their everyday activities in Camden in 1916 (see pages 158 and 159). Not only did these subjects suit the artist's informal, unpretentious approach to figural work, but he also saw in them the quintessential American quality of industriousness. Other artists working with similar subjects, such as Charles Hawthorne (like Bellows, a student of William Merritt Chase), had followed the example of Winslow Homer and ascertained picturesque qualities of human endurance (fig. 27). Beginning around the turn of the century, Hawthorne had focused on the inhabitants of Cape Cod, and his paintings were well received by contemporary audiences and critics.[67] In works which emphasized the more commercial and communal aspects of his subjects' lives, Hawthorne suggested the sentimentality of nineteenth-century genre painting grafted onto the American realist tradition.

Bellows's images of Maine shared the narrative underpinning of Hawthorne's work, but they had a more intense autobiographical element. In *Fisherman's Family* and *Evening Group*, two paintings begun during the summer of 1914, Bellows established a strong link uniting himself and his family with the fishermen and their habitat. Both paintings depict the artist, his wife, and their daughter, Anne, in settings that obscure the demarcation between portraiture and landscape and tantalizingly suggest literary and biblical associations. Like the individual portraits of this period, the group paintings employ a bold palette which reinforces their implied symbolic content. *Evening Group* (see page 157) describes the intense light of a summer sunset, imparting to the scene an elegiac aspect similar to that in *Geraldine Lee No. 2*. An otherworldly quality is also suggested by the "deep slate grey, emerald greens, ultra marine blues and strange reds" noted in a contemporary description of *Fisherman's Family*, which was destroyed sometime after 1919.[68] In both paintings, the simplified landscape is geometrically ordered in large masses, providing a structured environment for the figural groupings with Bellows himself as the focal point (see page 47). Within this setting, as seen in *Evening Group*, Bellows's family commingles with the

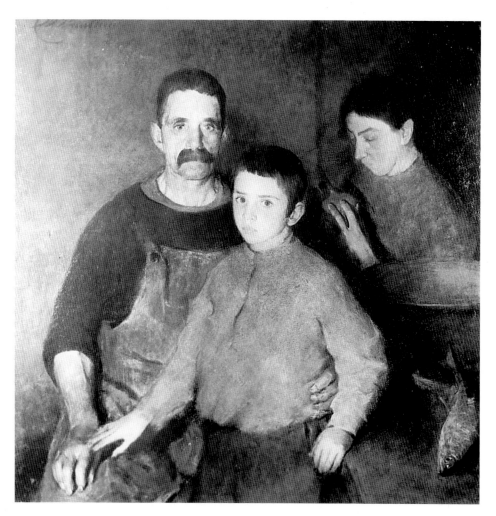

Charles Hawthorne. *The Family*, 1911. Oil on panel, 40 x 40 in. Albright-Knox Art Gallery, Buffalo, New York; Friends Fund, 1911 or before.

common folk of coastal Maine—a people who embodied earnest hard work and a precarious life surrounded by nature's unpredictability. The result is a romantic fantasy about life's struggles, in which the artist and his family unite with the fishermen's families to meet the challenge of a rugged existence.[69]

Bellows used portraiture to take stock of himself artistically. He frequently appraised his work not only in relation to his own efforts but in comparison with acknowledged masters. His inquisitive nature prompted him to investigate a broad range of historical prototypes, including some he would soon discard. He acknowledged the adaptability of his approach: "I am not trying to complete everything, but rather searching for new ideas and impressions and trying to learn as much as possible."[70]

Although Bellows could not countenance the genteel portrait tradition, he found a middle ground in the diverse portrait styles represented by the National Association of Portrait Painters. From 1915 to 1920, he exhibited with this group, which had organized in 1912 to express "more natural pictorial interest" and to dispense with "the tiresomely conventional and perfunctory portrait."[71] Bellows allowed himself the freedom to explore new arenas of figural painting; during his last summer trip to Maine in 1916, he began to experiment with figures out-of-doors and subsequently used the landscape to intensify the expressiveness of his portraits.

This spirit of experimentation is evident in two unfinished canvases of Emma and their children (figs. 28 and 29), likely executed in Camden, Maine, during the summer of 1916. Bellows attempted an ambitious composition, in a size like that of his early boxing pictures. The works depict Emma on a hammock, Anne at her side and a young Jean on her lap, in

FIGURE 28
George Bellows. *Study for Emma and the Children*, [1916]. Oil on canvas, 58¼ x 67 in. Museum of Fine Arts, Boston; Abraham Shuman Fund.

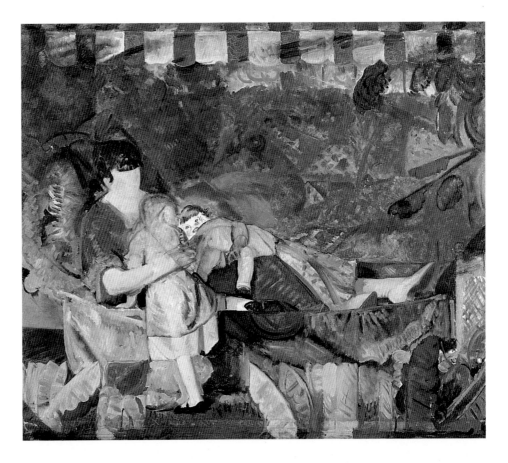

FIGURE 29
George Bellows. *My Family*, 1916. Oil on canvas, 59¾ x 66⅛ in. National Gallery of Art, Washington, D.C.; Collection of Mr. and Mrs. Paul Mellon.

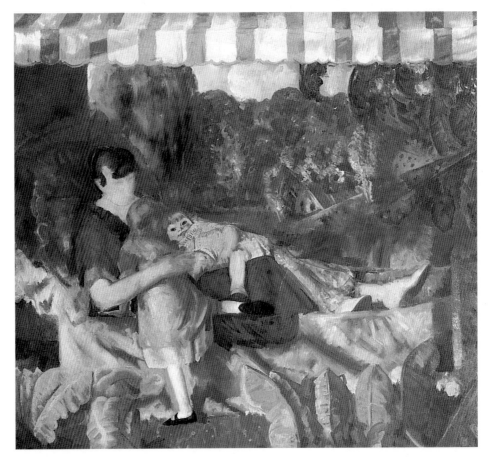

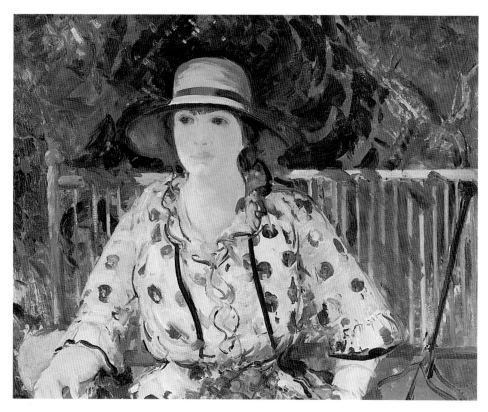

FIGURE 30
George Bellows. *Emma in the Orchard*, 1916. Oil on canvas, 30 x 38 in.
Cummer Gallery of Art, Jacksonville, Florida.

FIGURE 31
Leon Kroll. *In the Country*, 1916.
Oil on canvas, 46 x 52 in. Detroit
Institute of Arts; Founders Society
Purchase, Special Membership and
Donations Fund with a contribu-
tion from J. J. Crowley.

a verdant setting surrounded by trees and ferns. Exploring the interstices of portraiture and the natural world, Bellows daringly invoked a range of European sources, from the English "conversation piece" of the eighteenth century to the avant-garde, tapestry-like paintings of the French Nabis, Pierre Bonnard and Edouard Vuillard. These tentative forays into a more ambitious multifigural portrait genre, each possessing a singularly strident color scheme, apparently fell short of Bellows's expectations, however, for he completed neither.[72]

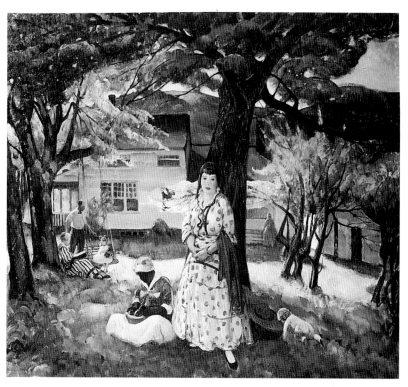

Another of Bellows's paintings from 1916, *Emma in an Orchard* (fig. 30), brings to mind another European prototype: the venerable Manet had depicted his own wife (as for Bellows, a favorite subject) in a comparable verdant setting in *Madame Manet in the Conservatory* (1879, Nasjonalgalleriet, Oslo). Bellows's fellow artist and close friend, Leon Kroll, who spent the summer of 1916 with the Bellows family in Maine, likewise investigated luminous and colorful outdoor figural compositions, including his own pastoral rendering of Emma Bellows (wearing a dress identical to that in *Emma in an Orchard*), surrounded by members of her family (fig. 31). Kroll was an admirer of Renoir and Cézanne, and he encouraged Bellows toward experiments in Impressionism and Postimpressionism.[73] As he later

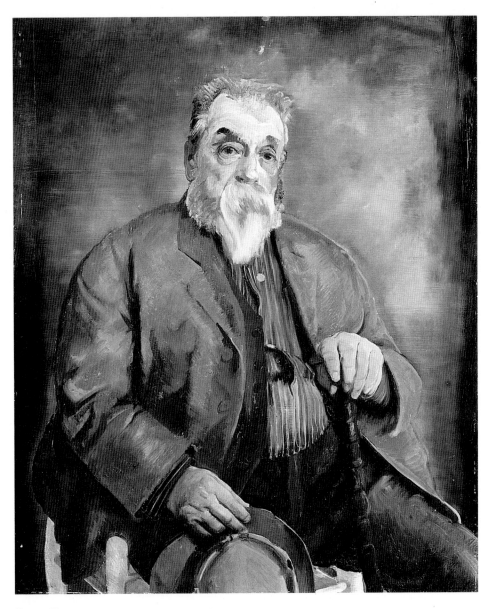

FIGURE 32
George Bellows. *Padre*, 1917. Oil on panel, 40 x 32 in.
Metropolitan Museum of Art, New York; Rogers Fund, 1941.

recalled that summer: "I gave Bellows some criticism every day. He was in a rut, and he loved the criticism."[74]

During a trip to California in the summer of 1917, Bellows began to synthesize his study of artistic precedents with his broader thematic concerns. His portraits, genre paintings, and figural landscapes of the preceding few years had sought to embrace humanity's colorful diversity: "The men of the docks, . . . summer evening and romance, village folk, young people, old people, the beautiful, the ugly. . ."[75] Now he began to give his portrait figures even broader connotations; more than individual characters, they now became allegorical representations of larger qualities of the human spirit, such as fortitude, permanence, or continuity. Reprising and expanding a theme Bellows had first attempted in his 1906 painting of his father, the California portraits explored questions of age. Their titles, *Padre* (fig. 32) and *The Widow* (fig. 33), suggest broader implications by identifying

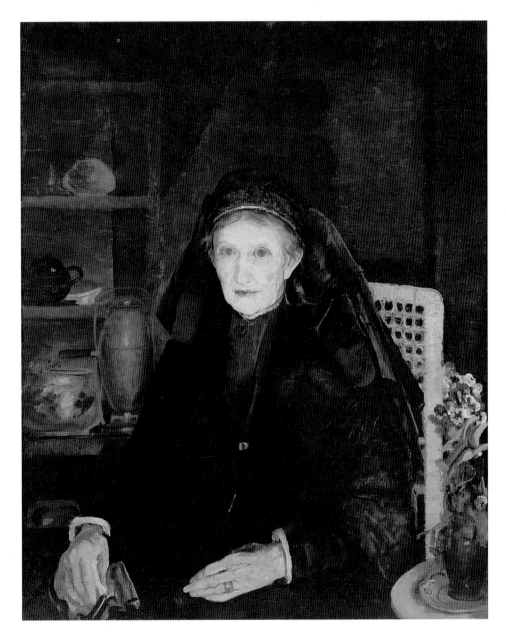

FIGURE 33
George Bellows. *The Widow*, 1917. Oil on panel, 39½ x 31½ in.
Baltimore Museum of Art, Maryland; Museum purchase.

the sitters as types rather than as named individuals. (*The Widow*, for example, is a portrait of Bellows's aunt, Elinor "Fanny" Daggett.) The effects of age are accentuated by the substantial size of the paintings, which are forty by thirty-two inches each. *Padre* has a particularly powerful presence, and Bellows wrote to Emma that "nothing I have done except 'Padre' is any better—at least for a long time."[76]

Bellows deeply admired Thomas Eakins, whom Henri had proclaimed as the greatest American portrait painter, and Eakins, whose memorial exhibition would open at the Metropolitan Museum of Art late in 1917, undoubtedly brought Bellows to a more profound understanding of portraiture as an essential and noble expression of human nature.[77] It has recently been suggested that Eakins's later conception of the portrait extended to an examination of professional types, as in *The Art Student* (1890, Manoogian Collection),[78] whereas Bellows's mature portraits emphasized the more universal human experience of the stages of life. Like Eakins, Bellows was drawn to subjects, principally women, who patiently endured and candidly projected the emotional vicissitudes of life. Both men also excelled

George Bellows

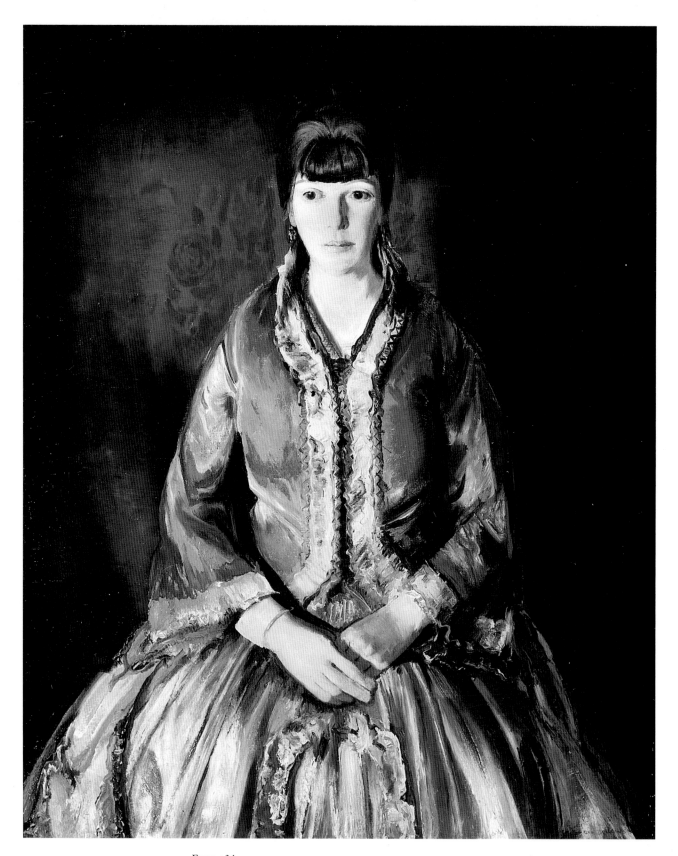

in rendering individuals who were close to them and used the empathy achieved by a close identification between sitter and artist to endow the work with significance; Eakins, however, ultimately painted the more poignant and painfully honest portraits.[79]

Applying this more cerebral approach, Bellows undertook a careful study of the individuals in his immediate sphere when he, his wife, daughters, and mother summered in Middletown, Rhode Island, in 1919. Two portraits of Emma, *Emma in the Black Print* (see page 69) and *Emma in a Purple Dress* (fig. 34), and a portrait of his mother, *Grandma Bellows* (see page 70), from that season anticipate his more concentrated explorations of womanly qualities over the next few years. Bellows's deep respect for Emma, which he romantically expressed during their early days together—"Can I tell you that your heart is in me and your portrait is in all my work"[80]—remained constant throughout their marriage, and his paintings of his wife are pictorial tributes to femininity and steadfastness, fortitude and other stalwart qualities Bellows deeply admired. Portraits like *Emma in the Black Print* convey his affectionate regard for her as an equal, indispensable participant in the enduring family structure.

When Bellows treated his mother on canvas during the summer of 1919 (see page 70),[81] he used a heightened solemnity reminiscent of Eakins. The dignity of advanced age was to be one of his frequent subjects during these years, and he seemed to concur with Henri's observation that "age need not destroy beauty. There are people who grow more beautiful as they grow older. If age means to them an expansion and development of character this new mental and spiritual state will have its effect on the physical."[82] Instead of glossing over the inescapable signs of aging, he thoughtfully documented, through the painted passages of wrinkled and translucent skin, the vulnerabilities and imposed quietude of old age. His treatments of aging sometimes were complicated by the questions of marital state, which often involved loss, such as widowhood or an unrealized union.

Although Bellows frequently expressed these themes in terms of his own family, the issues unfold most dramatically in his three portraits of an elderly woman who was, in fact, unrelated to him. Bellows met Mary Brown Tyler (1841–1922), a member of a prominent Illinois family, near the end of 1919, when he assumed a two-month teaching position at the Art Institute of Chicago.[83] In the first version, taken from life, Mrs. Tyler, then in her late seventies, is attired in an old-fashioned, yet sumptuous, magenta silk dress (fig. 35). In the second and third versions (fig. 36 and page 72), she wears the dress in which she was married in 1863.[84] Together, the three portraits candidly assess the ravages of age. Bellows was unquestionably attracted to the strength and character of this woman, yet there is an undeniable air of underlying sadness disclosed through the conspicuous fact of her years, which appear to advance noticeably with each presentation.

This serial repetition of Mrs. Tyler over a brief time span is the most overt example of Bellows's temporal concerns—a theme he also exhibited in his repeated images of his daughters' development. In the first portrait, she comes across as a woman of indomitable spirit who, despite her frailty, displays an inner strength through her slight, knowing smile. Among the most immediate and accessible of Bellows's portraits, *Mrs. T. in Wine Silk* is an effective merging of individual characterization and impressionistic details. Intimations of character—the slight tilt of the head, the drooping shoulders, and the gloves gracefully entwined in her left hand—are animated by painterly flourishes which describe a stylish headpiece and frilly blouse. The second and third portraits lack the vibrancy of the first and express the more despairing aspects of the aging process. Her drawn visage, elaborate yet brittle dress, and incongruously gay bouquet speak to lost opportunities, decay, and melancholia—a shift that the artist's eventual geographic remove from his subject does not entirely explicate. In the end, two of the portraits returned to New York with Bellows: their purported rejection by the Tyler family extended to Mary Brown Tyler's name, which was soon truncated in the titles to the more anonymous "Mrs. T."[85]

Certainly, Bellows did not regard the three versions of Mrs. Tyler as redundant. The subsequent addition of the wedding dress created a variation on a theme that significantly, yet subtly, altered the first painting's meaning.[86] In principle, Bellows believed that no painting could be reproduced precisely, for analysis of method and formula alone were inadequate without the creative mind, and "there would . . . be elements which [the artist]

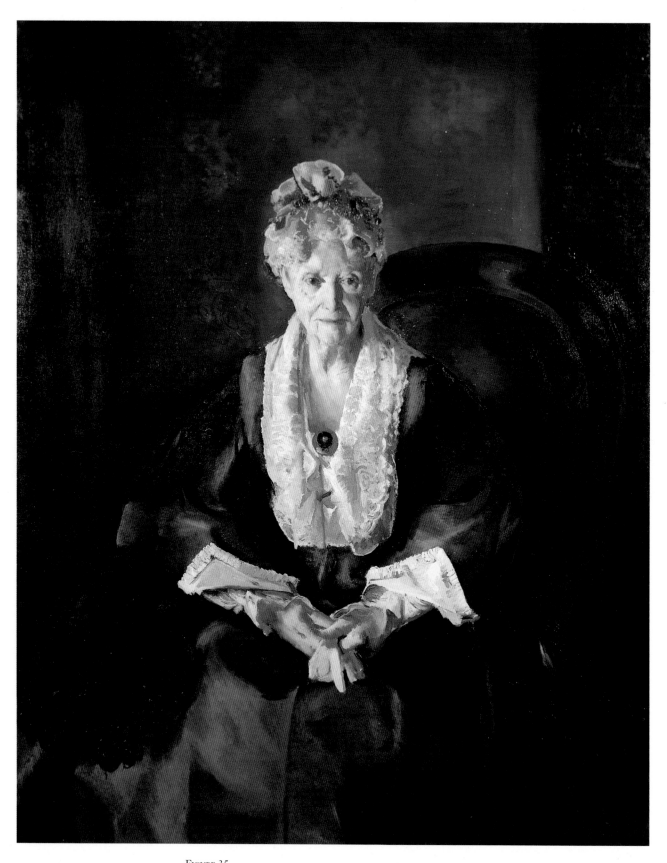

FIGURE 35
George Bellows. *Mrs. T. in Wine Silk*, 1919. Oil on canvas, 48 x 38 in.
Mitchell Museum, Mount Vernon, Illinois; gift of John R. and Eleanor R. Mitchell.

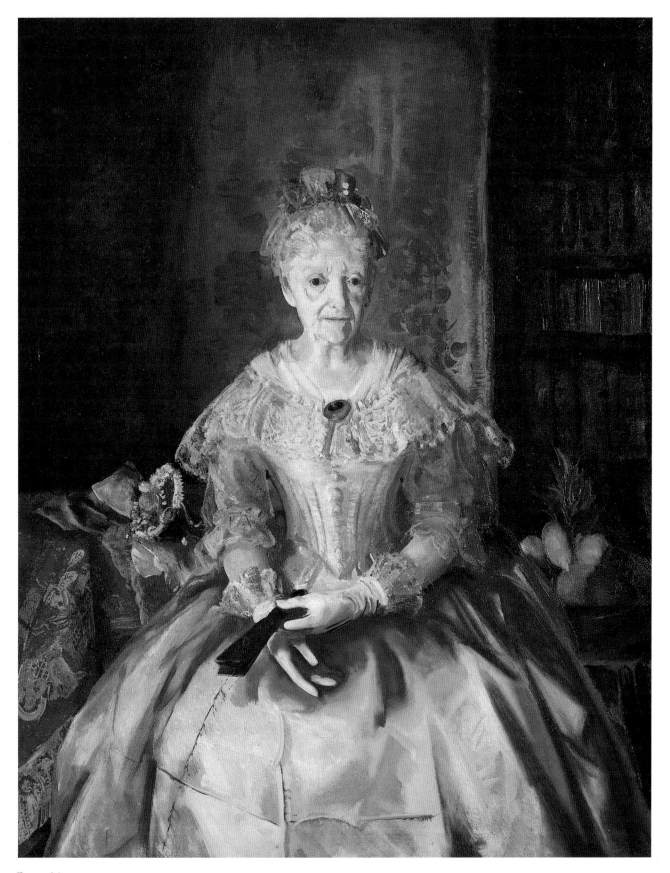

FIGURE 36
George Bellows. *Mrs. T. in Cream Silk, No. 1*, 1919–23. Oil on canvas, 48⅛ x 38 in.
Hirshhorn Museum and Sculpture Garden, Smithsonian Institution, Washington, D.C.;
Joseph H. Hirshhorn Bequest, 1981.

FIGURE 37
Emma Bellows (?). *Lorna Hazel, Jean Bellows, George Bellows, Anne Bellows, and Helen Hazel, Woodstock, New York*. Undated photograph in George Bellows Papers, Special Collections Department, Amherst College Library.

could not duplicate: mysterious effects resulting from the subtle mental power which we term inspiration."[87]

A few years before he painted Mrs. Tyler, and echoing his earlier comments about Sloan's painting of a clown, Bellows had professed a mandate to portray "the story of the emotion."[88] An avid reader of popular fiction, who relished spinning a good yarn, he had profitably combined his skills as a draftsman with his vivid imagination in his commissioned magazine illustrations. The deep reservoir of individual human experience informed Bellows's view of the portrait subject: "To me art is an interpretation of life. It may be in pictures or in music or in literature, but whatever the form of expression is, art must tell a

story."[89] There seems to be a fictional dimension in the *Mrs. T.* paintings as well, although the narrative content, despite the plethora of details, never is stated directly. Mrs. Tyler's wistful attitude and faded gown suggest the unrequited longing and demented tenacity of Charles Dickens's Miss Haversham.[90] Indeed, the facts of Mrs. Tyler's life suggest a sorrowful matrimonial state, for she had maintained a separate address from her husband for several years prior to his death.[91] While Bellows likely was unaware of this biographical detail, nevertheless, the resurrection of the wedding gown curiously alludes to an unfulfilled marriage.

Increasingly fascinated by curious, incidental details and by patterns and textures, Bellows selected Mrs. Tyler's bull's-eye brooch, a prominent element in the preparatory drawing done from life (1919, Fogg Art Museum), as the fixed focal point for all three compositions.[92] In his later versions of the *Mrs. T.* series, the patterned wallpaper, bouquet, fruit still life, bookcase, and embellishments of the wedding gown help to place the sitter in an anachronistic purgatory and further distance the viewer from the contemporary fact of Mrs. Tyler. Her antiquated attire itself must also have appealed to Bellows's romantic side, and particularly to his fascination with nineteenth-century historical dress. (In fact, Bellows greatly appreciated the decorative potential of "dress up" clothes in general; at the annual bohemian romp known as the Maverick Festival, near the Bellows's summer home in Woodstock, New York, the artist indulged his insatiable sense of play with fancy, imaginative attire [fig. 37].)[93]

To impart to the viewer specific feelings he experienced in portraying a scene, Bellows included, and often exaggerated, contextual details. In both his choice of props and his increasing concern for period costume, he again emulated Eakins. The prominent arc of the carved Victorian chair in *Mrs. T. in Wine Silk* and *Mrs. T. in Cream Silk No. 2* conveys the aura of a bygone era, and Bellows so appreciated the effect that he employed this prop in a number of subsequent portraits, both lithographs and paintings, including *Emma at the Window* (1920, see page 81), two portraits of his mother (see fig. 47 and page 79), *Katherine Rosen* (see page 78), and *Anne in Purple Wrap* (see page 82). (Eakins also had a favorite carved Victorian chair which figured in a number of portraits.) Reflecting his veneration of heritage and tradition, Bellows treated costume as a descriptive component of a scene[94]; Eakins, too, had a strong sense of a better, more contemplative time in the past, and his interest in historical costume, especially colonial subjects, was expressed in a number of his works from the late 1870s and early 1880s.

In 1920, three years after he had first painted her in *The Widow*, Bellows decided to paint a second portrait of his Aunt Fanny, a champion of his boyhood artistic aspirations. Urging her to join them for their first summer in Woodstock, Bellows wrote: "if I can paint another picture with you as model, as good as the one I have done, . . . every thing will be paid for. You did not see the canvas as completed. I worked a great deal on it when I got to N.Y. I chose it to represent me in the great exhibition in the Luxembourgh [sic] Paris."[95] Bellows's second portrait, *Aunt Fanny (Old Lady in Black)* (fig. 38), reveals a woman even more advanced in years; her frail frame is cradled in a Windsor chair that seems exaggerated in scale, so diminutive is its occupant. Her conspicuous gold wedding band adds dimension to the sitter's biography and relates the painting to the recent portrayals of the elderly Mrs. Tyler. Fanny had waited a considerable part of her adult life for the man she loved, Henry Daggett, who was already married, to disengage himself from an infirm wife. Only upon the woman's death were Daggett and Fanny free to wed, which they did in 1890. When Bellows first painted his aunt in 1917, she had just lost her husband. In Bellows's second portrait Fanny, grasping a crumpled handkerchief in her wrinkled hands, raises her eyes upwards, disclosing a strength and human dignity that age could not extinguish.

During his last five painting seasons, spent with his family and friends in the artists' colony of Woodstock, Bellows regularly painted new interpretations of a few family members. As was the case with the portraits of his aunt, his new imagery built upon past motifs. The pronounced sense of gravity in *Aunt Fanny* infused Bellows's portraits during the summer of 1920. In addition to reprising his portrayal of his aunt, and of his wife in *Emma at the Window*, the artist featured his young daughters in ambitious works which delved into their growing maturity, such as *Anne in White* and *Elinor, Jean and Anna* (see figs. 43 and 44).

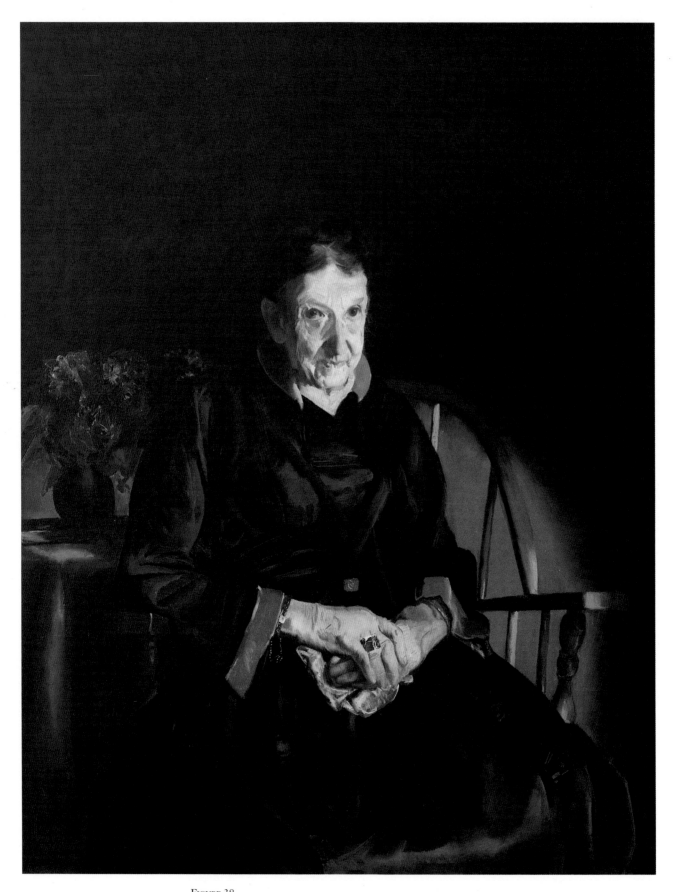

FIGURE 38
George Bellows. *Aunt Fanny (Old Lady in Black)*, 1920. Oil on canvas, 44⅛ x 34¼ in.
Des Moines Art Center; purchased with funds from the Edmundson Art Foundation, Inc.

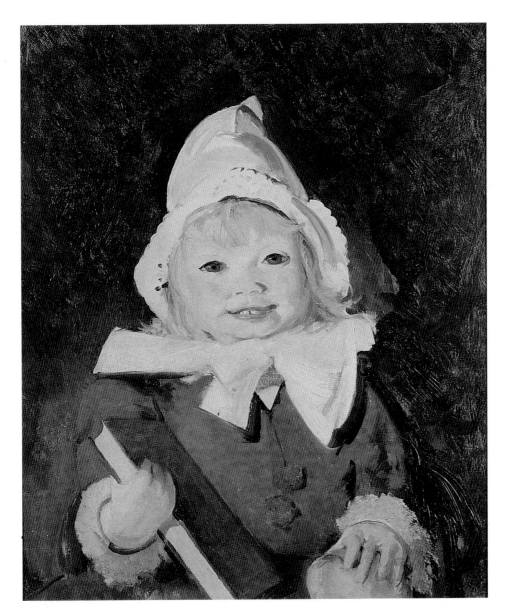

FIGURE 39
George Bellows. *Jean with Blue Book and Apple*, 1916. Oil on panel, 21½ x 17½ in. Metropolitan Museum of Art, New York; Edward Joseph Gallagher III Memorial Collection, 1957.

In his nearly annual portraits of Anne and Jean over the preceding years, Bellows had projected their lively spontaneity in paintings and drawings (figs. 39 and 40). In repeated images of his daughters' development—a series that he would continue in several media (fig. 41) up until his death—he not only showed their growth but also revealed the subtle distinctions between their temperaments: Anne was the more reserved and Jean the more impish of the two.[96] Bellows treated them as individuals, fascinating in their emerging adulthood, and created an intimate document of their family circle with his portraits. His daughters enjoyed an easy rapport with their father, and he indicated his paternal respect through these tributes to their evolving, promising lives.

During the family's first summer in Woodstock, Bellows employed a new, innovative sophistication in his use of context, posture, and design. He began to impart greater emotional weight to his portraits of family members, in paintings that were more emblematic and less concerned with the sitters' individual personalities. He believed that a figure could synthesize many sentiments and once asserted: "the lover must typify . . . the strength . . . and the nobility of all mankind, and the girl must reflect the tenderness of all womanhood."[97] The concept of femininity itself also was important to Bellows, who before Jean's birth had hoped for a son but had subsequently decided that there were manifold

214

George Bellows

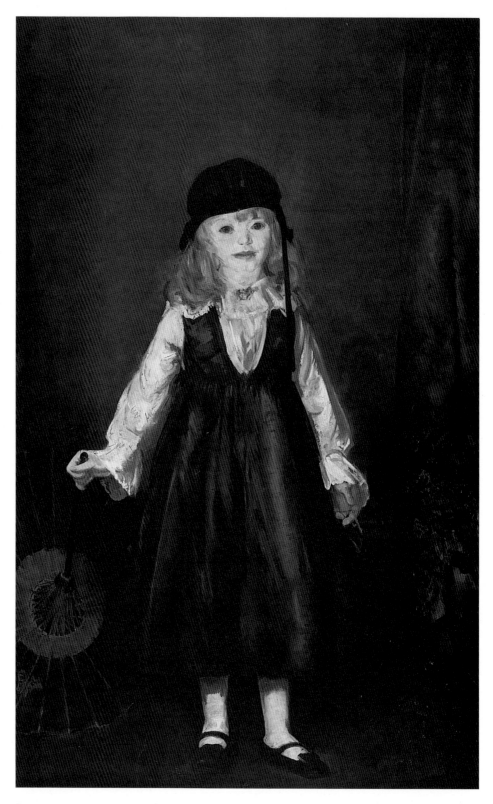

FIGURE 40
George Bellows. *Anne with a Japanese Parasol*, 1917. Oil on canvas, 59⅛ x 36⅛ in. National Gallery of Art, Washington, D.C.; Collection of Mr. and Mrs. Paul Mellon.

benefits to having only daughters. (He once exclaimed to Emma about a young male portrait subject: "The boy is an awful fine kid. but god what an itch. I am glad we have girls."[98]) This delight in his daughters' developing femininity is evident in *Anne in White*, which depicts a self-assured nine-year-old who approaches adolescence. The dominant design elements in the preliminary drawing (fig. 42) are the two objects she holds, an oriental fan and a hat,

FIGURE 41
George Bellows. *Sketch of Anne*, 1923-24.
Lithograph, 9⅞ x 8 in. Amon Carter Museum.

FIGURE 42
George Bellows. *Portrait of Anne*, 1920. Graphite on paper, 16⅞ x 12⁵⁄₁₆ in. Cleveland Museum of Art; gift of Leonard C. Hanna, Jr.

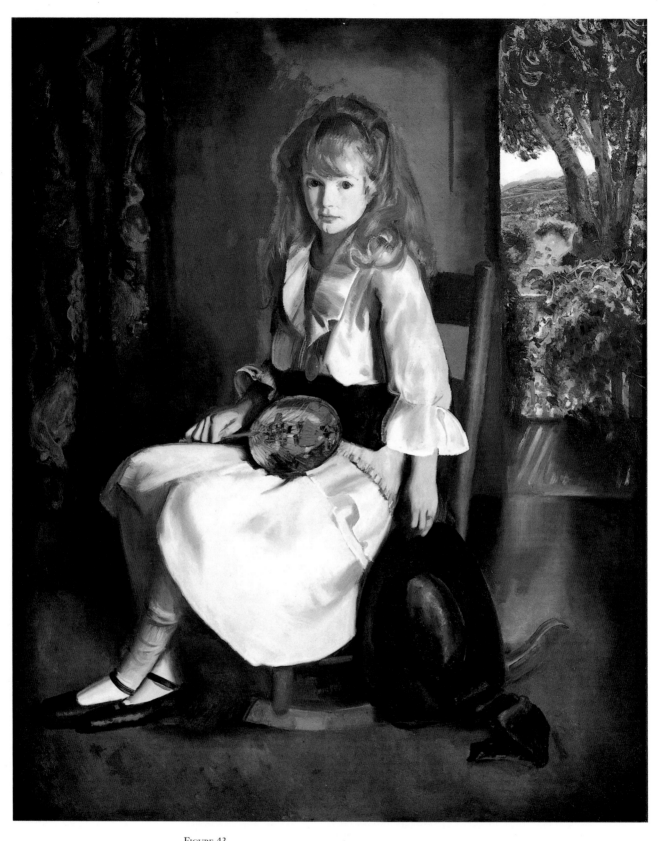

FIGURE 43
George Bellows. *Anne in White*, 1920. Oil on canvas, 57⅞ x 42⅞ in. Carnegie Museum of Art, Pittsburgh; Patrons Art Fund. Photograph by Tom Barr.

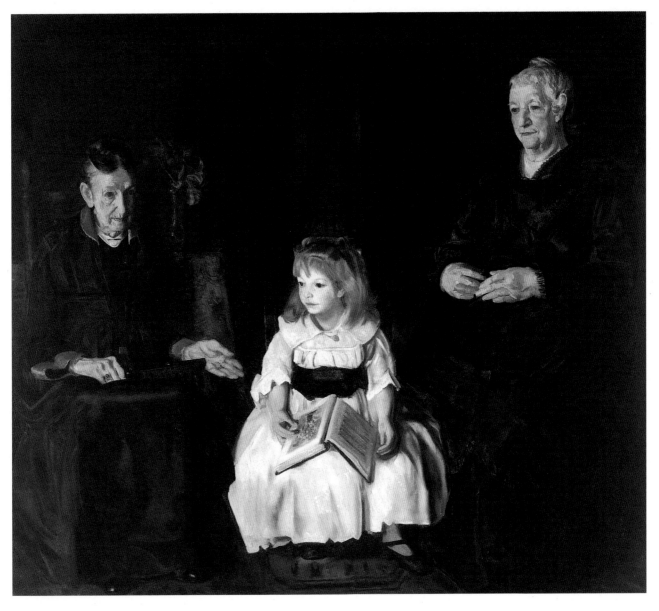

FIGURE 44
George Bellows. *Elinor, Jean, and Anna*, 1920. Oil on canvas, 59 x 66 in. Albright-Knox Art Gallery, Buffalo, New York; Charles Clifton Fund, 1923.

suggesting her emerging femininity.[99] Not recorded in the sketch is the brightly illuminated landscape of the painting (fig. 43), with its long shadows and distant hills suggesting otherworldly connotations. Bellows had not previously combined the view outside with a figural subject posed indoors, although he utilized it in the portrait of *Emma at the Window* (see page 81) that he painted the same month. The motif of the external world allegorically reinforces the subtle theme of *Anne in White*: the vividly enhanced landscape holds promise for the girl as she embarks on a journey from the comfortable haven of her youth toward a future ultimately filled with hope and opportunity.

Several months later, in *Elinor, Jean, and Anna* (fig. 44), Bellows united one of his young daughters with family members from different eras, to treat the theme of successive generations. This complex portrait, the culmination of a successful summer's work, became a signature painting for the artist, drawing the notice of many writers.[100] In terms of composition, it represents Bellows's most emblematic and intellectually complex grouping

FIGURE 45
Photographer unknown. *Elinor (Fanny) Daggett, Jean Bellows, George Bellows, Anne Bellows, and Anna Bellows, Woodstock, New York.* Undated photograph in George Bellows Papers, Special Collections Department, Amherst College Library.

to date, with a monumental, yet restrained, rendering of his mother, his aunt Fanny, and his daughter Jean on the ambitious scale of the old masters. In the self-conscious sobriety of this painting, so contrary to the spontaneous and playful lifestyle in Woodstock (fig. 45), Bellows deliberately transcended his factual basis, alluding to broader generational themes and symbolic content and subtly reinforcing them through composition, gesture, and color. The painting's static quality is attributable, in part, to Bellows's enthusiasm for the lessons of Dynamic Symmetry, which involved laying out the composition on a geometrically determined grid (see page 76).[101] The deliberateness of this organizational principle also is reflected in the sequence of execution: the drawing was laid down first, then the background was painted in, followed by the costumes, the hands, and finally the sitters' faces.[102]

Beyond this technical foundation, every element underscores the painting's meaning and pays homage to traditional portraiture. Jean's bright white dress and deliberate placement in the center of the image, where she is framed by the two older women and by the rigidly vertical arrangement of subdued red curtains in the background, makes her the clear foundation of the composition. Her white clothing, like that in *Anne in White*, is ostensibly appropriate summer attire that also suggests symbolic connotations of innocence and purity. Jean's pensive reflection as she pauses in her reading is sympathetically echoed by the simultaneous gazes of her elderly relatives, forming a close bond among the figures despite the fact that they do not touch one another. Jean, a precocious five-year-old portrayed in a rare moment of repose, holds the promise of a new generation, but she is also the fortunate recipient of her ancestors' knowledge. Her great-aunt Fanny, then in her mid-seventies, presents the girl in a self-conscious gesture derived from seventeenth-century Dutch group portraits, while Jean's grandmother, then in her early eighties, echoes her granddaughter's concentration on distant thoughts, offering tacit approval of Jean's ruminations.

The selection of Jean, rather than Anne, for this work may simply indicate that she was taking her turn at the nearly annual portrait, or perhaps, by virtue of her youth, Jean better suited the dualities Bellows hoped to convey. Her small figure contrasts with Anna's imposing one, which recalls Eakins's portraits of *Mrs. William D. Frishmuth (Antiquated*

Music) (1900, Philadelphia Museum of Art) and *Archbishop William Henry Elder* (fig. 46) and dominates the right side of the canvas. The knowledge that Fanny, having married so late in life that she could never have children of her own, adds a particular poignancy to the scene. Bellows's own fondness for children and sensitivity to the importance of regeneration would have made him sympathetic to this issue, and he seems to accord her a participatory role in child-rearing.[103] The props seem more than incidental, suggesting metaphorical associations as well. Still lives and jewelry, primary components in Bellows's descriptive idealism, connote femininity. The flowers illustrated in Jean's book and echoed by the still life on the table behind Fanny are mementoes of the passage of time, reflecting the transmutation of mortal life.

In using family members for some of his most extensive pictorial commentaries, Bellows again demonstrated his esteem for tradition and his nostalgic contemplation of the past. Contemporary art of the modernist school offered few guidelines for expressing allegorical content, and not surprisingly, his portraits of the individuals he most revered drew upon the most chronologically distant, traditional sources.

The year after Bellows painted his mother in *Elinor, Jean, and Anna*, he appropriated her earlier image for two large portraits (fig. 47 and page 79), based on lithographs he had executed earlier that year. Varying only slightly in detail, these large paintings are simple, straightforward accounts of a "warmhearted and sentimental" woman, widowed in 1913, who, as Emma Bellows remembered her, "always cried when [her son] went away."[104]

FIGURE 46
Thomas Eakins. *Archbishop William Henry Elder*, 1903. Oil on canvas, 99⅛ x 85⅛ in. Cincinnati Art Museum; Louis Belmont Family in memory of William F. Halstrick, bequest of Farny R. Wurlitzer, Edward Foote Hinkle Collection, and bequest of Frieda Hauck by exchange.

These candid yet tender portrayals demonstrate the artist's increasing reliance on contextual clues to serve the paintings' content, and they are tinged with nostalgia and even some of the melancholy of the Mrs. Tyler series. In the first version (*My Mother*, fig. 47), Bellows's mother is seated in her Columbus parlor, surrounded by familiar accoutrements, including a fishbowl, books, and a framed picture.[105] The scene's somber aspect is relieved by the nonplussed expression of one of the fish, which gives the portrait a humorously affectionate tone. The pronounced Victorian aspect and obvious artificiality of the paintings attracted much commentary, including criticism of the artist's ability to render the human figure. For Bellows, however, the historical aspect of a subject often superseded contemporary reality. The criticism that his mother's stiff, formal pose resembled the "tin-type era" may demonstrate precisely Bellows's aim, for his nostalgic reflections are rendered in the muted palette associated with nineteenth-century photographic processes.[106]

The evocative content of Bellows's family portraits failed to translate to his commissioned portraits of the early 1920s. The latter were neither profitable nor plentiful, and even more obviously, they failed to conform to Bellows's artistic program. Ironically, in view of the small amount of personal satisfaction that commissions gave him, Bellows still consid-

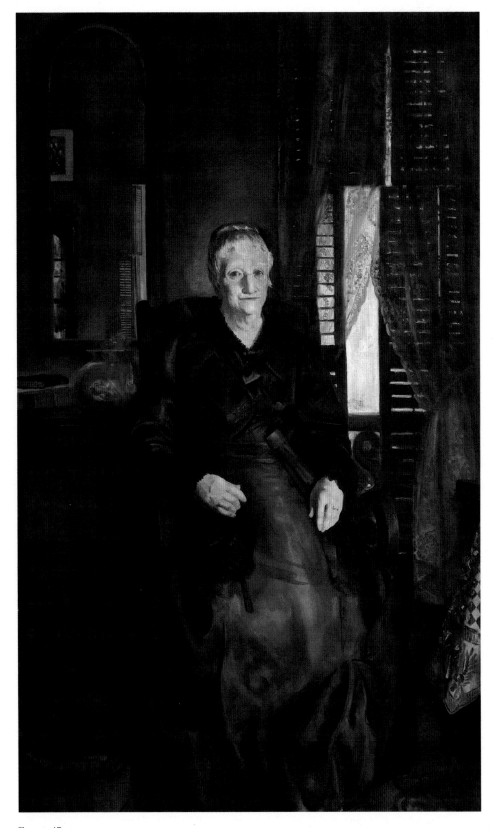

FIGURE 47
George Bellows. *My Mother*, 1921. Oil on canvas, 83 x 49 in. Art Institute of Chicago;
Frank Russell Wadsworth Memorial.

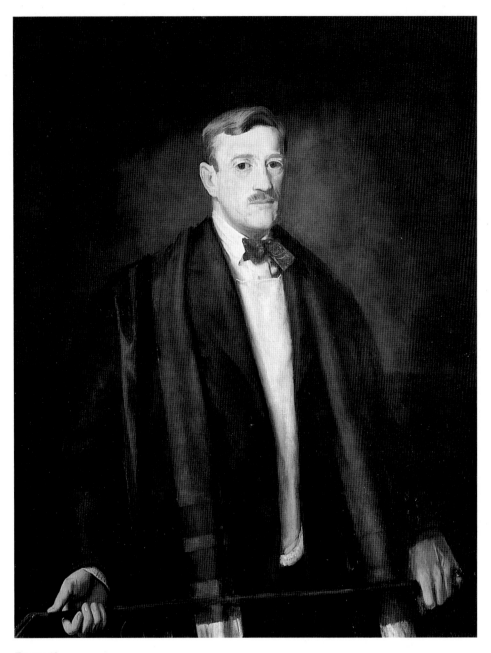

FIGURE 48
George Bellows. *Chester Dale*, 1922. Oil on canvas, 44¾ x 34¾ in. National Gallery of Art, Washington, D.C.; Chester Dale Collection.

ered them important for an artist of stature. A family friend recalled that as late as the early 1920s, Bellows was irritated that no viable portrait commission had presented itself in some time.[107] He repeatedly entered into such arrangements with high hopes, only to be disappointed. His commissioned portraits of the 1920s often had a wooden, lifeless quality (see figs. 48 and 49). Without the valuable insight of an admiring father, husband, or friend, Bellows was bereft, it seemed, of critical and compelling identification with his subject. Left to draw upon a more distant personality, with whom he was not personally involved, he found little character to enhance or ally to his larger themes.

His commercial success would have been more assured if he had painted more works like *Katherine Rosen* (see page 78), avidly sought by collector Stephen Clark.[108] The deep reverie and stunning beauty of the girl, the daughter of his artist friend Charles Rosen, is a rare illumination of Bellows's affinity for women outside the family during his mature career. His admiration for female qualities once again combines with reverence for the historic past in the nineteenth-century gown that she wears.

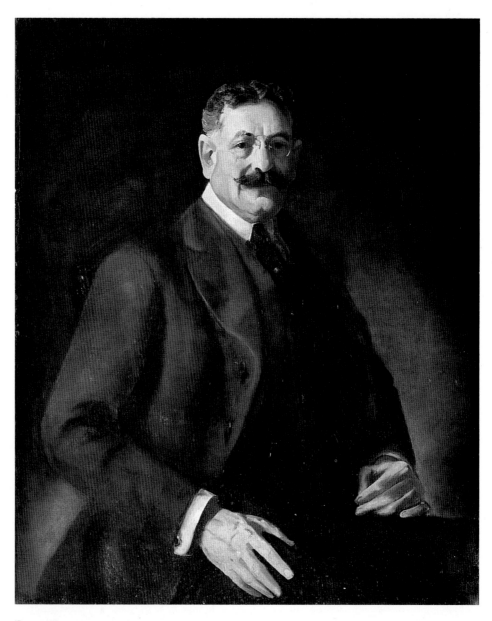

FIGURE 49
George Bellows. *Samuel Knopf*, 1922. Oil on canvas, 39¹¹⁄₁₆ x 31⅞ in. Metropolitan Museum of Art, New York; gift of Alfred A. Knopf, 1964.

Bellows again took up portraiture with fervor during a difficult period in 1923, as personal concerns again seemed to propel him toward more elaborate figural statements. Listless during the early months of his sojourn to Woodstock, the artist entered an intensely productive period following his mother's death in August. Several of his major paintings from that September and October were the culmination of themes that he had reflected on for some time. He recreated *Fisherman's Family* (see page 165); finished two portraits begun years earlier, *Emma in a Purple Dress* (fig. 50) and *Mrs. T. in Cream Silk No. 1* (see page 72); and painted his consummate portrait, *Emma and Her Children*. To Henri he commented: "On the whole I am going home quite proud."[109]

Emma and Her Children (fig. 51), the only finished portrait of his wife and both daughters, was a crowning achievement. A sensitive portrayal enhanced by time and experience, the work reflects Bellows's determination to become a leading figure among American portraitists. The painting depicts Emma, Anne, and Jean, attired in their finery, in their Woodstock home. Programmatically, the painting has more to do with wealth and status than the tradition-bound *Elinor, Jean, and Anna*. This elegant New York-bred trio

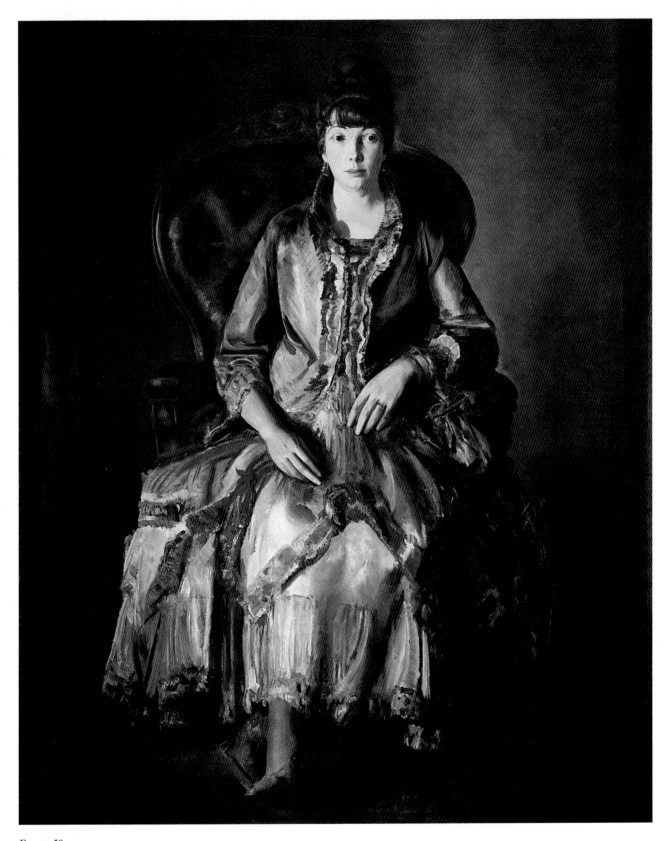

FIGURE 50
George Bellows. *Emma in a Purple Dress*, 1920–23. Oil on canvas, 63 x 51 in.
Dallas Museum of Art; Dallas Art Association purchase.

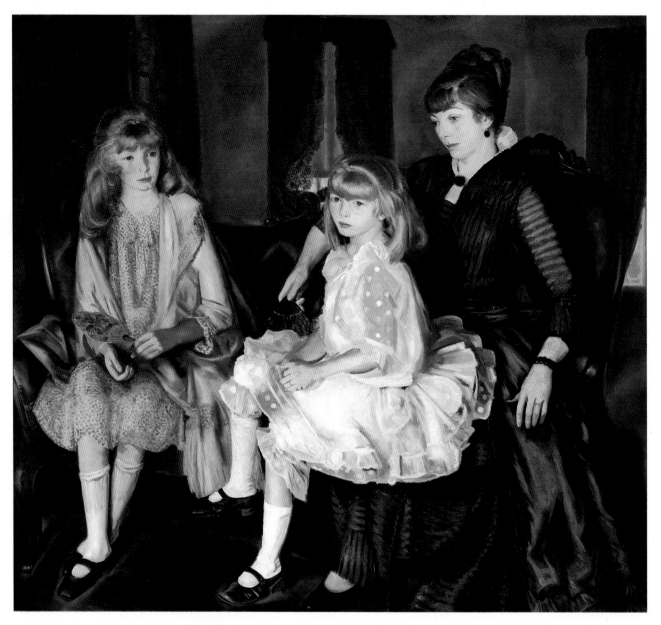

FIGURE 51
George Bellows. *Emma and Her Children*, 1923. Oil on canvas, 59 x 65 in. Museum of Fine Arts, Boston;
gift of Subscribers and the John Lowell Gardner Fund.

bore little relation to Bellows's modest midwestern upbringing, but this family was of his own making, nurtured through his personality and successes. The painting recalls the tripartite grouping and overall poses of *Elinor, Jean, and Anna*, but Bellows now took his cue from nineteenth-century French rather than seventeenth-century Dutch and Flemish portraiture. The sheer luxury of Emma's and the girls' dresses and the graceful accents of heirloom jewelry bespeak the elegance of Renoir, while the photographic realism and probing characterizations recall Manet.[110] Jean, again the focal point, looks confidently beyond the pictorial space and is supported by her mother in Emma's most overtly matriarchal presentation. Although *Emma and Her Children* is ultimately successful, the feverish intensity with which Bellows worked following his mother's death and the lingering enigma of a successful portrait made for frustrating labor as he created this painting. His wife later recalled: "The painting of Jean and myself went well from the start but Anne was very difficult. The nervous tension was very great because if George did not get Anne there was no picture. Perhaps this is why most artists avoid painting portraits of more than one person on one canvas."[111]

FIGURE 52
George Bellows. *Lady Jean*, 1924.
Oil on canvas, 72 x 36 in. Yale
University Art Gallery, New
Haven, Connecticut; bequest of
Stephen Carlton Clark.

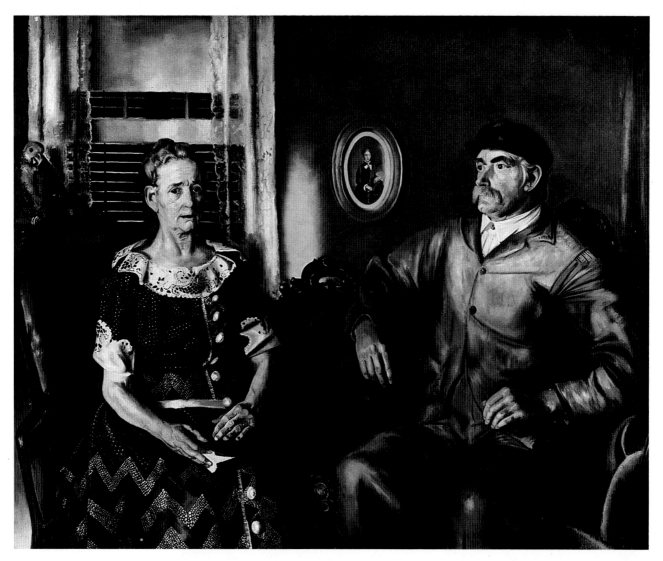

FIGURE 53
George Bellows. *Mr. and Mrs. Phillip Wase*, 1924. Oil on canvas, 51¼ x 63 in.
National Museum of American Art, Smithsonian Institution, Washington, D.C.; gift of Paul Mellon.

In 1924, Bellows's final summer in Woodstock, his ambitious figural subjects reveal a heightened interest in the imaginary. The careful placement of figures within a patently constructed landscape underscores his fascination with the family; their immediate natural surroundings, their interrelationships, and their relationship to the landscape suggest his sense of life's larger questions. The stilted quality of an imaginary scenario, a deliberately fictional construct, in such paintings as *The Picnic* (1924, Baltimore Museum of Art) and *Fisherman's Family* imparts non-literal, somewhat metaphorical associations for the human figures.[112] During this intensely creative period, and in anticipation of an upcoming one-man exhibition at the Durand-Ruel Galleries, Bellows executed several monumental figural works.[113] He departed further from a naturalistic viewpoint, using bright colors in expressive and independent fashion and giving a predominant role to unusual patterned textures that earlier had been confined to accents. The humorous tone of *Lady Jean*'s title permeates the painting (fig. 52), with its lively palette of cerulean blue and orange-red. Bellows again demonstrates his attraction to imaginative and decorative costume; wearing a nineteenth-century dress from the stock of clothes her mother made available for "dress up,"[114] Jean finds herself in a gaily colored ambiance as theatrical as her attire.

Like *Lady Jean*, *Mr. and Mrs. Phillip Wase* (fig. 53) displays an artificial quality, this time in an ironic presentation of an elderly couple, Bellows's Woodstock acquaintances,[115] who transcend their individual characteristics to convey a sentiment. The psychological

interaction is troubling, as Bellows resurrects the matrimonial theme to project a stagnant marriage of puritanical severity. Mr. Wase, although handsome, is awkwardly inanimate, his vacant stare detaching him from his wife and the scene. Mrs. Wase, a more credible personality who suggests a momentary quality with her finger marking a place in her book, is, paradoxically, strangely static. Her concerned look and furrowed brow imply a long-suffering stoicism, her ill-fated romantic destiny ironically underscored by the presence, on the wall between the couple, of an old photograph depicting a primly severe young woman whose posture echoes her own. Indeed, a photographic aspect informs the entire presentation: the figures are momentarily frozen in time with a gulf of silence between them.[116] This literal photographic quality found favor with Bellows and other artists during the 1920s. Eugene Speicher, Bellows's close friend, employed a similar hard-edged realism in his popular portraits of heavy-lidded females, whom he rendered with crisp transitions that impart a similar static quality (fig. 54).

FIGURE 54
Eugene Speicher. *Mlle. Jeanne Balzac*, 1923. Oil on canvas, 50¼ x 40⅜ in. Cleveland Museum of Art; Hinman B. Hurlbut Collection.

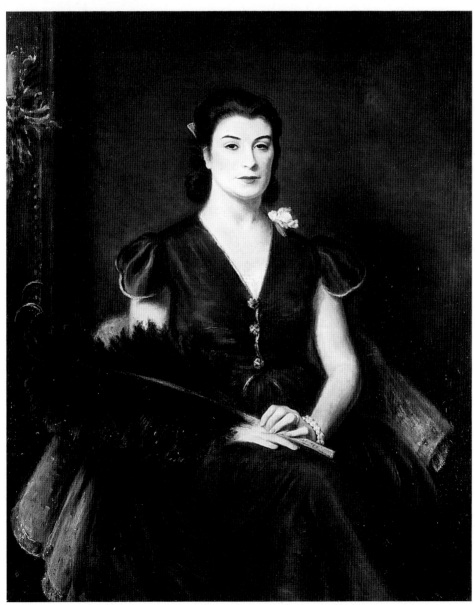

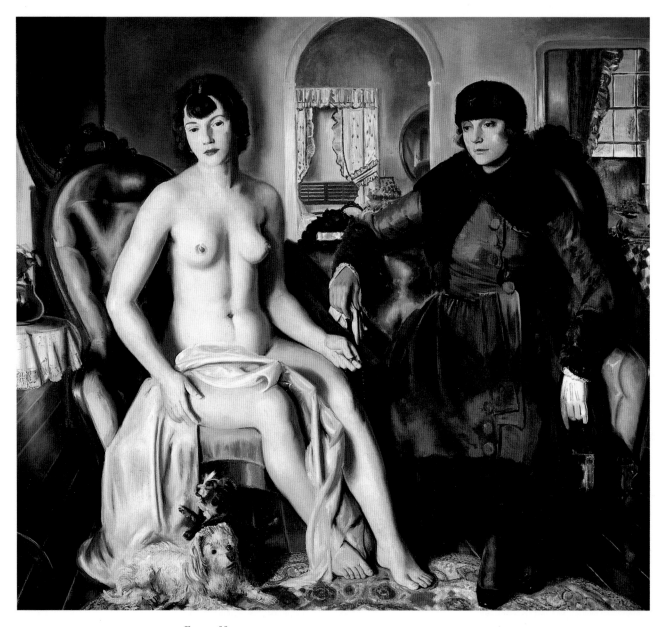

FIGURE 55
George Bellows. *Two Women*, 1924. Oil on canvas, 57 x 66 in. Portland Museum of Art, Maine;
lent by Karl Jaeger, Tamara Jaeger, and Kerena Jaeger.

At the time of his sudden demise in January 1925, Bellows appeared to be extending his range beyond the traditional conventions of portraiture, toward using the figure to express carefully constructed pictorial conceits. *Two Women* (fig. 55), painted in October 1924, recapitulates the dichotomous tone of *Mr. and Mrs. Wase*; the figures are posed in similar fashion on the same Victorian horsehair sofa. In composition and content, the picture frankly emulates Titian's *Sacred and Profane Love* and presents an odd juxtaposition of two opposing figures with nearly identical features. The painting's symbolic connotations are not explicated by any surviving personal commentary from the artist himself, and the portrayal of two women, one nude, the other completely covered with heavy attire, in Bellows's Woodstock house, seems incongruous and enigmatic. The figures are anchored to reality, however, by the careful way they are rendered and the sensory quality of a bold color scheme.

The romantic, mystical quality of this scenario conformed to Bellows's aim for the ever grander conception, but this quest was never realized because Bellows died of appendicitis at age forty-two. His portraits earned many accolades, but more were being lavished upon European portraitists at the time. Since relatively few of his portraits were

commissioned, his portraiture reveals more about his overall artistic scheme than about the demands of patronage. However, Bellows was keenly sensitive to the importance of portraiture in an artist's career. The Spanish portraitists were notably in ascendence during Bellows's later career, and although Bellows had initially approved their work, he and other artists in the Henri circle found their arrogance objectionable. Still, painters such as Ignacio Zuloaga attracted an adoring following for their conservative realism tinged with exoticism,[117] and a certain mysticism had arisen around Zuloaga, whom Bellows had met on several occasions. The former was probably involved in an incident later described by Emma Bellows: "George did not like portrait commissions and when after a large dinner in New York given in honor of some foreign artist who had been quite patronizing of American art—the foreign artist (as he was putting on his overcoat) turned to George and said—'You Americans do not go in for portrait painting do you Bellows' George said 'No. We import most of our labor.'"[118] The ultimate insult occurred upon Bellows's death, when Zuloaga, who was on his third triumphal tour of America, offered five thousand dollars (considerably less than he himself was earning for paintings) to buy Bellows's *Two Women*, in memory of the artist, for the Metropolitan Museum of Art. Bellows's friends, resenting this interference, closed ranks and rejected the offer.

At his death, Bellows, the most famous among Henri's circle, had produced a body of portraiture and other figural work surpassing that of his colleagues. His reputation as the quintessential modern artist, esteemed by the press and the artistic community alike, somewhat obscured his reverence for past traditions in his renderings of the human figure. Portraits by artists like Velázquez, Manet, and Eakins encouraged his belief that the study of human character was a noble pursuit, and in his own portraiture, Bellows essayed themes dealing with family, age, and gender. Though realistic in intent, his portraiture worked in tandem with his tendency to seek symbolic content born of an intangible otherworldliness; he defined inspiration as "the marshalling of all one's faculties, including those which we are unconscious of possessing."[119] A realist by training, Bellows was a romantic at heart. These strains coalesce most obviously in his last figural works, where decoration and realism converge in images like young Jean, garbed in fanciful attire and presented in a few startling colors. In aiming for romanticism through the rigid form of prosaic subjects and incidental, peculiar details, Bellows self-consciously illustrated his belief in the individuality of the artist. This idea, central to Henri's teachings, was one Bellows quoted: "The only true modern movement is the frank expression of self. Those who express even a little of themselves never become old fashioned. But few are capable of holding themselves in a state of listening to their own song."[120] The ability to steer a unique course was Bellows's triumph.

NOTES

I would like to thank Rick Stewart and Doreen Bolger of the Amon Carter Museum for their guidance and their thoughtful reading of this essay; Deborah Pelletier of the Special Collections Department, Amherst College Library, for her assistance in finding and doublechecking quotations from Bellows's correspondence; and Jean Bellows Booth for her gracious hospitality and generous sharing of information.

[1] When George Moore commissioned a portrait (location unknown) from the artist in 1917, Moore's familiarity with Irish portraitists Sir John Lavery and Sir William Orpen and expatriate John Singer Sargent led Bellows to exult in the compliment Moore had paid him. George Bellows to Emma Bellows, undated [July 1917], George Bellows Papers (Box I, Folder 5), Special Collections Department, Amherst College Library.

[2] Bellows did paint his father's brother, Charles, around 1908 (Mr. and Mrs. William DuPont III) and his father-in-law William Story in 1911. He subsequently destroyed the latter painting, which measured twenty-four by thirty inches. (Artist's Record Book A, p. 97, no. 110). In 1917 Bellows began a portrait of William Story and Bellows's youngest daughter, Jean, which remained unfinished (Allison Gallery). William Story also appears in several of the artist's lithographs; see Lauris Mason, *The Lithographs of George Bellows: A Catalogue Raisonné* (Millwood, N.Y.: KTO Press, 1977), pp. 166–167.

[3] Autobiographical typescript, p.3, Bellows Papers (Box IV, Folder 5), Amherst College Library. Bellows's misspellings are reproduced without the distracting notations of [sic].

4 Bellows lived in this apartment, located in the Lincoln Arcade building at 1947 Broadway, from 1906 until his marriage in 1910. The building also provided a studio space for Robert Henri, beginning in January 1909, after he severed relations with the New York School of Art in a disagreement over his salary. See William Innes Homer, *Robert Henri and His Circle* (Ithaca, N.Y.: Cornell University Press, 1969), pp. 149–150.

Among the identifiable paintings in photographs of Bellows's studio are a Rembrandt self-portrait; a portrait of Rembrandt's wife, Saskia; and a detail of Velázquez's *Surrender of Breda*. Bellows's friend Eugene Speicher recalled Bellows, later in life, poring over reproductions of the old masters. Frank Seiberling, Jr. "George Bellows, 1882–1925: His Life and Development as an Artist," Ph.D. diss., University of Chicago, 1948, p. 217; this dissertation contains valuable interviews the author conducted with Bellows's family and friends. Henri, too, was an avid collector of reproductions of European paintings; Homer, *Henri and His Circle*, p. 163.

5 Quoted in Emma S. Bellows, ed., *The Paintings of George Bellows* (New York: Alfred A. Knopf, 1929), p. 10. The Foreword consisted of Bellows's writings on art. Another of Bellows's dicta was: "Watch all good art, and accept none as standard for yourself. Think with all the world and work alone"; Charles H. Morgan, *George Bellows: Painter of America* (New York: Reynal and Company, 1965), p. 211. Morgan's biography of Bellows remains the most complete account of the artist's life to date. Although he does not provide documentation, Morgan had access to the artist's papers and to family and friends who were still alive in the early 1960s. Much of the information Morgan provides can now be verified, indicating that his description of Bellows's life is generally accurate.

6 George Bellows to Emma Bellows, July 29, 1917, Bellows Papers (Box I, Folder 5), Amherst College Library. The painting in question was Bellows's commissioned portrait of George Moore.

7 Clifton Webb (1891–1966) later became a dancer and leading man on the New York stage as well as a popular screen actor. Bellows was a role model for Webb, whose father had abandoned him when he was a child: "George completely fulfilled my concept of what an artist should be—breezy, happy-go-lucky, adventurous, hearty, and enormously talented. He was serious about nothing except art. . . . In retrospect, I know that I gained more from companionship with him than from anything else the Chase School had to offer me." Webb's friendship with Bellows contrasts with the debonair, aristocratic persona that the actor later cultivated in such films as *Laura* (1944): "In [Bellows's] company it was impossible for even the most callow adolescent to develop neurotic or trumpery ideas about life or art." Webb described his friendship with the artist in his unpublished autobiography; typescript in possession of John Neylon.

8 Robert Henri, *The Art Spirit* (Philadelphia: J. B. Lippincott Company, 1930), p. 11. This volume, reproduced in several editions, beginning in 1923, was a distillation of Henri's teachings.

9 Bellows himself had known the stinging embarrassment of being an outsider, and his sympathetic portrayal of Webb was conceivably tinged by the artist's own humiliation when, as a college freshman, he was rejected by the fraternity of his choice, an exclusion that was subsequently reversed. Morgan, *George Bellows: Painter of America*, pp. 27–28.

10 Christian Brinton, an advocate of modernism, reviewing the 1911 exhibition of American paintings at the Roman Exposition, noted that Whistler and Sargent, among other Americans, were represented by older efforts. He praised Bellows, who "though meagerly presented, reveals incontestable talent"; "The American Exhibition in Rome," *International Studio* 45 (November 1911): 7.

11 *Nation* 88 (March 18, 1909): 286.

12 "Studio Talk," *International Studio* 26 (September 1905): 263.

13 George Bellows to Joseph Taylor, January 15, 1914, Bellows Papers (Box I, Folder 12), Amherst College Library.

14 *American Art News* 8 (January 29, 1910): 3. *Little Girl in White*, the first figural work he widely exhibited, was initially greeted with indifference or disparagement upon its inclusion in the 1910 annual of the Pennsylvania Academy of the Fine Arts. Bellows persisted in his attempts to exhibit the painting, however, and in 1913 it won the National Academy of Design's Hallgarten Prize (an award conferred on artists under the age of thirty-five). In a dispute indicative of the factionalism in the art world at that time, the awarding of this prize led to accusations of nepotism at the Academy because Bellows had participated as a juror for the annual. Morgan, *George Bellows: Painter of America*, p. 168. Another of Bellows's early figural works to receive belated recognition was *Paddy Flannigan*, which was shown several times in 1915, at the MacDowell Club and in his one-man exhibition at the Whitney-Richards Galleries.

15 George Bellows to Joseph Taylor, April 21, 1910, Bellows Papers (Box I, Folder 11), Amherst College Library. Most of the letter is reprinted in Seiberling, "George Bellows, 1882–1925," with some omissions and errors.

16 George Bellows to Joseph Taylor, April 21, 1910. Interestingly, Sloan apparently did not reciprocate Bellows's admiration. When Bellows's *North River* and *Forty-Two Kids* were on exhibition at the National Academy of Design annual in 1908, Sloan noted, "Bellows is already too much 'arrived'—it seems to me. . ." Bruce St. John, ed., *John Sloan's New York Scene From the Diaries, Notes and Correspondence 1906–1913* (New York: Harper and Row, 1965), p. 209. See also Van Wyck Brooks, *John Sloan: A Painter's Life* (New York: E. P. Dutton and Company, 1955), pp. 95, 193–194.

[17] The absence of an American school of portraiture was a complaint among some critics throughout Bellows's career. Henry McBride, surveying the offerings at the 1916 exhibition of the National Association of Portrait Painters, acerbically noted the dearth of talented native portraitists in the *New York Sun*, April 9, 1916. See also the *Sun* for November 7, 1915, n.p.; the *New York Tribune* of November 6, 1915, p. 11; and Hamilton Easter Field's comments in the *Brooklyn Daily Eagle* on February 15, 1920, section 6, p. 5.

[18] During the years of Bellows's association with Henri, the older artist traveled to Spain in 1906, 1908, 1910, 1912, and 1923; to England in 1907; to Holland in 1907 and 1910; to France in 1912; and to Ireland in 1913 and 1923. See Homer, *Henri and His Circle*, and Bennard B. Perlman, "Chronology of Robert Henri's Life and Art," in *Robert Henri, Painter* (Wilmington: Delaware Art Museum, 1984), pp. 168–171.

[19] Giles Edgerton [Mary Fanton Roberts], "The Younger American Painters: Are They Creating a National Art?" *Craftsman* 13 (February 1908): 521.

[20] *Outlook* 88 (January 18, 1908): 117.

[21] One critic tellingly remarked of Henri's *Lady in Black Velvet*: "Henri seems to like the *tour de force* of contrast in a light face shining luminous and direct from a darkened canvas, the effect of a Rembrandt with the technique of a Sargent . . . yet for all the sombreness of his formula of light and shade there is always an impression of unmistakable *chic* conveyed"; G. Mortimer Marke, "Representative Portraitists: Notes on the Second Annual Exhibition of the National Association of Portrait Painters," *Arts & Decoration* 3 (April 1913): 207. See also Homer, *Henri and His Circle*, pp. 111, 116, 122.

[22] *New York Sun*, February 5, 1910, n.p. Charles Wisner Barrell noted in "Robert Henri—'Revolutionary,'" *Independent* 64 (June 25, 1908): 1431: "As a figure painter [Henri] is often ranked with Sargent, tho there are many in the country and abroad who prefer his work to that of the elder man." Still later, another critic observed: "With the exception of Sargent . . . and Orpen . . . who is there among the present day brushmen that carries on the tradition of [Velázquez] and Hals with the winning bravura of Bellows and . . . Robert Henri?" (*World*, December 11, 1921, p. 7).

[23] The painting was first recorded in the artist's record book as "Little Laundry Girl," a title that was subsequently crossed out and replaced with the titles "Little Girl in White" and "Queenie Burnett"; Record Book A, manuscript in possession of Jean Bellows Booth, p. 35, no. 42. In 1913 Bellows listed the painting as "Queenie" in his account book, "Sales and Proffesional [sic] Income" (hereafter referred to as Artist's Account Book), manuscript in possession of Jean Bellows Booth.

[24] Henri, *The Art Spirit*, p. 112.

[25] Homer, *Henri and His Circle*, p. 125. Henri tended to generalize about ethnic groups, thus contrasting the Spanish, "in their costume and in all their customs, the most child like people I have ever seen," with the Italians, who were "colorful and weakly romantic"; ibid., p. 123. While Bellows did not pursue ethnic or character types to the same extent as Henri, in the 1920s he did execute drawings and lithographs of the Irish peasants who held a particular fascination for him. A number of these works were associated with his 1922 commission to provide illustrations for *The Wind Bloweth*, a novel by Irish author Donn Byrne, serialized in *Century Magazine*; see Frank Kelly's essay, "Bellows and the Sea," pp. 163–164.

[26] According to the Artist's Account Book, Bellows's first commissioned illustrations dated from 1912, when he made drawings for *Delineator Magazine*, *Collier's Weekly*, *Everybody's Magazine*, and *American Magazine*. As early as 1909, a drawing entitled "I Want You Two Girls to Know Each Other," apparently non-commissioned, was reproduced in the *Craftsman* 17 (December 1909): 272.

[27] Henri, *The Art Spirit*, p. 10.

[28] For Bellows's recollection of his father's resistance to his becoming an artist, see Margaret C. S. Christman, *Portraits by George Bellows*, exhibition catalogue (Washington, D.C.: National Portrait Gallery, Smithsonian Institution, 1981), p. 16. See also Morgan, *George Bellows: Painter of America*, pp. 34, 167. The artist's wife and his Columbus neighbors and relatives described George Bellows, Sr., as dogmatic and frugal; Seiberling, "George Bellows, 1882–1925," pp. 176, 178, 179, 180, 181.

[29] For a discussion of this portrait type, see Michael Quick, "Achieving the Nation's Imperial Destiny: 1870–1920," in *American Portraiture in the Grand Manner: 1720–1920*, exhibition catalogue (Los Angeles: Los Angeles County Museum of Art, 1981), p. 62.

[30] George Bellows to Emma Bellows, August 5, 1912, Bellows Papers (Box I, Folder 4), Amherst College Library. Bellows painted a second portrait of his father (location unknown) during the same trip; Record Book A, p. 24, no. 30. Again in Columbus over the Christmas holidays in 1907, Bellows painted a three-quarter-length portrait of his father (location unknown); Record Book A, p. 42, no. 49.

[31] Bellows gave Pach's article ("Manet and Modern American Art," *Craftsman* 17 [February 1910]: 483) an enthusiastic reading: "There is a bully reproduction of a drawing of mine in the Feb. Craftsman and a corking article on Manet by Walter Pach a friend of mine"; George Bellows to Joseph Taylor, February 5, 1910, George Bellows Papers (Box I, Folder 11), Amherst College Library. Pach, an artist and an organizer of the Armory Show, had also been a Henri student.

32 According to Pach (p. 485), "... Manet was a man struggling first of all for principles; ... Fortunately he was too deeply imbued with a realization of the greatness of his work to heed the chance of failure." Henri also articulated the theme of an unrecognized artist struggling to uphold his individuality: "His story is the story of every man of whatever calling ... Walt Whitman, whose book of poems Whittier cast into the fire ... Degas, Manet and Whistler and their Academy of the Rejected"; quoted in Barrell, "Robert Henri—'Revolutionary,'" p. 1430.

33 Undated *Philadelphia Inquirer* clipping, Bellows Papers (Box VIII, Album 4), Amherst College Library. *Emma on Divan* (exhibited as *Girl on Couch*) was reproduced in the *New York Daily Tribune*, December 17, 1911, Bellows Papers (Box VIII, Album 4), Amherst College Library. The paintings were listed in Record Book A as follows: "*Candle Light* November 1910" (p. 95, no. 109); "*Girl on Couch/Portrait of Emma on Divan* June 1911, 2' x 4',": p. 96, no. 109. The sketch that accompanies Bellows's entry for *Candlelight* shows a horizontal composition with a woman reading at a table. The *Baltimore Sun* identified the woman as Bellows's wife wearing a grey silk frock; undated clipping, Bellows Papers (Box VIII, Album 4), Amherst College Library.

34 *New York Herald*, December 9, 1911, p. 12.

35 *Philadelphia Public Ledger*, February 4, 1912, section 2, p. 9. Another reviewer noted: "Though this is an exhibition without a Sargent, the portrait painters are here in force. ... The reclining figure on the sofa, the thoroughly-at-ease young woman, by George Bellows, which appeared with so much eclat at the New York Academy, renews the delicious aspect of comfortable languor. There is still something the matter with her foot." *Nation* 94 (February 22, 1912): 195, 196.

36 George Bellows to Emma Bellows, August 6, 1917, Bellows Papers (Box I, Folder 5), Amherst College Library.

37 Bellows's portrait commissions overall were relatively modest in number. After 1913 he received only about eleven commissions. Family friend Ethel Clarke recalled Bellows's aversion to portrait commissions; "George Bellows as Seen by E.A.C.," March 1961, Charles Morgan Papers (Box IV, Folder 4), Special Collections Department, Amherst College Library. Later in life, Bellows cautioned a Chicago schoolteacher who approached him about a portrait commission that "portrait painting with me is a long gamble" and that she should avoid attaching any hope to the idea; George Bellows to Rose Mullay, May 20, 1924, Bellows Papers (Box I, Folder 9), Amherst College Library. On four occasions Bellows made more than one commissioned portrait of a single subject, apparently striving for a successful outcome: *Peter Butler Olney* (1914 and 1915), *Paul Clark* (1917), *Meredith Hare* (1921), and *Mrs. Chester Dale* (1919).

38 Canfield, the fourth president of the university, died on April 5, 1909. Bellows finished the portrait (now in the Ohio State University Libraries), and the three hundred dollars he earned for his effort represented one-half of his total income for the year; Artist's Account Book. (The same year, Bellows sold *Forty-Two Kids* to Robert C. Hall of Pittsburgh, also for three hundred dollars.) For this portrait commission, see Morgan, *George Bellows: Painter of America*, p. 90. Bellows presumably was referring to the Canfield portrait when, in 1910, he wrote Joseph Taylor that the Alumni Association still owed him two hundred dollars; George Bellows to Joseph Taylor, April [no date] 1910, Bellows Papers (Box I, Folder 11), Amherst College Library.

39 George Bellows to Joseph Taylor, March 16, 1922, Bellows Papers (Box I, Folder 14), Amherst College Library.

40 George Bellows to Joseph Taylor, May 27(?), 1913, Bellows Papers (Box I, Folder 12), Amherst College Library.

41 Bellows received one hundred dollars in prize money; Artist's Account Book. He exhibited the work widely that year. The painting also appeared at the MacDowell Club, the Albright Art Gallery in Buffalo, and the Corcoran Gallery of Art, Washington, D.C.

42 Scott, whose liberal posture made him a controversial figure, had only a brief tenure, resigning under pressure in 1883, the year after Bellows was born. Scott's ignominious departure was due to differences with the Board of Trustees, including his refusal to mandate daily prayer services and his socialist views concerning the distribution of land. It is unknown whether Bellows knew about the details of Scott's dismissal. Scott went on to become the principal of Phillips Exeter Academy and a Presbyterian minister in Albany, New York. In 1909, the Trustees rescinded the earlier affront by conferring upon Scott the title of president emeritus and professor of philosophy. See James E. Pollard, *History of The Ohio State University, The Story of Its First Seventy-Five Years, 1873–1948* (Columbus: Ohio State University Press, 1952).

 Bellows complained that his portrait of Mendenhall, a member of the original faculty, was worth more than he was receiving, "when you consider cutting in on my other work"; George Bellows to Joseph Taylor, May 27(?), 1913. Much to his dismay, the intangible element that made for a successful portrait also eluded Bellows in his portrayal of Mendenhall. He wrote Taylor of his doubts and mentioned Emma's and Mendenhall's positive appraisals of the work, although the sitter's wife did not approve of it. George Bellows to Joseph Taylor, May 24, 1913, and June 21, 1913, Bellows Papers (Box I, Folder 12), Amherst College Library. Bellows received five hundred dollars for the portrait; Artist's Account Book.

43 Bellows conceived an ambitious scheme whereby the university would become a patron of the arts, sponsoring a gallery to house original artworks, along with reproductions of well-known paintings, sculpture, and

architectural monuments. George Bellows to Joseph Taylor, April 25, 1912, Bellows Papers (Box I, Folder 14), Amherst College Library. Quoted in Seiberling, "George Bellows, 1882–1925," pp. 241–242. Bellows later chastised the university for being narrow-minded; George Bellows to Joseph Taylor, March 16, 1922.

44 Bellows's trip was occasioned by a one-man exhibition of his work which opened in November 1912. Joseph Taylor's daughter recalled that during this visit, her parents had hosted a party for Emma and George during which Bellows asked three of the guests and her father to sit for him. Mrs. Wesley (Diana) G. France to Charles Morgan, April 5, 1963, Morgan Papers (Box IV, Folder 11), Amherst College Library.

45 For the popularity of Georgian portraits in America, see Quick, "Achieving the Nation's Imperial Destiny."

46 The portrait of Mrs. Miller, exhibited in the Armory Show (February 15–March 15, 1913), would have been on view simultaneously with the Arnold portrait at the Pennsylvania Academy Annual (February 9–March 30, 1913). The Arnold portrait was singled out by several critics: ". . . as time goes on Mr. Bellows will perhaps gain in concentration, so that his canvases will have a somewhat more precious aspect. At present they are sometimes a little large for the amount of thought to be conveyed" (*New York Sun*, January 19, 1913, p. 13) and "[*Mrs. H. B. Arnold*] is a large and vigorous conception that compels the attention from the moment of entering the gallery. The eye goes with keen delight from the liberal handling of the handsome blond head to the down-stretched bare arm, so brilliantly painted that it all but takes the centre of interest" (*Evening Post*, January 11, 1913, p. 7).

47 George Bellows to Joseph Taylor, May 27(?), 1913. In his account book, Bellows indicated that he was paid eight hundred dollars for the portrait of Mrs. Miller. The portrait of Mrs. Arnold remained in the artist's estate until 1934, when the artist's widow sold it back to the family. Joseph Taylor's daughter was undoubtedly referring to these portraits when she recalled that one of Bellows's Columbus patrons was not pleased with a portrait and never paid for it, while another paid only half; Mrs. Wesley (Diana) G. France to Charles Morgan, February 17, 1963, Morgan Papers (Box VI, Folder 11), Amherst College Library. Mrs. Arnold, the former Grace Russell of Montclair, New Jersey, was a friend of Emma Bellows, who also grew up in Montclair; see *George Bellows, Paintings, Drawings and Prints*, exhibition catalogue (Chicago: Art Institute of Chicago, 1946), p. 39. Mrs. Arnold's son later married Mrs. Miller's daughter, and the two donated the paintings of their mothers to the Columbus Museum of Art in 1955 and 1974, respectively.

48 Bellows articulated this viewpoint some years later in a newspaper interview: "Art thrives when the people want the artist to create the best and rarest he can, when they cease to be divided into parties, holding artists to fixed standards of academyism or modernism, as at present, and take joy in the man who carves away at his own ideas"; "Artists Approve Mrs. Sterner's Junior Art Patrons Project," *World*, May 2, 1921.

49 Henri's radical approach was more novel than revolutionary and centered on ethical issues such as the jury system, rather than technique or style. In fact, the American realists gladly assumed the role of *provocateurs* in the contemporary art scene, which they sought to enlighten with their progressive outlook. In actuality, they were more unconventional than radical. The Henri school was often endorsed over the traditionalists who "lapse into landscape or 'set' into official portraiture"; Frank Jewitt Mather, Jr., "Some American Realists," *Arts and Decoration* 7 (November 1916): 16.

50 *New York Sun*, December 26, 1915, section 5, p. 7.

51 "I tried to do something as genuine as the painting of a shipbuilder's work when I painted a famous old man for a famous New York Club House. I put my kind of imagination into it. I wanted to make him live just as he was . . . And then I made a canvas with the color that belonged to life, full of it, but the art committee of the club sent my picture back. And now I am very glad of it." "The Big Idea: George Bellows Talks about Patriotism for Beauty," *Touchstone Magazine* 1 (July 1917): 270.

52 The painting was featured in the Fifth Annual Circuit Exhibition of the National Association of Portrait Painters and in an exhibition entitled "To Whom Shall I Sit for My Portrait?" held in December 1916 at Gertrude Vanderbilt Whitney's studio in New York.

53 "With the Portraitists and Elsewhere," *International Studio* 57 (January 1916): 87.

54 Bellows to Forbes Watson, November 11, 1915, Bellows Papers (Box I, Folder 15), Amherst College Library.

55 George Bellows to Joseph Taylor, January 15, 1914, Bellows Papers (Box I, Folder 12), Amherst College Library.

56 The summer of 1918 was an exception. That year, Bellows focused his efforts on paintings, drawings, and lithographs illustrating the atrocities committed by the Germans in occupied Belgium during World War One.

57 George Bellows to Robert Henri, August 21, 1914, Robert Henri Papers, Yale Collection of American Literature, Beinecke Rare Book and Manuscript Library, Yale University. Record Book B lists seventeen portraits among the summer's work.

58 It is unknown when or by whom the first version of the portrait, which is signed by the artist's widow, was cut down. Reproductions of the original portrait appeared at the time of the painting's exhibition in the Pennsylvania Academy of the Fine Arts Annual; *Philadelphia Public Ledger*, February 7, 1915, p. 7, and *Arts and Decoration* 12 (November 15, 1919): 10.

59 For the footlight effect employed by fashionable American portraitists at the end of the nineteenth century, see Quick,"Achieving the Nation's Imperial Destiny," p. 68.

60 Emma's friend Ethel Clarke recalled that Emma and George were ardent suffragettes; Ethel Clarke to Charles Morgan, January 14, 1962, Morgan Papers (Box VI, Folder 8), Amherst College Library.

61 George Bellows to Mary Witherspoon, February 7, 1917, possession of Mary Witherspoon. It is perhaps surprising that a young girl would effect such discourse, yet it is also typical of Bellows's willingness to freely share his views on art matters. The child had seen *Geraldine Lee, No. 1* in 1917 when it was included in a national tour of American paintings sponsored by the American Federation of Arts. Bellows made a similar remark in a magazine interview the same year: "It's a queer thing about models. Do you know some people have the design of a painting in their features and bodies, and some haven't. I have seen beautiful women whom you couldn't paint at all, you couldn't get a design from them, you couldn't make their bodies compose. And along comes a little girl, not especially pretty, not striking, but you can paint her; she can make designs for a dozen paintings." "The Big Idea: George Bellows Talks about Patriotism for Beauty," p. 270. Henri similarly remarked: "Beauty is an intangible thing; . . . 'pretty' faces are often dull and empty . . ."; *The Art Spirit*, p. 91.

62 Henry McBride, *New York Sun*, October 18, 1914. On the impact of the Armory Show on the Realists, see also Homer, *Henri and His Circle*, p. 170; and Milton Brown, *The Story of the Armory Show*, 2d ed. (New York: Abbeville Press, 1988), pp. 236–237. The discrepancy between the Realists' objectives and those of the modernists was noted by writers who perceived the exhibition's implications: "it is amusing to realize how, in comparison with the work of Cezanne, Gauguin, Van Gogh, and notably Matisse and others, that of such Americans as J. Alden Weir, Childe Hassam,. . . Geo. Bellows . . . Geo. Luks, W. Glackens. . . seem almost academic, while . . . Bolton Brown, Jonas Lie . . . Robert Henri . . . have no 'place in this gallery'"; "A Bomb from the Blue," *American Art News* 11 (February 22, 1913): 9.

63 Henri, "Progress in Our National Art Must Spring from the Development of Individuality of Ideas and Freedom of Expression: A Suggestion for a New Art School," *Craftsman* 15 (January 1909): 399.

64 Manet, for example, frequently painted his wife at the piano (*Madame Manet at the Piano*, 1867–8, Musée d'Orsay, Paris). The composition also bears a resemblance to Manet's *Woman Playing a Guitar* (1867, Hill-Stead Museum, Farmington, Connecticut). *Emma at the Piano* was one of Bellows's favorite paintings. When he submitted the work to the National Academy Annual in the winter of 1914, he assigned it a high price to deter its sale. Collector Adolf Lewishon matched the asking price, however, and in 1915 bought the painting for $1,350, the most the artist had ever received for a single work; Artist's Account Book and Joseph Russell Taylor, "On the Death of George Bellows," *Ohio State University Monthly* 16 (February 1925): 3, 5.

65 L. C. Driscoll, "American Art at the Chicago Institute," *International Studio* 57 (February 1916): 114.

66 Guy Pène du Bois, "Among the Art Galleries," *Evening Post Magazine*, April 5, 1919, p. 7. Differing opinions on Bellows's portraiture at the time are reflected in the reviews of his one-man exhibition at New York's Whitney-Richards Gallery (December 15–31, 1915). Of thirteen paintings featured, eight were portraits. See *Globe and Commercial Advertiser*, December 16, 1915, p. 16; *New York Tribune*, December 19, 1915, part III, p. 3; *Evening Post*, December 24, 1915, pp. 7–8; *New York Sun*, January 2, 1916, n.p.

67 On Hawthorne's popularity see, for example, Sadakichi Hartmann, "Studio-Talk," *International Studio* 26 (September 1905): 261–264, and Arthur Hoeber, "Charles W. Hawthorne," *International Studio* 37 (May 1909): 65ff. Hawthorne took Henri's place as instructor at the New York School of Art when the latter departed in 1909.

68 The painting, which measured thirty by thirty-eight inches, was reproduced in Evelyn Marie Stuart, "The Twenty-Ninth Annual Exhibition at the Art Institute," *Fine Arts Journal* 34 (December 1916): 619, and in *Catalogue of the Twenty-Ninth Annual Exhibition of American Oil Paintings and Sculpture* (Chicago: Art Institute of Chicago, November 2–December 7, 1916). Another description cited the "murderous greens" and "assassinating blues" of the painting's "horrific color scheme"; transcription of a review that appeared in the *Kansas City Star*, January 5, 1917, in scrapbook in possession of Charles Wesley Nash.

69 Although the painting, which Bellows signed, appears to be incomplete, with the individual features of the figures only schematically rendered, according to the artist's widow it was considered a finished work; Emma Bellows to Gertrude Herdle Moore, curatorial files, Memorial Art Gallery, University of Rochester, October 20, 1941. Bellows sold it to a California resident, Miss Augusta Senter of Pasadena, who was vacationing on Monhegan that summer; Artist's Account Book and curatorial file, Memorial Art Gallery.

70 Morgan, *George Bellows: Painter of America*, p. 203.

71 Alice T. Searle, "Exhibition of the National Association of Portrait Painters," *International Studio* 46 (May 1912): 63. See also G. Mortimer Marke, "The National Association of Portrait Painters, a New American Group," *Arts and Decoration* 2 (May 1912): 258–260. Bellows exhibited with the group in the Fourth and Fifth Annuals (both held in 1915), the Sixth Annual in 1916, and the Ninth Annual in 1920.

72 The Boston version, probably a preliminary study, is rendered in russet and purple; it is divided into a grid pattern, and the canvas was folded over the top and bottom, then enlarged again, suggesting the experimental

nature of the undertaking. Green and purple hues predominate in the Washington painting. The striking monumentality of these works had precedent in a large (thirty-three by forty-one-inch) group portrait depicting Bellows's daughters and the family's maid, Mabel, from 1915. The artist subsequently destroyed the work; Record Book B, p. 38. In 1915, the year of its execution, the latter painting was exhibited in the Fifth Annual Circuit Exhibition of the National Association of Portrait Painters. The following description appeared in one review: ". . .the present painting is not a bad example of color, as Mr. Bellows understands color. It is a little hot in places, as in the chocolate color of the nurse's head, but the canvas as a whole, although hardly a unit, is vivid and witty. The entertaining verve of the work springs largely from the fact that the nature of the subject allowed the artist to gratify his love of contrast in a natural way, without forcing the issue. His sense of humor has not here forsaken him, and the work is therefore spontaneous and sufficiently human." *Evening Post*, November 6, 1915, section I, p. 9.

[73] Kroll had studied at the Académie Julian in Paris. Nancy Hale and Fredson Bowers, eds., *Leon Kroll: A Spoken Memoir* (Charlottesville, Virginia: University Press of Virginia, 1983), p. 30.

[74] *Kroll: A Spoken Memoir*, p. 42. The summers of 1915 and 1916 appear to have been difficult for Bellows. See Lucie Bayard to Charles Morgan, January 23, 1964, Morgan Papers (Box VI, Folder 5), Amherst College Library. The arrival of a second child in the spring of 1915 created an additional financial burden. See George Bellows to Hamilton Easter Field, undated [April 1915], Hamilton Easter Field Papers, Archives of American Art, reel 68–2, fr. 5. In 1916, Bellows borrowed money from Henri; see Morgan, *George Bellows: Painter of America*, pp. 199–200, and George Bellows to Robert Henri, September 1, 1916, Robert Henri Papers, Beinecke Rare Book and Manuscript Library, Yale University. Kroll told Morgan that Bellows was depressed in Camden, Maine, during the summer of 1916; interview, July 11, 1963, Morgan Papers (Box VI, Folder 17), Amherst College Library.

[75] "The Big Idea: George Bellows Talks About Patriotism for Beauty," pp. 270, 275.

[76] George Bellows to Emma Bellows, August 6, 1917, Bellows Papers (Box I, Folder 5), Amherst College Library.

[77] Homer, *Henri and His Circle*, p. 177. Bellows spoke frequently of Eakins; see, for example, Bellows's letter to Robert Henri, November 16, 1917, Henri Papers, Beinecke Rare Book and Manuscript Library, Yale University; George Bellows to Dr. S. C. G. Watkins, Montclair, New Jersey, February 25, 1924, Bellows Papers (Box I, Folder 15), Amherst College Library. Eakins, in turn, admired Bellows; Lloyd Goodrich, *Thomas Eakins* (Cambridge: Harvard University Press, 1982), 2: 15.

[78] Nicolai Cikovsky, Jr., entry on Thomas Eakins's *The Art Student*, in *American Paintings From the Manoogian Collection*, exhibition catalogue (Washington: National Gallery of Art, 1989), pp. 126–130.

[79] A joint exhibition of the two artists at the Ferargil Gallery in 1921, five years after Eakins's death, provided an opportunity for direct comparison. At least several critics noted that Bellows did not entirely match Eakins's achievement: "Mr. Bellows makes a breezy companion for so serious a temperament" (*New York Times*, March 2, 1921, p. 8). See also *New York Tribune*, February 27, 1921, part III, p. 8, and Hamilton Easter Field, "Paintings and Sculpture at Various Galleries," *Brooklyn Eagle*, February 27, 1921, part III, p. 6.

[80] George Bellows to Emma Bellows, undated draft, Bellows Papers (Box I, Folder 2), Amherst College Library.

[81] Bellows had first painted his mother in June 1911 (listed in the Artist's Record Book A, p. 98, as "Portrait of My Mother, 30 x 38, destroyed, 3/4 length, hands clasped").

[82] Henri, *The Art Spirit*, p. 91.

[83] Mrs. Tyler's father, William Hubbard Brown (1796–1867), was an important figure in the early history of Chicago. A politician, banker, and lawyer, he was an advocate for women's rights and the abolition of slavery and took an active role in the founding of the Chicago Historical Society. Brown and his wife, Harriet Seward Brown (d. 1883), who was active in philanthropic causes, were close friends of Abraham and Mary Todd Lincoln. I am grateful to Claire Myers for providing information on the Brown and Tyler families.

[84] *Mrs. T. in Cream Silk No. 1* was begun in Chicago, but not completed until the summer of 1923, while *Mrs. T. in Cream Silk No. 2*, executed in early 1920, shortly after Bellows's return to New York, was apparently hastily painted for inclusion in the annual exhibition of the National Association of Portrait Painters, which opened in February of that year.

No contemporary evidence indicates Bellows's motivation for painting the elderly woman three times. The portraits occasioned an oft-repeated, yet apocryphal, story which held that upon meeting Mrs. Tyler at an opening, Bellows was so entranced that he requested a sitting. The story appeared in the *Blade* (an unidentified newspaper) at the time *Mrs. T. in Cream Silk No. 2* was exhibited with the National Association of Portrait Painters in New York (February 7–28, 1920); see also Morgan, *George Bellows: Painter of America*, pp. 231, 234–235. But the paintings may have been a more straightforward commission, as Bellows wrote a relative from Chicago's Hotel Stratford: "This journey however was only decided up on thru the necesity of painting a portrait commison"; Bellows to Shirley McMahon, November 4, 1919, in possession of Charles Wesley Nash. Since the only portraits to result from the trip were those of Mrs. Tyler, the possibility remains that, in addition to the teaching opportunity, the trip may have been instigated by the promise of Mrs. Tyler's patronage. Mrs.

Tyler's only child, an artist, Carolyn D. Tyler, had studied at the Art Institute and conceivably played a role in introducing Bellows to her mother.

[85] Bellows's initial citations for the three works give Mrs. Tyler's full surname. The original entries are: "Portrait Mrs. Mary Tyler in Wine Silk," "Portrait Mrs. Mary Tyler in Cream Silk," and "Portrait III of Mrs. Tyler 1860." The names were subsequently altered by the artist's widow to "Mrs. T. in Wine Silk," "Portrait Mrs. T. in Cream Silk," and "Mrs. T. in Cream Silk No. 2," respectively. Bellows's fascination with the transitory aspects of life has parallels in the postwar literary movement of Aestheticism. One of its leading practioners was novelist Joseph Hergesheimer (1880–1954), whom Bellows knew; see George Bellows to Alfred Knopf, November 17, 1924, Bellows Papers (Box I, Folder 8), Amherst College Library. Bellows wrote his half-sister that Hergesheimer was writing an essay on the artist, but it apparently was never published; George Bellows to Laura Monett, May 20, 1924, Bellows Papers (Box I, Folder 8), Amherst College Library. Emma Bellows, among many others, recalled Bellows's enthusiasm for contemporary literature; Seiberling, "George Bellows, 1882–1925," p. 227.

[86] On at least one occasion, Bellows exhibited the wine silk version along with the 1920 cream silk version, further underscoring the fact that he regarded them as independent efforts, however interrelated they might be. Both appeared in the artist's one-man exhibition at the Carnegie Institute, Pittsburgh, in February and March of 1923. See *An Exhibition of Paintings, Drawings and Lithographs By George W. Bellows* (Department of Fine Arts, Carnegie Institute, February 26–March 31, 1923).

[87] Louis H. Frohman, "Bellows as an Illustrator," *International Studio* 78 (February 1924): 425.

[88] Interview with George Bellows in "George Bellows, N.A. Paints 'The Call of the City,'" *Sun*, December 26, 1915, section 5, p. 7.

[89] "George Bellows Paints 'The Call of the City,'" section 5, p. 7.

[90] Critics often commented upon Mrs. Tyler's age; the *Philadelphia Public Ledger* (February 6, 1921, p. 6) called the painting "a remarkable Bellows in the shape of a veritable faded grand dame of the old school ready for a ball." Henry McBride mentioned the association with Miss Haversham in his review of the painting in the *Sun and New York Herald*, February 15, 1920, section III, p. 7).

[91] Chicago city directories reveal that Mrs. Tyler's husband, Romeyne (variously spelled Romain and Romaine), who was in the hardware business, maintained a separate address from his wife beginning in 1901 and continuing to his death around 1908, at which time Mrs. Tyler is listed as a widow.

[92] Bellows apparently took special pride in the red beaded bag which appears in *Mrs. T. in Cream Silk No. 2*. A magazine interview noted that he "considered it the most beautiful thing in the picture"; Ameen Rihani, "Luks and Bellows," *International Studio* 71 (August 1920): 22–23.

[93] On these occasions, Bellows also dressed in the buffoonish attire of his mother's old-fashioned clothes, imaginatively substituting an old photograph in place of the cameo pin that Anna Bellows often wore. On the Maverick Festival and Bellows's attire, see Morgan, *George Bellows: Painter of America*, p. 277. For details about the summer of 1915, see Lucie Bayard to Charles Morgan, January 23, 1964, Morgan Papers (Box VI, Folder 5), Amherst College Library. Bellows also participated in the costume parties popular in New York's bohemian art circles. The night before Bellows was stricken with appendicitis, he attended a party dressed as Queen Victoria; Rollo Walter Brown, *Lonely Americans* (New York: Coward-McCann, 1929), p. 161.

[94] The *Mrs. T.* series was part of, and may have served as an impetus for, a large group of lithographs and drawings that Bellows produced in the early 1920s, with titles evoking Victorian sentimentality. Bellows did a number of drawings depicting women in nineteenth-century gowns. Some relate to his commission to illustrate Donn Byrne's *The Wind Bloweth* for *Century Magazine* in 1922.

[95] George Bellows to Elinor Daggett, May 14, 1920, Bellows Papers (Box I, Folder 7), Amherst College Library.

[96] Morgan, *George Bellows: Painter of America*, pp. 205–206.

[97] Frohman, "Bellows as Illustrator," p. 423.

[98] George Bellows to Emma Bellows, June 21, 1921, Bellows Papers (Box I, Folder 5), Amherst College Library.

[99] The decorative motif on the curtains also suggests a subtext. In his record book, Bellows initially identified the painting as *Anne in White with Peacock Curtains*, with "peacock curtains" later crossed out (peacock elements can be recognized in the drapery's busy design). In the late nineteenth century the peacock was well known as "an apt symbol for woman's sensual appeal"; see Charles C. Eldredge, *American Imagination and Symbolist Painting*, exhibition catalogue (New York: Grey Art Gallery and Study Center, New York University, 1979).

[100] Before Bellows and his wife returned to New York around Thanksgiving, the artist sent the painting ahead to New York in order to include it in the New Society of American Artists exhibition in November. The following year, the painting won the Beck Medal at the Pennsylvania Academy of the Fine Arts and, in 1922, the first prize at the Carnegie International. It was purchased in 1923 by the Albright Art Gallery (now the Albright-Knox Art Gallery), Buffalo, for more than six thousand dollars.

[101] See Bellows's article on Dynamic Symmetry which appeared a few months after he completed this painting: "The Relation of Painting to Architecture: An Interview with George Bellows, N.A., in Which Certain Characteristics of the Truly Original Artist Are Shown to Have a Vital Relation to the Architect and His Profession," *American Architect* 118 (December 29, 1920): 847–851.

[102] Joseph Taylor, "On the Death of Bellows," p. 5.

[103] In writing about the painting, Fanny's step-daughter, Edith Daggett, described an unfulfilled element in her mother's life: "Her hand is outstretched toward the child, while in those smouldering, far-away eyes is a yearning expression I have often seen, a yearning for something that even the devotion of step-children could not satisfy"; Edith G. Daggett, "George Wesley Bellows, American Painter," pp. 6–7, undated essay in Bellows Papers (Box IV, Folder 11), Amherst College Library. Fanny died in San Diego, where she had spent her married life, just a few months before her nephew.

[104] Seiberling, "George Bellows, 1882–1925," p. 222.

[105] Confusion over the year of execution for the version in the Columbus Museum of Art dates to the time of Bellows's death. In the artist's Record Book B, he listed "Portrait of My Mother in the Sitting Room, March 1921, 49 x 83" on page 254, followed by "Portrait of My Mother Full Length in the Sitting Room September 1921, 49 x 79" on page 261. Emma Bellows later changed the record book entry for the second work (the version now in Columbus) to September 1920 and published the painting as *Portrait of My Mother No. 1* in her book, *The Paintings of George Bellows* (New York: Alfred A. Knopf, 1929), no. 109. The Chicago painting likewise was listed as the second version in the catalogue for Bellows's 1925 memorial exhibition (*Memorial Exhibition of the Works of George Bellows*, Metropolitan Museum of Art, New York, October 12–November 22, 1925, pp. 29, 86). Documentary evidence indicates, however, that this rearrangement of the original order was in error. Bellows wrote Joseph Taylor in the fall of 1921 (and not the fall of 1920) that he was working on "a portrait of my mother life size full length, seated in the old Sitting Room at 265 Rich St."; George Bellows to Joseph Taylor, September 30, 1921, Bellows Papers (Box I, Folder 14), Amherst College Library. Two exhibition reviews also suggest that the Chicago painting was executed first and the Columbus version second. In May 1921, the Chicago pictures appeared in the exhibition of the Junior Art Patrons of America in New York City, under the direction of Marie Sterner, where details unique to this version of the painting—"the gold fish [and] . . . the checkered table cover"—were described; *New York Times Book Review and Magazine*, May 15, 1921, p. 20. In addition, according to Bellows's record book, it was the Columbus version that appeared in the Third Annual Exhibition of the New Society of Artists in New York City. A review of this oil described it as the second version of the two: "a blackish portrait of his mother . . . a trifle better than his previous blackish portrait of his mother"; New York *Herald*, November 20, 1921, section III, p. 4. The Chicago painting is titled *My Mother*, based on the inscription Bellows recorded on the verso of the canvas.

[106] A critic for the *Nation* also remarked upon the brutal photographic fidelity of the 1919 portrait of Bellows's mother, *Grandma Bellows*; "Art Put to the Test" (November 15, 1919), p. 109. The *New York Herald* (November 20, 1921, section III, p. 4) criticized the painting's poor rendering: ". . . the hands and arms were evidently a trouble to the artist to place. One feels instinctively the artist swaying them backward and forward uncertainly and finally and in spite of the Hambidge theory saying to himself 'Hang it all, I'll let 'em go like that.'" Bellows apparently was sensitive to comments about his ability to draw the human figure. Jean Bellows commented on the issue in the *Enjoyer*, a magazine of original poetry, fiction, artwork, and drama reviews that she produced after her father's death: "He was very particular about his portraits. Some artists said that he made his hands too big, but daddy said just the opposite. Quoting him 'Some artists make their hands to [sic] small. Your own hand covers up the greater part of your face, therefore you should make the hands in your picture as big as the face,' or words to that effect." *Enjoyer* 11 (December 1929): 7, in Bellows Papers (Box IV, Folder 17), Amherst College Library.

[107] Ethel Clarke to Charles Morgan, July 23, 1963, Morgan Papers (Box VI, Folder 8), Amherst College Library. Commissioned portraits continued to be troublesome throughout Bellows's life. In 1924, he was presented with an opportunity to paint Ignacy Jan Paderewski (1860–1941), the Polish pianist and statesman whose heroic stature as a patriot in the United States must have appealed to Bellows's romantic side. Bellows glumly noted: "Like most sitters, however, he didn't show up"; George Bellows to Laura Monett, May 20, 1924, Bellows Papers (Box I, Folder 9), Amherst College Library.

[108] Morgan, *George Bellows: Painter of America*, pp. 258–259.

[109] In a November 1923 letter to Robert Henri (Bellows Papers [Box I, Folder 8], Amherst College Library), Bellows noted the importance of his production since his trip to Columbus for his mother's funeral, calling *Emma and Her Children* "as fine as any work of mine." He wrote a similarly enthusiastic letter to Leon Kroll outlining his summer's work: "I have had a very successful summer, with a few, for me very good pictures"; undated letter, Leon Kroll Papers, Archives of American Art, reel D326, fr. 102.

[110] Awarded first prize at the Corcoran Gallery of Art's Ninth Biennial in 1923, it was compared with Degas and Renoir paintings.

[111] Emma Bellows to Museum of Fine Arts, Boston, May 28, 1943, curatorial files, Museum of Fine Arts. Bellows's uncertainty about the figure of Anne is also reflected in a drawing for the painting (Museum of Fine Arts, Boston), where the figure of Anne is less finished than that of the other two individuals. Bellows endured

a similar struggle in painting *Emma in a Purple Dress* (fig. 50), which was completed the following month. Emma recalled "the terrific struggle George had with the head. He scraped it out again and again. Finally one day he said 'get up on the model stand and I'll have another try' I said 'well—you had better make it snappy, this dress will not hold out much longer' That afternoon everything worked together for good—the head just blew on— and the painting was finished." Emma Bellows to Jerry Bywaters, July 25, 1956, curatorial files, Dallas Museum of Art.

[112] In 1921, Bellows, Eugene Speicher, Robert Henri, and Leon Kroll taught a class in outdoor figure painting in Woodstock; Richard Le Gallienne, *Woodstock* (Woodstock, N.Y.: Woodstock Art Association, 1923), p. 15.

[113] Bellows wrote Frank Crowninshield that he was excited about the Durand-Ruel exhibition because they "held such a high standard of quality in the pictures they have shown, and since practically no American has ever been included in their gallery, this exhibition may have added a significance which I am very glad to accept"; George Bellows to Frank Crowninshield, December 15, 1924, Bellows Papers (Box I, Folder 6), Amherst College Library.

[114] Author's interview with Jean Bellows Booth, April 1991.

[115] According to Jean Bellows Booth (letter to author, September 16, 1991), Mrs. Wase worked for their friend Elsie Speicher as a laundress or cleaning woman, and Mr. Wase probably did some gardening.

[116] For a report of the Wase's troubled marriage, see *It Happened in Woodstock* (Woodstock, N.Y.: Stonecrop, 1972), p. 111. Bellows did several lithographs of married couples; one, *Auntie Mason and Her Husband* (winter 1923–24), has the appearance of a staged portrait.

[117] John Sloan also commented on Zuloaga; see Brooks, *John Sloan: A Painter's Life*, p. 194. See also *Kroll: A Spoken Memoir*, p. 35.

[118] Emma Bellows to Homer Saint-Gaudens, Carnegie Institute, Pittsburgh, curatorial files. Bellows also may have been speaking of Zuloaga when he wrote: "An itinerant painter of portraits has come to our shores, he is said to have a great name in far places, and to have spoken to Kings and Princes. We will judge if he please us." George Bellows to Joseph Taylor, March 16, 1922, George Bellows Papers (Box I, Folder 14), Amherst College Library. On Zuloaga's public reception in America, see Priscilla E. Muller, "Zuloaga and America," in *Ignacio Zuloaga 1870–1945*, exhibition catalogue (Bilbao, Spain: Basque Government, Culture and Tourism Department, 1991).

[119] Frohman, "Bellows as Illustrator," p. 424.

[120] "'The Art Spirit,' By Robert Henri in Which He Makes Clear the Relationship of Art to Life," *Arts and Decoration* 20 (December 1923): 26.

Chronology

1882

August 12
George Wesley Bellows born, Columbus, Ohio

1884 (?)

Emma Story born, New York City

1897

Enters Central High School, Columbus, Ohio

1901

Graduates from Central High School

Enrolls at Ohio State University, Columbus, Ohio; drawings begin to appear in Ohio State University student publications

1904

Withdraws from Ohio State University after spring of junior year and moves to New York, where he resides briefly at the YMCA; moves with Ed Keefe and Fred Cornell to 352 W. 58th; enrolls in William Merritt Chase's New York School of Art (commonly known as the Chase School), where he studies with Robert Henri; meets Emma Story of Upper Montclair, New Jersey

1905

Paints *Central Park* (Ohio State University)

December
Spends Christmas with Emma's family in New Jersey

1906

August
Paints *River Rats* (private collection)

September
Moves to 1947 Broadway, Lincoln Arcade Building, with Ed Keefe and Fred Cornell; other roommates over the next few years include Eugene O'Neill

December
Takes his first trip to Columbus in two years; paints *Portrait of My Father* (Columbus Museum of Art)

1907

February
Paints the first of four oils depicting the excavation for Pennsylvania Station

March–April
River Rats exhibited in the National Academy of Design's Spring Annual

July
Makes first boxing picture, *The Knock Out* (pastel; Rita and Daniel Fraad Collection)

[Summer]
Paints *Little Girl in White* (National Gallery of Art, Washington)

Photographer unknown. *George Bellows*, n.d. Photograph. Courtesy of Allison Gallery, New York.

August
Paints *Forty-Two Kids* (Corcoran Gallery of Art)

August–September
Paints *Club Night* (originally titled *Stag at Sharkey's*) (National Gallery of Art, Washington)

December
Travels to Columbus

1908

February
Exhibition of The Eight opens at the MacBeth Gallery, New York; paints *North River* (Pennsylvania Academy of the Fine Arts), which is exhibited in the National Academy of Design's Spring Annual (March and April) and is awarded the second Hallgarten Prize there

April
Paints *Up the Hudson* (Metropolitan Museum of Art)

[Summer]
Spends six weeks teaching at University of Virginia

1909

January
Henri leaves the Chase School and sets up his own school in the Lincoln Arcade Building; Bellows attends his life classes; accompanied by Eugene O'Neill and Edward Keefe, spends part of January and February at O'Neill's family home in Zion, New Jersey

March
Sells *North River* to Pennsylvania Academy of the Fine Arts

April
Elected Associate Member, National Academy of Design; receives commission from Ohio State University Alumni Association to paint a portrait of Professor James Canfield (Ohio State University Libraries); Canfield dies after the second sitting

August
Paints *Stag at Sharkey's* (originally titled *Club Night*) (Cleveland Museum of Art)

October
Paints *Both Members of This Club* (National Gallery of Art, Washington)

December
Paints *The Bridge, Blackwell's Island* (Toledo Museum of Art) and *The Lone Tenement* (National Gallery of Art, Washington); travels to Columbus

1910

April
Exhibits in the Independent Artists Exhibition organized by Robert Henri, John Sloan, Arthur B. Davies, and others at 29 W. 35th; visits patron Joseph B. Thomas, in Lakewood, New Jersey, where he attends polo matches; paints *Polo at Lakewood* (Columbus Museum of Art)

May
Appointed life class instructor at Art Students League

Moves into house at 146 E. 19th Street, where he has created a studio on the third floor; because of the renovation, paints little this summer

September
Marries Emma Story in St. George's Episcopal Church, the Bronx; reception at National Arts Club; honeymoon at Montauk, Long Island; also goes to Sag Harbor to see his family vacationing there

November
Paints *Blue Snow, the Battery* (Columbus Museum of Art)

1911

January
Exhibits twenty-four paintings at first one-man show, Madison Gallery, New York; paints *Shore House* (Rita and Daniel Fraad Collection)

[Early in year]
Organizes exhibition of The Eight and his own work in Columbus

February
Paints *New York* (National Gallery of Art, Washington)

Hugo Reisinger buys *Up the Hudson* and presents the work to the Metropolitan Museum of Art

April
Sells *Polo at Lakewood* to Columbus Art Association

July
Henri invites Bellows and Randall Davey to join him on Monhegan Island, Maine; during the month of August there, Bellows experiments with Maratta colors, producing at least twelve large oils

September
Daughter Anne born

[Fall]
Paints four large canvases based on Monhegan sketches: *Evening Swell* (Berry-Hill Galleries), *The Sea* (Hirshhorn Museum and Sculpture Garden), *Three Rollers* (National Academy of Design), and *The Rich Woods* (location unknown)

December
Paints *Snow Dumpers* (Columbus Museum of Art); invited to join Association of American Painters and Sculptors

1912

February
Paints *Men of the Docks* (Maier Museum of Art, Randolph-Macon Woman's College)

Accepts several commissions for magazine illustrations

[Summer]
Stays with Emma's family in Upper Montclair, New Jersey

October
Visits Onteora, New York (in Catskills), at the invitation of the mother of his friend and fellow artist Ben Ali Haggin; paints ten small landscapes there; first portrait of Anne, *Portrait of Baby Anne* (private collection)

November
First one-man show in Columbus opens (it later travels to Toledo and Detroit)

December
George, Emma, and Anne visit Columbus through Christmas; commissioned to paint portraits of Mrs. Albert M. Miller and Mrs. H. B. Arnold

1913

February
Works on installation of Armory Show; so involved with the exhibition that he attends every day, produces no paintings in February or March

March
Father dies in Columbus; exhibits *Little Girl in White* at National Academy of Design, where it receives the Hallgarten Prize

April–May
Contributes drawings to *The Masses*

May
Paints *Cliff Dwellers* (Los Angeles County Museum of Art) and *Dr. T. C. Mendenhall* (Ohio State University Libraries)

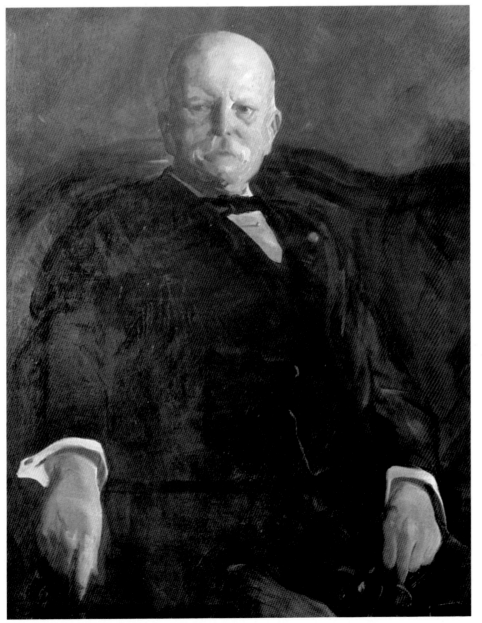

George Bellows.
Dr. T. C. Mendenhall, 1913.
Oil on canvas. Ohio State
University Libraries.

[Spring]
Becomes full Academician, National Academy of Design

July–October
Spends several months with Leon Kroll on Monhegan and Matinicus islands, Maine, where he paints over one hundred small panels and thirteen in a larger format

1914

January
Exhibition of twenty-seven paintings, primarily Monhegan seascapes, at Montross Gallery

February
Paints *Love of Winter* (Art Institute of Chicago)

June–August
To Monhegan Island with Emma and the Randall Daveys; paints first version of *Fisherman's Family*, which is completed in January 1915, and *Evening Group* (Memorial Art Gallery, Rochester), both in June; also paints over fifteen portraits, including *Emma at the Piano* (Chrysler Museum) in July and *Geraldine Lee No. 2* (Butler Institute of American Art) in August

[Fall]
Works on house alterations, 146 E. 19th Street; Emma's parents move into first floor apartment there; paints little during fall and winter

December 1914
Exhibition of his paintings opens at Art Institute of Chicago (runs through January 1915, then travels to Detroit and Los Angeles)

1915

January
Sent by *Metropolitan Magazine* to Philadelphia with journalist John Reed to see Billy Sunday

April
Daughter Jean born; paints second version of Judge Peter Olney (private collection) for the Harvard Club (April and May)

[Summer]
To Ogunquit, Maine, with Leon Kroll, the Henris, Anna Bellows, the Storys, and Henri's student, Lucie Bayard

[Fall]
Furor over Olney portrait at Harvard Club, including disagreement over whether he should be paid; public argument with Forbes Watson

1916

[Early in year]
Makes first lithographs

February
Paints *The Sawdust Trail* (Milwaukee Art Museum)

June–September
To Camden, Maine, with Anna Bellows and the Storys (Kroll later joins them); paints *Dock Builders* (Antonette and Isaac Arnold, Jr.) in June and *The Rope* (Yale University Art Gallery) in August. After daughters return to New York, takes Emma to visit the islands of Matinicus and Criehaven (back in Camden by October)

October
Returns to New York and concentrates on lithographs

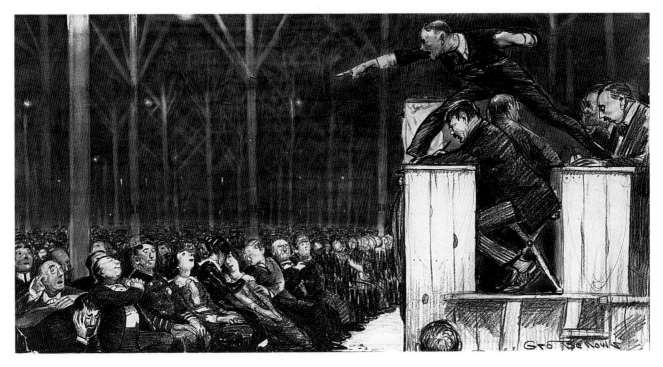

George Bellows. *Billy Sunday*, 1915. Pencil (?), black crayon, pen and ink, and ink wash on paper. Courtesy of Boston Public Library, Print Department; gift of Albert H. Wiggin.

1917

March
One-man exhibition of paintings, prints, and drawings (three-quarter of canvases from Camden and Matinicus) at Milch Galleries

May
Bellows and family visit California; reside in artists' and writers' colony of Carmel

July
Paints commissioned portrait of Paul Clark, the son of wealthy mine owner, in San Mateo

August
Paints *The Widow* (Baltimore Museum of Art), while his aunt, Fanny Daggett, visits the family in Carmel; has tonsillectomy in San Francisco's Mount Zion Hospital

[Early Fall]
Bellows family and Anna Bellows go to Santa Fe, join the Henris and Kroll there; return to New York in October

[Fall]
Attends a series of lectures on Dynamic Symmetry by Jay Hambidge

November
Thomas Eakins memorial exhibition opens at the Metropolitan Museum of Art

1918

[Spring]
Begins series of sixteen lithographs depicting German atrocities against the Belgians during World War One

July–November
Executes five oils on same theme

Photographer unknown. *Anne, Emma, and Jean Bellows*, c. 1917. Photograph. George Bellows Papers, Special Collections Department, Amherst College Library.

[Late Summer and September]
Goes to Middletown, Rhode Island, with family and longtime friends, Eugene and Elsie Speicher

1919

March
Exhibition of Paintings by George Bellows opens at Knoedler & Company; sells several works

[Summer]
Family summers in Middletown, Rhode Island, with Anna Bellows

Serves on a committee to select American paintings for exhibition at the Luxembourg Gallery in Paris and proposes a democratic selection procedure

September
Paintings by George Bellows opens at Albright Art Gallery, Buffalo, then travels in November to Chicago, where Bellows is teaching

November–December
Goes to Chicago with Emma to teach at the Art Institute of Chicago; paints *Mrs. T. in Wine Silk* (Mitchell Museum, Mount Vernon, Illinois) in December and begins *Mrs. T. in Cream Silk, No. 1* (Hirshhorn Museum and Sculpture Garden); stops in Columbus en route back to New York

1920

January
Back in New York, paints *Mrs. T. in Cream Silk, No. 2* (Minneapolis Institute of Arts)

June/November
At Speicher's invitation, Bellows's family makes their first trip to Woodstock, where they rent Shotwell House with Anna Bellows and Bellows's Aunt Fanny; paints *Anne in White* (Carnegie Museum of Art) in June, *Aunt Fanny (Old Lady in Black)* (Des Moines Art Center) in August, *Elinor, Jean and Anna* (Albright-Knox Art Gallery) in September; sends children back to New York, but stays in Woodstock with Emma until Thanksgiving; wins first prize at National Arts Club for *The Widow* (Baltimore Museum of Art)

1921

January–March
Makes numerous lithographs

February
Paintings by Thomas Eakins and George Bellows at Ferargil Galleries, New York

March
Paints *My Mother* (Art Institute of Chicago)

[Summer]
Stays at Shotwell House, Woodstock, and works four months on house; purchases land to build his own studio

June
Paints Meredith Hare (on commission); hired by *New York World* to cover Jack Dempsey-Georges Carpentier fight at Boyle's Thirty Acres, Jersey City, New Jersey

July
Paints *Katherine Rosen* (Yale University Art Gallery)

September
Paints *Portrait of My Mother* (Columbus Museum of Art)

1922

April
Elinor, Jean, and Anna wins first prize at the Carnegie International Exhibition, Pittsburgh

[Spring]
Sells *Stag at Sharkey's* (then titled *Club Night*) to Cleveland Museum of Art

April–August
Builds house in Woodstock, devoting energies exclusively to building; family, including Anna Bellows, spends summer there

April–September
Century Magazine publishes Donn Byrne's *The Wind Bloweth* with illustrations commissioned from Bellows

October
Begins painting again in earnest

November
Paints *The White Horse* (Worcester Art Museum)

December – May 1923
Hearst's International Magazine publishes H. G. Wells's story, *Men Like Gods*, with illustrations commissioned from Bellows

1923

January–June
Makes over thirty lithographs

June–November
Summer in Woodstock not productive; mother dying in Columbus

August
Emma and George go to Columbus; Bellows's mother dies

September
Paints *Emma and Her Children* (Museum of Fine Arts, Boston); assigned by *New York Evening Journal* to provide drawings of Jack Dempsey and Luis Firpo fight at Polo Grounds in New York

September
Paints *The Crucifixion* (Lutheran Brotherhood, Minneapolis)

October
Paints second version of *Fisherman's Family* (private collection)

[Winter 1923–24]
Makes thirty lithographs by March

1924

May/November
To Woodstock with family; sends daughters back to New York in the fall

June
Paints *Dempsey and Firpo* (Whitney Museum of American Art)

July
Paints *Lady Jean* (Yale University Art Gallery)

October
Finishes *Two Women* (Portland Museum of Art; lent by Karl Jaeger, Tamara Jaeger, and Kerena Jaeger)

November
Aunt Fanny dies

1925

Ruptured appendix (January 2, 1925); dies of peritonitis (January 8, 1925)

February
Paintings by George Bellows at Durand-Ruel Galleries, New York

October–November
Memorial Exhibition of the Work of George Bellows, Metropolitan Museum of Art

1929

The Paintings of George Bellows, edited by Emma S. Bellows, published by Knopf

1959

Emma Story Bellows dies

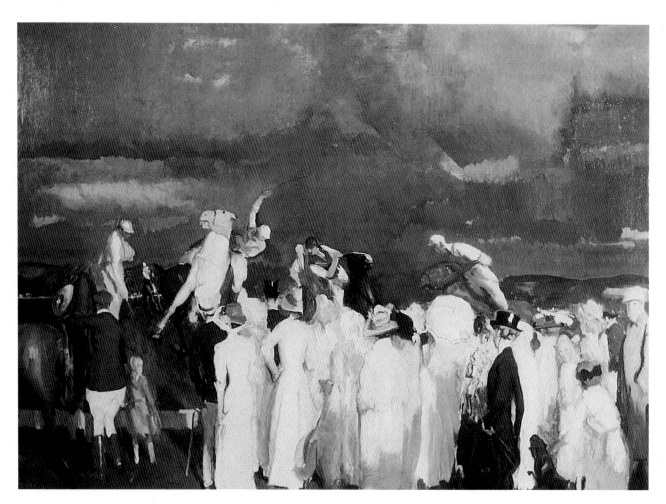

George Bellows. *Crowd at Polo Game*, 1910. Oil on canvas, 44½ x 63 in.
Collection of Mrs. John Hay Whitney.

The Paintings of George Bellows

Checklist of the Exhibition

Robin, Portrait of Clifton Webb, 1905, oil on canvas, 44½ x 30½ in.,
Mr. and Mrs. Richard D. Zanuck

River Rats, 1906, oil on canvas, 30½ x 38½ in., private collection, Washington, D.C.
 Los Angeles and New York only

Portrait of My Father, 1906, oil on canvas, 28⅜ x 22 in., Columbus Museum of Art, Ohio;
gift of Emma S. Bellows

Little Girl in White (Queenie Burnett), 1907, oil on canvas, 62¼ x 34¼ in.,
National Gallery of Art, Washington; collection of Mr. and Mrs. Paul Mellon

Frankie the Organ Boy, 1907, oil on canvas, 48 x 34½ in., Nelson-Atkins Museum of Art,
Kansas City, Missouri; acquired through the bequest of Ben and Clara Shlyen

Forty-Two Kids, 1907, oil on canvas, 42⅜ x 60¼ in., Corcoran Gallery of Art,
Washington; Museum purchase, William A. Clark Fund

Club Night, 1907, oil on canvas, 43 x 53 in., National Gallery of Art, Washington;
John Hay Whitney Collection
 New York, Columbus, Fort Worth only

In Virginia, 1908, oil on canvas, 29¼ x 37 in., private collection

Paddy Flannigan, 1908, oil on canvas, 30¼ x 25¼ in., Erving and Joyce Wolf Collection
 Los Angeles and New York only

Excavation at Night, 1908, oil on canvas, 34 x 44 in., Berry-Hill Galleries, New York

Rain on the River, 1908, oil on canvas, 32³⁄₁₆ x 38³⁄₁₆ in., Museum of Art, Rhode Island
School of Design; Jesse Metcalf Fund

Winter Afternoon, 1909, oil on canvas, 30 x 38 in., Norton Gallery of Art,
West Palm Beach
 Los Angeles and New York only

The Palisades, 1909, oil on canvas, 30 x 38 in., Terra Museum of American Art, Chicago;
Daniel J. Terra Collection

Pennsylvania Station Excavation, 1909, oil on canvas, 31¼ x 38¼ in., Brooklyn Museum;
A. Augustus Healy Fund

Stag at Sharkey's, 1909, oil on canvas, 36¼ x 48¼ in., Cleveland Museum of Art;
Hinman B. Hurlbut Collection
 Los Angeles and New York only

A Morning Snow—Hudson River, 1910, oil on canvas, 45⅜ x 63¼ in., Brooklyn Museum;
gift of Mrs. Daniel Catlin

Floating Ice, 1910, oil on canvas, 45 x 63 in., Whitney Museum of American Art,
New York; gift of Gertrude Vanderbilt Whitney

Polo Game, 1910, oil on canvas, 38 x 48 in., private collection
 Los Angeles only

Polo at Lakewood, 1910, oil on canvas, 45¼ x 63½ in., Columbus Museum of Art, Ohio;
Columbus Art Association Purchase

Blue Snow, the Battery, 1910, oil on canvas, 34 x 44 in., Columbus Museum of Art, Ohio;
Museum Purchase, Howald Fund

Shore House, 1911, oil on canvas, 40 x 42 in., Collection of Rita and Daniel Fraad
 New York and Fort Worth only

New York, 1911, oil on canvas, 42 x 60 in., National Gallery of Art, Washington;
Collection of Mr. and Mrs. Paul Mellon

Evening Swell, 1911, oil on canvas, 30 x 38 in., Berry-Hill Galleries, New York

An Island in the Sea, 1911, oil on canvas, 34¼ x 44⅛ in., Columbus Museum of Art,
Ohio; gift of Howard B. Monett

The Sea, 1911, 34 x 44⅛ in., Hirshhorn Museum and Sculpture Garden,
Smithsonian Institution, Washington; Joseph H. Hirshhorn Foundation

Snow Dumpers, 1911, oil on canvas, 36⅛ x 48⅛ in., Columbus Museum of Art, Ohio;
Museum Purchase, Howald Fund

Men of the Docks, 1912, oil on canvas, 45 x 63½ in., Maier Museum of Art,
Randolph-Macon Woman's College, Lynchburg, Virginia
 Los Angeles and New York only

Portrait of Dr. Walter Quincy Scott, 1912, oil on canvas, 44 x 34 in.,
Ohio State University Libraries

The Circus, 1912, oil on canvas, 33⅞ x 43⅞ in., Addison Gallery of American Art,
Phillips Academy, Andover, Massachusetts; gift of Elizabeth Paine Metcalf
 Los Angeles, New York, and Columbus only

Mrs. Albert M. Miller, 1912, oil on canvas, 77 x 40¼ in., Columbus Museum of Art,
Ohio; gift of H. Bartley Arnold

Shaghead, c. 1913, oil on paperboard, 22¹/₁₆ x 29⅝ in., Telfair Academy of Arts and
Sciences, Inc., Savannah, Georgia; Museum purchase, 1936

Cliff Dwellers, 1913, oil on canvas, 40³/₁₆ x 42¹/₁₆ in., Los Angeles County Museum of Art;
Los Angeles County Funds

Monhegan Island, 1913, oil on panel, 18 x 22 in., Worcester Art Museum, Massachusetts; gift of Mrs. Janet Morgan and her children in memory of Charles H. Morgan

Wave, 1913, oil on panel, 15 x 19½ in., private collection; courtesy of Spanierman Gallery, New York

Beating Out to Sea, 1913, oil on panel, 15½ x 20 in., William A. Farnsworth Library and Art Museum, Rockland, Maine

Evening Blue, 1913, oil on panel, 17½ x 21½ in., private collection

Summer Surf, 1914, oil on panel, 18 x 22 in., Delaware Art Museum, Wilmington; gift of the Friends of the Art Center

Geraldine Lee, No. 2, 1914, oil on panel, 38 x 30 in., Butler Institute of American Art, Youngstown, Ohio

Riverfront, No. 1, 1915, oil on canvas, 45⅜ x 63⅛ in., Columbus Museum of Art, Ohio; Museum purchase, Howald Fund

Harbor at Monhegan, 1913–15, oil on canvas, 26 x 38 in., Jordan-Volpe Gallery, New York

Easter Snow, 1915, oil on canvas, 34 x 45 in., IBM Corporation, Armonk, New York

Lucie, 1915, oil on canvas, 22 x 19 in., Everett D. Reese

The Sawdust Trail, 1916, oil on canvas, 63 x 45⅛ in., Milwaukee Art Museum; Layton Art Collection

Dock Builders, 1916, oil on canvas, 30 x 38 in., Antonette and Isaac Arnold, Jr., Houston, Texas

In a Rowboat, 1916, oil on canvas, 30½ x 44¼ in., Montclair Art Museum; purchase made possible through a special gift from Mr. and Mrs. H. St. John Webb
 New York, Columbus, and Fort Worth only

The Rope, 1916, oil on canvas, 30 x 44 in., Yale University Art Gallery; gift in memory of Chauncey K. Hubbard

Matinicus from Mt. Ararat, 1916, oil on panel, 18 x 22 in., Portland Museum of Art, Maine; lent by Ellen Williams

Ox Team, Wharf at Matinicus, 1916, 22 x 28 in., Metropolitan Museum of Art; gift of Mr. and Mrs. Raymond Horowitz
 Los Angeles and New York only

Romance of Autumn, 1916, oil on canvas, 32½ x 40 in., William A. Farnsworth Library and Art Museum, Rockland, Maine; gift of Mr. and Mrs. Charles Shipman Payson, 1964

Criehaven, Large, 1917, oil on canvas, 30 x 44⅛ in., William Benton Museum of Art, University of Connecticut; Louise Crombie Beach Memorial Collection

The Fisherman, 1917, oil on canvas, 30 x 44 in., Berry-Hill Galleries, New York

Edith Cavell, 1918, oil on canvas, 45 x 63 in., Museum of Fine Arts, Springfield, Massachusetts; James Philip Gray Collection

Emma in the Black Print, 1919, oil on canvas, 40 x 32 in., Museum of Fine Arts, Boston; bequest of John T. Spaulding

Mrs. T. in Wine Silk, 1919, oil on canvas, 48 x 38 in., Mitchell Museum, Mount Vernon, Illinois; gift of John R. and Eleanor R. Mitchell

Mrs. T. in Cream Silk, No. 1, 1919–23, oil on canvas, 48⅜ x 38 in., Hirshhorn Museum and Sculpture Garden, Smithsonian Institution, Washington; Joseph H. Hirshhorn Bequest, 1981

Tennis at Newport, 1920, oil on canvas, 50 x 61 in., private collection

Anne in White, 1920, oil on canvas, 57⅞ x 42⅞ in., Carnegie Museum of Art, Pittsburgh; Patrons Art Fund

Aunt Fanny (Old Lady in Black), 1920, oil on canvas, 44⅛ x 34¼ in., Des Moines Art Center; purchased with funds from the Edmundson Art Foundation, Inc.

Elinor, Jean, and Anna, 1920, oil on canvas, 59 x 66 in., Albright-Knox Art Gallery, Buffalo, New York; Charles Clifton Fund, 1923

My Mother, 1921, oil on canvas, 83 x 49 in., Art Institute of Chicago; Frank Russell Wadsworth Memorial

Katherine Rosen, 1921, oil on canvas, 53 x 43⅛ in., Yale University Art Gallery, New Haven; bequest of Stephen Carlton Clark

The White Horse, 1922, oil on canvas, 34⅛ x 44¹/₁₆ in., Worcester Art Museum, Massachusetts

Emma and Her Children, 1923, oil on canvas, 59 x 65 in., Museum of Fine Arts, Boston; gift of Subscribers and the John Lowell Gardner Fund

The Crucifixion, 1923, oil on canvas, 59½ x 65½ in., Lutheran Brotherhood, a Fraternal Benefit Society, Minneapolis

Fisherman's Family, 1923, oil on canvas, 38½ x 48¾ in., private collection

Dempsey and Firpo, 1924, oil on canvas, 51 x 63¼ in., Whitney Museum of American Art, New York; purchase, with funds from Gertrude Vanderbilt Whitney

Lady Jean, 1924, oil on canvas, 72 x 36 in., Yale University Art Gallery, New Haven; bequest of Stephen Carlton Clark, B.A. 1903
 Los Angeles, New York, and Columbus only

My House, Woodstock, 1924, oil on panel, 17¾ x 22 in., Sid and Diana Avery Trust

Two Women, 1924, oil on canvas, 57 x 66 in., Portland Museum of Art, Maine; lent by Karl Jaeger, Tamara Jaeger, and Kerena Jaeger

The Picket Fence, 1924, oil on canvas, 26 x 38¼ in., Wellesley College Museum; gift of Mr. and Mrs. Chauncey L. Waddell (Catherine Hughes, Class of 1920)